A Garland Series

OUTSTANDING
DISSERTATIONS
IN THE

FINE
ARTS

The Descent from the Cross

Its Relation to
the Extra-Liturgical
"Depositio" Drama

Elizabeth C. Parker

Garland Publishing, Inc., New York and London

1978

All volumes in this series are printed
on acid-free, 250-year-life paper.

Library of Congress Cataloging in Publication Data

Parker, Elizabeth C
 The descent from the Cross.

 (Outstanding dissertations in the fine arts)
 Bibliography: p.
 1. Jesus Christ--Art. 2. Art, Medieval--Themes,
motives. 3. Drama, Medieval--History and criticism.
4. Liturgical drama. I. Title. II. Series.
N8053.2.P37 700 77-94713
ISBN 0-8240-3245-4

Printed in the United States of America

THE DESCENT FROM THE CROSS: ITS RELATION TO

THE EXTRA-LITURGICAL DEPOSITIO DRAMA

by

Elizabeth C. Parker

A dissertation in the
Department of Fine Arts
submitted to the faculty of
the Graduate School of Arts and Science
in partial fulfillment of
the requirements for the degree of
Doctor of Philosophy
at New York University

June, 1975

TABLE OF CONTENTS

INTRODUCTION

The starting point for this dissertation is Emile
Mâle's chapter on the influence of the liturgical drama on
the style and iconography of art in his book <u>L'Art Religieux
du XII siècle en France</u>. Although neither the first nor the
last word on the subject, Mâle succeeded in setting forth a
problem that continues to challenge art historians, particu-
larly as further texts and monuments come to light. While
Mâle's discussion took him in quite another direction, it
was his insight that the relation of art to the drama in es-
sence depends on their common source in the liturgy that led
to my concentration on the Good Friday <u>Depositio</u> drama and
the theme of the Descent from the Cross in art.

My intention is to examine and interpret the image of
the Descent from the Cross in the context of the Mass and
within the Easter liturgy. This approach is intended to
supplement rather than to deny the considerable work already
done on the subject of the Descent from the Cross. Previous
studies of this theme have analyzed variants within individ-
ual compositions and have served to establish the basic
iconography of the scene. Mainly concentrating on works of
the Gothic period and later, however, these studies have
left unanswered questions as to the meaning of certain icon-
ographic nuances outside the main line of the evolution.

More important, they fail to account for the monumental appearance of the scene in Romanesque art of the twelfth and thirteenth centuries.

In considering the place of the Descent from the Cross within the liturgy of the Mass, I propose to trace the allegorical meanings assigned to the Mass in eastern liturgies and the turn they took in western interpretations stemming from the ideas of Amalarius of Metz. Underlying this method is an assumption held by Mâle but only recently affirmed by the theater historian O. B. Hardison, Jr., that the medieval Mass must be considered genuine drama. Until this view was more widely taken, the extra-liturgical Depositio had no chance of being seen as anything more than a "quasi-dramatic form," in the words of Karl Young, who nonetheless pioneered in collecting the bulk of extant texts.

A reassessment not only of the Depositio as genuine drama but also of what it actually represents is necessary in order to begin to see the Good Friday drama in its proper relationship to the images of the Descent from the Cross. The Depositio will then be placed within the wider drama of the Easter liturgy as a whole and seen as an outgrowth of earlier rites originating at the Holy Sepulchre in Jerusalem as well as of the Mass liturgy. In this larger context, its meaning extends beyond its symbolism in the Mass to include the themes of Resurrection and the Last Judgment. To understand the full implications of these themes for the Depositio

and for the image of the Descent from the Cross, considera-
tion will be given to the symbolism of the parts of the
church where the Easter liturgy, including the Depositio,
was performed and where representations of the Descent from
the Cross are often found. Moreover, the iconography of the
early processional crosses associated with the Easter rites
will be analyzed to show how these themes were expressed in
them.

The monument which most fully conveys the meaning of
the Depositio within the Easter liturgy in an image of the
Descent from the Cross is Antelami's marble relief for the
roodscreen at Parma. Other examples will be discussed,
within their original context whenever possible, to show how
some or all of these meanings apply. To one work, the Bury
St. Edmunds Cross, I have devoted a detailed study in an
appendix since it has particular relevance for the question
of how the cross, having first been associated with the Eas-
ter rites, came to be used as a symbol of Christ in the Mass.

The idea for this dissertation emerged from a seminar
on Medieval Iconography with Professor Harry Bober. I am
particularly grateful to him for his patience and guidance
throughout the course of my research and writing.

I am also indebted to Professor Colin Eisler for the
many important insights and suggestions that he gave me, and
to Professor Hugo Buchthal for his generous help, especially
on points pertaining to Byzantine art. I appreciate the

opportunity to have made a preliminary study of the relation of the theme of the Descent from the Cross in Byzantine and western art in a seminar with Professor Buchthal, and of Italian Depositions in wood with Professor James Beck of Columbia.

In addition, I wish to thank my friend Professor Lotte Brand Philip and Professor Florens Deuchler, as well as Charles Little and Robert Nelson for their interest in my study and for their valuable suggestions as to literature and examples.

CHAPTER I

THE DESCENT FROM THE CROSS:

A NARRATIVE THEME?

Summary of Previous
Studies of the Theme

The theme of the Descent from the Cross has not been
neglected by art historians, but neither, it seems, has it
been fully understood.[1] Existing iconographic analyses are
essentially compositional discussions tracing a steady evo-
lution of the unnailing process and an ever greater intensity

[1]No distinction is made in this dissertation between
the terms "Deposition" and "Descent from the Cross." Louis
Réau, Iconographie de l'art Chrétien, II, Iconographie de la
Bible, 2, Nouveau Testament (Paris, 1957), p. 518, suggests
the Deposition properly refers to Christ unnailed from the
cross and laid out on the Stone of Unction. This scene,
however, is rare and usually conflated with the Lamentation.
 Along with that by Réau, the most important studies
of the Deposition are: Walter W. S. Cook, "The Earliest
Painted Panels of Catalonia," V, The Art Bulletin, X, No. 2
(1927), 193ff.; Emile Mâle, L'Art Religieux du XII siècle en
France (Paris, 1922), pp. 101-04; Raymond van Marle, "Die
Ikonographie der Afneming van het kruis tot het eind der
14de eeuv," Het Gildeboek, 1925 (not available in N.Y.C.);
Gabriel Millet, Recherches sur l'iconographie de l'Évangile
au XIV, XV et XVI siècles (Paris, 1916), pp. 467-88; idem,
"L'Art des Balkans de l'Italie au XIIIe siècle," Atti del V
Congresso internazionale di studi bizantini (Rome, 1940), II,
pp. 247-81; Otto Pächt, C. R. Dodwell, Francis Wormald, The
St. Albans Psalter (London, 1960), pp. 70ff.; Erna Rampen-
dahl, Die Ikonographie der Kreuzabnahme vom IX. bis XVI.
Jahrhundert (Bremen, 1916); Gertrud Schiller, Ikonographie
der christlicher Kunst, II (Gütersloh, 1968), pp. 177-81;
Evelyn (Sandberg) Vavala, La Croce Dipinta Italiana e l'ico-
nografia della Passione, 2 vols. (Verona, 1929).

of expressed grief, especially on the part of the Virgin.[2] The development is seen as a kind of cinematic progression in time from Depositions with Christ having both arms attached to the cross (San Zeno doors, Fig. 1),[3] to just one (Antelami's relief at Parma, Fig. 2),[4] and then with Nicodemus shifting his attention to the feet (Lectionary from St. Trond, Fig. 3),[5] while the Virgin, at first aloof (Salzburg Gospel Book, Fig. 4),[6] gradually increases her participation, first by taking hold of one hand (Reliquary top, Fig. 5),[7] and eventually of the whole body, Joseph having moved out of her way (St. Blasien Psalter, Fig. 6).[8] The

[2]Ibid., I, pp. 286-93, and her table, pp. 446-55, for the fullest analysis of this process.

[3]A. Boeckler, Die Bronzetür von San Zeno (Marburg, 1931). This section of the doors is dated ca. 1080.

[4]G. de Francovich, Benedetto Antelami, Architetto e Scultore e l'arte del suo tempo, 2 vols. (Milan, Florence, 1952). An inscription dates Antelami's marble relief in the Cathedral at Parma 1178.

[5]Morgan Library, M. 883, f. 51v. This manuscript is a mid-twelfth-century lectionary from Belgium thought to have been made for use at St. Trond: Medieval and Renaissance Manuscripts; Major Acquisitions of the Pierpont Morgan Library, 1924-1974 (New York, 1974), cat. no. 14.

[6]Morgan Library, M. 781, f. 223v, Austrian, first half of the eleventh century, from the Benedictine monastery of St. Peter, Salzburg, ibid., cat. no. 10.

[7]Bronze cast. Top of reliquary casket from Lorraine, now in the Victoria and Albert Museum, London, dated ca. 1130 by Hanns Swarzenski, Monuments of Romanesque Art (Chicago, 1955), cat. no. 154 (Fig. 341).

[8]St. Blasien Psalter, f. 93v: H. Bober, The St. Blasien Psalter, Rare Books Monographs Series, III (New York: H. P. Kraus, 1963), p. 51.

3

anomaly of the Cappadocian examples in which the earliest
versions already show Christ with both arms detached (Old
Church, Toqale, Fig. 7)[9] and His body held by the Virgin
(New Church, Toqale, Fig. 3)[10] has been pointed out by Mil-
let. Even so, he sees the main line of the evolution East
and West to have followed from the "reserved" Byzantine
Christ with one arm nailed to the cross to the more dramatic
and complex renderings of the body more nearly freed (Gospel
Book in Florence and Nerezi fresco, Figs. 9 and 10).[11] "Une
des plus vieilles images qu'il nous ait laissées, antérieure
à tous nos manuscrits byzantins, dans la nef de Toqale [Fig.
7], devrait se placer logiquement au terme de l'évolution."[12]

[9]Fresco of Deposition in the Old Church, Toqale Kilisse,
is part of a large gospel cycle on the wall of the nave, Guil-
laume de Jerphanion, Les églises rupestres de Cappadoce
(Paris, 1925). See also the drawing on plate 69. It is
dated 910-20 by M. Restle, Die Byzantinische Wandmalerei in
Kleinasien (Recklinghausen, 1967), I, p. 23.

[10]Deposition fresco in the New Church, Toqale Kilisse,
of the later tenth century, ibid., I, p. 24, is one of sev-
eral scenes below the central representation of the Cruci-
fixion in the conch of the central apse, Jerphanion, Cappa-
doce, pl. 84. A similar composition is found in another
Cappadocian monument, the Chapel of Tavchanle, dating to the
time of Constantine Porphyrogenitos (913-54), Millet, Re-
cherches, p. 596.

[11]Ibid., p. 474. Florence, Laurentian Library, Conv.
Soppr. 160, f. 213v, dated by Millet, ibid., p. 471, in the
tenth century, more probably belongs, as Prof. Buchthal has
explained (Seminar, Spring, 1971), in the eleventh century.
The Deposition from the little church at Nerezi, near Skoplje
in Jugoslav Macedonia, is one of a series of scenes depicting
the important feasts of the liturgical year. The frescoes
are dated 1164 by an inscription which reports that the
church was founded by a member of the Comnenian family, A.
Grabar, Art of the Byzantine Empire (New York, 1963), pp.
137-38.

[12]Millet, Recherches, p. 474.

Even if the chronology cannot be followed exactly and an eastern source for every iconographic nuance found in the West must at times be only supposed, this generalization has seemed "true enough" to accept. This approach has had the distinct advantage of providing at least some sort of handle to deal with a subject where even a cursory glance makes it safe to say that no two representations are exactly alike. Besides, one can recognize an overall development toward a more explicit humanizing of the theme and a tighter interlocking of the figures within the composition.

Moreover, this view of the scene's evolution conforms with an underlying view about its original conception as an emotional amplification of the Entombment episode. The Descent from the Cross is seen to have arisen as a subsidiary scene closely tied to the Entombment--a secondary subject, purely narrative, by no means obligatory in the Passion cycle.[13] There are any number of major Passion cycles where the scene is not included. When it does occur it is thought that it shares with the Entombment the emotions of grief-- the threnos--and that as these two scenes developed in time, they share an increase of the same emotions.[14] This assump-

[13]Kurt Weitzmann, "The Origin of the Threnos," De Artibus Opuscula XL: Essays in Honor of Erwin Panofsky, ed. by Millard Meiss (New York, 1961), p. 478.

[14]Idem, "A Tenth Century Lectionary. A Lost Masterpiece of the Macedonian Renaissance," Revue des Études Sud-Est Européennes, IX, No. 3 (Bucharest, 1971), 629: ". . . the grief and tender love which are so characteristic of the Virgin's behavior in both the Deposition and the Threnos . . .;"

tion prompts Millet, for example, to ascribe to the Virgin and to John attitudes not actually depicted: in the Paris Gregory (Fig. 11),[15] he describes them as "immobiles dans leur douleur."[16] Similarly, Pächt sees in an eleventh-century Descent from the Cross a reflection of the tendency of the scene "to shift the accent from the physical action of the Deposition to a lamentation over Christ's death,"[17] a shift which Weitzmann would attribute to the Macedonian Renaissance of the mid-tenth century.[18] The force of these emotions was seen to have been intensified as a consequence of the impassioned Greek Staurotheotokia--long lyric poems--and the Syrian Good Friday hymns, and the Western planctus laments.[19]

Cook, "Catalonia," pp. 203-04, more correctly characterizes the increased emotion as simply "tender sentiment."

[15]Homilies of Gregory Nazianzenus, Paris, Bib. Nat., Ms. grec 510, f. 30v, dated 883-86; H. Omont, Miniatures des plus anciens manuscrits grecs de la Bibliothèque Nationale (Paris, 1929).

[16]Millet, Recherches, p. 470.

[17]Pächt, The St. Albans Psalter, p. 70, Fig. 120a, referring to the Militene Gospels, dated 1067.

[18]Weitzmann, "A Tenth Century Lectionary," p. 628.

[19]Yrjö Hirn, The Sacred Shrine (Boston, 1957), p. 275, adds that the emotional element is stronger in the writing of the East than of the West. Karl Young, Drama of the Medieval Church (Oxford, 1962), I, pp. 493ff., for the planctus. Otto von Simson, "Compassio and Co-Redemptio in Roger van der Weyden's Descent from the Cross," The Art Bulletin, XXV, No. 1 (1953), 10-16. See literature cited in notes 12, 13, and 15 on p. 11. Otto Demus, The Mosaics of Norman Sicily (London, 1949), p. 420, attributes the new dramatic spirit in the representations of the Comnenian period partly

Compositional borrowings from Crucifixion scenes can
easily be recognized: the so-called "early phase" with both
arms still attached to the cross is a clear transposition
from a Crucifixion, as is the upright pose of Mary and John;
so, too, are such features as the sun and moon, attending
angels, and the soldiers gambling for the cloak.[20] But such
elements are seen as pictorial embellishments without any
real bearing on the essential meaning of the Descent from the
Cross--"un épisode purement narratif, sans importance au
point de vue liturgique."[21] In the East this image at times
achieved a liturgical status equal in importance to the Cru-
cifixion, but this development is seen as an emendation of
its original conception.[22] The eastern practice of allowing
the Deposition to serve on a par with--and at times even to
replace--the Crucifixion in great feast pictures is consid-
ered only an offshoot of the main line of its evolution in a
subsidiary place within a cycle.[23] The narrative view holds

"to the growing influence of religious theatre in Byzantium"
and partly to the intense interest in mysticism in the first
two decades of Manuel's reign.

[20]These features borrowed from the Crucifixion can be
seen, for example, in the Descent from the Cross on the San
Zeno doors and in Antelami's Parma relief (Figs. 1 and 2).

[21]Réau, Iconographie, II, p. 519.

[22]Kurt Weitzmann, Catalogue of the Byzantine and Early
Medieval Antiquities in the Dumbarton Oaks Collection, III:
Ivories and Steatites (Washington, 1972), pp. 65-68.

[23]For examples of the Descent from the Cross achieving
the liturgical importance of a Crucifixion, see the bilateral
icon from the Monastery at Serres, dated late thirteenth or

for western Depositions, too, because they occur in consid-
erable number only after the twelfth century and then usu-
ally in the context of a cycle.[24] Later versions where the
scene emerges as a powerful devotional image--those by Roger
van der Weyden or Rubens, for example (Figs. 12 and 13)[25]--
are not regarded as a full-blown statement of the theme's
original intent; rather, they are seen as a fusion of a
semi-historical scene charged with the emotions of the Lamen-
tation and the eucharistic connotations of the Man of Sorrows
theme.[26] Thus, these later Depositions are considered a
transformation of the earlier representation into a new or-
der, an Andachtsbild--a compelling example of "image by aug-
mentation."[27]

early fourteenth century, P. Milkjović-Pepek, "Une icone bi-
lateral au Monastère de Saint-Jean-Prodome dans les environs
de Serres," Cahiers Archéologiques, XVI (1966), 177, and the
icon from Mount Athos (at Vatopedi), O. Demus, Byzantine Art
and the West (New York, 1970), Fig. 47. The expected repre-
sentation would be either a cross or a Crucifixion.

[24]Demus, Mosaics of Norman Sicily, p. 272, notes that
the first appearance in monumental painting was not before
the mid-eleventh century at Nea Moni, Chios. Even in monu-
mental cycles, the narrative is not always primary, see for
example note 11 on Nerezi.

[25]Roger van der Weyden, Descent from the Cross, ca.
1435 in the Escorial. Peter Paul Rubens, Descent from the
Cross, Antwerp Museum, 1611-14, midpart of an altarpiece.

[26]Sixten Ringbom, Icon to Narrative (Abo, 1965), pp.
67-68; Von Simson, "Compassio," pp. 12 and 16.

[27]Ringbom, Icon to Narrative, pp. 66-68, and p. 124.

Elements Which Do Not Conform

The foremost difficulty with the traditional analysis of the evolution of the theme lies with the fact that a considerable number of Depositions of the twelfth and thirteenth centuries particularly, scattered though the examples may be, do not fit this view at all. Some, monumental in size, stand completely apart from the framework of a cycle. Such is the case, for example, with the large stone relief at the Externsteine and Antelami's Deposition at Parma (Figs. 14 and 2);[28] the same is true for the large wood groups from Italy, Spain and France (Figs. 15-17).[29] A few fill tympana, as at Foussais (Fig. 18)[30] and Lucca (Fig. 20).[31] In each

[28]The Descent from the Cross at the Externsteine, near Horn, Germany, is dated 1115-30, M. Creutz, Die Anfänge des monumentalen Stiles in Norddeutschland (Cologne, 1910), pp. 57-60; for Antelami's Parma relief, see note 4.

[29]The Tivoli group, dated in the first quarter of the thirteenth century, is the earliest of the Italian Deposition groups preserved, G. de Francovich, "A Romanesque School of Wood Carvers in Central Italy," The Art Bulletin, XIX (1937), 5-57. The Spanish group from Eril-la-Vall, at M.A.C., Barcelona and at Vich, see P. de Palol and Max Hirmer, Early Medieval Art in Spain (London, 1967). The earliest of all preserved examples of this type is the exceptionally fine French Courajod Christ in the Louvre dated to the second quarter of the twelfth century, see M. Aubert, Encyclopédie Photographique de l'art: Le Musée de Louvre; Sculptures du Moyen Âge (Paris, 1948), p. 18. See Chapter IV, p. 179, for further discussion of these groups.

[30]The Deposition in the north lunette of the west facade of the Church of St.-Hillaire at Foussais (Vendée) was inscribed by Giraud Audibert of St.-Jean-D'Angely and is generally dated ca. 1140, see W. S. Cook, "The Earliest Painted Panels of Catalonia," IV, The Art Bulletin, X, No. 2 (1927), 197, who tried to show the derivation from it of the Deposition relief in the cloister at Silos (Fig. 19). See Palol, Early Medieval Art in Spain, p. 480, for the now accepted dating of the Silos relief.

[31]The damaged tympanum of San Martino, Lucca, has

case they function in place of a Crucifixion. In fact, in

this form, it is the Deposition rather than the Crucifixion

which takes precedence in the Romanesque period.[32]

been widely attributed to Nicola Pisano. See, for example,
G. H. and E. R. Crichton, Nicola Pisano and the Revival of
Sculpture in Italy (Cambridge, 1938), pp. 111-12, who place
it chronologically between the Siena pulpit and the Perugia
fountain, i.e., 1260-77.

[32]Another example, little known, for which I thank
Prof. Lotte Brand Philip, is the Deposition on the portal
tympanum of the chapel at Schloss Tirol, near Meran, dated
ca. 1150 (Fig. 21).
Other tympanum reliefs show the Deposition in place
of the Crucifixion as the center of a three-part scene, for
example on the early twelfth-century Puerta del Perdon on
the Church of San Isidoro, León (Palol, Early Medieval Art
in Spain, Figs. 96 and 97) and the mid-twelfth-century tym-
panum at Oloron-Ste.-Marie (Basses Pyrenées), see A. K.
Porter, Romanesque Sculpture of the Pilgrimage Roads (Bos-
ton, 1923), IV, Fig. 461. The two arched subdivisions are
inaccurate nineteenth-century reconstructions. A similar
three-part arrangement with the Deposition in the center is
found on the twelfth-century architrave from Monopoli in
Southern Italy (ibid., III, Fig. 157) and in an early thir-
teenth-century Apulian relief from Monte Sant'Angelo in Fog-
gia (ibid., III, Figs. 197 and 198).
Also to be considered with Depositions in monumental
form are reliquaries such as the one from Lorraine in the
Victoria and Albert Museum in London (Fig. 5 and note 7).
Another, from St. Servatius in Maastricht in the Germanische
Nationalmuseum in Nuremberg of ca. 1100, combines a Deposi-
tion and an Entombment (Fig. 22), see A. Essenwein, "Ein
Reliquar des 11. Jahrhunderts in der Sammlungen des German-
ischen Museums," Anzeiger für Kunde der deutschen Vorzeit,
N.F., LXX, No. 1 (1870), 6-8. A third example is an ivory
fragment of a Deposition perhaps from Bamberg, dated between
1070 and 1100, and now in the Schnütgen Museum in Cologne,
see Das Schnütgen Museum, eine Auswahl (Cologne, 1968), cat.
no. 13 (Fig. 32).
Examples of Crucifixions may be found at Lavoute
Chilhac (Haute Loire), of the second half of the twelfth
century; at Dienne (Cantal), mid-thirteenth century; and
Lanvandieu (Auvergne) now in the Louvre, 1130-40, see Gott-
fried Edelmann, "Notes on Wood Corpus for Crucifix, Catalan,
XII c.," Isabella Stewart Gardner Museum, October 28, 1958,
unpublished, who records the doubt that the torso in the
Metropolitan Museum in New York which has been related to

The substitution of the Deposition for the Crucifixion in monumental works occasionally occurs within a cycle as well, becoming the focal point of the program as a whole. Examples of this format in fresco and sculpture may be found at St.-Savin-sur-Gartempe (Fig. 23)[33] and in the thirteenth-century Host container at the Metropolitan Museum in New York (Fig. 24).[34] The substitution also takes place when the scene is one among many given equal prominence within a cycle: in manuscripts such as the St. Albans Psalter (Fig. 25),[35] on cloister capitals, as at La Daurade (Fig. 26),[36]

this head actually belongs to it because of the two different kinds of wood involved. These examples are all from the Auvergne but it is in fact also rare to find Crucifixions elsewhere in monumental form in this twelfth-century period.

[33]The late eleventh-century Deposition at St.-Savin-sur-Gartempe is centrally located on the west gallery wall. In its monumental size and semicircular format, it is directly comparable to a west portal tympanum, see P. Deschamps and M. Thibout, La Peinture Murale en France (Paris, 1951).

[34]Tabernacle, champlevé enamel and copper gilt on wood frame, French, Limoges, dated second half thirteenth century by the Metropolitan Museum of Art in New York, and 1225-35 by M.-M. Gauthier, Émaux du moyen âge occidental (Fribourg, 1972), p. 372, cat. no. 130. The Descent from the Cross is the central representation on the inside of the back panel.

[35]Hildesheim, Library of St. Godehard, p. 47, full-page miniature in a series of scenes showing the life of Christ, see Pächt, The St. Albans Psalter, pp. 70ff. and 90. The Psalter is dated pre-1123, ibid., p. 5.

[36]Cloister capital from Ste.-Marie-la-Daurade, now in the Musée des Augustins, Toulouse, ca. 1120, see Paul Mesplé, Toulouse, Musée des Augustins: Les sculptures romanes (Paris, 1961), pl. 134. A Descent from the Cross within a series of capitals may be found in Spain at the Church of San Pedro el Viejo at Huesca (Aragon), the Cathedral at Tarragona, see Cook, "Catalonia," IV, Figs. 70 and 71; Pamplona Cathedral,

and in fresco.[37] Even here, however, there has to be a ques-

tion as to whether the subject is selected more for its li-

turgical importance than simply as a scene from the life of

Christ.[38]

Nor is the grief of the Virgin the dominant emotion;

ca. 1145, and Santillana del Mar (Santander), ca. 1200, see
Palol, Early Medieval Art in Spain, Figs. 141 and 231.

[37]Mid-twelfth-century French Depositions occur in the
extensive fresco cycle in the crypt of the Church of St.-
Nicholas at Tavant (Indre-Loire); to the right of the chancel
arch at the Church of St. Martin, Nohant Vicq, see Otto
Demus, Romanesque Mural Painting (New York, 1970), pp. 124-
25; and as the third of six major representations in the
circular chapel at St. Jean-du-Liget, Chemille-sur-Indrois
(Indre-Loire), ca. 1200, see Paul Deschamps, La Peinture
Murale en France au début de l'époque gothique, 1180-1380
(Paris, 1963), Fig. 10. In these cycles no scene is cen-
trally weighted but the Deposition in each case takes the
place of the Crucifixion. The scene also occurs in place of
the Crucifixion within a cycle on doors--at San Zeno, Verona
(Fig. 1 and note 3) and at Nowgorod, see A. Goldschmidt, Die
Bronzetüren von Nowgorod und Gnesen, pl. II, 1. It appears
as a single scene together with the Harrowing of Hell on
each of the three bronze doors by Barisanus of Trani, at
Trani, ca. 1174; at Ravello, 1179 (dated by inscription);
and at Monreale, end twelfth century, see Albert Boeckler,
Die Bronzetüren des Bonanus von Pisa und des Barisanus von
Trani (Berlin, 1953), Figs. 97, 131, and 147.

[38]It is not possible to examine individually each pro-
gram here cited. However, while some apparently do have a
primarily narrative intent, it is clear that the selection
in some cases depends on a particular iconocraphic emphasis
or on a program of feast day representations. A selective
symbolic use of the scene in Barisanus' doors is also found
in the pulpit originally from the Church of San Pietro Scher-
ragio, Florence, and now in San Leonardo in Arcetri, see
Crichton, Romanesque Sculpture, Fig. 63b. Compare its place-
ment here on the front of the altar to the left of the Tree
of Jesse with W. Biehl, Toskanische Plastik des Frühen und
Hohen Mittelalters (Leipzig, 1920), pl. 125c and d, where it
is seen on the side to the right of the Baptism. A compara-
ble selectivity is true at the cloister of the monastery of
Santo Domingo at Silos, Palol, Early Medieval Art in Spain,
Fig. 96, see also note 20.

in a number of works she is not even present. In the earliest known western depiction of a Descent from the Cross in the Angers Gospels of the first half of the ninth century, only Joseph and Nicodemus are shown in the act of removing Christ's body from the cross (Fig. 27).[39] The same small group is also seen in late tenth- and eleventh-century representations: in the Codex Egberti (Fig. 28),[40] in the Gospels of Otto III (Fig. 29),[41] and in the Codex Aureus in Nuremberg,[42] to name but a few.[43] This composition with Joseph more nearly carrying the body of Christ--and no Virgin--persists throughout the twelfth century in this northern region. It is depicted thus in the mid-century lectionary from St. Trond (Fig. 3) and on two ivory plaques of the first half of the century: one in Rouen, thought to be

[39]Angers Gospels, Angers, Mun. Lib. Codex 24, North French. Schiller, Ikonographie, dates it in the second half of the ninth century.

[40]Codex Egberti, ca. 980, Trier, Stadtbibliothek Cod. 24, fol. 85b, see Codex Egberti der Stadtbibliothek Trier, ed. by Hubert Schiel (Basel, 1960).

[41]Gospels of Otto III, Aachen, Treasury, ca. 1000. W. Vöge, Eine deutsche Malerschule um die Wende des ersten Jahrtausends; kritische Studien zur Geschichte der Malerei in Deutschland im 10. und 11. Jahrhundert (Lintz, 1891), p. 61.

[42]Codex Aureus of Nuremberg, Germanische Nationalmuseum; see Peter Metz, The Golden Gospels of Echternach (New York, 1957), p. 84, for his dating of ca. 1040, while H. Schnitzler, Rheinisches Schatzkammer (Dusseldorf, 1957), dates them 1020-30.

[43]For other examples, see Gottingen Univ. Lib. Cod. Theol. 231, f. 58v, ca. 975; Sacramentary from Fulda, Bamberg State Lib. Ms lit. 1, f. 68, ca. 1020, see Schiller, Ikonographie, Figs. 546-47; and Pericopes of Henry III, Bremen State Library, 1030-40, Millet, Recherches, p. 468, n. 2.

either English or Northern French by Goldschmidt, and the
other in the Morgan Library, which he calls English (Figs.
30 and 31).[44] In addition, there is a fine Christ figure in
stone from Cambrai of about 1180 in the Palais des Beaux-Arts,
Lille, which proved to be part of a Deposition when a frag-
ment of Joseph of Arimathea with Christ's right hand on his
shoulder was discovered (Fig. 33).[45] The placement of the
hand tends to preclude the presence of the Virgin in the
original group, for she would ordinarily hold that hand, or
reach for it, as it hangs free from the cross.

Also Northern French or possibly English is another
fine fragment, an ivory Deposition of the early thirteenth
century with only Christ and Joseph, in the Hunt Collection
in Dublin (Fig. 34).[46] On the outer limits of the Romanesque

[44]See note 5 for St. Trond Lectionary. Adolph Gold-
schmidt, Die Elfenbeinskulpturen aus der Zeit der Karoling-
ischen und sächischen Kaiser, IV (Berlin, 1926), notes on
pl. VI, Fig. 22, and Pl. VIII, Fig. 30. One cannot be sure
of the original form of the late eleventh- or early twelfth-
century Rhenish Deposition fragment, probably from Bamberg,
in Cologne (Fig. 30), but affixed to a cross atop a reliquary
base, it is not likely that the figures of Mary and John were
included. See note 32.

[45]This pair from Lille may have belonged to a sculp-
tured group placed above the tomb of Bishop Nicholas (d.
1167) on the porch under the western belfry of Cambrai Ca-
thedral, near an altar to St. John, see J. Vanuxem, "Portails
détruits de Cambrai et d'Amiens," Bulletin Monumental, CIII
(1945), 92; see also idem, "La sculpture du XII siècle à
Cambrai et à Arras," Bulletin Monumental, 1955, pp. 7-35,
for discussion of the style, as well as The Year 1200, I:
The Exhibition, Metropolitan Museum of Art (New York, 1970),
p. 1 and Fig. 1, and W. Sauerländer, "Die Marienkronungspor-
tale von Senlis und Nantes," Wallraf-Richartz Jahrbuch, XX
(1958), p. 133.

[46]Year 1200, cat. no. 56, pp. 48-49. Walrus ivory,
dated 1200-05 in collection of Mr. and Mrs. John Hunt, Dublin.

style, it represents a high point in both craft and expressive power. Emotion is conveyed not simply by the faces but through the heaviness of the drapery, the limp pose of Christ, the firm grip of Joseph, and even such a telling detail as the upward turn of the open-toed foot of Christ. An undeniable potential for eliciting the emotion of grief from the viewer in the very nature of the subject is perhaps one reason for a tendency to misread the emotions actually portrayed. Here the emotion depicted is not grief; it is Christ's endurance and Joseph's compassion. The intensity of this work which is due to the energetic containment of these feelings within the compact forms of the two figures becomes diffused in an ivory of the latter half of the century in the Louvre which is related in kind to this group of northern Depositions (Fig. 35).[47] Even though now fully Gothic and more naturalistic in pose and delineation of form, the monumentality and power of the earlier work has here given way to the cooler elegance of the Parisian court style. While similar to the Hunt ivory in the position of Joseph and Christ, a place has now been made for the Virgin; but still she appears as only an appendage to the central pair. Taken as a whole, then, these northern works provide a sobering balance to the view that the Virgin must play a dominant role in the scene and that the expression of her grief is

[47]R. Koechlin, Les Ivoires Gothiques Français, II (Paris, 1924), pp. 8-9, notes on Pl. VIII, no. 19, dated to the third quarter of the thirteenth century.

paramount.

Moreover, the context in which Depositions occur in
preserved Byzantine works must further modify the traditional
stress on the evolution of the theme as a narrative scene.
The earliest eastern example of a Descent from the Cross oc-
curs on the Crucifixion leaf of the Paris Gregory, a Con-
stantinopolitan work dated 879 (Fig. 11).[48] Here the Cruci-
fixion is made the dominant image by virtue of its size and
by the way the cross extends into the register below showing
the Deposition and Entombment. These two scenes are also
subordinated to the image of the Resurrection--the rather
unusual representation of the risen Christ appearing outside
the tomb to two prostrate Maries--depicted at the bottom in
a register of its own. It has been shown that in the present
binding of the Gregory, this page has been misplaced: the
text belonging to this miniature is the First Oration for
Easter, with readings drawn from the Gospel of John.[49] The
scenes on this page are clearly not set out as straight nar-
rative. Rather a new concept of illustration seen elsewhere
in the Gregory is at work whereby the miniatures are to be

[48]The Paris Gregory, see note 15, was written for
Emperor Basil I. It has been dated 883-86 on the basis of
the death of Basil's wife Eudokia, see Sirapie der Nerses-
sian, "The Illustrations of the Homilies of Gregory of Nazi-
anzus, Paris, grec. 510," Dumbarton Oaks Papers, XVI (1962),
197. However, Prof. Buchthal very kindly pointed out to me
that a recent article in Cahiers Archéologiques, vol. XXIII
(not yet available), sets the date at 879.

[49]Ibid., p. 218.

seen as "theological exegesis in pictorial form"--a "symbolic
interpretation of the text in order to focus the reader's at-
tention on the main thesis of the oration."[50] The special-
ized format of the page is the primary clue to its proper
reading.

Although the scene occurs on the tenth- and eleventh-
century ivories, there is a gap in manuscript examples of
Depositions after the Gregory until the eleventh century.
It occurs in Florence, Laur. VI. 23, where it is part of a
continuous narrative.[51] Paris Ms. gr. 74, on the other hand,
is a gospel cycle under the influence of feast scenes and
accordingly has a more liturgical character.[52] It is a rec-
ognized characteristic of the illumination in such gospel
lectionaries that it forsakes the simple descriptive form for
the hieratic and iconic mode; the intention was to focus on
the liturgical elements embodied in a given scene.[53] Simi-

[50]Ibid., p. 227.

[51]Florence, Laurentian Lib. Cod. Plut. VI. 23, f.
59v, see Tania Velmans, "Le Tetraévangile de la Laurentienne,"
Bibliothèque de Cahiers Archéologiques (Paris, 1971).

[52]Paris, Bib. Nat. Cod. gr. 74, f. 59v, see H.
Omont, Évangiles avec peintures byzantines du XI siècle
(Paris, 1916).

[53]Kurt Weitzmann, "Narrative and Liturgical Gospel
Illustrations," pp. 64ff. (cf. M. M. Parvis and A. P. Wil-
gren, eds., New Testament Manuscript [Chicago, 1950], pp.
151-74, 215-19) and Weitzmann, "Byzantine Miniature and
Icon Painting," pp. 290ff. (cf. Proceedings of XIII Inter-
national Congress of Byzantine Studies, Oxford, Sept. 1966
[London, 1967], pp. 207-44) reprinted in idem, Studies in
Classical and Byzantine Manuscript Illumination (Chicago,
1971), pp. 247-70; 271-313.

larly, the ivories are iconic depictions of liturgical acts.
Preserved examples, such as the one in the Victoria and Al-
bert Museum in London (Fig. 38),[54] usually formed part of a
diptych or triptych to be used as a small altarpiece for
private devotions.[55] The Deposition, when it occurs, could
either be a side scene or a central one, shown alone or to-
gether with a Crucifixion or an Entombment.[56] These ivories

[54]Adolph Goldschmidt and Kurt Weitzmann, Die Byzan-
tinischen Elfenbeinskulpturen des X.-XIII. Jahrhunderts, II
(Berlin, 1934), for ivory in Victoria and Albert Museum,
London (5-1872), see notes to Pl. VII, no. 23, right side of
diptych, dated in eleventh century, belonging to so-called
"malerische" group. Kurt Weitzmann, "A Tenth Century Lec-
tionary, A Lost Masterpiece of the Macedonian Renaissance,"
Revue des Études Sud-Est Européennes, IX, No. 3 (Bucharest,
1971), places it in the mid-tenth century.

[55]Prof. Buchthal, Seminar, Spring, 1972.

[56]Goldschmidt-Weitzmann, Die Byzantinischen Elfen-
beinskulpturen, collect the following other examples:
Tenth century: pl. VIII, no. 25: Quedlinburg, Church
Treasury, Rahmen group; pl. XVII, Fig. 40: Hannover, Pro-
vinzialmuseum, left side of a diptych, Romanos group, Cru-
cifixion with a Deposition; pl. XXVIII, Fig. 71: Dumbarton
Oaks Collection (ex Chalondon Collection, Paris), center of
a triptych, Deposition alone (see also Weitzmann, Dumbarton
Oaks Catalogue, III, No. 27, 65-69); pl. XLVI, Fig. 127:
Victoria and Albert Museum, London, series of twelve plaques
(no Crucifixion), Nikephoros group.
Eleventh century: pl. VI, Fig. 22a: Munich, Staats-
bib. Cod. lat. 6831, Cim. 181, triptych with Crucifixion
above and Deposition/Entombment, Malerische group; pl. LVIII,
Fig. 204 (our Fig. 39): Ravenna, Mus. Bizantino, Deposition
Entombment, from a diptych with Birth of Christ (Fig. 203,
pl. LVII), Rahmen group; pl. LXVIII, Fig. 207: Berlin,
Staatsbib. cod. theol. lat. 3, middle plaque of triptych,
Deposition main scene with Entombment below, Rahmen group;
pl. LXVIII, Fig. 208; Rosgarten Museum, Constance, Deposi-
tion/Lamentation, center of triptych or an icon, Rahmen
group, same artist as Fig. 207 above; pl. LXVIII, Fig. 209:
London, Ludlow Collection, center of a triptych with Deposi-
tion/Anastasis/Lamentation/Koimesis, Rahmen group; pl. LXIX,
Fig. 211 b (and a): Pesaro, Museo Palazzo Ducale, Wings of a

when transported to the West were often separated into single

plaques, but, applied as they were to the covers of Gospel

books, their representations continue to convey their pri-

marily liturgical meaning. Only later does the scene begin

to take its traditional place in monumental narrative cycles

both in Byzantine art and in the West.[57]

Critique of Narrative
View of the Theme

Despite the non-narrative character of these early

examples from Byzantine art, it is Weitzmann's view that

they nonetheless betray a narrative source for the Deposition

triptych, Nativity/Deposition (with Fig. 211 a, Annunciation/
Crucifixion), center perhaps an Ascension (Vatican, Mus.
Christiano, Fig. 210), Rahmen group; pl. LXX, Fig. 219:
Hildesheim, Treasury, Rahmen group, Deposition. Inscription--
Episcopus Anno Domini Millesimo VI, Pontificis Ordinationis
Anno/ XII. Explicui ad diem Sancti Michaelis/ Archangeli in
nomine Domini--is late (fourteenth century). This plaque
must have come to Italy by the twelfth century, since it was
copied there. See pl. LXX, Fig. 220, where it is dated
twelfth-thirteenth century, but The Year 1200, cat. no. 75,
p. 67, dates it 1180-1200.

[57]The earliest post-iconoclastic mosaic cycles were
not strictly narrative. The program of those at the Church
of the Holy Apostles in Constantinople of the ninth century,
Weitzmann says, "was not a mere narration of the life of
Christ. Only certain scenes were chosen and these for par-
ticular reasons in some ways similar to the purposes of the
lectionary." See Weitzmann, "Narrative and Liturgical Gos-
pel Illustrations," p. 260. The Descent from the Cross does
not seem to have appeared in this cycle, see notes 105-07.
Demus, Mosaics, p. 272, says this scene does not appear in
Byzantine monumental painting before the mid-eleventh cen-
tury at Nea Moni, Chios. See Millet, Recherches, pp. 31-52,
for discussion of liturgical and passion cycles. The Descent
from the Cross occurs in the mosaic cycle at Monreale, 1172-
89, cf. Demus, Mosaics, p. 100, and pl. 71 B (drawing after
Gravina). See p. 18 for discussion of cycles of rock churches
in Cappadocia.

image.[58] His argument is important to consider in some de-
tail, because it represents an attempt to prove the prevail-
ing assumption regarding the nature of the theme. In the
Gregory page and in ivories such as the one in Munich (Fig.
39), he thinks the original narrative conception has been
subsumed by the format of the tri-partite great feast picture
taken from a lectionary that had served as their immediate
model.[59] The Deposition ivories, especially those of the
malerische group, "must surely hark back to painted models,"
he says.[60] The Deposition and Entombment representation in
the Gregory he sees as a fusion of two scenes which existed
as distinct scenes in a pre-iconoclastic picture cycle; spe-
cifically the painted model is an illustration for the Gospel
of John.[61]

[58]Weitzmann, "Threnos," pp. 478ff. (see note 13).
This article is the fullest discussion of his view of the
origin of the Deposition scene. In his most recent discus-
sion of the subject, he seems to suggest that the Descent
from the Cross was derived from the Crucifixion in the first
instance: "The Deposition as seen from its earliest stage
developed from a Crucifixion proper and, in the course of
time, the composition became more and more independent and
acquired a distinct character of its own. Yet, like the
Crucifixion, it was a feast picture for Good Friday and the
two were interchangeable. It is only because of this litur-
gical importance as an alternate icon for the great feasts
that the Deposition could be chosen as the central subject
of a devotional triptych," cf. Dumbarton Oaks Catalogue, p.
68. Nevertheless, his assumption of a non-liturgical narra-
tive source for the image lingers in his observation that the
"genre element of the ladder has been eliminated," ibid., p.
67. See notes 56 and 84.

[59]Idem, "Threnos," pp. 480-82; idem, "Lectionary," p.
3; idem, Dumbarton Oaks Catalogue, p. 68. See note 56, for
Munich ivory.

[60]Idem, "Threnos," p. 480. [61]Ibid., pp. 479-80.

For a start one must question the idea of a great
feast picture as model. There are no surviving examples be-
fore the eleventh century and none at all that have the tri-
partite format. Even the mid-tenth-century lectionary that
Weitzmann reconstructs would be too late to refer to the
Gregory page.[62] Moreover, it is not so likely that the Dep-
osition, which is an alternate scene in only some of the
later great feast pictures, would have been part of the ear-
liest series--much less an Entombment, which is never part
of this genre insofar as it is preserved.[63] The construction
of this source for the Gregory is further strained by his
having drawn only from the top two-thirds of the miniature
to make the analogy (Fig. 40).[64]

Secondly, the idea that the Deposition and Entombment
depicted in the Gregory originally existed as separate enti-
ties in a single Gospel cycle model is belied by the dis-
tinctly different styles in which the two scenes are ren-
dered. This difference is even more puzzling when one thinks
that the two scenes were supposed to have been previously
combined in the intermediary model, the lectionary. While
the depiction of the Entombment conforms to the contemporary
style of Constantinopolitan art seen elsewhere on the page,

[62]Idem, "Lectionary," passim.

[63]See Millet, Recherches, chart on p. 23 from his
chapter on feasts, pp. 15-30.

[64]Weitzmann, "Threnos," p. 479. Full page, see Fig.
and note 11.

the Descent from the Cross has alien features which betray a
separate source: the short tunics of Nicodemus and Joseph,
the short hair of Christ, and His representation with the
left arm as well as the right one detached from the cross.[65]
Moreover, a graceful fluidity in the conception of the figures
individually and as they are combined in a cohesive group,
characteristic of the sophisticated Byzantine court style of
this period, is here denied by an unlooked-for rigidity of
pose and a treatment of drapery which is on the one hand
rather summary--in the figures of Joseph and Nicodemus--and
on the other overdrawn and unclear--in the figure of the
Virgin. The rendering of the Virgin in the Descent, as con-
trasted to the figure of John just beside her or to the Vir-
gin in the Crucifixion, betrays a tentativeness perhaps due
to an unfamiliar model or to her having been drawn into the
scene from a separate source.[66]

But even if one were to discount such stylistic dif-
ferences between the two scenes as a denial of a common
source, we are still plagued by a dearth of preserved exam-
ples of either a Descent or an Entombment in any early Gospel
illustrations. As for ascribing these scenes to a cycle for

[65]Rampendahl, Die Ikonographie der Kreuzabnahme, p.
17, suggests a Syrian source but this cannot be proved.

[66]Weitzmann, "Threnos," p. 480, sees a reflection of
an earlier Byzantine Entombment composition in the marginal
psalter dated end ninth century from Mount Athos, Pantocrator
61, fol. 122 (illustration to Psalm 87,7--Vulgate 88,6--
Weitzmann, Fig. 1). The roots of the Descent from the Cross,
however, would seem to be distinct from the Entombment.

the Gospel of John, while it may make some sense for the En-
tombment since this is the only account to include Nicodemus
in that scene, John is one of the two Gospels which does not
describe the Descent from the Cross. Only Mark and Luke--
in a single phrase--specifically refer to the act of removing
the body from the cross; Mark's account is the more explicit:[67]

> It was now evening, and since it was Preparation Day
> (that is, the vigil of the sabbath), there came Joseph
> of Arimathaea, a prominent member of the Council, who
> himself lived in the hope of seeing the kingdom of God,
> and he boldly went to Pilate and asked for the body of
> Jesus. Pilate, astonished that he should have died so
> soon, summoned the centurion and enquired if he was al-
> ready dead. Having been assured of this by the centu-
> rion, he granted the corpse to Joseph who brought a
> shroud, took Jesus down from the cross, wrapped him in
> the shroud and laid him in a tomb which had been hewn
> out of the rock. He then rolled a stone against the en-
> trance to the tomb. Mary of Magdala and Mary the mother
> of Joset were watching and took note of where he was laid.

Luke's is a shortened version of Mark:[68]

> Then a member of the council arrived, an upright and
> virtuous man named Joseph. He had not consented to what
> the others had planned and carried out. He came from
> Arimathaea, a Jewish town, and he lived in the hope of
> seeing the kingdom of God. This man went to Pilate and
> asked for the body of Jesus. He then took it down,
> wrapped it in a shroud and put him in a tomb which was
> hewn in stone in which no one had yet been laid. It was
> Preparation Day and the sabbath was imminent.

Matthew and John skip from Pilate's allowing Joseph to have
the body to a description of the burial, only alluding to
the fact that the body was "taken."[69] In none of the accounts

[67]The Jerusalem Bible (New York, 1966), Mark 15:40-47.

[68]Ibid., Luke 23:50-53.

[69]Ibid., Matthew 27:55-66; John 19:38-42.

is the Virgin present at either moment. Thus, the Gospels
cannot readily be seen as the direct source for the repre-
sentation of the Descent from the Cross in art.

Literary Sources for the
Descent from the Cross

Descriptive embellishments of the scene of the Descent
from the Cross in the literature develop only gradually. The
evidence we have not only denies the conception of the scene
as narrative but casts into doubt its emotional bond with
the Entombment as well. The account in Recension A of the
Apocryphal Gospel of Nicodemus, the _Acta Pilati,_ dating not
earlier than the fourth century, closely follows the version
in Luke:[70]

> But a certain man named Joseph, a member of the Council,
> from the town of Arimathaea, who also was waiting for
> the kingdom of God, this man went to Pilate and asked
> for the body of Jesus. And he took it down, and wrapped
> it in a clean linen cloth, and placed it in a rock-hewn
> tomb, in which no one had ever yet been laid.

The story begins to take a broader shape in the ninth-century
Recension B of the _Acta Pilati._[71] Lamentations by Joseph,
the Virgin and the Magdalen are added to the burial. Jo-
seph's visit to Pilate to ask for the body is extended into
a separate scene. In one version, the Virgin asks him to do

[70]For date of Recension A, see M. R. James, The Apoc-
rhyphal New Testament (Oxford, 1926), p. 94; see also Edgar
Hennecke, New Testament Apocrypha, ed. by Wilhelm Schnee-
melcher, I (Philadelphia, 1963), pp. 444-47; for text, p. 460.

[71]James, The Apocryphal New Testament, p. 115. Three
later Greek manuscripts, no known copy earlier than the fif-
teenth century.

this; in another, Nicodemus although refusing to go with him
to Pilate, agrees to help with the burial:[72]

> And as the day of preparation was drawing towards eve-
> ning, Joseph, a man well-born and rich, a God-fearing
> Jew, finding Nicodemus whose sentiments his foregoing
> speech had shown [in a previous chapter Nicodemus had
> spoken in behalf of Jesus before Pilate during his trial],
> says to him: I know that thou didst love Jesus when liv-
> ing and didst gladly hear his words, and I saw thee
> fighting with the Jews on his account. If then it seem
> good to thee, let us go to Pilate, and beg the body of
> Jesus for burial, because it is a great sin for him to
> lie unburied. I am afraid, said Nicodemus, lest Pilate
> should be enraged and some evil befall me. But if thou
> wilt go alone, and beg the dead, and take him, then will
> I also go along with thee and help thee to do everything
> necessary for the burial. Nicodemus having thus spoken,
> Joseph directed his eyes toward heaven and prayed that
> he might not fail in his request.

In still another version Nicodemus assists Joseph at the Dep-
osition:[73]

> After our lord God and Saviour had been crucified, the
> venerable princes Joseph and Nicodemus took him down
> from the cross and placed Him in a new sepulchre. The
> Virgin Mary wept and wished to go the sepulchre of her
> Son, but she could not do that because of the fear which
> was inspired by the Jews. It was the Sabbath Day that
> came after the sixth feast, and this day nobody was al-
> lowed to go out nor to engage in any occupation.

It is not quite clear just how Nicodemus managed to
secure his firm place in the Deposition proper. The first
suggestion of his presence may have come as early as the

[72]The text is Alexander Walker's translation of "The
Gospel of Nicodemus" (The Acts of Pilate), second Greek form,
cf. The Ante-Nicene Fathers, ed. by A. Roberts and J. Donald-
son (New York, 1899), VIII, Ch. 11, p. 431.

[73]Translation quoted by Paulina Ratkowska, "The Iconog-
raphy of the Deposition without St. John," Journal of the War-
burg and Courtauld Institutes, XXVII (1964), 315, who cites
the Latin text in J. P. Migne, Dictionnaire des Apocryphes,
I, 1856, col. 1101, from Paris, Bib. Nat., Ms Arabe 160.

second century from the <u>Diatesseron</u> of Tatian, a Syrian monk,
in which the story is told by an interweaving of the four
Gospel accounts:[74]

> And Pilate marvelled if he were already dead, and call-
> ing unto him the centurion, he asked him whether he had
> been any while dead. And when he knew it of the centu-
> rion he commanded the body to be delivered. And there
> came also Nicodemus (which at first came to Jesus by
> night) and brought a mixture of myrrh and aloes about an
> hundred pound weight. Then they took the body of Jesus
> and wound it in linen clothes with the spices as the
> manner of the Jews to bury.

But even though this text conveys the distinct impression
that Nicodemus was present at the Deposition, it does not
actually describe that event. It has been suggested that
this version may have come to the West well before any of
the apocryphal recensions; under the aegis of Charlemagne's
educational program, Rabanus Maurus had arranged for a trans-
lation of Tatian into High German.[75] The availability of
the New Testament story on epic scale was further increased
through its verse paraphrase in Old Saxon, the <u>Heliand</u>,
probably also done at Fulda, in the first half of the ninth
century.[76] On the matter of the Deposition, however, the
poem departs from Tatian and comes closer to the account in
Mark with Joseph alone:

> The he [Joseph] went to the "gallows" where he found the
> Son of God, the body of his Lord. He took it from the

[74]Translation quoted by F. P. Pickering, <u>Literature</u>
<u>and Art in the Middle Ages</u> (Coral Gables, Fla., 1970), p.
340, cf. E. Sievers' Vulgate Latin "crib" to Old High German
translation of Tatian (Paderborn, 1892).

[75]<u>Ibid</u>., p. 339. [76]<u>Ibid</u>., p. 329.

cross, freed him from his nails, received him into his arms . . . wrapped him in linen cloths. . . .

Only after the Descent is the presence of Nicodemus even implied:

> He [Joseph] carried him there where they had with their own hands hewn out a burial place; when they had buried him according to the custom of the land. . . . 77

Therefore, neither the Diatesseron nor the Heliand has a clear connection with such visual representations of the scene as that in the Angers Gospels (Fig. 27).

Nevertheless, in the Eastern literature of the tenth century, Nicodemus could even be foremost. Simeon Metaphrastes, in a lamentation of the Virgin, declares:[78]

> Where is the multitude of the infirm which thou has healed of their diseases or which thou has led out from Hell? Only Nicodemus draws out the nails from thy hands and feet and lays thy body down from the cross into these arms in which I held thee when a child.

The obvious, if not always articulated, point of the scene of the Descent from the Cross is the precious obligation of receiving Christ's body from the cross. And it is, of course, to Joseph of Arimathea that this task primarily falls. This thought is reiterated in ninth-century Byzantine homilies where Joseph is extolled for being "like the flesh of angels when you carry on your shoulders the Christ

[77]Ibid., p. 339, Heliand, Fitte LXVIII, cf. idem, "Christlicher Erzahstoff bei Otfrid und im Heliand," Zeitschrift für deutsche Altertum, LXXXV (1955), 262-91.

[78]Ratkowska, "Deposition without St. John," p. 316, cf. J. P. Migne, Patrologia Graeca (Paris, 1857-66), CXIV, col. 215.

king descending from the cross,"[79] or again, for "having

taken on your shoulders, O Joseph, the Son seated on the

right hand of the Father."[80] Even in the thirteenth-century

writings of St. Bonaventura, an acknowledgement of Joseph's

privileged role is preserved:[81]

> Two ladders are placed on opposite sides of the cross.
> Joseph ascends the ladder placed on the right side and
> tries to extract the nail from His hand. But this is
> difficult, because the long, heavy nail is fixed firmly
> into the wood; and it does not seem possible to do it
> without great pressure on the hand of the Lord. Yet it
> is not brutal, because he acts faithfully; and the Lord
> accepts everything. The nail pulled out, John makes a
> sign to Joseph to extend the said nail to him, in order
> that the Virgin may not notice it. Afterwards Nicodemus
> extracts the other nail from the left hand and similarly
> gives it to John. Nicodemus descends and comes to the
> nails in the feet. Joseph supported the body of the
> Lord; happy indeed is this Joseph, who has deserved thus
> to embrace the body of the Lord! Then the Lady respect-
> fully receives the hanging right hand and places it
> against her cheek, gazes upon it and kisses it with
> heavy tears and sorrowful sighs.

The fullness of this account represents an accumula-

tion of descriptive detail that accrued to the scene over

the centuries. The Gothic period in which Bonaventura wrote

was a high point of the predominantly narrative mode in rep-

resentations of the Deposition in art; it is then that it

occurs in vast cycles, such as that on the back of Duccio's

[79]Millet, Recherches, p. 467, cf. Pentecostarion,
Athens, p. 61B; Venice, p. 66A.

[80]Ibid., p. 467, cf. Athens, p. 63; Venice, p. 57B;
cf. also Migne, P.G., XLIII, col. 449C.

[81]Isa Ragusa and Rosalie B. Green, Meditations on the
Life of Christ: An Illustrated Manuscript of the Fourteenth
Century. Paris, Bibliothèque Nationale, MS. Ital. 115
(Princeton, 1961), pp. 341-42.

Maestà.[82] Nevertheless, the underlying symbolism remains,
so that at every point one must look to an eschatological
meaning for each element behind its ostensible value of en-
hancing the reality of the story. The particular emphasis
on the nail in this description, for instance, would seem to
be more than a mere genre element; the importance of this
relic in itself and as one of the arma Christi displayed at
the Last Judgment would be clearly understood to the contem-
porary reader.[83] Similarly the ladders, here two, are a
genre element not indispensable to the scene. Yet when pres-
ent they, too, would also seem to carry a symbolic connota-
tion beyond the practical exigencies of the action: the
eastern image of the ladder was an allegory of man's striving

[82]Duccio, Maestà, in the Opera del Duomo, Siena. It
was commissioned for the high altar of Siena Cathedral in
1308 and was completed in 1311, cf. R. Oertel, Early Italian
Painting to 1400 (New York, 1968), p. 197.

[83]"Arma Christi," from Engelbert Kirschbaum, Lexikon
der christlichen Ikonographie, I (Freiburg im Breisgau, 1968),
pp. 185-87. Gospel references: Matthew 27:27-50; Mark 15:
16-36; Luke 23:33-36; John 19:1-24. First secondary source
to mention the nail (and also the cross) was the Pseudo-
Hippolytus, De consummatione mundi, P.G., X, col. 941. It
was a frequent subject of meditation in literature and art
from the thirteenth century on, as exemplified in the writ-
ing of Bonaventura (see note 81). The nail appears as a
sign of the Passion in the portable altar in the Modena Ca-
thedral Treasury (cf. J. Braun, Der christliche Altar, I
[Munich, 1924], p. 464, and Rohault de Fleury, La Messe
[Paris, 1883-89], V, pl. CCCXLIII) and in the Hortus Delici-
arum, 1165-90 (destroyed in Strasbourg, 1870), the Kloster-
neuberg Altar, 1181, and in the Marian shrine from Tournai,
1205. In addition, we have the nail reliquary in the Trier
Cathedral Treasury, from Trier at the time of Egbert, 977-93,
ca. H. Schnitzler, Rheinische Schatzkammer, pl. 23 and note
5 on p. 22.

toward Christ.[84] The Descent from the Cross in the Salzburg
Gospels of the first half of the eleventh century, Morgan
781, strongly influenced by Byzantine art, is a striking de-
piction of this idea (Fig. 4). Here the ladder cuts drama-
tically across the entire page and serves to stress the ex-
alted position of Joseph (and Nicodemus, secondarily). The
Virgin and John stand at the foot of the cross dignified and
aloof.

Bonaventura's account makes the Virgin and John major
participants in the scene. John's role is in relation to
that of the Virgin; in assisting Joseph, he seeks to keep
her somewhat apart from the action in order to spare her
sensitivities which are now quite close to the surface. The
emotionalism she displays, however, is neither unrestrained

[84]The ladder as a symbol of man's spiritual improve-
ment was first mentioned in Christian literature by John
Chrysostom (347-407), cf. Migne, P.G., LIX, cols. 454-55,
and Theodoret (395-458), cf. ibid., LXXXII, col. 1484 C. It
also figures in Coptic texts, cf. G. Michailides, "Échelle
mystique chrétienne dessinée sur lin," Bulletin de la Société
d'Archéologie Copte, XI (1945), 87-94. The Heavenly Ladder
of John Climacus, a devotional manual for monks, was written
at the end of the sixth century by John, Abbot of Mount Sinai,
cf. John R. Martin, The Illustration of the Heavenly Ladder
of John Climacus (Princeton, 1954), pp. 3 and 14, and note
84. The earliest images of the ladder appear in the tenth
century and are simple and diagrammatic; in the eleventh
century, they were enlarged to more ambitious full-cycle il-
lustrations in scenic form, cf. ibid., pp. 7-13, and note
107. John Climacus relates the ladder to Jacob's, as does
John of Raithu, the monk to whom his treatise was addressed,
cf. P.G., LXXXVIII, cols. 840D and 1160C, and cols. 625 A-B.
The oldest copy with illustrations is the tenth-century Sinai,
Gr. 417. F. 13v shows the single ladder; f. 209r shows two
(Martin, Figs. 2 and 4). Athens, Vatopedi, Cod. 376, f.
421v (Martin, Fig. 17), shows the diagonal ladder similar to
the Salzburg Gospels Descent (Fig. 4).

nor simple grief. It also reflects a new emphasis in the
part played by the Virgin; by sharing Christ's passion she
participates in the work of redemption.[85] This important
new view of the Virgin--first articulated by Bernard of
Clairvaux--was a radical change from the original conception
of Mary as a person and as the symbol of the Church--Ecclesia--
standing at the Crucifixion self-contained and erect: "I read
that she stood at the cross," says St. Ambrose, "but I do
not read that she wept."[86] The older tradition had long
served as a governor on the expression of her unrestrained
grief--even in the face of powerful forces East and West
which were moving toward a greater humanization of the Pas-
sion themes.

The shift in focus to the Virgin rather than Joseph
in the Descent from the Cross is a variation on the theme
which began to be reflected in the ninth-century writings of
George, Metropolitan of Nicomedia, who had picked up the
thread from contemporary apocryphal accounts. But as he
did so he was careful to keep clear the distinction between
her decorum at the Descent and her lamentations at the

[85]Von Simson, "Compassio and Co-Redemptio," pp. 11-12,
notes that although the idea of co-redemptio is not expounded
in art before the fourteenth century, the doctrine goes back
earlier, as does the idea of her compassio. He attributes
the idea of her compassio to Bernard of Clairvaux' Dominica
infra Octavam Assumptionis B. V. Mariae Sermo, J. P. Migne,
Patrologia Latina (Paris, 1844-64), CLXXXIII, col. 1012, in
which her compassion is compared with Christ's passion.

[86]Ibid., XVI, col. 1431; cf. also Irjo Hirn, The
Sacred Shrine (London, 1958), pp. 274-78.

burial:[87]

> When Joseph had learned how matters stood and been en-
> couraged by the Virgin to do so, he betook himself to
> Pilate, a thing he had not dared to do before since he
> had been afraid like the other disciples and had hidden
> himself. A costly sepulchre having been made, he has-
> tened to place in it the body of the Lord.

> Now behold the Mother of God standing there, ready and
> anxious to do all that is fitting, noble in her gravitas,
> displaying no hint of meanness of soul. She waits upon
> her Son in His passion and ministers to Him with her own
> hands, receiving in the bosom of her garment the nails
> which have pierced Him and embraces and kisses His limbs
> and takes Him in her arms as He is released from the
> cross.

But it is not until the Entombment proper, which has been

made a separate moment, that the Virgin gives way to her

feelings of grief, for he continues:

> When His body is laid on earth, she runs to embrace it
> and bedews it with her tears. Then she sings songs of
> praise for Him and prepares the divine funeral clothes
> for His inviolate body, and, when the body is deposited
> in the tomb and Joseph and Nicodemus have withdrawn, she
> remains alone, attendant upon the entrance of the sepul-
> chre.

The eastern emphasis on the Virgin's active part in

the Deposition is increased a century later by Simeon Meta-

phrastes, who adds to the emotional coloring of the scene by

introducing the image well known from its later expression

in western art: the Pietà. At the same time, however, the

author takes pains to make clear the calm dignity of her

manner at the Descent. Her tears come only after Christ has

[87]Translation of George of Nicomedia, cf. Ratkowska,
"Deposition without St. John," p. 316, text cf. Migne, P.G.,
C, cols. 1486-87.

been removed from the cross:[88]

> Those who have dealt with the matter say that Mary bore
> herself throughout with fortitude and constancy, in a
> manner befitting a Mother and above all befitting the
> Mother of Him who shows His love to the dead: her love
> was continuous. With her own hands she received Him
> down from the Cross, placed in her bosom the nails which
> had pierced Him, and embraced His limbs, taking Him in
> her arms and bathing His wounds and His whole body with
> her tears, saying: "Behold, the mystery ordained from
> all eternity, O Lord, is fulfilled in thee." She hands
> over the linen cloths to Joseph and bids him prepare the
> ointments.

The Descent from the Cross
and the Crucifixion

The literature thus confirms what the artistic evi-
dence suggests: the Deposition comes into its own only in
the ninth century and is a scene separately conceived from
the Entombment. The Virgin, if present--and she need not
be--appears, just as does Joseph, the stoic intercessor for
mankind. Her lamentation begins only after Christ's body
has been removed from the cross and is part of the burial
process. The evidence further suggests that the essential
meaning of the scene is a sacramental one: the receiving of
Christ's crucified body as the fulfillment of the "mystery."

Such an interpretation of the Deposition must closely
depend on the image of the dead Christ. The Christus pati-
ens--Christ suffering or dead on the cross--was countered by
the representation of Christus triumphans--Christ the victor

[88]Translation of Simeon Metaphrastes, cf. Ratkowska,
"Deposition without St. John," p. 316, text: oratio que
tractat a venerando ortu et educatione Sancti Domini Nostri
Dei parae . . . , P.G., CXV, cols. 544-55.

over death.[89] The former idea was first officially argued
at the Trullan Council of 692 and won its place in eastern
orthodoxy following the iconoclastic controversy.[90] Although
this representation of Christ's human nature was firmly re-
sisted by Rome, it gained a foothold in the West, mainly in
Germany and in England, from the mid-ninth century on.[91]
The Descent from the Cross, a theme which emphasizes Christ's
physical death on the cross, could only develop in relation
to the image of the dead Christ. The alternate idea--that
of Christus victor--is a denial of this aspect of the Cruci-
fixion: it signifies the divine Christ untouched by death
and the suffering of the cross. In instances, therefore,
where the Descent from the Cross appears together with this
type of Crucifixion, the two scenes must be understood as a
simultaneous depiction of Christ's two natures: human and
divine.[92] When it occurs alone or with a Crucifixion with

[89]Reiner Haussherr, Der Tote Christus am Kreuz; zur
Ikonographie des Gerokreuzes (Bonn, 1963), pp. 164-69.

[90]Carol Heitz, Recherches sur les rapports entre ar-
chitecture et liturgie à l'époque carolingienne (Paris, 1963),
p. 146, and note 1, cf. F. Cabrol and H. Leclerq, Diction-
naire d'Archéologie Chrétienne et de Liturgie (Paris, 1907-
53), III, pt. 2, cols. 3083-84.

[91]Heitz, Architecture et Liturgie, p. 146, and note 2.
In so doing, the West emphasized the image of the Lamb.
Haussherr, Der Tote Christus, p. 113, says the sacramental
motif of the dead Christ was invented in the West 830-50.
For the early acceptance of the idea in England and Germany,
see ibid., p. 107; for opposition to the image of the dead
Christ by Cardinal Humbert of Silva Candida in 1054, see
ibid., pp. 156ff.

[92]See, for example, the Paris Gregory (Fig. 11 and

the dead Christ, it serves to emphasize the human side of
the equation.[93]

John Martin has traced the origin of the dead Christ
image in Byzantine art to the resolution of the basic issues
of the iconoclastic controversy concerning the appropriate-
ness of images at all and the attendant arguments over the
two natures of Christ.[94] He maintains that the earliest
clear representation of the dead Christ preserved is found
in a codex from the monastery of Pantokratoros on Mount
Athos dating to the late ninth century.[95] It shows the dead
Christ with eyes closed, wearing only a loin cloth instead
of the more conventional collobium. In the case of the
Gregory page (Fig. 11), the situation with respect to the
Crucifixion is less clear, for the depiction of the cruci-
fied Christ with eyes open wearing a collobium is a contempo-
rary overpainting of a nude Christ in a loin cloth.[96] Martin

notes 15 and 96); also Goldschmidt-Weitzmann, Die Byzantin-
ischen Elfenbeinskulpturen, pl. VII, Fig. 23 (Fig. 38 and
note 54) and pl. VIII, Fig. 25 and pl. XVII, Fig. 40 (see
note 56).

[93]It is not always clear whether the living or dead
Christ is specifically intended (see Haussherr, Der Tote
Christus, pp. 105, 113, 152-55), but the Munich ivory (Fig.
39 and note 56) appears definitely to be the dead Christ.
Haussherr, ibid., pp. 150-51, points out that western images
differ from Byzantine ones in their tendency to emphasize
the dead aspect of Christ.

[94]John Martin, "The Dead Christ on the Cross in Byzan-
tine Art," Late Classical and Medieval Studies in Honor of
Albert Mathias Friend, Jr. (Princeton, 1955), pp. 189-91.

[95]Pantokratoros Codex 61, f. 98r, ibid., Fig. 4 and
p. 190.

[96]Ibid., p. 191.

surmises that the intended image was altered because "the iconography of the dead Christ (if indeed he was shown in this way) was too new to be acceptable."[97]

Martin suggests that the source of the dead Christ image was the mosaic cycle from the Church of the Holy Apostles in Constantinople done shortly before the Gregory under the patronage of the same Emperor Basil.[98] Our knowledge of these mosaics is incomplete: gaps occur in the extant text of the tenth-century poem by Constantine of Rhodes just at this point in his description of the cycle.[99] The twelfth-century prose account by Nicholas Mesarites is no more enlightening on this matter.[100] In neither account is there any indication that a Deposition was included. However, it is clear that the dead Christ was represented, for he was described as "hanging as a dying man" or as "hanging dead," and thus certainly not the living Christ triumphant.[101]

Although Martin appears to have established the

[97]Ibid.

[98]For Church of the Holy Apostles in Constantinople, see ibid., p. 191, note 15, where Martin defends his ninth-century dating for the mosaics.

[99]For poem by Constantine of Rhodes, see E. Legrand, "Description des oeuvres d'art et de l'église des Saints-Apôtres de Constantinople, poème en vers iambiques par Constantin le Rhodien," Revue des études greques, IX (1896), pp. 63ff

[100]Cf. Glanville Downey, "Nikolaos Mesarites. Description of the Church of the Holy Apostles at Constantinople," Transactions of the American Philosophical Society, New Series, vol. 47, part 6 (1957), especially p. 876.

[101]Martin, "The Dead Christ," pp. 191-92.

earliest appearance of the image of the dead Christ in Con-

stantinople, a representation of the dead Christ does occur

earlier: in a Syrian icon dated in the eighth century from

the Monastery of St. Catherine at Mount Sinai (Fig. 41).[102]

Syria, where the human side of Christ had long been stressed,

had also produced the novel image of the Crucifixion in the

Rabbula Gospels of 586.[103] Whether or not Syria is also the

source of the Descent from the Cross must remain a matter of

conjecture.[104] The likelihood is strong, however, that

wherever its source the narrative level was not primary.[105]

[102]Kurt Weitzmann, "Sinai Peninsula: Icon Painting from the Sixth to the Twelfth Century," Icons from South-eastern Europe and Sinai (London, 1968), p. xi and Fig. 6, dated mid-eighth century, and idem, "Eine vorikonoclastische Ikone des Sinai mit der Darstellung des Chairete," Fest-schrift Johannes Kollwitz; TORTULAC, Studien zu altchrist-lichen und byzantinischen Monumenten, Rome, Quartalschrift, 30, Supplementheft, 1966. See also Haussherr, Der Tote Christus, pp. 129-30.

[103]For the Syrian Rabbula Gospels, Florence, Laur. Lib., Plut. I. 56, see A. Grabar, Christian Iconography: A Study of Its Origins, Tenth Mellon Lecture (Princeton, 1968), Fig. 230. Although Christ crucified appeared earlier, mainly on coins and gems, and on the fifth-century doors of Sta. Sabina in Rome, the Rabbula Gospels are the first we know to incorporate the image in a manuscript, and they are all the more remarkable because of the Crucifixion's having been combined with an image of the Resurrection--the Maries at the Tomb, cf. Cabrol-Leclerq, DACL, vol. 3, pt. 2, col. 3074. See also Haussherr, Der Tote Christus, p. 125.

[104]For references to the Syrian literature, see T. Mathews, The Early Churches of Constantinople: Architecture and Liturgy (University Park, Pa., 1971), p. 157, cf. Theo-dorus Mopsuestiae, Homily 15, 23-25 in Les Homelies catechetiques, ed. by R. Tonneau and R. Devresse, Studi e Testi, 145 (Vatican City, 1949), pp. 501-05. See also Haussherr, Der Tote Christus, pp. 129-30. Palestine is another likely source of iconographical innovations.

[105]Grabar, Christian Iconography, pp. 92-97, gives a strong argument against the narrative source of any Christian image.

The subject of the Descent from the Cross has been
dominated in the past not only by the pull of the idea of a
narrative origin, but, more important, by a rather narrow
understanding of the relation of the scene to the Crucifix-
ion. The tendency has been to think of the relationship
initially as mainly a matter of compositional borrowings.[106]
The commonly accepted four-phase theory sees the development
beginning with a close approximation of the Crucifixion and
ending with a separate depiction of the "process completed."
A more profound connection with the Crucifixion--that the
scenes function interchangeably--comes only after the compo-
sitional separation has been made. Support for this view,
however, necessitates taking examples for the first phase
which are later than those for the last.[107] It also dis-
counts the fact that earliest preserved versions of the De-
scent, whether in manuscripts, ivories or wall paintings,
are already set in a liturgical context. From the evidence,
which one must concede is incomplete, it is at least argu-
able that compositionally the scene could have been conceived
in the so-called final phase, but that it more closely

[106]Weitzmann, Dumbarton Oaks Catalogue, p. 68. See
note 58, where his statement is quoted in full.

[107]For the four-phase theory, see Vavala, La Croce
Dipinta, reference in note 2, and Weitzmann, Dumbarton Oaks
Catalogue, p. 66. Weitzmann cites three eleventh-century
ivories (Goldschmidt-Weitzmann, Die Byzantinischen Elfen-
beinskulpturen, pl. LXVIII, Figs. 207-09, see note 56) for
the first phase and the Hannover ivory of the tenth century
(ibid., pl. XVII, Fig. 40) for the last.

approximates the Crucifixion in certain versions due to the
iconographic interdependence of the two scenes. If one
takes the view that the iconic meaning was paramount in the
conception of the image, the considerable leeway in individ-
ual renderings of the scene becomes more understandable. In
fact, it is not until the Gothic period that the composition
of the scene tends to be more or less fixed, and it is only
then that the narrative aspect of the scene most consistently
predominates.[108]

This point can perhaps best be seen by a comparison
of the Descent from the Cross as one of several side scenes
on a painted cross, for instance Pisa No. 20,[109] with a Dep-
osition from a fourteenth-century French ivory diptych in
the Louvre (Figs. 42 and 43).[110] To the left of the central

[108]See pp. 10-11 and 18ff. and notes 36-38, and 57, for
discussion of the Descent within earlier cycles in manu-
scripts, sculptured capitals, fresco and mosaic. See also
note 112.

[109]Pisa, Museo Nazionale No. 20. It is generally
dated in the early thirteenth century, cf. Oertel, _Early
Italian Painting_, p. 37. However, Kay Giles Hennessy rather
convincingly demonstrated that it may be as early as the
fourth quarter of the twelfth century (Seminar, Spring,
1972, with Prof. Buchthal).
 Vavala, _La Croce Dipinta_, lists the following other
painted crosses which include the Descent from the Cross
(her figures): Pisa, A. Martino (Enrico Tedice), Fig. 243;
Sarzana, Fig. 244; Florence, Accademia, Fig. 251; Castellare,
near Vico Pisano, Fig. 400; Siena, Galleria, Fig. 414; Ro-
sano, Fig. 383; Pisa, S. Marta, Fig. 401; Pisa, Mus. Civ.
no. 9, Fig. 402; Pistoia, Duomo, Figs. 249 and 475; Florence,
Accademia, Fig. 260.

[110]Koechlin, _Les Ivoires Gothiques françaises_, pp.
101-02, notes on no. 237 (pl. LXII).
 For a number of other examples, see _ibid._: no. 34,

image of <u>Christus patiens</u> in Pisa No. 20 is the scene of the
Descent from the Cross. Joseph, mounted on the ladder,
gently supports the body of Christ, his arms freed from the
cross, his body arched backward in a graceful curve, his
face meeting that of the Virgin who stands to the left hold-
ing one hand as John on the right kisses the other. Nico-
demus kneels to the left of the cross and works to free the
feet; two Maries flank the Virgin and John. The arrested
motion, the lyricism in tone--drawing heavily on the Byzan-
tine mode--presents a poetic representation not so much of
the event per se but of its mystical meaning. The angels
with veiled hands hovering in the ethereal gold ground on
either side of the cross are prime indicators that this and
all the other scenes on this painted cross, which functioned
as an altarpiece, should be "read" in a liturgical context.[111]

The ivory diptych in the Louvre also served a litur-
gical purpose, but here the narrative statement of the

pl. VIII; nos. 36-37, pl. XIV; nos. 57-58, pl. XXII; no. 61
bis, pl. XXIII; no. 205, pl. XLVII; no. 227, pl. LIX (the
original context of this one in the Metropolitan Museum of
Art, New York, has not been determined); no. 234, pl. LXI;
no. 237, pl. LXII; no. 240, pl. LXIII; no. 256, pl. LXVI;
no. 258, pl. LXVII; no. 257, pl. LXVIII; no. 286, pl. LXIII
bis; no. 290, pl. LXXIV; no. 502, pl. XCI; no. 823, pl.
CXLV; no. 823bis, pl. CXLVI; no. 833, pl. CXLIX.

[111]G. de Jerphanion, "La Baptême de Jesus dans la
liturgie et dans l'art chrétien," <u>La Voix des Monuments</u>
(Paris, 1930), p. 182: the veiled hands of the angels point
to the liturgical veil with which the priest covers his
hands when he touches the sacred objects at the altar. It
is derived from the eastern ceremonial gesture of respect.
See Chapter II for a further discussion of the place of the
scene of the Descent from the Cross within the Mass.

events, including the Descent from the Cross, is the primary

emphasis, although a symbolic intention still governs the

particular choice of subject.[112] The shift in emphasis goes

beyond a greater naturalism in the style of rendering the

figures and a decrease in monumentality in the conception of

the altarpiece--as a whole or of its individual parts; it

goes beyond the shift from abstraction characteristic of the

Romanesque to the humanism of the Gothic. It reflects a

change in the character of the altarpiece itself which no

longer serves in the place of a cross or crucifix.[113] De-

spite the greater naturalism of the Gothic period, the

[112]The full program of this diptych is as follows:
left wing: above, Crucifixion; below, Kiss of Judas; right
wing: above, Deposition; below, Flagellation. A consider-
able variety governs the choice of scenes. The Descent from
the Cross, although frequent, is not always included. It is
clear that narrative scenes from the Passion story and post-
Resurrection appearances of Christ have been incorporated
into these cycles. The Descent, however, is an alternate
image from the original sequence of major feast and liturgi-
cal scenes around which these programs were built. Further
work needs to be done on the question of just why particular
choices might have been made. See note 111. A recent pub-
lication, Demetrios Pallas, Die Passion und Bestattung
Christi in Byzanz: der Ritus--das Bild (Munich, 1965) (not
so far available in N.Y.C.), appears to relate the choice of
an iconographical theme used on a liturgical object to the
practical needs of the liturgy, cf. review by Christopher
Walter, Revue des Etudes Byzantines, XXVII (1969), 340. See
Appendix II, for a discussion of the basis for ordering
scenes in Gospel cycles.

[113]In the course of the tenth through the thirteenth
centuries, an altarpiece or retable could take the place of
an altar cross or crucifix as an expression and proof of the
renewal of the Sacrifice, cf. J. Braun, Das christliche Al-
targerät (Munich, 1932), pp. 471-73. Gradually, however,
the tone of the altarpiece had a tendency to move away from
the symbolic toward a more historical representation.

abstract iconic element persists but it is concentrated in
the crucifix alone or in other devotional images, such as
the Man of Sorrows or the Pietà, separated out from the
scene from which they are drawn.[114]

The more narrative character of thirteenth- and
fourteenth-century Gothic altarpiece representations, how-
ever, is a rather brief moment in the course of the develop-
ment of the theme of the Descent from the Cross. The full
iconic force of this image is restored in the fifteenth cen-
tury in representations such as that by Roger van der Weyden
(Fig. 12).[115] Here the Descent is not one of many side
scenes, but the central panel of an altar triptych. In this
form it is a demonstration not of a mutation of an earlier
narrative theme, but a retrieving of its original conception
as a sacramental image.[116] As such it is a monumental ver-
sion of the Byzantine ivories of the tenth and eleventh

[114]For increasing use of the crucifix, see ibid., p.
473, and my article on "The Bury St. Edmunds Cross" (Appen-
dix II). For devotional images, see Ringbom, Icon to Narra-
tive, pp. 53-55.

[115]Roger's Descent from the Cross in the Escorial
(see note 25) was formerly in the crossbowmen's chapel of
the church of Our Lady Outside the Walls, Louvain. The
shutters are lost, cf. Max J. Friedländer, Early Netherland-
ish Painting, II, Rogier van der Weyden and the Master of
Flémalle (New York, 1967), p. 60. See also von Simson, "Com-
passio and Co-Redemptio," passim. Alan Rosenbaum is working
on a study of the iconography of a Descent from the Cross by
Pontormo. In Italy we find a return to the iconic depiction
of the Descent from the Cross in Pietro Lorenzetti's Trecento
fresco in San Francesco, Assisi, 1320-30, cf. Oertel, Early
Italian Painting, pp. 227ff., pls. 88 and 89.

[116]See p. 7 and notes 26 and 27 for the traditional
view of the character of the later Depositions.

centuries.

The essential question, therefore, is just how does the Deposition relate to the sacramental meaning of the Crucifixion? What is the specific sacramental meaning of the Deposition itself? Just how was the Deposition able to burgeon from its Byzantine roots to achieve great prominence in western art? How can one reckon with its "un-Byzantine" ability to assume the monumental proportions it does in the twelfth and thirteenth centuries, even in Italy, where resistance to the idea of the dead Christ was the strongest and the longest? How do western Depositions manage to incorporate meanings beyond the sacramental one?

In an attempt to suggest an answer to these questions, this dissertation will begin by a consideration of the dramatic counterpart to the Descent from the Cross in art: the extra-liturgical Depositio drama. An understanding of what is known about this ceremony, how and when it evolved, its relation to the liturgy of the Mass, where in the church and in what ways it could be performed, its relation to other Easter rites, will be seen to be crucial to an understanding of the full implications of the theme in art.

CHAPTER II

THE EXTRA-LITURGICAL DEPOSITIO DRAMA

Summary of Previous Inter-
est in the Easter Rites

The extra-liturgical Depositio drama is also not a
subject unexplored by art historians. It first attracted
their interest with the identification in the early twenti-
eth century of a group of English Gothic monuments known as
"Easter Sepulchres."[1] In the Good Friday ceremony, this
monument was the receptacle for the cross or some other sym-
bol of Christ which was laid there and solemnly guarded un-
til Easter. The complementary rite was the Elevatio, at
which the symbol which had been buried was raised and put on
the altar. Signifying the moment of Christ's Resurrection,
the Elevatio was at first just a simple and undramatized ac-
tion within the Easter liturgy.[2] The emphatic proclamation

[1]J. K. Bonnell, "The Easter Sepulchrum in its relation
to the Architecture of the High Altar," Publications of the
Modern Language Association of America, XXXI, No. 24 (1916),
664-712; J. C. Cox and A. Harvey, English Church Furniture
(New York, 1907); Daniel Rock, The Church of our Fathers, I-
IV (London, 1905).

[2]Neil C. Brooks, "The Sepulchre of Christ in Art and
Liturgy with special reference to the Liturgical Drama,"
University of Illinois Studies in Language and Literature,
VII, No. 2 (1921), 42. The Elevatio developed a dramatic
sequence only later, notably with the addition of the drama-
tization of the Descensus ad Inferos or the Harrowing of
Hell, cf. Karl Young, The Drama of the Medieval Church, I

of the Resurrection was asserted by the Visitatio Sepulchri,

a little drama with genuine dialogue--hence the Quem Quaeri-

tis as it is alternatively known. The action again centered

on the sepulchre. There a monk dressed as an angel showed

the Three Maries (sometimes also monks) that the tomb was

now empty except for the cloths in which the symbol of Christ

had been wrapped.[3]

The first modern scholarly thesis concerning the

Easter Sepulchre was Bonnell's proposition that it was bound

both to the form of the High Altar in church architecture

and to the sepulchre as depicted in representations of the

Three Maries at the Tomb, because a canopy or ciborium was

common to all three.[4] The idea was discarded by Brooks.[5]

He argued that most of these sepulchres lack the ciborium

(Oxford, 1967), Chapter V. According to O. B. Hardison, Jr.,
Christian Rite and Christian Drama in the Middle Ages (Balti-
more, 1965), pp. 170-71, and n. 80, the Elevatio took its
place at the beginning of the Easter nocturn as a kind of
makeshift resulting from the displacement of the Vigil Mass
(see also Young, Drama, I, p. 547). The Visitatio Sepulchri,
occurring at sunrise at the end of the Easter nocturn, was
the more developed rite. As its popularity grew, it occa-
sionally assimilated parts of the Elevatio rite. By the
later Middle Ages, it was the Visitatio Sepulchri and not
the Elevatio which marked the moment of the Resurrection
(see also Young, Drama, I, pp. 231-32).

[3]The basic literature on the Visitatio Sepulchri and
other liturgical dramas: E. K. Chambers, The Medieval Stage,
2 vols. (Oxford, 1963); Hardin Craig, English Religious Drama
of the Middle Ages (Oxford, 1955); Richard Donovan, The Li-
turgical Drama in Medieval Spain (Toronto, 1958); Grace
Frank, The Medieval French Drama (Oxford, 1960), as well as
the studies by Brooks and Young (see note 2).

[4]Bonnell, "The Easter Sepulchrum," passim.

[5]Brooks, "The Sepulchre of Christ," Chapter IV, pp. 26-29.

and that many architectural structures decorating real and
depicted altars are not really ciboria at all. Furthermore,
in Italy, where ciboria over altars do occur, the Easter
plays did not.

Still, interest in the monument continued. Church
records were culled for details of "dressing" the sepulchre
and for erecting temporary ones for the three-day period
climaxing Easter week.[6] At the same time, continental ver-
sions comparable to the English ones were collected.[7] For
the most part, scholarly attention has stayed fixed on the
form and style of these later Gothic monuments: grave
chests, Holy Sepulchres and sculptured Holy Graves of wood
and stone.[8] Information about the earlier forms of the De-
positio drama out of which they came, however, remains
sketchy and obscure. The texts themselves are mainly late.[9]

[6]Ibid., Chapter VIII, pp. 71-89, for discussion of
the "English Easter Sepulchres" and its references to the
literature.

[7]Ibid., Chapter IX, pp. 88-91, see especially the ref-
erence to the literature on continental examples, pp. 88-89.

[8]Among the most important studies on these monuments,
also indicating their range: D. G. Dalman, Das Grab Christi
in Deutschland: Studien über Christliche Denkmaler, XIV
(Leipzig, 1922); W. Forsyth, The Entombment of Christ: French
Sculptures of the Fifteenth and Sixteenth Centuries (Cambridge,
1970); I. Futterer, Gotische Bildwerke der deutschen Schweiz,
1120 bis 1440 (Augsberg, 1930); Anne-Marie Schwarzweber, Das Heil-
ige Grab in der deutschen Bildnerei des Mittelalters (Freiburg
am Breisgau, 1940). For one of the earliest of the holy
graves, ca. 1300, see H. Appuhn, "Der Auferstandene und das
Heilige Blut zu Weinhausen," Niederdeutsche Beitrage zur
Kunstgeschichte, I (1961), pp. 73-139.

[9]Most of the texts are fourteenth century or later.
See Appendix I for a tabulation of texts from the tenth to
the thirteenth century.

They appear to describe a custom so familiar by tradition that the details were rarely supplied.

When certain art historians, notably Émile Mâle, turned anew to the relation of the liturgical drama to representations in art, their idea was to identify works of art whose iconography included features peculiar to the drama's performance rather than to an earlier visual tradition.[10] For them, the sepulchre stayed a focal point but its value was still as the setting for the Resurrection scene and not the Depositio. For those scholars who saw the dependence in art on the drama's performance, their speculations begin with the Visitatio Sepulchri and representations of the Three Maries at the Tomb.[11]

Mâle's Thesis on the Liturgical Easter Dramas

The importance of Mâle to this issue is not so much that he was the first to suggest the connections of the

[10]Émile Mâle, L'Art Religieux du XII siècle en France (Paris, 1926; first edition, 1922), Chapter IV: "Enrichissement de l'iconographie de la liturgie et le drame liturgique," pp. 121-50. Mâle put forth his original thesis concerning the influence of the mystery plays on the iconography of the art in his L'Art Religieux de la fin du Moyen Âge en France (Paris, 1925; first edition, 1908), Chapter II: "L'Art et le théâtre religieux," pp. 35-84. His book on the twelfth century represents a certain temporizing of his original thesis and deals more directly with the earlier period with which this dissertation is concerned. See discussion of Mâle by Otto Pächt, The Rise of Pictorial Narrative in Twelfth Century England (Oxford, 1962), pp. 32ff.

[11]Mâle, XII siècle, pp. 129-37; Joan Evans, Cluniac Art in the Romanesque Period (Cambridge, 1950), p. 91, explains that dramas begin with dialogue in the form of the Quem Quaeritis tropes of the Visitatio Sepulchri.

Easter drama to art. Rather, it is his ability to synthesize and elaborate an earlier train of thought buried in both the French and German literature and to argue the point with such conviction that he made it a question which had to be answered one way or another by historians of art.[12] The degree of his success is seen first in the prevalence of the assumption that the drama had at least some influence on the iconography of art as the medieval period evolved. Some scholars went on to develop further specific instances of influence.[13] The very vehemence of opponents to some of his

[12]The major German sources from which Mâle drew were: H. Anz, Die lateinische Magierspiele (Leipzig, 1905); W. Creizenach, Geschichte des neueren Dramas, 3 vols. (2d ed.; Halle, 1911-23); H. Kehrer, Die heiligen drei Könige in Literatur und Kunst (Leipzig, 1909); W. Meyer, Fragmenta Burana, Nachrichten der Königlichen Gesellschaft der Wissenschaften in Gottingen: Abhandlungen der Philologischen Historischen Klasse (Berlin, 1901); G. Milchsack, Die Oster- und Passionsspiele, I. Die lateinischen Osterfeiern (Wolfenbüttel, 1880); P. Weber, Geistliches Schauspiel und Kirchliche Kunst: Vierteljahrschrift für Kultur und Literatur der Renaissance, I (Berlin, 1886).
 Mâle's major French sources were: E. Coussemaker, Drames Liturgiques du Moyen Âge (Rennes, 1860; new ed., New York, 1964); A. Didron, preface to Félix Clément, "Liturgie, Musique et Drame du Moyen Âge," Annales Archéologiques, VII (1847), 303-07; J. Durand, "Monuments Figurés du Moyen Âge, executés d'après des textes liturgiques," Bulletin Monumental (Paris/Caen), 1888, pp. 521-50; A. Gasté, Les Drames Liturgiques de la Cathédral de Rouen (Evreux, 1893); L. J. N. Monmerqué, and F. Michel, Théâtre français au Moyen Âge (Paris, 1865); Marius Sepet, Le Drame chrétien au Moyen Âge (Paris, 1878).

[13]Among the later scholars to supplement Mâle's thesis: Gustave Cohen, "The Influence of the Mysteries on Art in the Middle Ages," Gazette des Beaux-Arts, Series 6, XXIV, No. 922 (1943), 327-42, and idem, Histoire de la Mise en Scène dans le Théâtre religieux français du Moyen Âge (Paris, 1926), working largely with the later texts; Evans, Cluniac Art, pp. 90-97, discusses scenes from the early Easter, Christmas and

ideas demonstrates the seriousness with which his propositions were taken.[14]

So far, no comprehensive critique has been made of his discussion of the Visitatio Sepulchri. It has a direct bearing on the question of Depositio because the setting is the same. In fact, Mâle shows instances where the performance of the Depositio Crucis is actually implied--either by the presence of the cross shown above the tomb, as in the relief from St. Paul-de-Dax (Fig. 44),[15] or held by the angel, as in

Epiphany plays as they influenced Cluniac art; Ilene Haering Forsyth, "Magi and Majesty: A Study of Romanesque Sculpture and Liturgical Drama," The Art Bulletin, L, No. 3 (1968), 215-22, and idem, The Throne of Wisdom (Princeton, 1972), pp. 49-60, demonstrates the use of wood-carved Madonnas in the Christmas plays; Pächt, Rise of Pictorial Narrative, pp. 32-51, defends Mâle's thesis to a large extent, while rephrasing the issue as follows: "The question is not if innovations of iconography were inspired by the liturgical drama but whether the style of pictorial narrative as such was influenced by the new venture of the Bible story as staged drama," ibid., p. 32. Pächt concentrates on English works, and in particular on the Supper at Emmaus scenes in the St. Albans Psalter, idem, St. Albans Psalter, pls. 38-40. He argues that the motif of one of the pilgrims' pointing to the setting sun is specifically derived from the rubrics of the play and not the gospel account.

[14]Among the scholars who have taken issue with Mâle are: A. Rapp, Studien über der Zusammenhang des geistlichen Theaters mit der Bildenden Kunst im ausgehenden Mittelalter (Kallmunz, 1932; so far unavailable); A. Watson, The Early Iconography of the Tree of Jesse (London, 1934), pp. 35ff., disputes Mâle's relation of the prophet dramas to art; K. M. Swoboda, "Der romanische Epiphaniezyklus in Lambach und das lateinische Magierspiel," Festschrift für J. Schlosser (Vienna, 1927), pp. 82ff., says that these eleventh-century wall paintings are mainly derived from Byzantine motifs rather than the liturgical drama texts also at Lambach; Gilbert Vezin, L'Adoration et le Cycle des Mages dans l'art chrétien primitif (Paris, 1950), pp. 65ff., takes broader issue with Mâle on the influence of the liturgical drama on the iconography of representations of the Three Magi in art.

[15]Mâle, XII siècle, p. 129. Bas-relief in exterior

the Poitiers Crucifixion window and the Nantouillet chasse (Figs. 45 and 46).[16]

As to the sepulchre itself, Mâle makes the far-reaching assertion that the change in art from representing the tomb of Christ as a towered structure, as seen for example on a capital from Mozac (Fig. 47),[17] to a sarcophagus, as at Dax, is due to its first having taken this form in the early Easter dramas.[18] Instances where this sarcophagus is crowned by a "sort of baldachin," as at Chalais, Charente (Fig. 48)[19] or the Crucifixion window at Poitiers, again are drawn from the drama's performance--either at the altar or at a special Easter Sepulchre.[20] He goes on to suggest that the gestures

of apse of church of St. Paul, Dax (Landes) in Aquitaine.

[16]Ibid., p. 130. Poitiers, window in chevet of the cathedral, lower register below the central Crucifixion representation, ca. 1165, cf. M. Aubert, et al., Le Vitrail Français (Paris, 1958). pl. I. Nantouillet Chasse from Limoges, France, 1200-20, copper gilt and champlevé enamel, in church at Nantouillet, cf. The Year 1200, I, cat. no. 142, pp. 138-39. Evans, Cluniac Art, also cites representations of angels upholding the veiled cross on cloister capitals from Ste.-Marie-la-Daurade, Toulouse (Musée des Augustins) and Moissac, both dated ca. 1100, her Figs. 159 a and b (Figs. 65 and 66).

[17]Mozac, Puy-de-Dome, Cluniac house, first half of the twelfth century, cf. ibid., p. 36, relates it to the time of Peter the Venerable.

[18]Mâle, XII siècle, pp. 127-29. Evans, Cluniac Art, p. 93, however, points to the Mozac capital as an example of an Easter sepulchre.

[19]Chalais, Charente tympanum. Dependent on St. Martial de Limoges, first half of the twelfth century, cf. ibid., Fig. 160a.

[20]Mâle, XII siècle, p. 130.

of the Maries, either to show their excitement or actually
to touch the cloth left in the tomb, for example on a capital
from La Daurade (Fig. 50)[21] or the Nantouillet chasse, are
so far removed from the somber reserve of the Byzantine
Maries, from which this iconography as a whole is derived,
as also to demand this explanation. The idea that the drama
is the source for the dramatic in art extends as well to the
angel shown lifting the sarcophagus lid on the cloister capi-
tal from St.-Pons-de-Thomières (Fig. 50)[22] to conform to the
drama's rubric for the angel "découvrant le tombeau."[23]

Mâle supplements his argument by pointing to instances
where scenes such as the spice buying, which were added to
the drama in the late twelfth century, are imitated in art.
He cites a frieze from Notre-Dame-de Beaucaire (Fig. 51),[24]
as well as the lintel at St.-Gilles (Fig. 52),[25] and a large
relief from St.-Trophîme at Arles (Fig. 53).[26] To these

[21]Ste.-Marie-La-Daurade, Toulouse, cloister capital,
ca. 1120, now in the Musée des Augustins, cf. Paul Mesplé,
Toulouse, Musée des Augustins: Les sculptures romanes (Paris,
1961).

[22]St.-Pons-de-Thomières, Herault, early twelfth cen-
tury, cf. Evans, Cluniac Art, Fig. 160b.

[23]Mâle, XII siècle, p. 131, although Mâle gives no
source for the text out of which this rubric comes.

[24]Beaucaire (Gard), Notre-Dame-des Pommiers, frieze
now in the southern facade.

[25]St.-Gilles (Gard), western facade, lintel of the
southern portal--Crucifixion in the tympanum, ca. 1160-70.

[26]St.-Trophîme, Arles (Bouches-du-Rhone), north wing
of cloister--Three Maries above; spice merchants below, 1170-
90.

examples from Provence he relates two reliefs from Modena--
one with the spice buying and another of the Three Maries
showing a singular depiction of the Magdalen fainting on a
sarcophagus tomb (Figs. 54 and 55).[27] Both scenes he ex-
plains through the assumption that the Tours drama from
which they derive had also been performed in Italy.[28] The
force of his prose achieves a kind of crescendo with the ad-
mittedly speculative idea that the representation of Christ
physically emerging from his sarcophagus on another capital
from La Daurade was also inspired by the drama (Fig. 56).[29]

The change in western art to the use of the sarcopha-
gus tomb without any architecture began to take place at the
end of the tenth century.[30] Since this period also marked

[27]From Modena Cathedral, in Cathedral Museum--Three
Maries at Tomb (Magdalen fainting) and Three Maries at the
Spice Merchants--either from capitals or a holy water basin,
cf. Richard Hamann, Die Abteilkirche von St. Gilles und ihre
kunstlerische Nachfolge, I (Berlin, 1955), third quarter
twelfth century.

[28]Mâle, XII siècle, p. 136. On p. 133, note 3, Mâle
cites Tours Ms. 237, from the second half of the twelfth cen-
tury, with Coussemaker, Drames Liturgiques, and Milchsack,
Die Oster- und Passionsspiele, as his sources (see note 12).
However, Young, Drama, I, p. 438, n. 2, refers to Tours, Bib.
de la Ville, Ms. 927, Miscellanea Turonensia, saec. XIII, f.
1r-8v, also citing Coussemaker and Milchsack among other
sources. Young gives the Latin text to which Mâle refers,
pp. 439-47.

[29]Toulouse, Musée des Augustins, cloister capital from
Ste.-Marie-la-Daurade, ca. 1120. Mâle, XII siècle, p. 132.
Brooks, "Sepulchre of Christ," p. 25, says that Meyer (see
note 12) was the first to propose an origin in the drama of
the latter half of the twelfth century for this motif.

[30]Millet, Recherches, p. 517.

the beginnings of the drama, the pull of the idea of their
relationship is strong, although its proof is elusive.[31]
The few early texts which are preserved, if at all clear on
this point, mainly stipulate the use of the altar itself, or
a part of it, or a box or book arrangement set on it, rather
than the sarcophagus-shaped Easter sepulchre of later use.[32]
Moreover, the boxes could take varying shapes--not always
the rectangular sarcophagus form. Mâle is not correct, for
example in his interpretation of the capsa described in the
Metz text as a coffer.[33] To conform to the usual represen-
tation of the Three Maries at the Tomb, one would expect the
coffer, when it was used, to be flat-topped. In fact, how-
ever, its lid was usually gabled, as at Dax, or a truncated
pyramid. Furthermore, as we have seen, Brooks has convinc-
ingly refuted Bonnell's idea, endorsed by Mâle, that depic-
tions of the sarcophagus under a "sort of baldachin" could
come either from the structure of the High Altar in France
or from presumed early versions of the separate Easter sep-
ulchre.[34] The use of the separate sepulchre, even later,

[31]Pächt, St. Albans Psalter, p. 72, the sarcophagus
form of the tomb "was in flat contradiction to the scriptural
account, but evidently in accordance with the stage conven-
tions of the liturgical Easter plays."

[32]Brooks, "Sepulchre of Christ," pp. 59-62. The sim-
ple arrangement of silver books is described at Narbonne,
ibid., p. 61.

[33]Cabrol-Leclerq, D.A.C.L., II, pt. 2, "capsa" ("cas-
sette"), cols. 2340-47: "Ce mot applique plus spécialement
à des récipients de forme circulaire."

[34]See pp. 44-45 of this chapter and notes 1, 4, and 5.

appears to have been less prevalent in France than in England or in areas related to the German customs. In France the _Visitatio Sepulchri_ often took place without the prior performance of any _Depositio_.[35] Brooks concludes that when the sepulchres were draped they "were more likely flat testering with curtains rather than a domed canopy on pillars."[36] The earliest curtain device was probably simply a veil hung on a circular wire as at Winchester, with a somewhat similar arrangement recorded at Metz and Narbonne.[37]

Millet attributes the change in the form of the tomb to a confusion by western artists of the Byzantine depiction of the cube of stone set to secure the sepulchre door with the door of the upright tomb, and also with the rectangular Stone of Unction on which Christ's body had lain.[38] Both the stone "which was rolled away" and the Stone of Unction they took for a sarcophagus.[39] Drawing from Lazarus scenes,[40] the door set at a slant was taken for its cover. The

[35]Brooks, "Sepulchre of Christ," pp. 33-36.

[36]Ibid., p. 63.

[37]Ibid., p. 6., cf. Chambers, _Medieval Stage_, II, p. 17, n. 1.

[38]Millet, _Recherches_, pp. 520-30.

[39]The sixteenth-century lectionary at St. Petersburg (Petropol. 21), cf. _ibid._, Fig. 570 and Florence, Laur. Plut. VI. 23, f. 209v, cf. Velmans, _Le Tetraévangile de la Laurentienne_, Fig. 299, where Stone of Unction also serves as the stone "which was rolled away," cf. Millet, _Recherches_, p. 524. See also _ibid._, Fig. 487 (Berol qu. 66).

[40]Florence, Laur. Plut. VI. 23, f. 193v.

depiction of the Resurrection scene in a late eleventh-century Salzburg lectionary can serve to show what he means (Fig. 57).[41]

It is difficult to fault Mâle's assessment of this reasoning as ingenious but "complicated."[42] Indeed the point was not always confused by western artists, as can be demonstrated through examples from Carolingian art. An ivory bookcover of ca. 870 in Munich plainly shows the sepulchre with the sudarium and the sarcophagus lid seen through its open door (Fig. 58).[43] That the new form of the tomb in both the drama and the art could more simply derive from actual burial custom is shown by the motif on this ivory of the men seen emerging from their tombs below the cross. This type of coffin is clearly seen within the sepulchre in a miniature from the Gero Codex (Fig. 59).[44] Similarly, the

[41]Lectionary of the Gospels from the Benedictine Monastery of St. Peter, Salzburg; second half of the eleventh century; made by Custos Bertolt; New York, Morgan Library M. 780, f. 31 (formerly Salzburg, Stiftsbib. St. Peter Cod. VI. 55, cf. G. Swarzenski, Die Regensburger Buchmalerei des X. und XI. Jahrhunderts (2d ed.; Stuttgart, 1969).

[42]Mâle, XII siècle, p. 128.

[43]Ivory plaque of ca. 870, Liuthard group, originally belonged to the Gospel Book of Charles the Bald in Munich (cod. lat 14000, clm. 55). It was set into the cover of the Pericopes of Henry II, dated 1007-12, Munich, Bayr. Staatsbib. clm.4452, formerly in Bamberg, cf. J. Hubert, J. Porcher, and W. F. Volbach, The Carolingian Renaissance (New York, 1970), p. 356, notes to Fig. 229.

[44]Gero Codex, Darmstadt, Landesbibliothek, f. 86r: illustrated initial M, 969-76, cf. Adolf Schmidt, Die Miniaturen des Gero-Codex (Leipzig, 1924).

marked sarcophagus character of the tombs which Mâle points
to in reliefs from Italy and Provence need not come from the
drama from Tours, the text of which is actually later than
the monuments he cites, but draws instead on examples of
sarcophagi from Roman and Early Christian times that existed
in great supply in this region. Thus it appears that Mâle's
theory concerning the liturgical drama is no more valid than
Millet's concerning the misreading of Byzantine motifs to
explain the change effected in western art from the tower-
shaped sepulchre to the sarcophagus form. From the evidence,
the transition looks to have begun to take place within the
art itself a full century before the drama was born.

The difficulty in interpreting such works as the Mu-
nich Ascension ivory (Fig. 60)[45] may be symptomatic of some
of the reasons behind the change in representing Christ's
tomb. The simultaneous depiction of the soldiers at the
closed tomb and the Maries discovering the tomb open and
empty gives rise to problems in compositional logic. In a
ninth-century book cover in Florence the scene of the sleep-
ing soldiers is separated from that of the Maries approaching

[45]Munich, Bavarian National Museum, Ivory panel,
Women at the Sepulchre and Ascension of Christ, North Ital-
ian, ca. 400. This so-called "temple type" and composi-
tional problems of presenting both the sleeping soldiers and
the angel with the Three Maries is discussed by Brooks, "Sep-
ulchre of Christ," pp. 22-23. It has been questioned whether
these were not originally two separate scenes, as in the
ivory leaf of a diptych from the Trivulzio Collection at
Castello Sforzesco, Milan, ca. 400, cf. W. F. Volbach, Early
Christian Art (London, 1961), p. 325, notes on Fig. 92.

the angel, who is perched on a squarish stone (Fig. 61).[46]
The value of each scene has been given equal weight with the
tomb as the link between the two. The desire to emphasize
the Resurrection is achieved in Ottonian art by what Brooks
describes as a "transitional form" where the soldiers are
less significant. Now the Three Maries are placed within
the enclosing architecture of the sepulchre, seen for exam-
ple in one of the medallions framing the portrait of Mark
in the Gospels of Abbess Uta of Niedermunster (Fig. 62).[47]
This solution is reflected as well in the Poitiers Crucifix-
ion window which Mâle discusses (Fig. 45). This formulation
persists alongside the representation of the sarcophagus
alone, which can already be seen in an eleventh-century
manuscript in Paris (Fig. 63).[48]

The Uta Gospels also show another scene whose appear-
ance in art Mâle had argued could only be explained by its
reference to French drama. On the same Mark page is a

[46]Adolph Goldschmidt, Die Elfenbeinskulpturen aus der
Zeit der karolingischen und sächsischen Kaiser. VIII-XI
Jahrhundert (Berlin, 1914), Fig. 9 on pl. V, Florence, Muz.
Nazionale, IX c., Ada group. Fig. 84, pl. XXXV, in Paris,
Bib. Nat. Lat. Ms. 9390, IX-X c., from Metz, has the order
reversed with the sleeping soldiers on top as in the example
cited in note 45 and in ibid., Fig. 145, pl. LXIII. See
also examples cited by Brooks, "Sepulchre of Christ," Figs.
9 and 12-14.

[47]Gospels of Abbess Uta of Niedermunster, Uta Codex,
Munich, Kaiser Hof- und Staatsbib., Clm. 13601, Cim. 54, f.
41v: upper right-hand medallion, 1002-35.

[48]Paris, Bibliothèque de l'Arsenal, MS 1186, cf.
Brooks, "Sepulchre of Christ," p. 24.

medallion showing the spice-buying scene to illustrate Mark

16:1, "Maria Magdalena et Maria Jacobi emer[unt] arom[ata]"

(Fig. 62).[49] Ottonian art is the source of other motifs

Mâle mentions as well: the angel holding the cross occurs

in the Resurrection scene from the Sacramentary of Henry II;[50]

a depiction of Christ, cross in hand, rising from his tomb

appears above the portrait of Mark in a Gospel Book from

Bamberg (Fig. 64), the first known representation in this

important form--and long before any hint of it in the drama

performance.[51]

[49]See note 47 and Swarzenski, _Regensburger Malerei_,
p. 101.

[50]Sacramentary of Henry II, Munich, Staatsbib. Cod.
Lat. 4456, Cim. 60 (formerly Bamberg, Cathedral Treasury), f.
15r, 1002-14.

[51]Munich, Staatsbibliothek, Cod. Lat. 4454, Cim. 59,
f. 86v (formerly Bamberg, Cathedral Treasury), early eleventh
century. See also "Auferstehung Christi," _Reallexikon der
deutschen Kunstgeschichte_, I, ed. by O. Schmitt (Stuttgart,
1937), cols. 1239ff. The earliest suggestion of the personal
appearance of Christ in the drama texts is a note added to
the margin of the late thirteenth-century _Carmina Burana_,
Munich, Staatsbibliothek Ms. Lat. 4660a, cf. Young _Drama_, I,
pp. 437-38. Impersonation of Christ by an actor seems at
first to have been approached by indirection, as in the _Noli
me tangere_ scene where the Magdalen meets Christ in the guise
of a gardener or in the Supper at Emmaus, where Christ ap-
pears dressed as a pilgrim. See for example the plays from
the Fleury play-book from the Monastery of St.-Benoit-sur-
Loire, Orleans, Bibl. de la Ville, Ms 201 (olim 178), _Mis-
cellanea Floriacensia_, saec. XIII, p. 176-243, cf. _ibid_., p.
665. Forsyth, "Magi and Majesty" and _Throne of Wisdom_ (see
note 13), has shown for the Christmas plays what appears to
have been true for the Easter ones: the principal figures--
Christ and the Virgin--were presented by wood sculpture
rather than by living actors. The prevalence well into the
Gothic period of wood Christ figures with movable arms (see
note 60) as well as wood images of the Resurrected Christ, cf.
Appuhn, "Weinhausen," (see note 8) suggest that this form

Just as the innovative formulations of Ottonian art
and not the drama can be seen to lie behind specific icono-
graphic elements of French sculpture of the early twelfth
century, so, too, can the emphasis Mâle places on dramatic
gesture be accounted for by other means. The expressiveness
found at La Daurade, for example, is not unique to the scene
of the Three Maries at the Tomb but extends to others whose
composition cannot be said to be dependent on the drama at
all, such as the Descent from the Cross (Figs. 49 and 26).[52]
The tension radiating from the pose of Joseph struggling to
support the far heavier and larger body of Christ conforms,
with the Three Maries' gestures, to the regional style char-
acterized by energy and movement, and expressed through
tight drapery folds and a vigorous rendering of bodily ac-
tions. In its intensity, this particular style matches
later Gothic monuments, such as Nicola Pisano's tympanum at
Lucca (Fig. 20),[53] when a greater stress on naturalism and

continued to be preferred through the fourteenth century.
However, Pächt, Rise of Pictorial Narrative, p. 72, tends to
side with Mâle on the issue of the drama as the source of
the image of the Resurrected Christ. He makes the distinc-
tion regarding the Bamberg Gospels that it depicts a word
image and not the mystery as such.

[52]Mesplé, Toulouse (see note 21). The earliest De-
positio performances took the form of simply placing the
cross in the sepulchre. Even the later use of the corpus
alone cannot have affected the visual representation of the
scene in any way except possibly to encourage (as well as to
reflect) a difficult-to-specify tendency to dramatize the
event--a tendency which can as well be explained by the sty-
listic development toward increasing naturalism within the
artistic tradition. The issue instead regarding this scene
is why it was singled out in both the art and the drama.

[53]See Chapter I, note 31.

on human emotion became stylistic hallmarks of the period.

The remarkable quality of Mâle's chapter lies in the fact that even after a thorough dissection of his literary method in which his separate assertions concerning individual iconographic detail can be minimized or discarded, his premise remains essentially true. Even though the simultaneous appearance of the scenes in the drama expanded from its Visitatio Sepulchri base and the expanded scenes in the cycles cannot definitely be demonstrated to have exerted an impact one on the other, a common impetus was certainly "in the air." As a result, a greater dramatic freedom is evident in the art, especially in secondary scenes whose narrative aspect was primary, but even in traditional scenes whose iconic meaning was less outspoken. This increasing freedom is most noticeable in small-scale works. Thus, Mâle's examples from this period are largely drawn from reliefs and capitals rather than a more monumental context such as the central representation of a tympanum.

However, there is another more specific factor, I think, which contributes to the force of this part of Mâle's thesis: it is his important insight into the liturgy as the source of both the art and the drama.[54] Intuitively, he seemed to know that the closer the scene to its liturgical

[54]Mâle, XII siècle, p. 125: "Le drame liturgique ne fut qu'une des formes de la liturgie. Le culte chrétien est d'essence dramatique. La messe reproduit sous des formes voilées le sacrifice de Calvaire."

source the more profound the relation of drama and art.
Mâle's thesis gains strength, not in its proliferation into
additional scenes and iconographic detail, but in the reverse
process which returns both the drama and the art to their
font to seek their basic meanings. An analysis of the
Christmas drama has recently proved this to be true.[55] It
is the intention here to show that the same insight may be
applied to the Good Friday ceremony as well.

Mâle's appreciation of the dramatic character of the
liturgy itself, however, was daringly ahead of his time.
The prevailing view was that medieval drama began only when
the Quem Quaeritis tropes were separated off from the Introit
of the Easter vigil mass to form the Visitatio Sepulchri per-
formed at the end of Easter matins, thus becoming the first
true drama of the Middle Ages.[56] Since the Depositio did
not undergo this process, it was held to be no more than a
"quasi-dramatic" form and therefore beyond contention for
any real relationship between the drama and the art. Hence,
when citing the reference to the Depositio Crucis in the de-
piction of the veiled cross on cloister capitals at Ste.-
Marie-la-Daurade and at Moissac (Figs. 65 and 66),[57] Joan
Evans is careful to explain: "The actual transition from

[55]Forsyth, "Magi and Majesty" and Throne of Wisdom,
see note 13.

[56]Chambers, Medieval Stage, II, pp. 7ff.; Young,
Drama, I, pp. 178ff.; Frank, Medieval French Drama, pp. 20ff.

[57]See note 16.

liturgy to drama was made not within the unchanging formulas of the Mass itself but within the scheme of permissible and variable additions to it . . . [the Easter Quem Quaeritis tropes]."[58] Mâle's was a lone voice in the 1920's when he proclaimed the Depositio, too, to be genuine drama: "Ce jour-là [Good Friday] après avoir veneré la croix, on l'enveloppait dans un voile qui representait le linceul du Christ, et on la portait solennellement au tombeau: cette croix, c'était le Sauveur lui-même."[59]

The Mass as Genuine Drama

A number of factors have recently converged to force a re-examination of the relation of the Depositio drama to art. First of all, several new texts have come to light to add to our knowledge of the rite and of the secular Passion plays which developed out of it.[60] Secondly, another form of the symbol of Christ has emerged and can be shown to have been used in later ceremonies: the life-size corpus figure with movable arms which was actually taken down from the

[58]Evans, Cluniac Art, p. 90.

[59]Mâle, XII siècle, p. 126.

[60]Recent literature cited by the Tauberts (see note 62) not so far available in N.Y.C.: S. Corbin, La Déposition liturgique du Christ au Vendredi Saint. Sa place dans l'histoire des rites et du théâtre religieux (Paris-Lisbon, 1960); R. Gschwend, Die Depositio und Elevatio Crucis im Raum der alter Diözese Brixen. Ein Beitrag zur Geschichte der Grablegung am Karfreitag und der Auferstehungsfeir am Ostermorgen (Sarnen, 1965); A. Hänggi, Der Rheinau Liber Ordinarius (Freibrug, Switzerland, 1957).

cross and placed in the sepulchre (Fig. 67).[61] In a recent
article, Gesine and Johannes Taubert collected some thirty-
five of these corpora, from Germany, Switzerland, Austria
and Italy, together with five others reported to have existed
through literary sources, enough to demonstrate their fairly
widespread use in the rite from the mid-fourteenth century
on.[62] When added to the Grabbild group--the dead Christ
figure carved in one block of wood with arms at the sides--
and the Holy Graves in stone, a more illuminating picture of
the popularity of the rite takes shape, even if the use of
these alternate forms is not yet entirely clear.[63]

[61]Florence, S. Croce (Bardi da Vernio Chapel), poly-
chromed wood; height: 5' 6" x width: 5' 7-3/4"; ca. 1412,
H. W. Janson, The Sculpture of Donatello, II (Princeton,
1957), pp. 7-12.

[62]Gesine and Johannes Taubert, "Mittelalterliche
Kruzifixe mit Schwenkbaren Armen; Ein Beitrag zur Verwendung
von Bildwerken in der Liturgie," Zeitschrift des deutschen
Vereins für Kunstwissenschaft, XXIII (Berlin, 1969), 80-90,
for a complete listing.

[63]See the references listed in note 8. The Tauberts,
ibid., pp. 93-113, take the position that the wood Grabbild
was used unless the text specifies the actual taking down of
the "imago crucifixi" from the cross. They thereby challenge
the idea that Holy Graves in stone rather than the wood ones
were the principal setting for the Easter rites in the later
Middle Ages. The Tauberts argue that the stone Holy Graves
were essentially conceived as Andachtsbilder for prayer and
veneration rather than as the receptacle for the Host in the
Depositio rite. In fact, images in both wood and stone were
used in the rite on occasion (see Young, Drama, II, p. 538),
but it is not certain just when it was for either its primary
function. The Tauberts' argument that the inferior quality
of many wood images in comparison to those in stone is fur-
ther proof of their brief exposure only in the Depositio
ceremony is neither valid in itself nor even always accurate
(see Fig. 67 and note 61). The preserved examples may merely
testify to the objects' greater chance of survival in out-

The most decisive factor to a review of the _Depositio_, however, has been the effective challenge by Professor O. B. Hardison, Jr., to the established view of historians of the drama which had denied that the liturgy of the Mass is genuine drama.[64] Karl Young, among others, had insisted that the Mass was not a drama because the celebrants do not impersonate--a prime criterion in his definition of drama--but actually become what they represent.[65] Hardison assails this distinction as born of the nineteenth-century view of the "play theory of art," valid neither for the medieval standard of what constituted drama nor indeed for the twentieth-century one.[66] Hardison's assertion that the religious ritual _was_ the drama of the Early Middle Ages was a point never contested by liturgical specialists, who took the assertions of contemporary medieval writers at face value.[67]

lying, sometimes poorer, parishes, at the height of their suppression in the sixteenth century.

[64]Hardison, _Christian Rite_.

[65]Young, _Drama_, I, pp. 81-85.

[66]Hardison, _Christian Rite_, pp. 26-34, and Essay II: "The Mass as Sacred Drama," pp. 35-79.

[67]Joseph A. Jungmann, _The Mass of the Roman Rite: Its Origins and Development (Missarum Sollemnia)_ (abridged ed.; New York, 1959), p. 80. The most explicit statement of the Mass as drama is given in the _Gemma Animae_ of Honorius of Autun, written ca. 1100. Cited here is the translation made from text in Migne, _P.L._, CLXXII, col. 570, by Hardison, _Christian Rite_, pp. 39-40:

> It is known that those who recited tragedies in theaters presented the actions of opponents by gestures before the people. In the same way our tragic author [i.e.,

If we, too, can at last, along with Mâle, accept the dramatic
character of the liturgy, we can restore to art and drama
the root from which they branched and we can begin to seek
an interrelationship infinitely more profound than mere ques-
tions of iconographic detail.

The potentiality for the Mass of the western church
in the Early Middle Ages to be seen as sacred drama is
clearly lodged in the writing of Gregory the Great, which
was to become the orthodox interpretation of the Mass:[68]

> Let us meditate what manner of sacrifice this is, or-
> dained for us, which for our absolution doth always rep-
> resent the passion of the only son of God: for what

> the celebrant] represents by his gestures in the theater
> of the Church before the Christian people the struggle
> of Christ and teaches to them the victory of His redemp-
> tion. Thus when the celebrant [presbyter] says the
> Orate [fratres] he expresses Christ placed for us in
> agony, when he commanded His apostles to pray. By the
> silence of the Secreta he expresses Christ as a lamb
> without voice being led to the sacrifice. By the ex-
> tension of his hands he represents the extension of
> Christ on the Cross. By the chant of the Preface he ex-
> presses the cry of Christ hanging on the Cross. For He
> sang [cantavit] ten Psalms, that is, from Deus meus
> respice to In manus tuas commendo spiritum meum, and
> then died. Through the secret prayers of the Canon he
> suggests the silence of Holy Saturday. By the Pax and
> its communication [i.e., the "Kiss of Peace"] he repre-
> sents the peace given after the Resurrection and the
> sharing of joy. When the sacrifice has been completed,
> peace and Communion are given by the celebrant to the
> people. This is because after our accuser has been de-
> stroyed by our champion [agonotheta] in the struggle,
> peace is announced by the judge to the people, and they
> are invited to a feast. Then, by the Ite, missa est,
> they are ordered to return to their homes with rejoicing.
> They shout Deo gratias and return home rejoicing.

[68]Cited here is the translation given in ibid., p. 36,
of Dialogue IV, chapter lviii, from The Dialogues of Gregory
the Great, translated by P. W., ed. by Edmund Gardner (Lon-
don, 1911), p. 256.

> right believing Christian can doubt that in the very
> hour of the sacrifice, at the words of the priest, the
> heavens be opened and choirs of angels are present in
> that mystery of Jesus Christ; that high things are ac-
> complished with low, and earthly joined to heavenly, and
> that one thing is made of visible and invisible.

Although subsequent analyses of the Mass by Gregory's suc-
cessors tended to fuse aspects of the Mass with varying lay-
ers of symbolic meaning, it remained for Alcuin's pupil,
Amalarius of Metz, to set forth in his Liber Officialis, the
first edition of which was written in 821, a relatively con-
sistent reinterpretation of the Mass as a whole.[69] Amalarius,
who was prominent in the courts of both Charlemagne and Louis
the Pious, had been charged with the task of making clear to
the simpliciores the difficult concepts lying behind the per-
formance of the Mass.[70] In so doing, he recast the Mass as
a "rememorative allegory" of the life, ministry, Crucifixion
and Resurrection of Christ in which not only the clergy but
the congregation, too, have specific although changing roles
to play. In structure, it is a comedy because "it begins in
adversity and ends in peace."[71]

[69]Hardison, Christian Rite, p. 37. Amalarius wrote
three editions of the Liber Officialis between 821 and 835.
This version was more influential than his earlier interpre-
tation of the Mass, Eclogae de ordine Romano, of 814. Texts
are in Migne, P.L., CV, cols. 815-1360. See Alan Cabaniss,
Amalarius of Metz (Amsterdam, 1954), for an interesting dis-
cussion of Amalarius and his relationship to church drama.

[70]Carol Heitz, Recherches sur les rapports entre Archi-
tecture et Liturgie a l'epoque carolingienne (Paris, 1963),
p. 91, discusses Charlemagne's liturgical reform, and pp. 171-
73, Amalarius' Anglo-Saxon orientation.

[71]Hardison, Christian Rite, p. 46.

For an understanding of the shape of Amalarius' reading of the sacred drama of the Mass, it is important to recognize that unlike the liturgy of later periods when the climax of the Mass was the Crucifixion, in the ninth century the main emphasis was on the Resurrection.[72] The critical low point of the drama for Amalarius was the death, Deposition and Entombment as the dramatic foil to its resolution and climax in redemption through the Resurrection. This low point occurs at the nobis quoque peccatoribus, the Consecration prayer, which begins with the image of the Dead Christ. Christ, already crucified, is "sleeping with his head inclined on the cross."[73] This is the moment when the celebrant assumes the role of the centurion who plunged the spear into Christ's side from which flows the miraculous blood and water into the chalice. Then the Elevation takes place. The archdeacon, who assumes the part of Joseph of Arimathea, and the celebrant, as Nicodemus, raise the chalice and the Host from the altar; their gestures are a reenactment of the very moment of the Descent from the Cross. They then wrap both the chalice and the paten in the sudarium. Their act of replacing these objects on the altar signifies the Entombment as the concluding words per omnia saecula saeculorum of the Consecreation prayer are spoken. Thus, the

[72]Ibid., p. 65.

[73]Ibid., p. 69. See pp. 68-72 for Hardison's discussion of this section of Amalarius' Mass. For text, see Migne, P.L., CV, cols. 1143ff.

reenactment of the Descent from the Cross and the Entombment
at the so-called "little Elevation" of today was for Amalarius
the focus of the Consecration. The climactic high point of
Amalarius' Mass--the shift from tristium to gaudium--is the
reenactment of the Visit of the Maries to the Tomb. This
moment occurs when the subdeacons, representing the Maries
who were faithful and did not flee come to the altar to re-
ceive the Host but must wait for the Commingling and the
Fraction.

The achievement of Amalarius is a combination of in-
novation and of organization of existing thought. For the
increased force of his dramatic emphasis, he drew heavily on
the symbolic orientation of the Syrian liturgy. It was to
the mysticism of John of Chrysostom which also lies behind
Gregory's great interpretation of the Mass that Amalarius
turned.[74] Chrysostom initiated the tradition that fashioned
the liturgy into a mystigogical drama in which the death of
Christ was represented by the separation of the body and the
blood at the Consecration, and the Resurrection through their

[74]Konrad Burdach, Der Gral (Stuttgart, 1938), pp.
151ff. Burdach paraphrases the Chrysostom test; for his
source he cites Codex liturgicus ecclesiae universae, ed. by
Daniel, 4 vols. (Leipzig, 1847-53). Hardison, Christian
Rite, p. 43, n. 21, states that Amalarius actually went to
Constantinople, which would account for the fresh impact of
the eastern liturgical practice on his thinking. Hardison
also enumerates Amalarius' other major sources. Amalarius'
Constantinopolitan trip also means that Amalarius could have
known firsthand of the ideas of Maximus the Confessor, one
part of which was translated into Latin for Charles the Bald
but not until 869-70, see Knut Berg, "Une iconographie peu
connue du crucifiement," Cahiers Archéologiques, IX-X (1957-
59), 324ff.

being reunited at the Commingling. The most overtly dramatic element of the Chrysostom Mass was the First Entrance, when the deacons bring the bread and wine to the altar. Theodore of Mopsuestia proclaimed it an "awe inspiring event" representing the appearance of Christ accompanied by angels on the way to the sacrifice of his Passion.[75] The Entombment process was portrayed through the actions of the priest after he has removed the cloths which had covered the chalice and the paten during the procession. He takes the aer--signifying both Christ and the cloth in which Christ was wrapped-- from the shoulders of the deacon, censes it and covers the sacraments before placing them on the altar. The symbolic meaning of this action is elucidated by his twice repeating: "The noble Joseph took the undefiled body down from the wood cross, wrapped it in a clean linen sheet, covered it with perfume and laid it in a new grave."[76]

Fifth-century writers elaborated upon the symbolism of the Chrysostom Mass. The Syriac homily of Narsai exhorts the believer to:[77]

[75]Thomas Mathews, The Early Churches of Constantinople: Architecture and Liturgy (University Park, Pa., 1971), p. 157 and n. 9, from Homily 15, 23-25 in Les Homélies catéchétiques, ed. by R. Tonneau and R. Devreese, Studi e testi, 145 (Vatican City, 1949), pp. 501-05.

[76]Burdach, Der Gral, p. 145.

[77]Hardison, Christian Rite, translation of Narsai homily given in note 5 on pp. 36-37, from "Homily XVII (A)," trans. Dom. R. H. Connelly, The Liturgical Homilies of Narsai, from Texts and Studies, Biblical and Patristic Literature, VIII (Cambridge, 1909), 3-4.

put away all anger and hatred and . . . see Jesus who is being led to death on our account. On the paten and in the cup he goes forth with the deacon to suffer. The bread on the paten and the wine in the cup are symbols of His death. A symbol of His death these [deacons] bear on their hands and when they have set it on the altar and covered it, they typify His burial. . . . The priest who celebrates bears in himself the image of our Lord at that hour. All the priests in the sanctuary bear the image of the Apostles who met together at the sepulchre. The altar is the symbol of our Lord's tomb, and the bread and wine are the Body of the Lord which was embalmed and buried.

Chrysostom's student, Isidore of Palusium, a city in Egypt, is the first to focus on the part of Joseph of Arimathea in the drama:[78]

As Joseph of Arimathea enfolds the body of the Lord in a linen sheet and lays him in the grave by which all of mankind received the reward of the Resurrection, so, too, we bless the bread of the Prothesis on the table and find there without question the body of Christ, poured out for us, so to speak, as the source of our immortality, which the Holy Jesus, who was buried by Joseph in the grave after which he rose from the dead, has given us.

Maximus the Confessor, writing in the seventh century, presents immediately following the Great Entrance procession an image of the offertory even richer in symbolism:[79]

[78]Burdach, Der Gral, p. 153. Text of Isidore of Palusium: Epistolarum Lib. I, epist. 123 in Migne, P.G., LXXVIII, cols. 264ff. Given here is my translation of Burdach's German rendering of the Greek text.

[79]For the text of Maximus the Confessor's (580-662) interpretation of the Mass, see, S. Petrides, "Traités Liturgiques de St. Maxime et de St. Germain traduits par Anastase le bibliothécaire," Revue de l'Orient Chrétien, X (1905), 359. I am indebted to Constance Jewett for her translation of this passage. The Latin text is as follows:

Est autem et secundum imitationem sepulturae Christi quia Ioseph deponens corpus de cruce inuoluit in sindone et aromatibus et unguentis inunctum portauuit cum Nicodemo

et sepeliuit illud in monumento nouo quod exciderat in petra, quod est exemplar illius sancti monumenti altare et repositorium, in quo positum est sanctum et intemeratum corpus in sancta mensa.

Disci cooperimentum est pro sudario, quod erat super caput et faciem, cooperiens eum tanquam in sepulcro.

Discus est pro manibus Ioseph et Nicodemi, qui Christum sepelierunt. Item discus interpretatur, ubi portatur Christus, circulum caeli significans in modica circumscriptione spiritualem solem capiens Christum in pane uisum.

Calix est pro uasculo, quod suscepit sanctae diligentiae susceptionem, quae de cruentato et intemerando latere manibusque ac pedibus Christi effluxit. Calix iterum est secundum craterem ubi, secundum quod scriptum est, sapientia, id est filius Dei, miscuit sanguinem suum pro uino. Illic etiam addidit in sancta mensa sua omnibus dicens: bibite sanguinem meum pro uino mixtum uobis in remissionem peccatorum et uitam aeternam.

Uelum siue aer est et dicitur pro lapide, quo Ioseph muniuit sepulcrum, quod et signiuit Pilati custodia. Rursusque uelum dicitur propter apostolum, qui ait: Habemus fiduciam in introitum sanctorum in sanguine Iesu Christi, quam initiauit nobis uiam nouam et uiuentem per uelamen, id est per carnem suam, et sacerdotem magnum super domum Dei.

Apparently the Latin translator simply took over the Greek words disc and aer. Disc is the Greek equivalent of the Latin paten. See note 97 for a further discussion of the aer. Maximus the Confessor makes the identification of the aer with the epitaphios and also distinguishes the two separate cloths signifying the burial coverings of Christ--the sindon and the sudarium--widely used in western liturgies and often reflected in representations of the Three Maries at the Tomb (Figs. 45, 46, 49, 50, 55, 62 and 63). See note 98 for a discussion of these cloths in Descents from the Cross. These cloths were also important to the Visitatio Sepulchri. They are displayed by the Magdalen as proof that the tomb is empty, for example in the thirteenth-century play from Fleury performed at Columbia, Spring, 1974 (see note 51).

The scripture of the apostle referred to is Paul's letter to the Hebrews 10:19-22, which in the Jerusalem Bible is translated as follows: ". . . through the blood of Jesus we have the right to enter the sanctuary, by a new way which he has opened for us, a living opening through the curtain, that is to say, his body. And we have the supreme high priest over all the house of God."

Moreover, following the imitation of the burying of
Christ--since Joseph, taking the body down from the
cross, wrapped it in the sindon and, having anointed
it with spices and ointments, bore it, with Nicodemus,
and buried it in a new sepulchre which he had cut out
of stone--the altar is a replica of that holy monument
and the resting place for the sacred and undefiled body
on the sacred mensa.

The covering of the disc stands for the sudarium which
was over the head and face, covering him as it did in
the sepulchre.

The disc represents the hands of Joseph and Nicodemus
who buried Christ. The disc where Christ is carried
also stands for the circle of heaven signifying in its
smaller circumference the spiritual sun holding Christ
seen in the bread.

The chalice stands for the vessel which took on the re-
ceiving of the sacred love which flowed from the blood-
stained and undefiled side of Christ and also out of his
hands and feet. The chalice also represents the cup
wherein, following what is written, Wisdom, that is the
son of God, mixed his own blood as wine. Likewise, he
placed the cup on his sacred table, saying to all,
"Drink my blood (mixed as wine for you) unto forgiveness
of your sins and life everlasting."

There is a veil or aer which stands for the slab of stone
by which Joseph closed the sepulchre which Pilate's guard
sealed. On the other hand, the veil is also interpreted
according to the Apostle as follows: We have faith in
the entry of the holy places by means of the blood of
Jesus Christ, which initiated for us a new and living
way through the veil, that is through his body, and in
the high priest over the house of God.

Incorporating the ideas educed in the commentaries on
Chrysostom, Maximus further specifies the place of Joseph of
Arimathea at the Descent and, with Nicodemus, at the Entomb-
ment. The meanings are additionally enriched by the elabora-
tion of the cloths involved in the burial--the sindon in
which Christ's body was wrapped and the sudarium to cover
his face and head--and the equation of the aer with the

Epitaphios--the Stone of Unction.

In Amalarius' Mass, Nicodemus is also included in the
Descent from the Cross. His presence was assumed in Tatian's
Diatesseron, as we have seen, and is standard in preserved
representations of the Descent both East and West. The ef-
fect of his presence in both scenes within the liturgical
sequence is to equalize the balance between the Descent and
the Entombment. Until this point, following the gospel ac-
counts, it was the latter scene which was the more emphasized
moment in the liturgy and in the commentaries on it. Now
the Descent achieves a separate significance and is an image
of its own. In fact, with Amalarius the Descent from the
Cross is made the very focus of the Consecration. When the
archdeacon, as Joseph, raises the chalice and the celebrant,
as Nicodemus, holds up the host, the mystery of the Transub-
stantiation is accomplished.[80]

[80]Amalarius, De ecclesiastiis officiis, Lib. 3, cap.
XXVI: De corpore domini post unissimum spiritum in cruce,
in Migne, P.L., CV, col. 1144. It is not clear if the ico-
nography of the Holy Grail affected the change in Amalarius'
version of this part of the Mass. Since Chrysostom, the cup
used at the Last Supper was identified with the one used to
catch the blood from Christ's wound at the Crucifixion, see
Burdach, Das Gral, p. 152 and p. 85 for its further being
the source of the four rivers of Paradise. L'Histoire du
Saint Graal was written by Robert de Baron at the end of the
seventh century and the legend became increasingly popular
throughout the Middle Ages, see Berg, "Une iconographie peu
connue," passim, where he relates the iconography of Joseph
and the Grail legend to a Crucifixion on Cross 15 in Museo
Civico in Pisa (Vavala, La croce dipinta, I, Fig. 19) in
which Joseph appears in the place usually allotted to Ec-
clesia. As an aside, I have wondered if it is possible for
the exchange of place of Joseph for the Virgin as Ecclesia
in this Crucifixion to have a relation to the tendency for

Sacramental Meaning of the
Descent from the Cross

Amalarius' writings were condemned by the synod of
Quiercy in 849 in a fight led by Deacon Florus of Lyons.
The argument centered around a distinction that was made be-
tween the symbolism of Gregory, for example, and the newer
allegorical method of interpreting the liturgy first espoused
by Alcuin of York.[81] While Alcuin's writings were consid-
ered still vague enough, Amalarius, they felt, went too far
in his explicitness. The vigorous opposition failed, how-
ever, to halt the rapid spread of his ideas. He initiated a
tradition which was continued and elaborated by a long suc-
cession of interpreters, including Walafrid Strabo, Hugh of
St. Victor, Honorius of Autun, and Durandus of Mende.

It is clear that images familiar in art have been
drawn into the liturgical sequences of Amalarius' interpre-
tation of the Mass. The Descent from the Cross, the Entomb-
ment, the Three Maries at the Tomb--among others--were each
individualized as a moment of liturgical importance. An in-
teresting question for further study is the effect that his
interpretation may have had on the choice and meaning of
scenes represented in the art of succeeding periods.[82] One

Mary to share the role of Joseph in many representations of
the Descent. Usually, Joseph is the principal actor, or the
Virgin and Joseph together; in the Bury St. Edmunds Cross,
however, Joseph does not appear--only the Virgin.

[81]Heitz, Architecture et Liturgie, pp. 171-73.

[82]Adelaid Winstead touched on this question in her

may wonder, for example, if the earliest western instance of the Descent from the Cross in the Angers Gospels, seen together with but dominating the Entombment, is not meant to express the place of these scenes at the Consecration (Fig. 27). Such an interpretation would seem valid for their appearance in the St. Trond lectionary, where these scenes balance that of the Three Maries at the Tomb on the following page (Fig. 3).[83]

Doubtless fueling the fire of the proceedings at Quiercy was a profound disagreement concerning the interpretation of the Host in the Mass "as Christ's human, suffering body, or His spiritual flesh existing forever in Heaven."[84] Paschasius Radbertus had set forth the former view in a tract written in 831 for Charles the Bald. It was answered by Ratramnus of Corbie, who upheld the official position of the Church in Rome. Although Amalarius does not figure directly in this controversy, his dramatization of Christ's humanity links him to the counterview and we find that his

paper, "The Drogo Sacramentary," Smith College, 1973. I am grateful to her for the reference to Berg's article.

[83]See Chapter I, notes 39 and 2. This question could be pursued with greater precision by working directly with manuscripts or facsimiles. Examples in the literature are usually cited without specifying their context within their manuscript.

[84]Adolf Katzenellenbogen, The Sculptural Program of Chartres Cathedral (Baltimore, 1959), p. 13; see his note 26 for references to Paschasius Radbertus and Ratramnus of Corbie: Paschasius Radbertus, Liber de corpore sanguine Domini, P.L., CXX, cols. 1267ff.; Ratramnus of Corbie, De corpore et sanguine Domini, P.L., CXXI, cols. 125ff.

influence spread from Northern France to England and Germany,
where the idea of the Host as Christ's human body--expressed
through the image of the dead Christ--first took hold, even-
tually winning out completely in the mid-twelfth century.[85]

Katzenellenbogen, in explaining the evolution of the
process by which the newer interpretation gradually took
over, points to the change in the iconography of the French
tympanum in the twelfth century from the superposition above
the scene of the Last Supper of the image of Christ in
Heaven as St.-Julien-de-Jonzy to that of Christ crucified at
the Church of Condrieu.[86] The direct equivalence of the De-
scent from the Cross for the Crucifixion as an expression of
this idea is seen in two wall paintings on the west walls of
the transepts of the Church of Sankt Marien in Neuenbenken
(Westphalia) of ca. 1230, where the north transept shows a

[85]Ibid., p. 13; see Hardison, Christian Rite, p. 38,
for the early acceptance of Amalarius' ideas in France. See
also the reference to Haussherr, Der Tote Christus, cited in
Chapter I, note 89. The Gero Cross of ca. 967 was the first
expression of the idea of the Dead Christ in Ottonian art.
The explicit sacramental reference is to be seen in the
double-page miniature from the Gospels of Uta of Niedermun-
ster (Munich, Bayr. Staatsbibl., clm. 13601, f. 3v and 4r,
1007-35), where the crucified Christ is directly juxtaposed
with a representation of the Mass celebration, see A. Boeck-
ler, "Das Erhardbild im Uta Codex," Studies in Art and Liter-
ature for Belle da Costa Greene (Princeton, 1954), pp. 219ff.
For the revival of the ninth-century dispute in eleventh-
century France, see: P. Brieger, "England's Contribution to
the Origin and Development of the Triumphal Cross," Medieval
Studies, IV (1942), 89.

[86]Katzenellenbogen, The Sculptural Program of Chartres,
Figs. 22 and 23.

Last Supper and the south a Deposition (Figs. 68 and 69).[87]
This rationale is also quite clearly behind the Depositions
in wall painting and the large wood sculpture groups that
were placed behind an altar (Figs. 97 and 15).

There are other works, however, that explicitly depict
the sacramental aspect of the Descent from the Cross. Some
are specifically English, while some have been called either
English or North French, since the style of these two regions
is at times virtually indistinguishable in the twelfth cen-
tury. Two--an ivory from Rouen and one from Münster in the
Morgan Library--have been mentioned before because of the
fact that the Virgin does not appear (Figs. 30 and 31).[88]
Both depict the Descent from the Cross with the unmistakably
eucharistic feature of the chalice placed at the foot of the
cross. Above the Christ the Rouen ivory shows the dove hold-
ing a crown; in the Münster one, the hand of God emerging
from a cloud holds a cross nimbus--both motifs signifying
the divinity of the dead Christ.

Both have a number of angels above the cross: the
Münster ivory has six, with their hands held together in a
gesture of prayer; the Rouen ivory shows two angels above
the cross and two more below it. We have already noticed
angels at a Descent in the representation on Pisa Cross No.

[87]Otto Demus, Romanesque Mural Painting (New York,
1970), p. 614, calls this Deposition (labelled correctly
elsewhere) a Crucifixion.

[88]See Chapter I, note 44.

20 (Fig. 42) we find them again in another twelfth-century English ivory from Hereford and in an English Psalter of ca. 1200 (Figs. 70 and 72).[89] They also appear originally to have been part of many of the Italian Deposition groups in wood (Fig. 15). The presence of angels at the cross reflects their presence in the liturgy at the Sanctus at the end of the Preface which precedes the Canon of the Mass.[90] The Sanctus is the angelic hymn which proclaims the renewal of the sacrifice by means of the Crucifixion. The angels' hands if veiled recall the manner in which the priests approach the sacramental objects at the altar.[91] But striking in these northern examples is the active part the angels play in the scene. They appear to reflect the Anglo-Saxon belief in the presence of angels not only at the Preface but at the Consecration as well.[92]

[89]For the Pisa Cross, No. 20, see Chapter I, note 112; for the Hereford ivory, see Goldschmidt, Die Elfenbeinskulpturen, IV, notes on pl. XXXVI, Fig. 102, and J. Beckwith, "An Ivory Relief of the Deposition," Burlington Magazine, XCVIII (1956), 228ff.; the Deposition from the Psalter is in London, British Museum, Arundel MS 157, f. 10v.

[90]Jungmann, Mass (abridged ed.), pp. 380-84.

[91]See Chapter I, note 114.

[92]Brieger, "England's Contribution," p. 90. Brieger discusses the importance of angels in English art, citing in particular two homilies of Bede and Rabanus Maurus' De laudibus crucis, written under the influence of Bede. The western interest in angels relied heavily on the formulations of the Pseudo-Dionysius, but liturgically it is also related to the eastern Cherubicon, the solemn sixth-century hymn sung in accompaniment to the Great Entrance. While the Cherubicon never entered the western liturgy proper, it was taken over first in the Gallican and later in the Roman rites in the

Other iconographic peculiarities of these northern
works may also refer to the Mass. The Münster ivory, which
Goldschmidt asserts is English, shows four men in the process
of removing Christ's body from the cross, while a fifth, ac-
cording to Goldschmidt, gives orders. It is possible that
this grouping, which is unusual in a Descent composition,
refers to the priests and deacons who symbolically perform
this task in the Mass.

Goldschmidt identifies the motif of the cloth beneath
the cross of the Rouen ivory as Christ's mantle, which the
two angels display as they engage in gestures of speech. If
correct, this vignette refers to the well-known passage from
John.[93] But it is also possible that in this context, the
angels are pointing to the sindon in which Christ was
wrapped, which was symbolized in the medieval Mass by the

form of the Trisagion which is part of the Reproaches of
Good Friday, see ibid., p. 93, and "Cherubicon" and "Tri-
sagion," The Oxford Dictionary of the Christian Church, ed.
by F. L. Cross (New York, 1966), pp. 270 and 1377.

[93]John 19:23 (translation from The Jerusalem Bible
[New York, 1966]):

When the soldiers had finished crucifying Jesus they
took his clothing and divided it into four shares, one
for each soldier. His undergarment was seamless, woven
in one piece from neck to hem; so they said to one an-
other, "Instead of tearing it, let's throw dice to de-
cide who is to have it." In this way the words of
scripture were fulfilled:

They shared out my clothing among them
They cast lots for my clothes [Psalm 22:18].

See again Chapter I, note 44, for references to Goldschmidt's
discussion of the Rouen and Münster ivories.

humeral veil worn by the sub-deacon and used when he touched

the sacraments after they had been brought to the altar.[94]

Other English (or North French) works of the period betray

a similar emphasis on the sindon in representations of the

Descent from the Cross. Rolled up, it is held by Joseph in

the depiction of this scene below an image of the Crucifixion

in the Psalter of Henry of Blois (Fig. 71).[95] This feature

recurs, if somewhat ambiguously, in the Psalter of ca. 1200

(Fig. 72) and also in the ivory Deposition group in the Hunt

Collection (Fig. 34).[96] In this last instance the fold of

material encompasses both Joseph and Christ, thereby subtly

[94]Jungmann, Mass (abridged ed.), p. 343. The humeral
veil is an alternate form to the corporal, which was a cloth
spread out on the altar with corners that folded up in order
to cover the chalice and paten. The corporal was derived
from the palla corporalis put on the altar at the time of
the Prayer of the Faithful on Good Friday, ibid., p. 340.
The earliest mention in the Roman rite of the humeral veil,
also called the amice, ibid., pp. 96-97, is by Pope Innocent
III (1198-1216) in his Tractatus de Sacro Altaris Mysterio,
lib. II, cap. LVIII, f. 58 (Antwerp, 1540), see Fr. Bock,
Geschichte der Liturgischen Gewänder des Mittelalters (Bonn,
1859-71; reprinted Graz, 1970), p. 128. Bock reports a num-
ber of them were mentioned in an 1128 inventory from Bamberg
Cathedral.

[95]London, British Museum, Cotton Nero C. IV, f. 22,
ca. 1150 (pre-1161). The Crucifixion includes the two
thieves and Stephaton and Longinus, whose presence serves to
stress Christ's body and the wound, the source of the sacra-
ments. A number of small heads appear on either side above
the figures of Mary and John, a feature which may refer to the
congregation as witnesses to the mystery at the Mass. There
is no indication that these are the heads of angels.

[96]In the Psalter the cloth is shown held in the hand,
presumably Joseph's, which rests on Christ's left thigh.
Given the pose of Joseph, the placement of the hand is not
altogether logical, but it does succeed in displaying the
cloth. For the Hunt ivory, see Chapter I, pp. 13ff., and
note 46.

emphasizing the profound bond which unites them.

The appearance of the humeral veil in these examples
is drawn from the use of the aer at the Oblation in Chrysos-
tom's liturgy.[97] Although this form of the veil appears to
be an instance of direct influence of Byzantine practice on

[97]Pauline Johnstone, The Byzantine Tradition in Church
Embroidery (London, 1967), pp. 23-26, provides the basis for
the following information on the Byzantine aer: Like the
western tradition, the eastern liturgy, too, had a number of
different cloths which symbolized that in which Christ's
body had been wrapped. This symbolism applied to the altar
cloth itself, as well as to another introduced in the fourth
century--the endyti--which covered it. Still another was
the eiliton (literally: that which is rolled up) which was
laid over the endyti so that the sacred vessels stood on it--
the eastern version of the Latin corporal. Unfortunately,
the distinctions between these terms for the cloth are not
entirely clear, since no examples survive before the four-
teenth century. Nor are there early examples of the aer, or
epitaphios, the most important to this discussion and to the
later Byzantine liturgy. In the fourteenth century when the
eastern liturgy was enriched and expanded, there were two
little aeres--one for the chalice and one for the Host--and
the great aer which covered them, bearing an image of the
body of Christ on the red stone of Ephesus--the Stone of
Unction. As early as the Chrysostom Mass, the eastern aer
had a dual meaning: as the body of Christ itself and the
cloth in which he was wrapped (see p. 26). This aer, worn
over the shoulders of the priest, is the form that corre-
sponds to the long and narrow humeral veil seen in our west-
ern examples, which carries the single meaning of the cloth.
The symbolism of the aer as the cloth is gone, however, from
the aer of Maximus the Confessor, who interprets it as the
Stone of Unction and as the body of Christ (see pp. 69-72).
In the later diversification of the aer, it is only the lit-
tle aer which retains the earlier connotation of the cloth.
The great aer used in the Mass liturgy must be distinguished
from the aer-epitaphios used on Good Friday, which underwent
a similar evolution. Originally it was used to wrap the
Gospel book carried on the shoulders of the priest in imita-
tion of Joseph at the Descent from the Cross and the Entomb-
ment; later, the shroud itself was carried in the Good Friday
procession to represent the body of Christ. For further dis-
cussion of the Good Friday epitaphios, see Chapter III, note
66.

the north separate from the Roman tradition, the context in
which it is used is independent from the eastern tradition
as well. Liturgies stemming from Rome, like the eastern
ones, had tied the symbolism of the Descent and the Entomb-
ment only to the Offertory, rather than to the Consecration,
as northern liturgies derived from Amalarius had done. The
conflicting practices of the early medieval period were even-
tually resolved as a result of the move, which began in the
French liturgy of the twelfth century, to make the Crucifix-
ion the central image of the Mass.[98] Further study of these
early liturgical variants--permitted by the autonomy of the
Benedictine monastic foundations up through the eleventh
century--may shed further light on puzzling questions not
only concerning iconographic nuances, but also the differing
contexts in which the Deposition occurs. The direct connec-

[98]"Elevation," Oxford Dictionary, p. 444. See varying
forms of the Offertory oblation discussed by Jungmann, Mass
(abridged ed.), pp. 340-44. The motif of the cloth has been
confined in this discussion to this group of North French
and English examples. However, it should be noted that it
also appears in a modest way in the Deposition at Foussais
(Fig. 18). In addition, there is a question as to the mean-
ing of the cloths held by the personifications of the Sun
and the Moon who appear at Foussais on either side above the
cross. It seems these should be read as the sindon and the
sudarium used to wrap Christ's body and to cover the chalice
and the paten, rather than as the veiled covering for the
hands. This interpretation seems true as well for those
which the Virgin and John hold in Morgan 781 (Fig. 4). A
similar motif occurs on the Descent from the Cross at Silos
(Fig. 19), where cloths are again held by Sol and Luna, and
the specifically liturgical reference is reinforced by the
censors the angels swing as they hover above the cross. The
motif of the cloth, rather rare in earlier works, comes into
its own in the later periods, for example with Roger van der
Weyden and with Rubens (Figs. 12 and 13).

tion of this image with the Mass liturgy offers only a partial explanation for these phenomena, however. Other factors stem from the relation of this image to the Depositio drama.

What the Depositio Drama Represents

The night of Easter Saturday, in the midst of the celebration of the climax of the Christian year, was the time traditionally reserved for the Sacrament of Baptism.[99] In Rome by the ninth century, Baptism was accorded mostly to infants. North of the Alps, however, adults were the focus due to the evangelical mission first inaugurated by Charlemagne, for which Amalarius was recruited, that was not without political overtones. The vivid appeal to the personal faith of his constituents was part of Charlemagne's grand design to consolidate the Carolingian Empire through its spiritual allegiance to Rome. Thus at Easter, following long weeks of prayer, instruction and penance the catechumens along with the penitentes were received triumphantly into the fold. Their spiritual agon, which during Lent had traced man's beginnings through the coming of Christ, reached its nadir on Good Friday by their own identification with the stark fact of Christ dead on the cross and its climax on Easter Eve with their joyful rebirth, assured by the simultaneous celebration of Christ's Resurrection. The campaign

[99]Hardison, Christian Rite, pp. 80-93, discusses the importance of political considerations to the Carolingian liturgical reform, and the importance of Baptism to the development of the Easter rites.

for converts initiated by Charlemagne had a life of its own for several centuries, necessitating ever larger churches and a change in the liturgy from the personal participation of the early congregations to more formalized and passive forms in which the value of dramatic representations was increasingly relied on to maintain the believer's ability to identify with the events of the Christian story.

But the burgeoning of the secular and liturgical drama in the twelfth century had its roots in the earlier tradition. It was at Easter, when the drama of the Mass unfolding in abstract time overlaps with its reenactment in historical time, that representational ceremonies first came to be woven into the liturgy. Some were older elements reflecting usage long traditional in the East and in Rome: the Palm Sunday procession, Maundy Thursday's Mandatum and the Adoration of the Cross on Good Friday. Others--the Elevatio and the Visitatio Sepulchri, as well as the Depositio-- were tenth-century extra-liturgical embellishments originating in the North. The connection of Amalarius to these dramatic sequences which developed out of the liturgy is a question which has only recently begun to be considered and the picture is not yet clear. It is known that seven manuscripts containing considerable portions of his writings are in the library of the monastery at St. Gall and that St. Gall is the source of some of the earliest Quem Quaeritis tropes.[100]

[100]Ibid., p. 38, n. 9. Hardison adds, "Of equal in-

The usual assumption, however, is that the idea for the tropes came from the musical notations in a choir book which a monk fleeing his destroyed monastery in Jumièges brought to Notker Balbulus of St. Gall in 841.[101] However the ninth-century tropes and the tenth-century dramas actually evolved, there is still no question that Amalarius' transformation of the liturgy into a genuine drama laid the basis for the elaboration of particular moments in the liturgy into isolated scenes, and that lodged within the framework of the liturgy, each scene, not only the Visitatio Sepulchri, but the Depositio, too, is genuine drama as well.

But the question of the Depositio has been clouded not merely by a reluctance to consider the rite as genuine drama. Further uncertainties as to how it entered the liturgy and just what it represents have yet to be clarified. In most discussion of the early form of the Good Friday Depositio, the rite is looked upon as simply a burial and the varying use of the cross, Host, or both together, as equivalent symbols to the same end. This view prevails because it is thought that the form and content of the Good Friday

terest is the fact that an eleventh-century version of Pseudo Alcuin's De divinis officiis (Bibliothèque Nationale, Paris, MS lat. 2402, f. 83r-83v) incorporates a description of the Elevatio Crucis, indicating the compatibility of Amalarius with extra-liturgical dramatic ceremonies. Young, Drama, I, p. 555, suggests that this text "may be associated" with the famous Elevatio of the tenth-century Regularis Concordia of St. Ethelwold, Bishop of Winchester.

[101]Young, Drama, I, p. 184.

Depositio is essentially an extension of an older ritual for the Reservation of the Host on Maundy Thursday, when the Host, the _sancta_, was set aside for use at the first Easter Mass.[102] The repetition of Thursday's reservation rite on Good Friday developed despite the fact that originally the sense and order of the day's liturgy had stipulated the suspension of the daily Mass. To meet a growing demand for some form of communion on that day, the seventh-century Roman church provided for an abbreviated Mass by reserving a second Host on Thursday for use in the Friday service, the Mass of the Presanctified. Amalarius himself was still confused on this issue, for he proscribes Mass on Good Friday at one point and permits it in its shortened form in another. In any case, the practice grew, necessitating a second reservation of the Host which was to be used on Easter.

Hardison, going further than Young in stressing the connection of the Good Friday _Depositio_ drama to the Maundy Thursday ritual, points to the fact that the Host receptacle was originally called a _conditorium_--a resting place for bodies--or a _turris_ because of its being shaped in presumed imitation of the Holy Sepulchre. He cites Amalarius' description of the reserved _sancta_ as "the body of the Savior that sleeps in the tomb."[103] Certain other rituals, for

[102]Hardison, _Christian Rite_, pp. 123-24 and notes 95 and 96, for the evolution of the Mass of the Presanctified and his view of the origin of the _Depositio_.

[103]_Ibid._, p. 123, see text in _Liber Officialis_, Migne,

example, the stripping of the altar, the substitution of wood clappers in the bells, the elimination of the Kiss of Peace, he sees as underlining the somber tone of the burial of the Host on Maunday Thursday. But these actions are more properly related simply to the day itself, as part of the three-day commemoration of the Crucifixion, just as is the extinction of lights, the Tenebrae, repeated on Friday and again on Saturday.

The tendency of the later Middle Ages to emphasize the burial aspect of the Reservation of the Host ceremony was not, according to Brooks, part of its original meaning, except in a rather general way.[104] Even the terms monumentum and sepulchrum to describe Thursday's Host receptacle occur only in later texts, as do the more elaborate funereal accompaniments that grew to be associated with the rite. These funereal embellishments more logically developed around Friday's presentation of the physical entombment of the body of Christ and only extended back to an elaboration of the

P.L., CV, col. 115d. Hardison, Christian Rite, p. 125, also makes Thursday's Host receptacle the point of reference for the Quem Quaeritis: "The most important single stage property of the Quem Quaeritis play, a place symbolizing Christ's tomb, thus appears for the first time in the Easter liturgy on Maundy Thursday. What is equally important, if the Host is 'buried' on Maundy Thursday, it must be 'revived' at some later time. The idea of the resurrection from the sepulchre is implicit in this revival." This connection is strained. The Quem Quaeritis texts do not involve the Host. Moreover, the evidence suggests that the Visitatio Sepulchri was conceived separate and independent of the Depositio, often performed without it.

[104]Brooks, "Sepulchre of Christ," p. 33.

symbolic burial of the sancta, rather than the reverse pro-
cedure that Hardison envisions. Brooks points out that the
sixteenth-century text of the Missale Mixtum, one of the
first to attach special pomp to the rite, "developed in the
period in which the ceremonies at the 'true' sepulchre were
passing out of use."[105]

The earliest account of the reservation of the Host
following the Mass of the Presanctified on Good Friday comes
from Ulrich of Augsburg, ca. 950:[106]

> On Good Friday . . . early in the morning, he hastened
> to complete the Psalm Service; and, when the holy mys-
> tery of God was completed, the people fed with the Cor-
> pus Christi, and the remainder buried in the customary
> manner, he finished the Psalm Service while walking from
> church to church. . . . When the most delectable day of
> Easter arrived, he entered the Church of St. Ambrose af-
> ter prime, where he had placed the Corpus Christi on
> Good Friday covering it with a stone and there with a
> few clerks he celebrated the Mass of the Holy Trinity.

This text is generally cited as the first example of the
Good Friday Depositio, with the question left open as to
whether the Host or the cross was the original focus of the
rite. Hardison argues that the former was the case and that

[105]Ibid., pp. 50-52. See Hardison, Christian Rite,
pp. 134-35, for a translation of the Missale Mixtum, text
in Migne, P.L., LXXXV, cols. 432c-435a. The Tauberts, "Mit-
telalterliche Kruzifixe," p. 95, describe the process by
which at Prüfening separate processions for the Depositio
Crucis and the Depositio Hostiae came to be amalgamated.

[106]Translation from Hardison, Christian Rite, p. 136.
For text, see Young, Drama, I, p. 553, from Vita of St. Ul-
rich, in Acta Sanctorum, Julii, II (Paris and Rome, 1867),
p. 107. Hardison estimates that the phrase "customary
manner" would make the rite go back about fifty years ear-
lier.

the widespread use of the cross was simply a later variant, "a substitute designed to meet complaints that the consecrated Host, being the living Christ, cannot be buried."[107]

The most serious difficulty with this aspect of Hardison's analysis is the obvious fact that the substitution of the cross for the Host automatically denies to the reservation rite its essential purpose--the provision for the Host. Indeed, the Depositio Crucis can only be seen as a ceremony separately conceived and essentially independent from the Reservation of the Host, the Depositio Hostiae. The two rites are first of all radically different in kind. While the Maundy Thursday Reservation, even when transplanted to Good Friday, is simply a provision for a liturgical necessity, the Good Friday Depositio Crucis is an optional extra-liturgical addition designed to reenact that part of the Passion story which historically had taken place on that day. It is an integral part of the Adoratio Crucis, when meditations and reproaches--improperia--for the crucified

[107]Ibid., p. 138. Hardison is referring to a portion of a thirteenth-century Depositio text from Zurich, Zentralbibl. MS C. 8b, Ordin. Turicense anni 1260, f. 52r, see Young, Drama, I, p. 154 (my translation):

It is against all reason that in certain churches the Host is customarily set and locked in this kind of chest representing the sepulchre. In that place the Host, which is the true and living body of Christ, actually represents the dead body of Christ, which is indecent, sinful and absurd.

The text testifies to the basic distinction between the two rites despite the almost irresistible tendency to combine them.

Christ are expressed. The earliest known text of the Deposi-
tio Crucis comes from the Regularis Concordia written 965-75
by Aethelwold, Bishop of Winchester, for St. Dunstan, Arch-
bishop of Canterbury:[108]

> Since on [Good Friday] we solemnize the burial of the
> body of our Savior, if anyone should care or think fit
> to follow in a becoming manner certain religious men in
> a practice worthy to be imitated for strengthening the
> faith of unlearned common persons and neophytes, we have
> decreed this only: on that part of the altar where
> there is space for it there shall be a representation,
> as it were, of the sepulchre, hung about with a curtain,
> in which the Holy Cross, when it has been venerated,
> shall be placed in the following manner: the deacons
> who carried the cross shall come forward, and, having
> wrapped the cross in a napkin, there where it was ven-
> erated, they shall bear it thence, singing the antiphons
> Habebit and Caro mea requiescat in spe; to the place of
> the sepulchre. When they have laid the cross therein,
> in imitation as it were of the burial of the Body of our
> Lord Jesus Christ, they shall sing the antiphon Sepulto
> Domino, signatum est monumentum, ponentes milites qui
> custodirent eum. In that same place the Holy Cross
> shall be guarded with all reverence until the night of
> the Lord's Resurrection. And during the night let
> brethren be chosen by two's and three's, if the commu-
> nity be large enough, who shall keep faithful watch,
> chanting psalms.
>
> When this has been done, the deacon and subdeacon shall
> come forth from the sacristy with the Body of the Lord,
> left over from the previous day, and a chalice with un-
> consecrated wine, which they shall place on the altar.
> Then the priest shall come before the altar and shall
> sing in a clear voice: Oremus, Praeceptis salutaribus
> moniti, the Pater Noster and Libera nos quaesimus, Domini
> up to per omnia saecula saeculorum, Amen. And the abbot
> shall take a portion of the holy sacrifice and shall
> place it in the chalice saying nothing; and all shall
> communicate in silence.

[108]Translation from Hardison, Christian Rite, pp. 137-
37, from Regularis Concordia, ed. by Dom Thomas Symons (Lon-
don, 1953), pp. 44-45. The original text is London, British
Museum, Cotton MS Tiberius A. III, f. 18v-21v. See Chapter
III, pp. 119-20 and notes 48 and 49, for a discussion of the
sources of the Depositio Crucis, including the possibility
of an English source.

While this text sets the original place of the Depositio
Crucis before Communion, later it was sometimes shifted to
after Communion, thereby encompassing the Reservation of the
Host, or just after Vespers, where it maintained its inde-
pendence from the Reservation rite. Although overlapping
burial symbolism sometimes led to a merging of the two rites,
they are nonetheless further distinguished by the way in
which they were conceived. From its inception the Depositio
Crucis was a drama, while the Good Friday Reservation of the
Host was a modest part of the Mass of the Presanctified and
only developed with greater ceremony under the influence of
the Depositio Crucis drama.

In fact, it was not until the sixteenth century that
the Depositio Hostiae was performed with any real frequency.[109]
Confusion on this issue in the past is due, I think, to a
number of factors. First of all, the term Depositio has

[109]Young, Drama, I, p. 132. See also Hardison,
Christian Rite, p. 136:

> When we recall the late origin and irregular diffusion
> of the Mass of the Presanctified, the possibility occurs
> that the return and the burial of Good Friday are make-
> shifts, and that in its pure form the sequence required
> one burial on Maundy Thursday and one return during the
> first Mass of Easter.

However, this insight does not permit him to wonder if the
Good Friday Depositio should not be seen as separate from
these liturgical actions. It seems that Hardison, who did
so much to right the concept of the Mass as drama, remains
nonetheless tied to the traditional view of the Visitatio
Sepulchri as the first "true" drama of the Middle Ages. His
estimate of the Depositio's origin is the only real flaw in
his excellent study.

more than one liturgical reference. Originally the Depositio
meant the enclosing of the relics of a saint or martyr in an
altar at the time of its consecration since Early Christian
times.[110] In fact, aspects of the reconsecration of the al-
tar on Maundy Thursday, such as its washing with wine and
water, ultimately derive from the earlier practice. This
connotation may also lie behind the term Depositio to refer
to the burial of both the cross and the Host, although the
label was applied later and not in the texts themselves.
Secondly, all the Depositio texts have been lumped together
regardless of what was buried or when in the service, thereby
reinforcing the assumption that the two forms are only dif-
ferent versions of the same rite. An independent assessment
of the texts is further hindered by Young's having grouped
them, rather than in chronological order, primarily on the

[110]Louis Duchesne, Christian Worship: Its Origin and
Evolution, trans. by M. L. McClure (London, 1927), p. 401,
discusses the early Christian practice of gathering for
funerals, Masses and commemorations at a cemetery chapel,
frequently the site of a martyr's tomb. "If relics of the
saint were not already there, they were transferred to their
new resting place with solemn ceremonial. This was so to
speak a further interment--a depositio--but a triumphal one."
The Dedication ritual in the Sacramentary of Angoulême, late
eighth or early ninth century, Paris, Bib. Nat. Lat. MS 216,
ibid., p. 485, describes the procession and the washing of
the altar with wine and water and the blessing of crosses,
candelabra and relics. The Sacramentary of Drogo, Bishop
of Metz, 826-55, Paris, Bib. Nat. Lat. MS 9428, f. 100,
ibid., pp. 487-89, also describes the placing of the relics
in the confessio with three pieces of the Host, after which
a stone is placed to seal it. The similarity to Ulrich of
Augsburg's Friday Reservation (see p. 24) is striking. Com-
mon usage drawn from these earlier rites helps to explain
the tendency to identify the Reservation of the Host with
the Depositio Crucis.

basis of a Darwinian idea of their evolution from simple to complex forms.[111]

A recognition of Aethelwold's text--one of the fullest--as the earliest known, if not the original, Depositio Crucis proper allows for one final and most critical distinction from the Reservation of the Host: the idea of the Descent from the Cross is as essential to the Depositio Crucis as the Entombment. There is no room for this view as long as the premise holds that Ulrich of Augsburg's text is an earlier version, and that Aethelwold's reflects a variation developed from it. But the source of Aethelwold's text is completely separate. Although tied to the Adoratio Crucis, its structure is drawn from Amalarius' formulation of the Mass. The main difference from the Mass lies in the focus on the cross rather than on the chalice and the paten. The Tauberts argue that the practice of two priests assisting at the Depositio came into the rite only with the need to cope with the large-sized corpus with movable arms.[112] This type of corpus, they say, was introduced to comply with texts which specifically call for the enactment of the Descent--a later addition to the original rite which depicted simply the Entombment. But the provision for more than one deacon to wrap the cross in the sindon--a symbol of the Descent--

[111]Hardison, Christian Rite, Essay I: "Darwin, Mutations, and the Origin of Medieval Drama," pp. 1-34, gives an excellent analysis of this scholarly method.

[112]Tauberts, "Mittelalterliche Kruzifixe," p. 120.

before it is placed on that part of the altar designated as

the sepulchre is clearly prescribed in Aethelwold's text.

That in the Depositio, as in the Mass, the deacons are two,

representing Joseph and Nicodemus and enacting both the De-

scent and the Entombment, is spelled out in a fourteenth-

century English text from the Benedictine convent of Barking,

near London:[113]

> Let them take the cross to the high altar where in imi-
> tation of Joseph and of Nicodemus, let them take down
> the image from the wood, washing the wounds with wine
> and water.

This text, which goes on to describe the placing of the

image in the sepulchre, does no more than make explicit what

was implicit from the beginning.

Although the burial of the cross itself was more usual

in early Depositio texts, there is some evidence to suggest

that a corpus separated from the cross was taken down and

placed in the sepulchre long before the use of the large

wood corpora with movable arms for this purpose.[114] Young

[113]Young, Drama, I, p. 164, from Oxford, University
College, MS 169, Ordin. Berkingense, saec. XV, pp. 108-09.
This text is related to the reforms of Katherine of Sutton,
Abbess of Barking, 1363-76.

[114]The question hinges on the interpretation of the
phrase imago crucifixi used in the texts, an issue which in
the euphemism of Young is "far from clear." Brooks, "Sepul-
chre of Christ," p. 37, thought it usually, if not always,
meant the image of Christ, not attached to the cross. Karl
Young, "The Dramatic Associations of the Easter Sepulchre,"
University of Wisconsin Studies in Language and Literature,
X (Madison, 1920), p. 81, n. 3., said it might mean a corpus
alone or even some special representation of the Crucifixion--
a painting or a carving.

himself drew this inference from a tenth-century <u>Visitatio</u>
<u>Sepulchri</u> text from Verdun.[115] He interprets the phrase
<u>cruce vacua</u>, which the angels display as a sign of the Resur-
rection, to mean "a crucifix from which the corpus has been
removed."[116] An eleventh-century <u>Depositio</u> text from the
<u>Liber de Officiis Ecclesiasticis</u> of Jean d'Avranches, Bishop
of Rouen, leads more firmly to this conclusion:[117]

> Let the <u>crucifixus</u> be washed with wine and water in com-
> memoration of the blood and water flowing from the side
> of the Savior from which the choir and the people drink
> after the holy communion. After the response <u>Sicut ovis</u>
> <u>ad occisionem</u> is sung, let some carry it to a place made
> up in the manner of a sepulchre, where it is buried un-
> til the day of the Lord. Congregated there let the an-
> tiphon <u>In pace in idipsum</u> and the response <u>Sepulto Domino</u>
> be sung.

This <u>Depositio</u> text, whose eucharistic features serve to con-
firm the connection to its counterpart in the Mass, seems to
describe the use of a corpus detached from the cross. A
later gradual also from Rouen of the thirteenth century is

[115]See Young, <u>Drama</u>, I, p. 578, for text of <u>Consue-
tudines insignis monasterii Sancti Vitoni Verdunensis</u>, from
E. Martene, <u>De Antiquis Ecclesiae Ritibus</u>, IV (Venice, 1788),
p. 299.

[116]<u>Ibid</u>., p. 242.

[117]<u>Liber de Officiis Ecclesiasticis</u> of Jean d'Avranches
in Young, <u>Drama</u>, I, p. 555. For a similar eleventh-century
Rouen text, see <u>idem</u>, "Dramatic Associations," pp. 76-77.
That Young calls this text a <u>Depositio Crucis</u> although the
word <u>crux</u> is not actually used points to a fundamental ob-
stacle in interpreting these texts. The words <u>crux</u> and
<u>crucifixus</u> are considered synonymous even though one is a
noun and the other the past participle of a verb which in
Latin means simply: he who was crucified. A literal trans-
lation of <u>crucifixus</u> in these texts strictly refers, not to
a crucifix, but to the representation of the crucified
Christ, perhaps but not necessarily on the cross.

more suggestive, for it mentions that a "small" cross is washed with wine and water in a similar fashion (this time to be reserved for curing the sick), after which the priests and clergy "accipient crucifixum" and carry it to the sepulchre.[118]

A few other early texts convey the impression that a separate corpus was used.[119] However, there is no surviving example of a kind of corpus that could function in this way, unless it was true of the one now associated with the Bury St. Edmunds Cross (Figs. 73 and 74).[120] The deep hollows of the arm sockets and the presence of holes front and back, plus another behind the neck, for tenons with which to fasten the arms, is an arrangement far more complex than the usual dowel and socket by which legs and arms were usually attached. No firm decision has been reached as to whether

[118]Idem, Drama, I, p. 135, for text of Paris, Bib. Nat., Lat. MS 904, Grad. Rothamagense, saec. XIII, f. 92v-93r.

[119]Tauberts, "Mittelalterliche Kruzifixe," p. 103, cite texts from Rheinau, ca. 1120, and Salzburg, ca. 1160 (see ibid., p. 104, for text), where the phrase imago crucifixi is used. See Young, Drama, I, p. 267, for a related Visitatio Sepulchri text from Zweifalten, in Stuttgart, Landesbibliothek, MS 4°, 36, Lib. resp. Zwifaltensis, saec. XII, f. 122v-123v, refers to the crucifixus which had previously been placed in the sepulchre.

[120]Walrus ivory corpus, English, 1180-90, in Oslo, Kunstindustrimuseet, associated with and currently mounted on the Bury St. Edmunds Cross, English, ca. 1150 (often dated ca. 1180, see T. P. F. Hoving, "The Bury St. Edmunds Cross," The Metropolitan Museum of Art Bulletin, XXII (1964), 317-40), New York, The Metropolitan Museum of Art, The Cloisters Collection.

this corpus actually belongs to the Bury cross and, if so, whether or not it was added later. The projection of the cross's central medallion makes it difficult to mount the corpus at the proper height--a special hole was drilled recently for the present attachment; it may be the reason for the special arm arrangement. On the other hand, the character of the medallion and the fact that it shows no signs of wear suggest the further possibility that the corpus was not always displayed, perhaps only for the Good Friday ceremonies.[121]

While the proof of an actual enactment of the Deposition in early performances is fragmentary and inconclusive, there is further evidence that the image, although fleeting in the drama, was as essential to the rite as the more permanent action of the Entombment. In fact, of the two, it was the more important image. As early as the eleventh century, we

[121]I am grateful to Mr. Charles Little of the Medieval Department of the Metropolitan Museum of Art for the opportunity to examine the cross and the corpus at close hand, and for the chance to discuss the many problems concerning them which remain unresolved. One must at least question the assumption that the arm mechanism on the life-size wood corpora came out of nowhere in the mid-fourteenth century. There is some evidence, which I would eventually like to pursue, that Giovanni Pisano transformed the form from ivory to wood. The earliest known wood crucifix of this type, from the Church of Sant'Andrea at Palaia, is attributed to him, see Ugo Procacci, "Ignote sculture lignee nel Pisano," Miscellanea di Storia dell'Arte in onore di Igino Benvenuto Supino (Florence, 1933), pp. 233-45. The likelihood that such an idea started small seems only logical and conforms with the development of the Depositio cross. For a contemporary Anglo-Norman vernacular play in which such a corpus was used, see Chapter III, note 49.

have an indication of its meaning within the Depositio to
the catechumen. It was for him, after all, that these Eas-
ter dramas were designed--to give ultimate significance to
his Baptism on Easter Saturday Eve. Paul has given us the
crucial meaning of Baptism to the believer:[122]

> You have been taught that when we were baptised in
> Christ Jesus we were baptised in his death; in other
> words, when we were baptised we went into the tomb with
> him and joined him in death, so that as Christ was raised
> from the dead by the Father's glory, we too might live a
> new life. If in union with Christ we have imitated his
> death, we shall also imitate him in his resurrection.
> We must realize that our former selves have been cruci-
> fied with him to destroy this sinful body and to free us
> from the slavery of sin.

In the Ordo for Baptism in the Missal of Robert of Jumièges,
1008-25, the Descent from the Cross follows the image of the
Crucifixion, appearing on a page facing a representation of
the Three Maries at the Tomb (Fig. 75).[123] It depicts the
believer's willingness to follow Christ through his ordeal
on the cross in order to achieve his own resurrection.

We have seen that each of these images is also cen-
tral to the meaning of the Mass. Thomas of Mopsuestia ex-
presses the identity of Baptism and Communion as follows:[124]

[122]Paul's Epistle to the Romans 6:3-6, the Jerusalem
Bible translation.

[123]Rouen, Bibliotheque Publique, Ms Y.6, f. 72r. The
fourth representation chosen to illustrate the Ordo ad Bap-
tisandum Infirmum is the Betrayal. See the Missal of Robert
of Jumièges, ed. by H. A. Wilson (London, 1896), pp. 100ff.

[124]Translation in Jean Danielou, The Bible and the
Liturgy (Notre Dame, 1956), p. 140, from text in Migne, P.G.,
XV, col. 7.

As, then, by the Death of Christ our Lord, we receive the birth of Baptism, so with food, it is also in a figure that we receive It by the means of His Death. To participate in the mysteries is to commemorate the death of the Lord, which procures for us the resurrection and the joy of immortality: because it is fitting that we, who by the Death of our Lord have received a sacramental birth, should receive by the same Death the food of the sacrament of immortality. In participating in the mystery, we commemorate in figure His Passion, by which we shall obtain the possession of good things to come and the forgiveness of sins.

In the fourteenth century, we have the further testimony of Ludolf of Saxony to the identity of the Descent from the Cross in the Depositio and the Eucharist itself. In his Vita Jesu Christi, he says it is even more commendable to receive the body of Christ from the altar table than "from the Altar of the Cross [i.e., at the Depositio]. For in the latter they receive him in arms and hands only, while in the former they receive him in the mouth and in their hearts."[125]

Thus, the image of the Descent from the Cross in the Depositio encompasses for the believer not only the singular event of his Baptism, but its constant renewal through his partaking in the Mass. That the image also assures his resurrection after his death becomes clear when we examine more closely the way in which the Depositio was actually performed.

[125]Cited by Ringbom, Icon to Narrative, p. 124.

CHAPTER III

SETTING FOR THE DEPOSITIO DRAMA

Easter Rites at the Holy
Sepulchre in Jerusalem

While the Depositio Crucis can be seen to be a drama-
tization of the moment in the Consecration of the Mass which
depicts the taking of Christ's body from the Cross and His
Entombment, the structure into which it is inserted comes
from the more venerable Good Friday ceremony to which it is
liturgically related, namely the Adoration of the Cross.
The Adoratio Crucis is one of a number of ceremonies which
originated in Jerusalem in the fourth century. We find these
rites already fully described in the late fourth century by
the Spanish nun Etheria.[1] They commemorate the principal
events of the Christian year at the very sites where they
were thought to have occurred.

Scholarly research has been able to tell us much
about the original appearance of the Constantinian buildings
and the additions to them which Etheria saw. The best under-
stood is the central core of buildings which mark Christ's
tomb--the Anastasis--and the Martyrium, known as the Basilica

[1]M. C. McClure, The Pilgrimage of Etheria, Transla-
tions of Christian Literature, ser. III: Liturgical Texts
(London and New York, n.d.).

of Mount Sion (Fig. 76).[2] The latter building was a double-aisled basilica facing west terminated by a hemisphairion made up of the central part of a dwarf transept and an apse crowned by a semi-dome. This area was "garlanded" with twelve columns on top of each of which was a large silver crater, all gifts of the Emperor Constantine. Although the basilica was not originally intended to venerate the site of the Finding of the True Cross, it soon became associated with this event and that most important relic was kept in a crypt below the main one. An atrium joined the double-storied porch on the east facade of the church. The atrium was preceded by an extensive propylaea set on an angle and extending beyond the width of the church. In the southeast angle of the courtyard to the west of the Martyrium basilica was the hill of Calvary, called Golgotha, an L-shaped piece of land fourteen feet high where the cross had actually stood. The huge jewelled cross and the bema on which it stood, cutting off the view of the rock itself, are both dated ca. 350--later, that is to say, than the original buildings. Access to this site could be gained either through a passage from the transept and adjoining sacristy of the Martyrium basilica to the eastern slope of the hill or by a stairway from the courtyard. The tomb itself was a free-

[2] H. Vincent and V. Abel, Jerusalem Nouvelle, II, I (Paris, 1944); Kenneth J. Conant, "The Original Buildings at the Holy Sepulchre in Jerusalem," Speculum, XXXI, No. 1 (January, 1956), 1-48, from which all of the material in this paragraph is drawn.

standing shell of living rock over which Constantine built a
small tower-shaped tomb chamber, as seen for example in the
Munich Ascension ivory (Fig. 60), and framed it with a hemi-
cycle of columns at the westernmost end of the court. Just
when the large rotunda with interior colonnade and gallery
was constructed is not certain, but it was there by the time
of Etheria's visit. To the south of the court was the Bap-
tistery, which dates from at least 333. This building, with
an entrance to the court on its north side and toward the
city on the south, consisted of three main rooms connected
by a western corridor.

Outside the Anastasis group was the church dedicated
to Christ's Ascension, the Imbonon. It was situated on a
hill signifying the Mount of Olives.[3] A fourth-century ac-
count records seeing Christ's footprints on a sacred bit of
land in the central circle beneath a roof open to the sky.[4]
Second only to the Anastasis rotunda, the round or polygonal
Imbonon was one of the most important sanctuaries at Jerusa-
lem. In the mosaic in Sta. Pudenziana in Rome, dated 391
or later, the two appear as the most prominent buildings to
the left and right of Christ and the crux gemmata, with the

[3]Heitz, Architecture et Liturgie, p. 117.

[4]Ibid.; cf. also, M. Schapiro, "Image of the Disap-
pearing Christ in English Art around the year 1000," Gazette
des Beaux Arts, 6th ser., XXIII, No. 913 (1943), 135-52, es-
pecially pp. 140-42 for a seventh-century report by Arculf
and its importance for English literature and art. For
Arculf's description, see D. Meehan, ed., Adamnan's "De
Locis Sanctis' (Dublin, 1958), pp. 65-69.

four Evangelist symbols ranged in the sky above (Fig. 77).

With the arrangement of the sanctuaries in mind, it is perhaps possible to visualize the Good Friday ceremonies which Etheria describes.[5] These rites were especially charged for the group of catechumens to be baptized the following night. Friday began with a pre-dawn service ante crucem-- in the courtyard--with readings and orations about the deliverance of Christ to Pilate. The faithful then proceeded in Syon in order to stop at the Column of the Flagellation--in the middle of the Martyrium basilica, according to Arculf (Fig. 78).[6] The Adoratio Crucis itself took place in Golgotha post crucem--at the foot of the cross in the area between the bema and the Martyrium. There the relic of the True Cross which had been taken from its silver box was held in the hands of the bishop, while each member of the clergy and the congregation in his turn kneeled to touch it to his forehead and to kiss it.

There followed at the sixth hour a tearful three-hour service ante crucem of prayers and readings. Then, at the ninth hour, they returned to the Martyrium for Mass, after which they proceeded to the Anastasis for further Gospel readings and for the blessing of the catechumens. Most

[5]McClure, Etheria, pp. 73-78.

[6]Ibid., p. 74, note 1, suggests that it was located close to the ambo, which would conform with the position that Arculf gives it. Meehan, Adamnan, p. 63, Adamnan says that the actual rock where Christ was reputed to have been scourged was just west of the Martyrium basilica.

stayed for the rest of the night to keep a vigil at the sepulchre singing hymns and antiphons.

The Adoratio Crucis which Etheria witnessed in Jerusalem seems to have originated sometime after 348, since it is not mentioned by Cyril of Jerusalem.[7] By 392, when Etheria was there, it has the ring of an established tradition. The celebration of the rite continued until 633, when the relic of the True Cross was removed to Constantinople.[8] In the form in which the rite went North, apparently sometime in the seventh century, the Jerusalem ceremony was at times infused with elements of a later separate custom observed in Rome.[9] In Rome on Good Friday, in imitation of the Way of the Cross, a cross reliquary was tied on the back of the Pope. In his symbolic role as Christ himself, the Pope thus led the procession which went from the Chapel of St. Lawrence (the sancta sanctorum) to the Lateran, where the Presanctified Host was added to the train. When the procession reached Sta. Croce in Gerusalemme, the official station for the day, the Adoration of the Cross, with the very cross the Pope had

[7]Conant, "Holy Sepulchre," pp. 6-7. Eusebius in his Vita, III, 31-40, mentions neither Calvary nor the Holy Cross. Nor does Cyril of Jerusalem in his letter to Constantine of 348. Conant dates its arrival shortly after this time, c. 350.

[8]Heitz, Architecture et Liturgie, pp. 96, 116. After the departure of the True Cross relic, the exedra sheltered a silver chalice which was venerated as that used at the Last Supper and which prompted the legend of the Holy Grail.

[9]Karl Young, Drama, I, 114-15; Heitz, Architecture et Liturgie, p. 97.

carried, was celebrated, as well as a communion with the Presanctified Host. The procession ended when the cross was finally returned to its chest under the altar in the <u>sancta sanctorum</u>.[10]

Such dramatic and liturgical embellishments of the Good Friday procession serve to explain why the <u>Depositio Crucis</u> and the <u>Depositio Hostiae</u> were readily conflated by modern scholars. But a close examination also shows that the two strands--the <u>Adoratio Crucis</u> and the provision for the Presanctified Host--while they could be interwoven, were essentially separate. Thus, we have a further confirmation of the discussion in Chapter II concerning the difference between the Augsburg rite and the <u>Concordia Regularis</u> of Winchester.[11] In fact, it is clear from a rereading of the <u>Concordia Regularis</u> text how many of its elements stem purely and directly from the Jerusalem customs before the special provision for the Host on Good Friday was an issue: the Adoration of the Cross itself, the singing of antiphons, the chanting of psalms, the vigil at the sepulchre, even the provision for crowds.

[10]<u>Ibid</u>. In the tenth-century procession in Jerusalem, the patriarch carries the relic of the True Cross tied to his shoulders. Led on a rope by the archbishop, he is "imprisoned" temporarily but finally arrives at Golgotha.

[11]See Chapter II, pp. 87-88 and note 110.

Architectural Symbolism Related
to the Easter Rites

But it is not simply the liturgical form of the Adora-
tio Crucis rite which was taken up in the West and later am-
plified by the incorporation of the Depositio Crucis. More
profound is the conscious imitation of the architectural lay-
out of the Constantinian arrangement in Jerusalem. Although
various elements recalling the Jerusalem setting occur in
earlier buildings both in Italy and in the North, it is in
the Carolingian period that the system becomes crystallized
and the architectural positioning more or less fixed.[12] A
prime example is the church complex at Centula, the most im-
portant Benedictine monastery of its day, as seen in a draw-
ing of 1612 after an eleventh-century miniature now lost
(Fig. 79).[13] This church was considered to be the fruit of
the liturgical reform started under Pepin and continued un-
der Charlemagne to "romanize" the Gallican liturgy.[14] The
result, although incorporating aspects of the Roman rites,
such as the stational form, maintained its Gallican roots
and yet developed as an independent entity. By this time,

[12]G. Bandmann, "Früh- und Hochmittelalterliche Altar-
ordnung als Darstellung," Das Erste Jahrtausend, I (Dussel-
dorf, 1962), pp. 377-78; Joseph Braun, Der christliche Altar,
I, pp. 401-06.

[13]Heitz, Architecture et Liturgie, p. 2. Drawing
by Petau was after a miniature in La Chronique de Hariulf,
cf. Chronique de l'Abbaye St. Riquier (Paris, 1894), ed. by
F. Lot.

[14]Heitz, Architecture et Liturgie, pp. 87-91, for a
discussion of the various sources of the liturgy at Centula,
a subject which is by no means closed.

moreover, contemporary interest in Jerusalem was keen. There was not just the word of Etheria and more recent travellers on which to rely, but actual plans of the sanctuaries drawn and described in some detail by the seventh-century pilgrim Arculf and recorded by the Irish Abbot Adamnus (679-704) in his De Locis Sanctis.[15]

Not only the main church of St. Riquier-St. Sauveur but the outlying churches as well were topographically so arranged as to re-create approximations of the authentic setting for the ceremonies of Christmas and Easter week.[16] It was at St. Riquier-St. Sauveur that the Adoratio Crucis was performed. This church was erected 790-799 by the Abbot Angilbert. It was consecrated January 1, 799, and Charlemagne attended the Easter services in the year 800.[17] In reality, there were two separate churches: St. Riquier to

[15]Meehan, De Locis Sanctis; see note 5. Heitz, Architecture et Liturgie, pp. 113-14, cites four separate manuscripts of Arculf's plans at the important Benedictine centers of Corbie, Stavelot, Rheinau and Salzburg. On pp. 118-19 Heitz lists other pilgrims of the eighth and ninth centuries. Charlemagne himself sent money in the time of Constantine Porphyrogenitos. Around 808 Jerusalem became a kind of French protectorate and Charlemagne received the keys to the Holy Sepulchre, ibid., p. 119.

[16]Ibid., pp. 27, 96, 101ff., for relation of churches at Centula to those at Jerusalem, and the rites performed there. The laying out of churches in this way also occurred in Italy, but Heitz's point is that the porch church and its relation to Jerusalem were specifically northern ideas.

[17]Ibid., p. 21. Angilbert was reputed to have married a legitimate daughter of Charlemagne, cf. Honoré Bernard, "Premières Fouilles à St. Riquier," Karl der Grosse, III, Karolinginische Kunst (Dusseldorf, 1965), p. 369, n. 1.

the east and St. Sauveur to the west, each with a central
tower dedicated to their respective patron saints. They
were joined by a nave serving both churches, in the center
of which stood the Altar of the Cross. The arrangement thus
recalls Jerusalem's Martyrium and Anastasis with the Hill of
Calvary in between. Our information by which the plan is
reconstructed is based on the eleventh-century chronicle
of Hariulf, which describes the church, its fixtures, and
its early ceremonies.[18]

An atrium, called the paradisus, preceded the west
facade of St. Sauveur. All three sides had a gate, each
topped by a tower containing an oratory dedicated to one of
the three archangels--Gabriel and Raphael at each side, and
the central one to Michael. Two staircase towers stood on
either side of a triple-arcaded porch which opened onto the
atrium in front of the entrance to the church. Angilbert
was buried in this porch. There were three entrance door-
ways, the central one being larger and having above it a
sculptural relief of the Nativity. The ground floor area,
called the cripta sancti salvatoris, housed the capsa maior,
the abbey's most important reliquary. According to Effmann,
it was kept near the east wall of the church directly below
the altar to the Savior in the sanctuary above (Fig. 80).[19]

[18]Ibid., p. 369, n. 2, mentions texts of Angilbert
incorporated into Hariulf's chronicle. See our note 13.

[19]Edgar Lehmann, "Die Anordnung der Altäre in der
karolingischen Klosterkirche zu Centula," Karl der Grosse,

This crypt area was the location of the baptismal font as
well. The oratory where the altar to the Savior stood could
be reached by the two staircases. A passage describing the
customs for Mass at Christmas and Easter which were cele-
brated at this altar indicates that the stairs went higher
to upper tribunes, although it is not clear if they covered
all four sides of this area or only three.[20]

 The relief of the Nativity above the central door of
St. Sauveur was complemented by three others, of the Passion,
Resurrection and Ascension, arranged in the form of a _tau_
cross. The Passion was "_in medio ecclesiae_," probably on
the great arch to the crossing of St. Riquier beyond the Al-
tar of the Cross. The other two reliefs were described as
being "in the north and south parts" of St. Riquier, now
thought to be on the arches which lead from the aisles to
the transepts, according to the plan of Lehmann (Fig. 80).[21]

op. cit., Fig. 2, cf. Wilhelm Effmann, _Centula Saint-Riquier_.
_Eine Untersuchung zur Geschichte der kirchlichen Baukunst in
der Karolingerzeit_ (Munster in Westphalie, 1912).

 [20]Heitz, _Architecture et Liturgie_, p. 27.

 [21]Lehmann, _Centula_, Fig. 3 and _passim_; Heitz, _Archi-
tecture et Liturgie_, pp. 110, 122: "In medio ecclesiae S.
Passio, in australi parte S. Ascensio, in quilonali S. Resur-
rectio, et in porticu, secus januas, S. Nativitas, mirifico
opere ex gipso figurate, et airo musivo allisque pretiosis
coloribus pulcherrima compositae sunt." This passage from
Vita S. Angilberti and another of Hariulf, cf. Lot, _Chronique_,
p. 305, in which two choirs of monks descend, one toward the
Resurrection, the other toward the Ascension, are the only
clues to where these reliefs were located. Heitz, _Archi-
tecture et Liturgie_, p. 123, says their arrangement is
adapted from the Fraction of the Gallican liturgy, when parts
of the Host are laid out in the form of a cross but not in

Analogous to the bowls on the columns in the Martyrium, there were thirteen chasses, the capsa minores, placed on a beam surrounding the altar to St. Riquier in the apse. The tomb of the saint was in the choir on a lower level behind the Altar of St. Peter, located in the crossing just east, which was the High Altar. The relation of this altar to the altar of the Baptist in the north transept refers to an older tradition which recalls the position of the Anastasis in relation to the Baptistery in Jerusalem as it was translated in the ground plan of Old St. Peter's in Rome.[22] There, a separate Baptistery stood just beyond the north transept of the church (Fig. 81).[23] And in that transept, thus between the Baptistery and the High Altar to St. Peter, stood the Altar of the Cross. In this place it represented a direct transposition in a western church with an eastern orientation of its position to the southwest of the Anastasis at Jerusalem, which faced west. The Cross Altar was similarly placed at Santiago in Compostela.[24] Heitz's discussion of the

this precise order. The idea of putting the Resurrection to the left and the Ascension to the right of the door may relate to the same compositional logic in the apse mosaic in Sta. Pudenziana (Fig. 77); see also p. 101 of this chapter.

[22]Thomas F. Mathews, "Early Chancel Arrangements in the Churches of Rome" (Master's thesis, I.F.A., 1962), pp. 16-21, for the arrangement prior to the installing of the confessio and the designation of the altar over the tomb of St. Peter as the High Altar.

[23]Cf. Richard Krautheimer, Studies in Early Christian Medieval and Renaissance Art (New York, 1969), Fig. 12 on p. 384, reconstruction by Frazer.

[24]Braun, Christliche Altar, pp. 401, 437.

architectural arrangement at Centula stresses a fresh and direct influence from Jerusalem. However, this important relationship between St. Riquier and Early Christian Rome should not be discounted.[25]

Considerable controversy surrounds the question of architectural symbolism, especially in the Carolingian period, and particularly with respect to the porch church or westwork. Some scholars have argued for the priority of its connection to the cult of the ruler and Imperial Rome.[26] Heitz, as we have seen, considers the direct liturgical link to Jerusalem to be the key.[27] Still others have doubted the validity of these symbolic connections entirely.[28] While it

[25]Heitz, Architecture et Liturgie, pp. 166-67. states that the Altar of St. Peter is to be seen as a pendant to the altar to the Savior in St. Sauveur, thereby setting up in an east-west polarity an homage to Rome. The connection between the arrangement in St. Riquier and St. Peters, however, is more encompassing than he makes it to be.

[26]Ibid., pp. 153-54, cites A. Fuchs, Die karolingischen Westwerke und andere Fragen der karolingischen Baukunst (Paderborn, 1929); idem, "Entstehung und Zwechbistimmung der Westwerke," Westfälische Zeitschrift, C, 1950, pp. 227-91. Cf. also E. Baldwin-Smith, Architectural Symbolism of Imperial Rome and the Middle Ages (Princeton, 1956), pp. 79-96; E. Kantorowicz, "Ivories and Litanies," Journal of the Warburg and Courtauld Institutes, V (1942), 56ff.; and Ulrich Stutz, Die Eigenkirche als Element des mittelalterlich-germanischen Kirchenrechts (Berlin, 1895), cf. G. Bandmann, Mittelalterliche Architektur als Bedeutungstrager (Berlin, 1941), p. 210.

[27]Heitz, Architecture et Liturgie, pp. 162-64, discusses other architectural antecedents of the westwork as well, a problem still open in many respects.

[28]T. F. Mathews, Early Churches of Constantinople, p. 5, specifically criticizes Heitz's method.

is, of course, possible to trace the development of the west-
work without referring to the symbolic meanings attached to
it by writers of the time, much of the richness for the lit-
urgy, for art, and even for later developments in architec-
ture is thereby cut short. The difficulty, however, with a
view that would rely exclusively on either the reference to
Imperial Rome or to Jerusalem is that, valid as these ele-
ments are, they do not govern the rationale for the archi-
tecture as a whole. Rather, just as Amalarius' liturgy
worked from older roots to create a fresh allegorical formu-
lation, the architectural forms, as Bandmann has shown, can
be seen to incorporate these references to the past into a
new and highly symbolic scheme which endows each part of the
church and the positioning of the altars within it with a
particular meaning.[29] For our purposes, we can confine our-
selves to the main lines of the formulation, concentrating
on those areas which shed light on the performance of the
Adoratio Crucis and, later, the Depositio Crucis.

It is clear that at St. Riquier-St. Sauveur, Angilbert
had more in mind than a mere duplication of the old Jerusalem
sites or a recapturing of Early Christian and Imperial Rome.

[29]Bandmann, "Altarordnung," and also Heitz, Archi-
tecture et Liturgie, pp. 128-46. Heitz discusses the apoc-
alyptic theme in its relation to architecture and liturgy,
stressing the idea that the Heavenly Jerusalem was modelled
on the earthly city. Bandmann's approach, which gives pri-
ority to the apocalyptic ideas in order to provide the over-
all framework on which the Carolingian view depends, seems
to be the more accurate emphasis.

The oratories for the archangels, the vertical as well as the horizontal structuring of the layout, the reliefs of the four major church festivals are but some of the indications of a more inclusive orientation. The mainstays of this orientation were the Heavenly City of Dionysius the Pseudo-Areopagite and the Apocalypse of Revelations. Around the image of the Heavenly Jerusalem, such writers as Alcuin of York in the eighth century and Rabanus Maurus and Walafrid Strabo in the ninth, formulated a framework which was to be extended and refined up through the Gothic period.[30] This construction was based on two Early Christian ideas. The first was the idea of the church, laid out in the shape of a cross, as the image of the victory of Christ and His cross.[31] The one altar at the center of the cross for the celebration of the Eucharist was designated as the Throne of the Lamb. The apse was generally decorated with an apocalyptic expression of this idea. But the basic layout at St. Riquier-St. Sauveur, the four reliefs on the cross form, also continued a second idea of the memorial character of church meaning.[32]

[30]Ibid., pp. 128-30; Bandmann, Architektur, p. 63, points out that in the earlier period the literary interpretation tended to follow rather than lead the architectural fact, as was the case for example with Suger's St. Denis, cf. Otto von Simson, The Gothic Cathedral (New York, 1956), pp. 10-11.

[31]For the cross-shape of the church, see for example Krautheimer, "Iconography," p. 121, and J. Sauer, Symbolik des Kirchengebaudes (Freiburg, 1924), pp. 110ff., 291ff., and 431.

[32]Ibid., p. 400; Heitz, Architecture et Liturgie, pp. 145-46.

Centula represents a confluence of the antique tradition of Christ triumphal and symbolic and the new, more somber idea of the historic Christ.[33] What occurs is a reordering and blending of the older views toward an expression of the timeless present of both the historic and the superhistoric meanings of the church. The Altar of the Cross is central to this expression.[34] Having first appeared occasionally in the sixth and seventh centuries, it is now standard and placed, in contrast to its position at Jerusalem, directly *in medio ecclesiae*, according to the legendary belief that the cross was the center of the cosmos.[35] The image of the Lamb as Christ victorious was thus giving way to the image of Christ the man, who has been humanized through his Passion, but at the same time enlarged to cosmic dimensions, now assuming the role of the implacable judge.[36]

The new orientation becomes most explicit in the porch church of St. Sauveur, which constituted a separate image of the Heavenly Jerusalem now directly linked to the earthly city.[37]

[33]Ibid., p. 400; Heitz, Architecture et Liturgie, pp. 145-56.

[34]The Altar of the Cross was among the first signs of the proliferation of altars that was to continue throughout the medieval period. There are in fact eleven altars at St. Riquier-St. Sauveur. The increasing number of altars was due to the growing cult of martyrs' relics as well as added liturgical needs, cf. Bandmann, "Altarordnung," pp. 372-80.

[35]Sauer, Symbolik, pp. 91, 390.

[36]Heitz, Architecture et Liturgie, pp. 129, 145-46.

[37]Bandmann, "Altarordnung," pp. 98-103.

In this sense it combines the meanings of both the Martyrium, as the place of its most precious relic and the burial spot of the faithful, and of the Anastasis, as the place of the tomb and the altar to the Savior crowned by a sepulchral tower. The walls of the atrium, the paradisus, were its city walls and its angels the guardians of the city gates. The most important of these was St. Michael, who not only protected and watched over the city, but was the Commander of Heaven and the weigher of souls at the Last Judgment.[38] As the Heavenly Jerusalem, St. Sauveur at Centula was the primary site of both the Last Judgment and the Resurrection. This symbolism extends to the placement here of the baptismal font, which in Early Christian times had been housed in a separate building, inasmuch as Baptism was the worldly expression of the believer's own death and resurrection.[39]

These meanings in the westwork link St. Sauveur to the church to which it is joined. The place of Baptism and also the representation of the Nativity above the main entrance belong in a biblical historical relationship as precursors to the main altars in St. Riquier. Along this horizontal alignment, they lead to the Cross Altar, the site of the Passion, and the High Altar beyond, which marks the

[38]Ibid., pp. 388, 394, 410.

[39]Heitz, Architecture et Liturgie, p. 144; cf. also Krautheimer, "Iconography," pp. 136-37; and Danielou, The Bible and the Liturgy, pp. 20-45, for baptism symbolism; see also Chapter II, p. 97.

Resurrection and the Ascension.[40] The horizontal unfolding
west to east is balanced in the porch church by a vertical
one. The ground floor, encompassing the Nativity, Baptistery
and the Tomb of Christ, is the sphere of the earthly Jerusa-
lem; the upper level is the celestial Jerusalem with its al-
tars to the Resurrected Christ, the guardian angels, and
Michael as Christ's assistant in the Last Judgment.[41]

The rich interweaving of correspondence of earthly to
heavenly Jerusalem which enhanced the early Christmas and
Easter ceremonies, including Baptism, also applied to the
more worldly aspect of medieval life. For the earthly Jeru-
salem is not merely the historic locale of Christ's earthly
life but of that of the believer as well. Originally the
porch church was the sanctuary reserved for the Emperor, ac-
cording to a tradition which drew a correspondence of earthly
kingship to the heavenly one.[42] Later, it came to be the
focal point for lay services of the Mass, marriage and the
dispensation of earthly justice and judgment. The decline
of the monastic church as an Imperial seat was coupled with
the rise in the number of lay parishioners whose needs had
to be served in a place separate from the more sacred parts

[40]Bandmann, "Altarordnung," p. 400. The vertical sym-
bolism in the westwork is mirrored in the eastern end where
the Marian altar is placed in the crypt in relation to the
High Altar and the Altar of the Cross. For the discussion
of these altars at Hildesheim, see pp. 410-11.

[41]Ibid., pp. 410-11.

[42]E. Kantorowicz, The King's Two Bodies; A Study in
Medieval Political Theology (Princeton, 1957).

of the church still reserved for the monks and nuns.[43]

But even in this later period of predominantly lay usage, when the western area had been fully incorporated into the main body of the church, the heavenly reference as a gateway and judgment site was retained. This iconography can be seen both in the Judgment theme which dominates the early Romanesque portal tympanum and in the western altar to St. Michael that was a standard fixture in any number of medieval churches.[44] The most explicit expression of these ideas, however, is found in late Ottonian and Romanesque fresco decoration. Resurrection and Judgment was the theme of the painting in the west choir at Essen, dated just after 1050 by Clemen, who analyzed these frescoes when most of them could still be seen.[45] The central vault held a Last Judgment showing Heaven and Hell and St. Michael, with the Enthroned Christ and trumpeting angels above, a fullness of scope which makes one think of the Last Judgments of Giotto and of Michelangelo on the west walls of the Arena and Sistine Chapels. The remaining vaults depicted scenes of angels

[43]Bandmann, Architektur, p. 210, associates the change to more worldly uses of the western part of the church to the Cluny reforms of the twelfth and thirteenth centuries.

[44]J. Vallery-Radot, "Note sur les chapelles hautes dédiées à St. Michel," Bulletin Monumental (1929), pp. 453ff. For increasing power and duties of St. Michael throughout the medieval period, see Heitz, Architecture et Liturgie, pp. 226-28.

[45]Ibid., pp. 199-200, cf. Paul Clemen, Die romanische monumentalmalerei in den Rheinlanden (Dusseldorf, 1916), pp. 104-31, for a discussion of the frescoes at Essen and their dating c. 1050.

and archangels, and a number of Post-Resurrection appearances
of Christ.

A similar program governs the porch and west gallery
of St.-Savin-sur-Gartempe (Figs. 82 and 23).[46] The central
image over the door of the porch is a Christ in Glory with
angels displaying the instruments of the Passion. Apocalyp-
tic scenes from Revelations on the painted vault above the
middle bay are framed on either side by representations of
witnesses to the Judgment. The frescoes of the gallery above,
dating from the end of the eleventh century, are the earliest
of the vast cycle which covers the entire church. The main
representation on the gallery is a Deposition, placed on a
semi-circular vault over the bay opening onto the nave. This
image is completed by two others on the wall above: one
shows two angels holding the Glory of the Lamb; the whole
group is crowned by an Enthroned Christ.

In its central location in the west gallery and in its
semi-circular shape and monumental size, the Descent from
the Cross at St.-Savin is directly comparable to a west por-
tal tympanum. In particular, it is comparable to the north
lunette of the west portal of St.-Hillaire at Foussais and
the Puerta del Perdon at St. Isidoro, León, where in place
of the more expected Judgment or Majesty, a Deposition occurs

[46]O. Demus, Romanesque Mural Painting, pp. 420-23, see
p. 420 for a discussion of its dating by a stylistic compari-
son with St.-Hillaire-le-Grand in Poitiers, which he in turn
would date later than c. 1049 as suggested by P. Deschamps
and M. Thibout, La Peinture murale en France, p. 64.

as the main representation (Figs. 18 and 83).[47] In each in-
stance, the appearance of a Deposition in this place within
the iconographic program suggests an extension of the mean-
ings of the theme beyond its strictly sacramental one to en-
compass its connection to the Resurrection and Judgment as
well. Just how these meanings are tied into the theme in
art will be more thoroughly examined in later discussions
of the iconography of the cross used in the Depositio Crucis
and of Antelami's Deposition in Parma. An understanding of
the actual performance of the Depositio Crucis, however, is
the necessary first step to seeing the themes of Resurrection
and Judgment as a point of intersection between the drama

[47]For the tympanum at León, where the Deposition is
framed by the Ascension and the Three Maries, see Palol,
Early Medieval Art in Spain, pp. 100, 480. For the Deposi-
tion at Foussais, signed by Giraud Audibert of St. Jean
d'Angely and dated c. 1140, which is matched with the Supper
at Emmaus and the Noli Me Tangere in the south lunette, see
Cook, "Catalonia," IV. Cook argued that the iconographic
similarities between the Foussais Deposition and the one in
the cloister at Santo Domingo at Silos (Palol, Early Medi-
eval Art in Spain, pl. 88), which he thought to be mid-
twelfth century, suggested that Silos was derived from Fous-
sais. Ibid., p. 480, Palol gives current 1085-1100 dating
for Silos and the literature. The question of an iconographic
dependency between France and Spain must take into considera-
tion the particular context in which the works appear. The
Silos Deposition appears on a corner pillar of the cloister
together with several Resurrection scenes--an iconographic
program comparable therefore to that of these tympana and
the west galleries at Essen and St.-Savin. Thus, the icono-
graphic similarities are due to similar contexts rather than
a dependency of one region on another. The importance of
the cloister locale in the demonstration of the believer's
personal resurrection through Christ's becomes clear in the
description of the Good Friday and Easter rites at Essen.
For a discussion of the depositio drama in Spain, see Donovan,
Liturgical Drama in Medieval Spain. See Chapter IV for a
discussion of Ferdinand's ivory crucifix at León.

and the art.

Incorporation of the Depositio
in the Easter Liturgy

Many questions concerning the eventual joining of the
Depositio to the Adoratio Crucis are still open. The prevail-
ing view is that the rite originated on the continent in the
tenth century, either at Fleury or St. Bavo, Ghent, or per-
haps St. Martial, Limoges or St. Gall, where the earliest
quem quaeritis Easter tropes are found.[48] But others see
its having begun in the ninth century, or perhaps earlier,
so that neither the date nor its source can be called se-
cure.[49] As for its original setting, Heitz offers one strong

[48]Heitz, Architecture et Liturgie, pp. 181ff. Dom
Thomas Symons, "Sources of the Regularis Concordia," Downside
Review, LIX (1941), 14-30, 143-70, 204-89.

[49]Schwarzweber, Das heilige Grab, p. 61; Heitz, Ar-
chitecture et Liturgie, pp. 181, 220, also puts the birth
of liturgical drama in the ninth century. He links it to
the Cult of the Saviour, and specifically to a model of the
Holy Sepulchre erected at the entrance to the Cathedral of
Vienne, 860-875. J. N. Dalton, Collegiate Church of Ottery
St. Mary (Cambridge, 1917), pp. 252-53, says the depositio
was performed there in the seventh century, but he offers no
documentation. Still, the possibility of an English source
for the depositio is strong. The acknowledged dependence of
the Concordia Regularis on continental sources does not rule
out innovations of its own or a drawing on a native tradition.
Moreover, since there is no dialogue in the depositio crucis
and since it does not require the visitatio sepulchri--indeed
in France the visitatio was regularly performed without the
depositio--the tendency to link the Good Friday drama's be-
ginnings with the writing of the Easter tropes is not alto-
gether justified. What is important to the depositio is the
image of the dead Christ, early accepted in England, and the
consequent idea of the believer's identification with Christ's
sacrifice as the means to his personal salvation. R. Hauss-
herr, Der tote Christus, p. 90, points out that the English
source of the dead Christ image is not necessarily the same

possibility, based on Centula's architecture and ritual: the tribune of the westwork.[50] The subject matter of the western frescoes at Essen and St.-Savin-sur-Gartempe seems to confirm this suggestion, but unfortunately, we have no texts from St.-Savin and no early ones from Essen which might prove it. The sparseness of information even where there is an early text, particularly as to the specific location of the performance, forces the more difficult method of taking a later text where we know the early ground plan and working back. The most promising place to apply this approach is, in fact, at Essen. We have a fourteenth-century Depositio text from there containing features which can be traced back to the tenth century--among them, the provision for the sepulchre in the gallery of the westwork.[51]

as that for the continent. The essential connection of the depositio crucis with the idea of man's resurrection coincides with the English custom of placing its large stone crosses in graveyards. Coupled with their long interest in the cross is the advanced feel for the dramatic in English art and literature as well as in the liturgy. Regarding the depositio in particular, it is interesting to realize that a full-scale vernacular drama, distinct from the church liturgy, already existed in the late twelfth century in England which depicted the Descent from the Cross complete with a corpus which oozed "blood" when poked with a lance and which was able to be taken down from the cross and buried. Cf. Hardison, Christian Rite and Christian Drama, p. 268; La Seinte Resureccion, ed. by T. A. Jenkins, J. M. Manly, M. K. Pope, Jean G. Wright, Anglo-Norman Text Society (Oxford, 1943). And finally, it must be remembered that the later Easter sepulchres are by far the more numerous in England. See our note 59.

[50]Heitz, Architecture et Liturgie, pp. 202-05.

[51]Brooks, "Sepulchre of Christ," pp. 97-98 for Latin text, cf. F. Arens, Liber Ordinarius der Essener Stiftskirche (Paderborn, 1908).

The earliest part of the present church was erected
by Abbess Theophanu; the crypt was dedicated in 1051.[52] The
western end is a combination of the porch church, especially
in the design of the exterior (Fig. 84), the counter-apse or
west choir (to which the Carolingian structure had been
reduced), and the Palatine Chapel in Aachen, whose interior
it so strongly resembles (Fig. 85). The church in which the
Depositio Crucis was first performed at Essen was the enlarged
basilica erected 965-970 following a fire in 946 which
destroyed the small original Carolingian church begun by
Bishop Altfrid in 850 and consecrated ca. 870. The exterior
of the west part of the tenth-century building appears to
have had at least the look of a porch church, with its
triple-arcaded porch supporting a tribune dedicated to St.
Michael and probably crowned by an impressive square tower.
Thus, the eleventh-century church at Essen exemplifies the
contraction process in church architecture which Bandmann
describes, whereby the complex of separate sanctuaries was
gradually incorporated and ordered within the compact struc-
ture of a single building.[53] The text we have serves to

[52]Heitz, Architecture et Liturgie, pp. 58-59. All
of the following discussion on the Essen churches is drawn
from Heitz, who in turn relies on W. Zimmermann, Das Münster
zu Essen (Die Kunstdenkmäler des Rheinlands, III) (Essen,
1956). Heitz, p. 59, n. 1, refers to a passage from a sacra-
mentary of ca. 960 in Dusseldorf Landesbibliothek MS D2:
"III. Kal. Oct. dedicatio sancti michaelis in monte Gorgano,"
regarding the western tribune of St. Michael. Zimmermann is
responsible for the now accepted dating of the eleventh-
century church.

[53]Bandmann, "Altarordnung," pp. 388-89. Note how in

confirm the fact that the iconographic integrity of the separate parts were maintained in the process. The eleventh-century ground plan and the elevation of the western end help to visualize the ceremonies (Figs. 86 and 87).

The Adoratio Crucis which preceded the Depositio at Essen on Good Friday took place at two separate places; the nuns adored a silver cross in their choir in the north transept, while the monks stood before the Altar of the Cross in the eastern end of the nave. The cross stood on a marble column which had been erected behind the Cross Altar by Abbess Ida, who died in 971. (Fig. 85 shows its original location in the present church.) The column, 5.18m high, represented the Column of the Flagellation in the Martyrium basilica (Fig. 78).

The part played by the column in this portion of the Easter liturgy at Essen--certainly part of the original performance--may also explain the purpose for which the column at Hildesheim, dated ca. 1020, was designed (Fig. 88).[54] It

the Essen ground plan, cf. Zimmerman (Heitz, Architecture et Liturgie, Fig. 20), which shows the additions over the years that the Baptistery dedicated to St. John is placed in a forechurch before this western part, corresponding to the older tradition of placing the separate baptistery in front of the main church. Bandmann, "Altarordnung," pp. 397-98.

[54]Tschan, St. Bernward of Hildesheim, II (Notre Dame, Indiana, 1951), pp. 271-73. The column is thought to have held either a cross similar to the one shown in the miniature of Moses and Ecclesia from the Hildesheim Bible (ibid., III, Fig. 2) or a crucifix similar to the early eleventh-century wood one given by Bernward to his sister Judith, Abbess of the Benedictine convent at Ringelheim, a work recognized to be in the tradition of the Gero cross (ibid., III, Fig. 95).

is likely that it, too, once held a triumphal cross or cruci-
fix and stood behind the Altar of the Cross. The alternate
idea that it may have served as a holder for the paschal
candle on Easter Eve was a practice more characteristic of
Italy and Spain than of the North at this time. Such a func-
tion, as the symbol of the resurrection, is also not in keep-
ing with the iconographic program of this column, which in-
cludes only scenes from the life of Christ up to the Entry
into Jerusalem.

At the Depositio, the Essen clergy took the silver
cross which the nuns had venerated, together with the re-
served Host in its pyx and the reliquaries which had been
arranged at the Cross Altar at the Adoratio Crucis, and went
in procession from the Altar of the Cross, out through the
cloister, back into the church through the nuns' choir, then
to the Altar of St. Peter in the west choir, and finally up
a winding staircase to the Altar of St. Michael on the gal-
lery directly above. There a temporary Easter sepulchre had
been set up; a wood coffer was set upon the altar and the
whole arrangement was enclosed in a tent large enough for
the group to enter. One after the other, the pyx, the vari-
ous reliquaries, and the Gospel book--that of the Abbess
Theophanu[55]--were each placed in the sepulchre, which was

[55]The Gospel book is that of the Abbess Theophanu,
died 1058, in the Essen Münsterschatz, cf. Rhein und Maas,
Kunst und Kultur: 800-1400 (Cologne, 1972), E 12 (=D3). It
is a near copy of one from Liège, ibid., F 12. For a dis-
cussion of these ivories, see Appendix II. The detail of

then locked with a key. As the nuns chanted responses, the sepulchre was covered with a pall and censed. The cross was laid on its lid and it, too, was covered. At the end of the service, the _schola_ left the west tribune by the south staircase, while the monks and nuns returned along the gallery above the south aisle to the eastern choir.

On Easter Eve, the cross was taken up and the objects one by one were removed from the sepulchre and taken in procession to seven stations: first, they went to the Altar of St. Peter in the west choir; then they proceeded through the cloister to the nuns' cemetery, where the abbess made a special moment of the Resurrection and Judgment;[56] returning to the church, stops were made at the main altar, the altar in the nuns' choir, the main altar of the crypt, the Altar of St. Stephen at the crypt entrance, and finally at the Altar of the Cross, where the cross was set down and again adored.

locking the sepulchre with a key is a later feature introduced to prevent the desecration of the Host, cf. Young, _Drama_, I, p. 75.

[56]The translation of this portion of the text, cf. Brooks, "Sepulchre of Christ," p. 98 (see note 51), is as follows: "Then when the psalm and the conventual prayers have been completed, the abbess if she should be present, or, if not, the one who canonically takes her place, will get up on the scale (or balancing board), on one side of which a ham and a lamb will be lying and on the other the abbess will stand--or her substitute--reading, together with her canonically appointed chaplain, the psalm for the faithful departed: _de profundis_ as noted more fully above for Christmas night." I wish to thank Mr. James Rogers of Collegiate School for his help with the translation. Although certain portions of this rite, such as the use of a ham, remain unexplained (although it is a traditional Easter meal), the overall reference to resurrection, and by the use of scales to judgment, is clear.

The Host was then returned to the sacristy, and the reliquaries and the Gospel book taken to the High Altar.

Alternate Locations for the Easter Liturgy

The autonomy of the Benedictine foundations in England and on the continent allowed for considerable variation in individual performance, although there was a common framework overall. The Essen rites demonstrate the ability simultaneously to draw upon a number of sources, a practice which complicates the question of which is the originator of any given element. There are a number of features at Essen, other than the location of the sepulchre in the westwork, which clearly relate to the ritual at Centula.[57] But the Essen rites also include important elements from Winchester.[58] In particular, there is the matter of the separate silver

[57]The septiforme order, the seven stations, the carrying of reliquaries as well as the inclusion of cemetery and crypt in its basic itinerary are among the features that connect the Essen rites with the elaborate Easter procession at Centula in the early ninth century. The allusion to the Christmas rites which the abbess makes at the cemetery (see note 56) recalls the fact that at Centula the procession begins and ends at the station that is marked by the relief of the Nativity, cf. Heitz, Architecture et Liturgie, pp. 80-81.

[58]Ibid., p. 198, Heitz cites the similarity of the responses and antiphons and the form of the Visitatio to the Winchester rites. The dedication of the west choir altar to St. Peter where one to John the Baptist came to be expected from the ninth century on represents a formulation especially prominent at Winchester, cf. Bandmann, "Altarordnung," p. 394; Kantorowicz, "Ivories and Litanies," p. 78. See also the Liber Vitae of New Minster, 1020-1030, British Museum, Stowe MS 944, f. 6r, where Peter appears as man's intermediary at the Last Judgment (Fig. 123).

cross venerated by the nuns while the monks stood at the
Cross Altar. This cross--the one actually used in the De-
positio Crucis--was adored in the nuns' choir in the north
crossing of the transept. It will be recalled from the or-
dering of the altars at St. Riquier that, based on the ar-
rangement at Old St. Peter's in Rome, this north transept
area also carried the specific connotations of Calvary and
of the Resurrection and was thus symbolically a most meaning-
ful part of the church.

Through this same symbolic logic, the north side of
the chancel was the favored place for nearly all the Easter
sepulchres in English churches.[59] As early as the twelfth
century, the influential Sarum rites stipulate that the
Easter Sepulchre was in a niche on the north side of the
presbytery close to the High Altar, to the left of which was
the tomb of St. Osmund.[60] Many of these permanent structures
from the Gothic period are still in place, such as the one
from Cranley (Fig. 89). Since the rationale for this loca-
tion has a long tradition and because the Concordia Regularis
is not specific on this point, Heitz's surmise that since
Winchester, too, had a westwork, the drama originally took
place there and only later moved to the High Altar cannot be

[59]Brooks, "Sepulchre of Christ," p. 53.

[60]Sir William St. John Hope, "The Old Sarum Consue-
tudinary and Its Relation to the Cathedral Church of Old
Sarum," Archeologia, LXVIII (1916-1917), 113.

considered proved, logical as it may be.[61]

Whenever they were initiated, the varying locations
of the sepulchre nonetheless adhere to the logic which gov-
erned the Depositio since its inception. According to later
texts, in France, the sepulchre was either a separately pre-
pared structure in the chancel or at the High Altar itself.[62]
In Germany, the sepulchre was usually in the nave at the Al-
tar of the Cross. Or, it could be somewhere near it--in the
baptistery as at Halle, in a separate Holy Sepulchre chapel
as at Augsburg, or in a chapel dedicated to a favored saint,
such as the Chapel of St. Sebastian at St. Gall.[63] Occasion-
ally, it was a free-standing monument, such as the Gothic
Moritzkapelle at Constance (Fig. 90).[64]

Among the most interesting of this last type is the

[61]Heitz, Architecture et Liturgie, p. 188, cf. R. N.
Quirk, "Winchester Cathedral in the Tenth Century," Archeo-
logical Journal, CXIV (1959), 38ff.

[62]Brooks, "Sepulchre of Christ," p. 54.

[63]Ibid., pp. 56-57. See Bandmann, "Altarordnung," p.
407, for a discussion of how the Cross Altar became the chief
altar to Christ as the High Altar came to be associated with
a favored saint who held a greater sense of immediacy for the
believer.

[64]Brooks, "Sepulchre of Christ," p. 88, and Heitz,
Architecture et Liturgie, pp. 147ff., list a number of
others. Texts do not always accompany the monuments and in
any case the drama was not the only reason for their con-
struction. A connection is regularly made between the
smaller sepulchre replicas and the entombment groups in
stone, cf. Forsyth, The Entombment of Christ. Equally close
in spirit are the extensive calvaires erected in the ceme-
teries of Brittany in this later period, even though they,
too, are separate from the depositio performance.

little replica of the Holy Sepulchre attached to the north wall of the nave at Aquileia (Fig. 91).[65] The circular monument represents a synthesis now familiar to us of the Martyrium and the Anastasis rotunda: it was erected as the tomb of the Patriarch Sigeardo, who died August 12, 1087; the altar was consecrated February 23, 1083. Inside the sepulchre, along with the altar, is an arcosoleum with the three-holed slab in imitation of that erected by Constantine Monomachus over Christ's tomb in Jerusalem in order to protect the Stone of Unction (Fig. 92).[66] Liturgical texts

[65]Dina della Barba Brusin and Giovanni Lorezoni, L'Arte del Patriarco di Aquileia dal secolo IX al secolo XIII (Padua, 1968), p. 50, from which the following discussion of the San Sepolchro is drawn.

[66]The existence of this monument demonstrates that knowledge of the Stone of Unction reached the west before the twelfth century, cf. Forsyth, Entombment of Christ, p. 8, and Mary Ann Graeve, "Caravaggio's Painting for the Chiesa Nuova," Art Bulletin, XL, No. 3 (1958), 230. In connection with the reflection of contemporary ties with Byzantium seen here and elsewhere in the art, it may be worthwhile to describe briefly a contemporary eastern rite, the Epitaphios, which parallels the depositio. While there is no question of a dependency between the two, the eastern one may have been a spur to some of the elaborations of the Easter liturgy in the west.

On Good Friday a flat-backed plank with an image of Christ painted on it was taken down from the cross. It was wrapped in a linen cloth and laid out on a structure representing the Stone of Unction which was covered by a ciborium and stood in the center of the nave near the cross. Having been bitterly lamented all day, that night it is heavily censed and, following a somber procession with the cloth throughout the town, is finally buried along with the cloth in an elaborate version of the Holy Sepulchre set up in the sanctuary. Easter night the sepulchre is opened and displayed empty save for a painted board showing Christ emerging from Hades with a simple cross in his right hand and dragging Adam in his left. This "planchette" mounted on a long stick is taken to the courtyard where the priest climbs

from Aquileia testify to the use of this sepulchre for several episodes in an Easter liturgy drawn from German usage, including the Good Friday Depositio Crucis and the burying of the Presanctified Host.[67]

A large-scale fresco of the Descent from the Cross is one of the few now preserved dating from the late twelfth century that once appeared in each of the five lunettes that ring the crypt at Aquileia (Figs. 93 and 94). The program in which it occurs includes scenes from the life of St. Mark, framed by the Crucifixion and the Descent from the Cross immediately to each side, with the Dormition of the Virgin and

up on a stand and holds up the image of the Resurrected Christ. Since this event took place in the dark only dimly lit by candles, the effect on the assembled crowd must have been fairly staggering. Cf. Venetia Cottas, Le Théâtre à Byzance (Paris, 1931), pp. 136-42.
 The source of this rite, still performed in certain parts of the Christian east, is not entirely clear. The Christos Paschon, a literary drama not intended to be performed, once ascribed to Gregory of Nazianzenus in the ninth century, is now dated ca. 1100 and has been traced to Agerius de Trino, Abbot of Locedio in the Piedmont, cf. P. Verdier, "La grande croix de l'Abbé Suger à Saint Denis," Cahiers de Civilisation Medievale X-XIII Siècles, XIII (Université de Poitiers, 1970), p. 3. (The cloth in which Christ is said to have been buried is in the Cathedral at Turin.) It is thought that the ultimate source of the eastern rite later embellished with elements from apocryphal legends either goes back to the dramatic homilies of early Syrian writers or to a separate lost tradition of the Byzantine theatre, cf. G. La Piana, "The Byzantine Theater," Speculum, XI, No. 2 (1936), 171-211. Equally unresolved is the matter of the influence of the theatre on Byzantine art, cf. V. Cottas, L'influence du drame "Christos Paschon" sur l'art Chrétien d'orient (Paris, 1931).

 [67]Brusin, Aquileia, p. 50; Young, Drama, I, pp. 143-45. Later texts indicate the burial of a corpus detached from the cross.

the Lamentation on the outer ends. In style and conception these representations are related to Byzantine art of the Comnenian period. However, the place of the Aquileia Descent from the Cross is also in accord with the western, specifically South German, liturgical context into which the San Sepolchro and the Depositio Crucis performed there fit.

Its reference to the Aquileia Depositio performance may help to explain the pastiche character of this image in both composition and style. The central group is most closely to be compared with the Descent from the Cross of 1164 from Nerezi (Fig. 10). But the Maries, in a less fluid style of the early twelfth century, are identical to a fragment from a mosaic at San Marco (Fig. 95)--its subject not certain. They seem to be appended in order to stress the Lamentation character appropriate to its location in the crypt and to balance the open-doored sepulchre, an emphatic allusion to the Resurrection not usual in a Deposition scene. The sepulchre appears behind the figure of John, rendered in yet another style, close to that of the Ascension Master from San Marco (Fig. 96).[68] That this representation had a special importance within the group is made clear by the

[68]See the discussion by Brusin, Aquileia, pp. 58-69, comparing the Aquileia Deposition to Nerezi and to the fragment of the Maries from San Marco. Demus, Byzantine Art and the West, pp. 139-40, compared the style of the figure of John with Temperance at San Marco by the Ascension Master. The sepulchre in both the Deposition and the Crucifixion (Brusin, Fig. 138) may bear some reference to the San Sepolchro monument. See Demus, Romanesque Mural Painting, p. 308, for a discussion of the dating of the Aquileia frescoes.

curtain-like drapery painted on the wall below it--an indi-
cation that an altar once stood in front of it. A similar
arrangement is still intact at the dependent church of Santa
Maria di Castello at Udine, where the Descent from the Cross
occupies the apsidiole to the right of the apse (Fig. 97).[69]

A more straightforward expression of the idea of the
Descent from the Cross as a link to the Resurrection and
also to Judgment occurs in the Chapel of the Holy Sepulchre
at Winchester Cathedral, an instance, therefore, where the
Depositio drama and art again coincide.[70] The central rep-
resentation of the fresco decoration of the east wall dated
ca. 1230 is a Deposition and Entombment crowned by the half-
figure of Christ as Pantocrator (Fig. 98). The side walls
show the Entry into Jerusalem and the Resurrection scene of
the Noli me Tangere; medallions in the vaulting depict
Christ and the four Evangelist symbols as well as the Annun-
ciation, the Nativity, and the Annunciation to the Shepherds.
Restorations of 1965 revealed this scheme to be an elabora-
tion of a late twelfth-century decoration before the con-
struction of the roof vault. A Deposition--this time in
the style of the Master of the Morgan Leaf--was again the
central representation (Fig. 99).

[69]Brusin, Aquileia, pp. 79-80, 89-91, for a discus-
sion of the painted curtains at Aquileia.

[70]Demus, Romanesque Mural Painting, p. 509. M. Rick-
ert, Painting in Britain in the Middle Ages (Baltimore,
1965), pp. 114-15.

The Roodscreen as a Focal
Point for the Easter Rites

Considerable research remains to be done relating
drama text to ground plan in order to fill out the brief
summary presented here. Even when the drama and the art do
not coincide, an appreciation of the places important to the
Depositio can only extend our understanding of the context
in which the representation in art occurs and the symbolism
that thereby accrued to it. So far we have seen the special
meaning of the west gallery, cloister and crypt to the per-
formance of the Depositio rite. A focal point yet to be
considered is the roodscreen. This structure served as a
barrier between the nave and the chancel during the period
roughly between the twelfth and sixteenth centuries, at a
time when the sepulchre is almost consistently located
either at the Altar of the Cross or in the chancel just be-
yond. The roodscreen itself as well as its sculptural pro-
grams could well bear further study, but certain rudimentary
elements are known.

Its immediate forerunner was the ambo, from which the
Gospel was read. The ambo, which entered western churches
by way of Rome in the sixth or seventh century, was origi-
nally centered and closely connected with the low chancel
rail that separated off the head of the church reserved for
the clergy from the remaining area where the lay were per-
mitted.[71] The symbolism assigned to the ambo by Amalarius,

[71]Erika Doberer, "Lettner," Lexikon für Theologie und

and later by Sicardus of Cremona, links it to its Old Testa-
ment prototypes--the wood tribune in the middle of the Tem-
ple where Solomon spoke to the people and the site of the
commandment of the Exodus of the Israelites. These Old
Testament links were subsumed by its chief meaning as the
mons salvationis, the place of the cross and the cosmic cen-
ter from which flowed the four rivers of Paradise. The four
Evangelists, whose Gospels expound the fulfillment of the Old
Law in the New, were dominated by the Gospel of John, whose
eagle was frequently set on top of the lectern of the ambo
as an allusion to its ultimate meaning as the apocalyptic
tribunal for the fulfillment of the Last Judgment.[72] The
ambo could also be located to the left of the chancel, there-
fore again a direct reference to Christ, with a secondary
lectern sometimes to the south for the reading of the
Epistle. In twelfth-century Italy, the two could be con-
nected by a bridge, or pontile, as at Modena (Fig. 100).[73]
The roodscreen, a related structure sometimes called the
pulpitum or paradisus, was an invention of the North and
served a wide variety of everyday liturgical functions. For,

Kirche (Freiburg im B., 1961), p. 987. Mathews, Constantino-
ple, pp. 48-51, for the adoption of the ambo by the west in
the seventh century and its relation to the eastern liturgy.

[72]Sauer, Symbolik, p. 128: Amalarius, De eccl. offic.
3, 17 (P.L., CV, 1123ff.); Sicardus, 1, 4 (P.L., CVI 21D).

[73]"Ambo," Oxford Dictionary of the Christian Church,
p. 41. Francovich, Benedetto Antelami, note 31 on pp. 55-60,
for a discussion of the roodscreen in relation to the ones
at Modena and at Parma.

along with being the rostrum for Gospel readings and sermons
when given, it was also the place for chants and choir sing-
ing and the site of the organ loft.

In front of the roodscreen the Altar of the Cross now
stood, a move consistent with the overlapping symbolism of
the place of the ambo. But in addition to its special place
in the Easter liturgy, the Cross Altar had long been the
station for Masses of the Dead.[74] The rationale again goes
back to Calvary at Jerusalem, when in the early fifth cen-
tury, after Etheria's visit therefore, a double chapel was
erected at the rock of Golgotha, the one above showing the
hole which held Christ's cross and the one below showing
Adam's grave and a crevice in the rock through which the
Savior's blood flowed and anointed Adam's skull.[75] The
Cross Altar thus encompassed the relation of the Old and New
Adam, and the analogy of Christ's burial and Resurrection to
Adam's, and thus to all believers.

This iconography is evident in certain eleventh- and
twelfth-century crosses, which as we shall see in the follow-
ing chapter, may be directly related to the Depositio. Both
the ivory crucifix of Ferdinand from San Isidoro, León, and
the Bury St. Edmunds Cross (Figs. 126 and 73) show Adam's

[74]Bandmann, "Altarordnung," p. 399.

[75]Ursula Schlegel, "Observations on Masaccio's Trinity
Fresco in Santa Maria Novella," Art Bulletin, XLIV, No. 1
(1963), 26-27; "Adam-Christus (alter und neuer Adam)," Real-
lexikon zur deutschen Kunstgeschichte, pp. 158-67.

resurrection from the dead at the foot of the cross.[76] The
theme is expanded on a number of contemporary cross feet
today unfortunately separated from the cross in combination
with which they were meant to be read. One from Lüneburg
now in Hannover shows each of the Evangelists astride one
of the four rivers of Paradise as the "feet" of the sar-
cophagus from which Adam rises as he is released from the
weight of the column of Christ's flagellation by two angels
(Fig. 101).[77] Another now in Nuremberg of ca. 1130 in the
style of Roger of Helmarshausen shows Adam rising from his
sarcophagus, each corner of which was originally supported
by a writing Evangelist (Fig. 102).[78]

It is perhaps not entirely coincidence that this elab-
oration of the redemption theme in the cross iconography is
comparable to the expanded iconography of the Cross Altar.

[76]For Ferdinand's crucifix of 1063 in León, see Palol,
Spain, p. 478, and a further discussion in Chapter IV. For
the Bury St. Edmunds Cross, see Chapter IV. Adam and Eve
also occur in the Externsteine Descent (Fig. 14).

[77]For the crossfoot from the Guelph Treasure of St.
Michel, Lüneberg, now in Hannover Kestnermuseum, see Peter
Bloch, "Die Weimarer Kreuzfuss mit dem auferstehenden Adam,"
Anzeiger des Germanischen Nationalmuseums Nürnberg, 1964,
pp. 14-15. See also ones in Kunstgewerbemuseum in Berlin,
Northwest Germ. 2/2 12th C., ibid. (Fig. 22), and in the
Cathedral Treasury at Chur, 1131-1134, cf. G. Swarzenski,
"Aus dem Kunstkreis Heinrichs des Lowen," Städel Jahrbuch,
VII-VIII (1932), Fig. 237.

[78]Bloch, "Die Weimarer Kreuzfuss," pp. 7-23. The
Nuremberg crossfoot was made for a monastery in Cologne. It
was formerly in the Goethe-Museum, Weimar. Only two of the
four Evangelists are still preserved. Bloch reconstructs
this lower group as having been crowned by the sarcophagus
lid on top of which the cross had stood, ibid., Fig. 78.

For when this altar was moved east and joined to the rood-
screen, the traditional symbolism of the Cross Altar and the
ambo were consolidated and incorporated into the idea of a
threshold separating the western part of the church from
portal to crossing, accessible to lay members, from the more
sacred eastern chancel area. As such, the roodscreen was
also the symbolic gateway or vestibulum to the Heavenly
Jerusalem. The new iconographic synthesis embodied in the
new structure thus also mirrored the symbolism originally
attached to the porch church and still echoed in the west
portals.[79] For this reason, the Cross Altar--rather than
the porch church or the High Altar--became in the twelfth
century an important burial spot for bishops and favored
clergy.[80] The location of the roodscreen directly along the
western border of the crypt below extended its meanings to
this area as well.

[79]For a discussion of roodscreen as threshold similar
to the west portal and further references, see L. B. Philip,
The Ghent Altarpiece and the Art of Jan van Eyck (Princeton,
1970), p. 112. Heitz's view, Architecture et Liturgie, p.
75, that the westwork simply vanished seems to need some
modification.

[80]For the roodscreen as a burial place in English
churches, see Aymer Vallance, Greater English Church Screens
(London, 1947), p. 3, and Sir Walter St. John Hope, "Quire
Screens in English Churches, with special reference to a
twelfth-century quire screen formerly in the Cathedral Church
at Ely," Archeologia, LXVIII (1916-1917), 85-97, referring
specifically to bishops and abbots from Winchester, Ely and
Canterbury. The Cross Altar was also the burial site for
Henry and Cunegund at Bamberg, cf. J. Bier, "Riemenschneider's
Tomb of Emperor Henry and Empress Cunegund," Art Bulletin,
XXIX (1947), p. 95.

But the Cross Altar served the living as well as the dead. It was the principal lay altar now. And the rood-screen, like the porch church, served a number of functions other than its purely liturgical ones. Among them were the display of relics, the site of dedication and consecration ceremonies, the pulpit for public proclamations and for the dispensation of ecclesiastical justice.[81] Most important for our purposes, however, is the fact that the roodscreen was also used in the Easter liturgy, a shift not surprising in view of the transfer en masse to the roodscreen of the meanings of the westwork and the Cross Altar.

Although the sepulchre may sometimes have been set at an altar on top of the roodscreen--in which case there was the advantage of the drama's greater visibility to the con-gregation--such an arrangement was by no means the rule.[82] To some extent the varying shapes the structure could take may have a relation to the location of the sepulchre, which texts show was usually in the body of the church proper. The more closed form of the German lettner, for example the east lettner at Naumburg (Fig. 103), may account for the German sepulchre's location in the nave near the Cross

[81]Doberer, "Lettner," p. 988. See also G. Bandmann, "Zur Deutung des Mainzen Kopfes mit der Binde," Zeitschrift für Kunstwissenschaft, X (1956), 159, for the lettner as the site of the Last Judgment.

[82]Hope, "Screens," p. 50. Records of such altars in the roodscreen at Windsor Castle and Kings' College Cambridge are late fourteenth- and sixteenth-century Ascension cere-monies.

Altar.[83] The more marked gateway character of English
screens, for example at Gloucester (Fig. 104), would permit
the lay the privilege of entering the chancel on this special
occasion. One text of the fifteenth century from Parma de-
scribes the sepulchre as being inside the roodscreen, an ar-
rangement also possible in certain German churches, for ex-
ample at Gelnhausen (Fig. 105).[84] From what is known of the
French jubé, it seems to have followed the English form,
which would explain their sepulchres' usual place on the
chancel side of this structure.[85]

The earliest record of a roodscreen comes from Bever-
ley Minster, a dependency of Winchester, where the pulpitum
was erected 1060-1069 by Ealdred, Archbishop of York.[86]
Gervasius records that at Canterbury between 1070 and 1077
Lanfranc had placed on the roodscreen there a crucifix with
two cherubim and the side figures of Mary and John.[87] The

[83]Bandmann, "Maintz," p. 158. Naumberg and Mainz,
both double choired, had a west lettner as well as the main
one to the east.

[84]See Young Drama, I, p. 125, for the Parma text.
This arrangement appears to stem back to the Italian altars
located within the ambo, which thus acts as a kind of cibo-
rium. See, for example, the one at Ravello and the more
evolved arrangement at Salerno, cf. Hope, "Screens," p. 46,
and plates XI and XII, and Braun, Christliche Altar, pp. 51-52.

[85]Francovich, Antelami, p. 59, cf. note 31; G. Servi-
ères, "Les Jubés," Gazette des Beaux Arts (1918), pp. 355-80.

[86]Hope, "Screens," p. 51. Ealdred's coming from York
led Hope to surmise there was one at York also.

[87]Brieger, "Triumphal Cross," p. 85.

roodscreen at Winchester dated from 1070-1097, the time of
Bishop Wakelin; and the one at St. Albans was installed be-
tween 1077 and 1093.[88] Even though none of these records
predates the conquest, it is thought that they point to an
English source for the structure, given the prevalence of the
earlier English roodbeam and the English penchant for roods.[89]

[88]For records of these screens and others of the
twelfth century, see Hope, "Screens," pp. 88-89. Stigand
of Canterbury's gift of a rood to Winchester may narrow the
dating of the roodscreen there to before 1072, Stigand's
death date, cf. Vallance, Greater English Church Screens, p. 4.

[89]Francis Bond, Screens and Galleries in English
Churches (London, 1908), pp. 1-12, 103-07. Bond traces the
roodscreen to the roodbeam, which in turn developed out of
an early Italian type--usually marble--that had served to
separate the chancel from the rest of the church. The vary-
ing use of the roodscreen north of the Alps indicates an in-
dependent development from that which evolved in Italy. The
matter needs to be defined with greater precision.
 Vallance, Greater English Church Screens, pp. 4-7,
gives a number of fascinating accounts of early English reli-
quary roods with strong "personalities." One at Winchester
was moved to a prominent place in the Cathedral after it
spoke out in favor of celibacy at the Council held at Win-
chester in 978. Bermondsey Abbey installed one in 1117 that
had inexplicably surfaced in the Thames; Malmesbury's cured
a woman of blindness in ca. 1107; Boxley Abbey's, which
miraculously arrived by a single-minded donkey, had eyes
that blinked and a tongue that wagged (and was brutally de-
stroyed by sixteenth-century reformers). Bury St. Edmunds
had several: one was a copy of the renowned Volto Santo,
brought back by Abbot Leofstan from Lucca in 1050 and set at
the Cross Altar; a second was a gift of Anselm of Canterbury,
full of relics, and amazing because of the way it had split
off from the timber from which it was cut; when the rood-
screen was installed in ca. 1080, Geoffrey the Sacrist had
still another put there--this one with no spectacular attri-
butes. See Bond, Screens and Galleries, p. 8, for further
records of early roods. The pattern at Bury St. Edmunds
suggests that while the miraculous roods were the object of
special veneration, they were not used at the roodscreen--
perhaps their singular qualities were not considered entirely
appropriate to that location.

Brieger has suggested that Lanfranc's crucifix with
the liturgical embellishment of the cherubim, a feature
unique to these roods, was a motivating force in the new
arrangement.[90] He reasons that the importance of angels at
the cross in English art and on his crucifix was a reflec-
tion of their presence at the Consecration of the Host dur-
ing the Mass, a theme derived from the cherubicon which en-
tered the eastern liturgy simultaneously with the use of
the iconostasis. Beyond the fact that most scholars would
deny a connection of the roodscreen and the iconostasis, it
is doubtful that either Lanfranc's crucifix or the more nu-
merous examples of English roods of a more markedly miracu-
lous character played any fundamental part in the development
of this structure. Lanfranc's crucifix was already replaced
in 1090 by the reliquary crucifix given to Canterbury in
1064 by Stigand, Lanfranc's deposed predecessor.[91] The de-
cision to place the crucifix at the roodscreen more simply
follows in the tradition of those which like the Gero Cross
had long marked the Altar of the Cross.

Still, there is merit in Brieger's attempt to find an
explanation for the roodscreen's appearance beyond the iden-
tification of its component parts or the new liturgical de-
mands for a substantial space barrier. The key to under-

[90]Brieger, "Triumphal Cross," pp. 59-92. See also
Chapter II, note 92.

[91]Hope, "Screens," p. 95.

standing the development of this structure seems to lie at
least partially in its being approached more in the context
of architecture than of church furniture, and more in the
context of the Easter liturgy than of the Mass. A profound
transformation of the meaning of the Mass, signalled by the
crucifix in its liturgy, was to become crystallized in the
following century. Lanfranc's crucifix was a symptom of the
forces at work which brought about that transformation.[92]
But it was the Easter liturgy and specifically the Depositio
Crucis which was the agent of the visible evidence of that
change. The stabilization of the drama's setting in rela-
tion to the roodscreen was an important step in the crystal-
lization process.

[92]Brieger, "Triumphal Cross," p. 59, says that Lan-
franc's crucifix was specifically designed as a counter to
Berengar of Tours' opposition to the reality of the Tran-
substantiation. See Appendix II.

CHAPTER IV

RELATION OF THE DEPOSITIO TO THE

DESCENT FROM THE CROSS

Early Crosses Associated
with the Easter Rites

The Good Friday rites at Essen require that the
cross be adored in two separate places: the large cross at
its stand behind the Altar of the Cross in the center of the
church, and the smaller silver cross placed in the nuns'
choir in the north transept. Although no longer preserved,
the larger cross undoubtedly took a form similar to the one
made in 970-76 for Gero, Archbishop of Cologne, a near life-
size crucifix carved in wood (Fig. 106).[1] The relics placed
in the back of the head not only increased its special ven-
eration but provided its raison-d'être, for only as a reli-
quary could free-standing sculpture of this period avoid the
character of an image which was so strongly condemned by the
early church.[2] Many large-sized wood crucifixes remain from
the eleventh century that follow in the tradition of the Gero

[1]Cologne Cathedral; Gero Cross, Cologne, 970-76, 187
cm. For literature and a list of its relics, see Victor El-
bern, Das erste Jahrtausend: Kultur und Kunst im Werdenden
abendland an Rhein und Ruhr, III Tafelband (Dusseldorf,
1962), p. 79, and Haussherr, Der Tote Christus. For Essen
rites, see Chapter II, pp. 15-17.

[2]E. Meyer, "Reliquie und Reliquiar im Mittelalter,"
Festschrift für C. G. Heise, 1950, passim.

Cross, most reiterating, although in less outspoken terms,

the representation of the Dead Christ. This is true, for

example, of the early eleventh-century wood crucifix given

by Bernward of Hildesheim to his sister Judith, Abbess of

the Benedictine convent at Ringelheim (Fig. 107).[3] Although

the original mounting is gone, it is thought that these

along with other mid-century examples, such as those from

Cologne--at Benninghausen and Gerresheim (Figs. 108-09)--

were usually set on the type of column still preserved at

Essen and at Hildesheim.[4]

The earliest records of crosses at the Altar of the

[3]Ringelheim, church; wood crucifix, Lower Saxony, c.
1000, 162 cm., cf. Das erste Jahrtausend, p. 431. For a de-
scription of the relics in the back of the head and an in-
scription mentioning Bernward, and how the arms are attached,
see Tschan, Bernward of Hildesheim, pp. 109-10 and p. 272, n. 6.

[4]Benninghausen, in Cologne diocese; wood crucifix,
Westfalia, mid-eleventh century, cf. Das erste Jahrtausend,
p. 79, for description of its relics of the Holy Cross and
martyred virgins of Cologne, and for alternate dating of the
Gerresheim cross, in the Church of St. Margarete, also per-
haps from Cologne, either c. 970 or mid-eleventh century.
See also Das Schnütgen, no. 19, Crucifix of St. George, Co-
logne, c. 1067, and another in the Schnütgen Museum from
Trier, c. 1000, with a green cross stem signifying the Tree
of Life, cf. C. Beutler, "Ein Ottonischer Kruzifixus aus
Trier," Das erste Jahrtausend, I, p. 549ff., and Figs. 1-4.
Comparable to the almost life-size crucifixes are a
number of slightly smaller ones, such as the bronze cross of
c. 1070 from Werden and the early twelfth-century copper and
silver gilt Minden cross, attributed to Roger of Helmars-
hausen, cf. Swarzenski, Monuments of Romanesque Art, Figs.
218 and 237. It is possible that the ivory Christ from Her-
lufsholm Abbey belongs to this group as well, cf. ibid., Fig.
544. For the placement of the crucifix on the column, see
Chapter III, pp. 122-23. Note also the important element of
the column in the cross foot from Hannover (Fig. 101), cf.
Chapter III, p. 135 and note 77.

Cross go back to seventh-century England and France. From
the texts it is not always clear just what they looked like,
but most, like the seventh-century one from Sherbourne and
another of the eighth century from Hereford, were jewelled,
recalling the large cross erected by Constantine on the ar-
caded platform, or bema, marking Calvary at the Holy Sepul-
chre in Jerusalem.[5] These crosses were described as simply
"hanging" over the altar; others, such as the cross of Dago-
bert (died 639) at St. Denis and that of St. Aethelwulf of
c. 810, are specified as having been set behind the altar on
a high stand.[6] A few of these early crosses were crucifixes:
Gregory of Tours describes one of painted wood at the Cathe-
dral of Narbonne as so "shocking" it had to be covered with
a veil--an indication that it probably showed Christ in a
loin cloth rather than a collobium, and that it was probably
a Byzantine gift, rather than a local commission.[7] Dago-
bert's was a wood crucifix covered with gilt leather; it was
said to have spoken to Dagobert on the dedication day of the
second Merovingian church in 630.[8] Abbot Suger placed this

[5]Geza de Francovich, "L'Origine du crucifix monumental
sculpté et peint," La Revue de l'Art, LXVII, No. 362 (May,
1935), 201. See Chapter III, p. 100, for the cross at Jerusalem.

[6]Braun, Das Christliche Altar, pp. 467-68, also cites
others.

[7]Francovich, "L'Origine," p. 191. The view of Heitz,
Architecture et Liturgie, p. 146, n. 3, that any image of
Christ on the cross before the mid-eighth century would be
shocking is contradicted by our knowledge of Dagobert's
crucifix.

[8]Verdier, "La grande croix de l'Abbé Suger à St.

crucifix at the entrance to the crypt directly under the
grand cross which he commissioned for his new church at St.
Denis. On Good Friday, the precious nail, given to St.
Denis by Charles the Bald, was attached to its foot, and the
spine relic from the crown of thorns, also a present from
Charles the Bald, was put on its head.

The sparseness of records and difficulties of estab-
lishing a chronology among crosses now lost has so far left
vague the question of just how the cross first entered the
western church. The ubiquitous phrase of early texts--cruce
pendentem super altare--and the practice of hanging crosses
from a projection over the altar or from the ciborium could
suggest that the High Altar was their original site. How-
ever, since, as Braun has observed, the cross when a church
fixture was simply meant as a mark of the Crucifixion, with
no hint of the liturgical significance it was later to as-
sume, the Altar of the Cross and not the High Altar would
appear to have been its primary location.[9] Moreover, al-
though the Altar of the Cross in the west can be traced back
to fourth-century Rome, the appearance of the cross above it

Denis," p. 4, supplies the information here cited on Dago-
bert's cross and its subsequent disposition by Suger.

[9]Braun, Das Christliche Altar, p. 473. The connection
of the cross with the altar becomes more concrete in the
eleventh century. See ibid., p. 467, for the disposition of
early crosses at the altar. The distinction between the two
altars was not always so clear cut as it is in later churches:
two seventh-century altars specifically designated as Altars
of the Cross--at Paris and at Arles--served as the High Al-
tar as well, cf. ibid., p. 410.

seems to coincide with the introduction of the Adoratio

Crucis in the seventh century. The main line of the devel-

opment of the cross runs from a jewelled cross to a large

crucifix, first showing the living Christ triumphant and

later the Dead Christ, as set forth on the Gero Cross. And

all of them, whether set on a column or other stand, or hung

on a wall, had the same relation to the Altar of the Cross

as did the large triumphal cross on the rood screen at the

entrance to the choir in the later Middle Ages. Having

originated in the Easter liturgy, they perpetuated that mean-

ing throughout the Christian year.

The use of a second cross in the Essen rites recalls

the form prescribed in the Depositio of the Concordia Regu-

laris, where the Cross of the Adoratio was small enough to

be placed in a spot on the altar designated as the sepul-

chre.[10] Records do not indicate the size of the early

crosses at the Cross Altar but the evidence of the Concordia

Regularis suggests that not all were of the monumental pro-

portion they assume in Ottonian art. When in the tenth-

century Easter liturgy, the Adoratio was expanded to include

the Depositio, a crucifix the size and form of the Gero Cross

would be too large and unwieldy for any part in the newer

rite, and a second cross more the size of a reliquary cross

was needed. The independence of the second cross from the

[10]See Chapter II, pp. 89-90 for the Concordia Regu-
laris text and Chapter III, p. 125, for the relation of the
Essen text to Winchester practice.

cross at the Cross Altar signalled a development which would eventually lead to such later forms as those documented in wood: either a grabbild image--a dead Christ figure carved in one block of wood with arms at the sides, as at Weinhausen (Fig. 110)--or, a crucifix with a corpus which could be removed from its cross, and could, because its arms were movable, be placed in a sarcophagus (Fig. 67).[11]

The second cross in the Essen rites--the one revered by the nuns and subsequently placed on top of the casket in the sepulchre--was a type of processional cross frequent in Ottonian art from the end tenth century on. Some had a cross face richly jewelled and a Majesty scheme--the agnus dei with an evangelist symbol on each of the four terminals--on the reverse. Prominent examples of this form are the early eleventh-century Reichskreuz, Bernward's Cross of 996, and Theophanu's cross, also a reliquary cross, of the mid-eleventh century from Essen (Figs. 111-13).[12] The jewelled

[11]The fifteenth-century sarcophagus at Weinhausen had a "trap door" in the back so that the corpus might be removed and the tomb found empty on Easter, cf. Appuhn, "Weinhausen," p. 102 and Fig. 79 for the end thirteenth-century image of the Resurrected Christ, which permitted a view of the host through a hole in the wound. Although no Good Friday texts accompany it, Donatello's crucifix in Sta. Croce, Florence, is the finest example of the group cited by the Tauberts, "Mittelalterliche Kruzifixe," passim. See Chapter II, p. 62 and notes 61-63, and pp. 95ff. and notes 120-21, for possible links to the later forms.

[12]Vienna, Treasury; Reichskreuz, West German (Fulda?), c. 1030. A gift of Conrad II, it held a relic of the nail and a piece of the cross, among other relics. Originally a processional cross, its present foot was added by Charles IV in the fourteenth century, cf. R. E. Schramm and Florentine

side of these crosses refers to the crux gemmata marking

Calvary at Jerusalem. The allusion to Calvary in this con-

text is as a symbol of Christ's victory over death; the same

meaning applies in the enamel cross of c. 1000 from Essen,

which places the Crucifixion in the Majesty setting (Fig.

114).[13] The newer idea of Christ's suffering at the sacri-

fice was introduced in the Lothair cross, where the jewelled

side is faced with the dead Christ crucified drawn from the

Gero Cross engraved on the reverse (Fig. 115).[14] Eventually,

Mütherich, Denkmale der deutschen Könige und Kaiser (Munich,
1962), n. 145 on p. 170. It carries the inscription: Ecce
crucem Domini fugiat pars hostis iniquie. Hinc Chuonrade
tibi cedant omnes inimici. Hildesheim, Treasury. True
Cross reliquary of Bernward of Hildesheim, 996. The back
was replaced in c. 1200 by an older gilded copper plate en-
graved in the eighth century with Christ in the center and
the four evangelist symbols, cf. Tschan, Bernward of Hildes-
heim, III, pp. 82-90. Just before Bernward left his court,
Otto III gave him a particle of the True Cross which is en-
cased in this reliquary cross, probably finished by Septem-
ber 10, 996, the dedication date of the chapel Bernward built
to house it. The chapel was the first step in the founding
of the Monastery of St. Michael. Following its consecration
September 29, 1022, the Altar of the Cross of the Church of
St. Michael was permanent location for this cross, cf. ibid.,
p. 85.

Theophanu's reliquary cross, West German, mid-eleventh
century (44.5 cm.) in the Essen Münsterschatz, has its front
decorated with gold filigree, precious stones, cloisonné
plaques from the time of Abbess Mathilda (973-1011), and an
antique cameo. A rock crystal encases the True Cross relic.
The cross was a gift of Theophanu, 1039-56. In the mid-
twelfth century, the front was heavily restored and a new
back added, cf. Elbern, Das erste Jahrtausend, p. 82, and
Swarzenski, Monuments of Romanesque Art, note on Fig. 80,
pl. 33.

[13]Essen, Munsterschatz; Cloisonné Enamel Cross, Rhen-
ish, c. 1000 (46 cm.), cf. Elbern, Das erste Jahrtausend,
notes on Fig. 377.

[14]Aachen, Treasury; Cross of Lothair, Rhenish (Cologne),

the iconography of these crosses crystallized in an expression of Christ's dual nature, with an image of the crucified Christ on one side and a Majesty on the other. This is the form, for instance, of the "early" Mathilda cross, dating from 973-82, from Essen, and the "later" Mathilda cross, also at Essen (Figs. 116-17).[15] Both retain the rich gold filigree and stones on the front, while Bernward's silver cross from Hildesheim, dated 1007-08, is of the simpler form that persists into the later medieval period, for example in the Mosan cross of the mid-twelfth century, now in Cologne

end tenth century (50 cm.). The center of the front of the cross contains a Roman cameo with the portrait of Augustus; a Carolingian cut crystal is mounted on the shaft below with the inscription: XPE ADIVVA MLOTARIUM REG[em], which is thought to refer to Lothair II (855-69). It has been suggested that a double reference to Lothair is possible, if the crystal was a gift to Otto in 978 from Lothair of France (954-86), cf. Elbern, Das erste Jahrtausend, p. 67. The reading of the symbolism of God the Father into the cameo, or Adam in the Medusa cameo on the base of Theophanu's cross (Fig. 113, and note 12), ibid., pp. 67 and 82, seems to be an over-interpretation; more likely the inclusion of the antique gems, like the use of the earlier elements of Lothair's crystal or the cloisonné plaques on Theophanu's cross, were simply meant to increase the venerability of the cross and to cater to Otto's pretension that Aachen be a "second Rome."

[15]Essen, Münsterschatz; Early Mathilda Cross, also known as the Otto Cross, Rhenish (Cologne), 973-82 (44.5 cm.). The terminus ante quem is set by the death date of Duke Otto. Mathilda was Abbess of Essen, c. 973-1011, cf. Elbern, Das erste Jahrtausend, p. 82. The later Mathilda Cross, Essen?, is also in the Essen Münsterschatz. The date is debated: Schnitzler, Rheinische Schatzkammer, p. 33 leans to a date twenty years later than the first Mathilda cross; it has also been dated in the second half of the eleventh century, cf. discussion in Elbern, Das erste Jahrtausend, p. 82. It is similar in form, and appears to come from the same workshop as the Lothair cross (Fig. 115), see note 14.

(Figs. 118-19).[16]

It is quite possible that some, if not all, of these crosses could have served in the place of the silver cross of the Essen document and in comparable Good Friday texts. Many contained a relic of the True Cross, a characteristic also standard in the large wood crucifixes marking the Altar of the Cross.[17] This most precious relic, prized in itself, was the very focus of the Good Friday rites at Jerusalem and at Constantinople.[18] In later ceremonies performed in Rome the true cross reliquary took the form of a cross and was

[16]Hildesheim Treasury; Bernward's silver cross, 1007-08. This cross has been connected with a trip of Bernward to Paris and Tours for relics in 1006-07. A list of the relics kept in the corpus is inscribed on the back of the cross: Sts. Lawrence, Stephen and Dionisius and a piece of the True Cross. Further relics and inscriptions were added in the twelfth century. A further inscription: Bernwardus presul fecit hoc connects this cross with Bernward. It has been stylistically related to Trier; the present foot is late Gothic, cf. Elbern, Das erste Jahrtausend, notes on Fig. 423.
 Cologne, Schnütgen Museum; processional cross, Mosan, second half twelfth century, cf. Das Schnütgen, p. 27, Fig. 23.

[17]Most of the large monumental crucifixes contained relics, see Figs. 106-08 and notes 1-4 of this chapter. There is a literary reference to an ivory one containing relics at Canterbury in the twelfth century, cf. O. M. Dalton, Catalogue of Ivory Carvings of the Christian Era, London, 1909, p. xxiv, n. 2. For processional crosses containing relics, see Figs. 111-13, 118, and notes 12 and 16. See further examples of reliquary crosses in Elbern, Das erste Jahrtausend, Figs. 366, 392-93. A relic was not included in some of our examples of processional crosses, see Figs. 114-17, and notes 13-15, and Fig. 122 and note 26.

[18]See Chapter III, pp. 100-03 for the worship of the True Cross relic during the Good Friday rites at Jerusalem, and Chapter III, p. 104 and note 10 for the rites at Constantinople.

also the focus of the <u>Adoratio Crucis</u>.[19]

While the true cross relic in the Ottonian cross con-
nects it with the earliest Good Friday celebrations and with
the reliquary used for the <u>Adoratio Crucis</u> as performed at
Rome, other characteristics of the early processional cross
link it more specifically with the <u>Depositio Crucis</u> and its
complement the <u>Elevatio</u>. The triangular projection at the
base now permitted not only its insertion into its carrier
for the procession but also in its stand or foot on or behind
the altar.[20] This arrangement differs from the function of
earlier processional crosses, such as those used at Centula,
which were not meant to be set down along the way.[21] The
new flexibility also made it possible to remove the cross
from either holder and to place it in the sepulchre. The
specific intention of these crosses for the <u>Depositio</u> is
further indicated by the new distinction between its decoration

[19]See Chapter III, p. 103, for a description of the Good
Friday ceremony in Rome, cf. Young, <u>Drama</u>, I, p. 120, and
Heitz, <u>Architecture et Liturgie</u>, p. 97, who cites the text
"<u>post dorsum domni apostolici</u>." See J. Braun, <u>Die Reliquiare
des christlichen Kultes und ihre Entwicklung</u> (Munich, 1924),
Figs. 534 and 535 for the cross reliquary that was used.

[20]Braun, <u>Das christliche Altargerät</u>, p. 312. The
flexibility concerning the alternate uses of the cross con-
tinued until the sixteenth century.

[21]Heitz, <u>Architecture et Liturgie</u>, pp. 80-81, for a
description of the Easter procession at Centula. Early pro-
cessional crosses had the triangular metal piece at the base
for insertion into the holder, but it was only in the end
tenth century that a provision was made for its also being
set at the altar. See Elbern, <u>Das erste Jahrtausend</u>, Figs.
366, 392-93, and 395, for reliquary crosses with the pointed
projection.

front and reverse in accordance with the expanded meanings
of the Easter rite, for it could permit alternate sides of
the cross to be displayed when it was set at the altar: the
image of Calvary for the Adoratio and Depositio on Good Fri-
day, and the Majesty of the Lamb and Evangelist symbols as
a sign of the Resurrection on Easter.[22]

Another characteristic of these crosses that relates
to the Depositio is their commission by important religious
and political figures. The "early" Mathilda cross may be
among our first examples of a form of donor portrait that
was prominent throughout the Middle Ages: Duke Otto of
Bavaria and Swabia and his sister Mathilda, Abbess of Essen,
appear at the foot of the crucified Christ. They hold a
cross the shape of their own mounted on a long processional
holder (Fig. 116). Again, on the "later" Mathilda cross,
the Abbess kneels before the Madonna and Child in a cloisonné
plaque at the base of the cross (Fig. 117). More often, in-
scriptions without portraits make explicit the donor of the
cross: the Reichskreuz, for example, was the gift of Conrad
II (Fig. 111); Bernward is the named patron of the silver

[22]Our discussion of these crosses follows, for con-
venience, the general assumption that the side with the
crucifix is the front of the cross. It may be of interest
to note that the crucifix on the twelfth-century reliquary--
in the form of a double-choired church in the Hildesheim
Treasury (Fig. 120), from Kloster Escherde--is on the back
of the cross (note the hinges of the reliquary lid); a lamb
and Evangelist symbols are on the front.

cross (Fig. 118).[23] These inscriptions serve to underscore
a quality shared with the larger crucifixes at the Cross
Altar, for documents attest to their association with impor-
tant donors, too.[24] The naming of the donor on the cross
emphasizes its intention as a pious offering for the redemp-
tion of the donor's soul. Such a meaning is clearest, per-
haps, in those crosses which were placed in tombs, for ex-
ample the Gisela Cross of c. 1006, found in the grave of
Gisela of Hungary, the sister of Henry II (Fig. 121).[25]

It is possible for the artist of the cross to be the
subject of the inscribed prayer. An Italian cross of the
first half of the twelfth century at Princeton carries the
following request (Fig. 122):[26]

[23]See notes 12 and 16 for inscriptions on the Reich-
kreuz and Bernward's silver cross; Fig. 121 and note 25 for
the Gisela Cross; and note 32 for the donor inscriptions on
the Gunhild Cross and that of Ferdinand and Sancha at León
(Figs. 125-26). See also the reliquary cross of Archbishop
Herimann, Cologne, mid-eleventh century, cf. Schnitzler,
Rheinisches Schatzkammer, Fig. 68. It carries the inscrip-
tion: Herimann Archiepiscopus me fieri iussit and shows
Herimann and Ida, Abbess of Santa Maria im Kapitol (great-
granddaughter of Otto the Great) at the feet of the Virgin.

[24]The Gero Cross (Fig. 106) was made for Archbishop
Gero of Cologne, see note 1; see also Fig. 107 and note 3,
for the Ringelheim Cross, a gift of Bernward to his sister
Judith.

[25]Gisela cross, c. 1006, from Regensburg, is in Munich,
Schatzkammer der Residenz, cf. Schramm-Mütherich, Denkmale,
notes on pl. 143.

[26]Translation of the inscription: "You who look upon
this, pray God for me Tirolus Iafarinus who made me." Pro-
fessor Colin Eisler has pointed out that qui me fecit may
more properly read: "who had me made." If so, the name may

Vos qui aspizitis DM Rogate P[ro] M[e] Tirola Iafarino
Q[ui] me fe[cit].

The front face shows a corpus with the Archangel Michael
above, half-length figures of Mary and John to left and
right, and Adam below. The reverse, which has the inscrip-
tion, shows the Majesty with the Evangelist symbols. The
fact that this, a processional cross, was found in a tomb in
Perugia points to the link between the symbolism of cross
used in the _Depositio_ drama and the idea behind its placement
in an individual tomb.

The dominant theme of the Easter ceremonies is the
rebirth of the catechumen through his Baptism and the renewal
of the faith of the communicants participating in the liturgy.
That the assurance of redemption applies after their death
as well is emphasized at Essen by the stations at the crypt
below the main altar and at the nuns' cemetery in the Easter
Eve procession.[27] The gift of the cross, like the gift of
the sepulchre to be used in the Easter ceremonies,[28] was a

here refer to the donor and not the artist.
Another example is the crucifix reliquary of c. 1000
in the Victoria and Albert Museum found in the tomb of a
bishop, cf. John Beckwith, _Ivory Carvings in Early Medieval
England_ (London, 1972), frontispiece. See _ibid._, p. 122,
for the argument that the filigree as well as the ivory cor-
pus are English. Distinctive here from the processional
crosses under discussion is the loop at the top of the cross
by which it could be hung over the altar, cf. p. 2, and
Braun, _Der christliche Altar_, p. 467, for the reference to
cruce pendentem super altare.

[27]See Chapter III, pp. 122ff., for Essen rites, espe-
cially p. 124 and note 56.

[28]Forsyth, _The Entombment of Christ_, p. 16, cites the

special guarantee for an important soul to be saved. The
same logic governed the privilege of being buried in the
hallowed region of the sepulchre: Angilbert lay close to
the capsa maior at the west porch of St. Sauveur; later,
from the twelfth century on, the north side of the chancel
or the roodscreen came to be the honored place.[29] The ten-
dency of the Depositio drama increasingly to take on the
elements of a courtly funeral merely amplifies an idea in-
trinsic to the rite.[30]

These particular connotations of the gift of a cross
are most interestingly spelled out in a series of miniatures
from the Liber Vitae of New Minster, dated c. 1020-30 (Figs.
123-24).[31] One miniature, folio 6r, shows King Cnut and his
wife Aelfygu dedicating a cross to the Christ of the Last
Judgment seated above them in a mandorla. Another, paired
on folios 6v and 7r, depicts the consequences of the Judg-
ment: the blessed ushered by St. Peter through the entrance

1364 record of Bishop Berthold of Bucheck's turning over his
elaborate tomb for use as the Easter sepulchre and ordering
a more modest one for himself in the same chapel. Brooks,
Sepulchre of Christ, p. 65, discusses the English Easter
sepulchre's frequently having functioned also as the tomb of
a wealthy donor. See also Chapter III, pp. 128ff, for the
San Sepolchro at Aquileia.

[29]See Chapter III, pp. 107, 114, 126, 136, and notes
65 and 80.

[30]Tauberts, "Mittelalterliche Kruzifixe," pp. 98ff.,
publish the text of the highly evolved Wittenberg rites.

[31]Liber Vitae of New Minster, English, ca. 1020-30,
London, British Museum, Stowe MS 944, fols. 6r-7r.

of the Heavenly Jerusalem; the damned plunging into the hell mouth as an angel locks the gate behind them.

The theme of Judgment, alluded to in the Italian processional cross by the presence of Michael and Adam (Fig. 122), is first expounded on two ivory crosses of the mid-eleventh century: Gunhild's cross of ca. 1073 and that of Ferdinand and Sancha at León of 1054-56 (Figs. 125-26).[32] Helena, also called Gunhild, was the daughter of the Danish King Swend Estridsen and the niece of King Cnut; she died in 1076. The inscription says that the cross was made for her by Liutger. Although Liutger is the name of a canon from Lund of the second half of the eleventh century, considerable evidence has argued for Liutger's being an English artist

[32]Gunhild's Cross, walrus ivory, Anglo-Saxon?, ca. 1075 (28.5 cm.); Copenhagen, National Museum. The cross has the following donor inscriptions: QI ME CERNIT P[ro] HELENA MAGNI SVENONIS REGIS FILIA XP̄M ORET QĒ ME AD MEMORĪA DN̄ICĒ PASSĪOIS PARARI FECERAT; then QĪ IN XP̄M CRVCIFIXV̄ CRED̄[un]T LIVTGERI MEMORIĀ ORANDO FACĪAT Q̄I ME SCVLPSERAT ROGATV HELENE QVE ET GVNHILD VOCAT̄[ur]. For additional inscriptions, see Beckwith, Ivory Carvings, p. 127.
 Madrid, Museo Arqueologico; Ivory crucifix of Ferdinand and Sancha, 1054-56. Ferdinandus Rex and Sancha Regina are inscribed on the base of the front of the cross, below the figure of Adam. A testament of 17 December, 1063, includes the cross among a number of objects Ferdinand and Sancha gave to the Church of San Isidoro in León in 1063, the year Isidore's relics were transferred there from Seville, see M. Park, "The Crucifix of Ferdinand and Sancha and Its Relationship to North French Manuscripts," Journal of the Warburg and Courtauld Institutes, XXXV (1973), 77. For the dating of the cross, see M. Gomez-Moreno, "Entorno al Crucifijo de los Reyes Fernando y Sancha," Informes y Trabajos del Instituto de Conservación y Restauración de Obras de Arte, Arqueologia y Etnologia, 3 (1964), 9.

working in a style related to the St. Albans Psalter.[33]

On the front of this cross, the medallion to the left of the central portion, where unquestionably a corpus once belonged, shows the triumphant _Ecclesia_ crowned, with a cross staff and a book, and the defeated _Synagoga_ to the right. The medallion above has a personification of _Vita_, also crowned and holding a floral sceptre, while _Mors_ lies shrouded in a coffin at the base of the cross. On the back, the central medallion, ringed by four angels, shows Christ as Judge seated on a rainbow with his arms extended and a book on his lap, on which _alpha_ and _omega_ are inscribed.[34] Along the border of the medallion is written the words "Look at my hands and my feet says the Lord"--an allusion to the wounds of the Passion which were equally explicit on the corpus, judging from the bloodstains etched on the cross arms.

[33] Beckwith, _Ivory Carvings_, p. 127. The English attribution has been debated. Goldschmidt, _Die Elfenbeinskulpturen_, No. 124, called it Danish, but was the first to draw attention to its similarity to the style of the St. Albans Psalter. Pächt, _St. Albans Psalter_, p. 173, n. 3, sees it as the basis of the Danish elements in the style of the English monk, Anketil, whom he identifies with the Alexis Master of the Psalter. However, John Beckwith, _Ivory Carvings in Early Medieval England, 700-122_, Catalogue of the exhibition at the Victoria and Albert Museum, London, 1974, p. 46, reiterates his view that it is Anglo-Saxon and compares the style to a Judgment of Solomon capital at Westminster Abbey of the beginning of the twelfth century or earlier (comparison not illustrated).

[34] Idem, _Ivory Carvings_, p. 127, points to the similarity of the _omega_ to mid-twelfth-century English ivories-- his no. 85 and Fig. 70. His point is unclear because the comparisons are so much later than the cross and not very close--to the cross or to each other.

The medallion of the blessed to the left has six figures,
among them a bishop, a king and a queen; six damned figures
to the right are turned away from Christ. The top medallion
shows Lazarus, surrounded by other blessed souls, in the
bosom of Abraham; the damned Dives appears below between two
devils. A prayer for deliverance is inscribed on the lower
part of the shaft.

The earliest expression of the Judgment theme in the
west appears in the variable formulations of insular art.
It is depicted on two mid-eighth-century Irish Gospel books
through the image of the Christ of the Second Coming amid
rows of blessed, and in an Anglo-Saxon ivory of the late
eighth or early ninth century where Christ in a mandorla
presides over angels ushering the elect into Heaven, while
the damned are consigned to the tortures of Hell (Fig. 127).[35]
In two litany leaves added by an English artist to the Aethel-
stan Psalter and an ivory in Cambridge (Figs. 128-29),[36]

[35]London, Victoria and Albert Museum (Webb Collection);
The Last Judgment, ivory, Anglo-Saxon, late eighth or early
ninth century (13.2 cm.). The back shows a late tenth-century
representation of the Transfiguration, cf. ibid., no. 4 on p.
118, and no. 21 on p. 122 and Figs. 49 and 51. Of the two
eighth-century Hiberno-Saxon miniatures of the Second Coming,
one is in St. Gall (Stiftsbibl. MS 51), and the other in
Turin (Bibl. Nac. MS O IV 20), cf. Robert Deshman, "Anglo-
Saxon Art after Alfred," The Art Bulletin, LVI, No. 2 (1974),
182, and Fig. 11.

[36]London, British Museum, Cotton MS Galba A. XVIII,
fols. 2v and 21, cf. ibid., pp. 176-82. For the walrus
ivory Last Judgment, Anglo-Saxon, late tenth or early ele-
venth century in Cambridge, Museum of Archaeology and Eth-
nology, see Beckwith, Ivory Carvings, no. 18 on p. 121.
Christ in a mandorla flanked by the Virgin and Peter

Christ as Judge prominently displays, as does the Gunhild
Christ, the wounds of his Passion. These early examples al-
ready express the connection of the Majesty theme with the
ideas of Judgment and the sacrifice of Christ so clearly seen
on the Gunhild cross. Here the traditional Majesty of the
Lamb facing an image of the Crucifixion has been transformed
into a full representation of the Last Judgment. The source
of the traditional image of Christ as Judge is itself an
adaptation of a Majestas Domini.[37]

Although on the slightly earlier cross of Ferdinand
and Sancha the scheme of the Majesty of the Lamb is retained
on the back, the reference to the Judgment theme is nonethe-
less implied (Fig. 126). Unique to this cross is the fea-
ture of inhabited scrolls. While on the verso of the cross
and on the cross arms of the front, the figures are in a

(recalling his importance in Stowe MS 944) appear above the
cross held by two angels. The inscription on the mandorla:
O VOS OM[ne]S VID[e]TE MANVS ET P[edes Meos] recalls the one
on the Gunhild Cross, see note 32, and p. 156.

[37]Deshman, "Anglo-Saxon Art after Alfred," p. 182.
A question for further study is the relationship of the
Hiberno-Saxon stone crosses to the later crosses. Origi-
nally funerary monuments erected in cemeteries, they gener-
ally carry the inscription: "Pray for x who caused this
cross to be made." According to F. Henry, Irish Art of the
Early Christian Period (to 800 AD) (London, 1965), pp. 117-
18, they gradually tended to lose their specifically "funer-
ary character and . . . become a center for prayers and of-
fices, and, perhaps, in some cases, the mark of asylum."
It might be worthwhile to consider whether fresh reports of
the Holy Sepulchre at Jerusalem brought by the pilgrim Arculf
to Adamnan of Iona in the seventh century in any way affected
their being erected, cf. Heitz, Architecture et Liturgie, p.
113.

sort of stalemate with their entwining scrolls, the element of struggle is more active on the shaft of the front above and below the dominant image of the crucified Christ (Fig. 126). The figures below--the damned--are most hopelessly caught by their animal pursuers, while the blessed above break completely free as they reach up to the angel, perhaps Michael, in the upper left-hand corner.[38] A further depiction of the Judgment theme has been seen in the equivocal pose of the Ascending Christ at the top of the cross. The cross staff he carries and his slightly bent legs appear to add a second reference to this image.[39] Below the Christ on the front, Adam with his right hand extended is shown emerging from his tomb, a motif which refers to the Harrowing of Hell and carries a meaning associated not only with the Judgment theme but with Baptism as well.[40] A second reference

[38]This interpretation of the figures on the shaft of the cross depends on Professor Harry Bober's lecture on Hiberno-Saxon interlace, Medieval Club, New York, April, 1974. The tentative observation by Park, "The Crucifix of Ferdinand and Sancha," p. 80, that "the animals on the upper arm seem powerless," is precisely the point: the containment of the powers of evil through the victory of the cross.

[39]Ibid., pp. 80-81.

[40]Ibid., p. 78, for references to Bernard of Clairvaux's parallel of the Harrowing of Hell and Baptism. The extra-liturgical drama of the Harrowing of Hell was eventually added to the Elevatio Crucis, cf. Young, Drama, I, pp. 149-77, especially p. 152. Most texts from the fifteenth and sixteenth century, that from Barking, near London, being a particular dramatic one, cf. ibid., pp. 165-66. For the Barking Depositio, see Chapter II, p. 93, and note 113. Earlier, the ideas of Resurrection and Redemption were enacted by the simple raising of the cross or by such gestures as those made by the Abbess of Essen, cf. Chapter III, p. 124, and note 56.

to the Baptism theme occurs in the dove of the Holy Spirit
at the center of the top of the cross: Marlene Park has re-
marked on its similarity to the dove found in scenes of the
Baptism of Christ.[41]

The interweaving of the themes of sacrifice and Resur-
rection with Judgment and Baptism in the iconography of this
cross intimately binds it to the Easter rites. Spanish in-
terest in these rites stems from Etheria's visit to Jerusalem
at the end of the fourth century. The Mozarabic Easter
liturgy is rich with apocalyptic references and the linking
of Christ's Crucifixion, Descent into Hell, and Resurrection
with the redemption of the faithful.[42] No contemporary De-
positio text from eleventh-century León is preserved--only a
late eleventh-century Visitatio Sepulchri from Silos and
twelfth-century ones from Ripoll and Compostela.[43] Never-
theless, contact with emerging developments in the conti-
nental liturgy maintained by the Benedictine Abbey at Ripoll

[41]Park, "The Crucifix of Ferdinand and Sancha," p.
80. She also suggests a similarity to the dove in Pentecost
scenes.

[42]Ibid., pp. 82-83. Park cites two prayers from the
Brevarium Gothicum, cf. Migne, P.L., LXXVI, cols. 613-14, in
the Mozarabic Easter liturgy which link Christ's Crucifixion
and Descent to the life of the believer. Reference to the
Last Judgment was alluded to in one of three Bible readings
which was drawn from the Apocalypse. For Etheria's visit,
see Chapter III, pp. 99ff.

[43]Donovan, The Liturgical Drama in Medieval Spain, pp.
51-52. The eleventh-century text from Silos--London, British
Museum, Add. MS 30848, f. 125v--demonstrates the blending of
the different liturgies: the ritual is French, but the
script and notations are Mozarabic.

was influential in Spain, and eventually led to Castile's
abolition of the Mozarabic ritual in 1081. Both the iconog-
raphy of Ferdinand's cross and the prominence of the only
slightly later Deposition on the Puerta del Perdon at León
(Fig. 83)--seen together with the Three Maries and the As-
cension--certainly suggest that a performance of the Deposi-
tio drama at León using this very cross is by no means out
of the question.[44]

Transformation of the Cross into a Symbol of the Mass

The twelfth century brought the introduction of a
radical change in the form of the processional cross due to
a revision of purpose for which it was intended. Evidence
of the process of change may be seen in the Bury St. Edmunds
Cross of the mid-twelfth century (Fig. 73).[45] The central
medallion on the front shows Moses and the Brazen Serpent, a
familiar Old Testament antetype of the Crucifixion. To the

[44]This assumption leans heavily on the analysis by
Donovan, ibid., pp. 25-28, of the close ties between Spain
and France prevailing in Catalonia since Charlemagne's con-
quests ca. 800. The power of the Benedictine Abbey of Santa
Maria de Ripoll in Castile was at its height under Oliva
(1002-46), when there were close musical links to Moissac,
St.-Martial-de-Limoges, and further connections with Cluny
and Fleury--all centers of the development of liturgical
drama. The greatly elaborated Easter ceremonies of the six-
teenth century from Grenada and Huesca, ibid., pp. 58-60--
complete with guns, trumpets and mechanical angels--and the
Deposition groups in wood of the late twelfth and thirteenth
centuries, see pp. 173-83 of this chapter, serve to strengthen
the idea that a Depositio may well have been performed in
some form as early as the eleventh century.

[45]See Chapter II, p. 95, and note 120.

right is a depiction of the Passion through the Descent from
the Cross and the Lamentation; to the left is the Resurrected
Christ and the Three Maries at the Tomb: the Ascension ap-
pears above. It is more likely that a Nativity appeared be-
low than the Christ before Caiaphas plaque now in this loca-
tion.[46] Intervening scenes show Adam and Eve at the foot of
the "Tree of Life" cross and, just below the Ascension, Pi-
late and Caiaphas dispute the title of the cross.

The Bury Cross is an expansion of the programmatic
method of the Gunhild cross. It, too, is a "literary cross"
here replete with inscriptions drawn from the writings of
the Evangelists and of the Old Testament prophets, inscribed
not only on the cross shaft but on numerous scrolls held by
their authors. Also comparable to the Gunhild cross is the
thematic interlinking of medallions and inscriptions front
and back, but rather than an exposition of the Last Judgment,
the sacrifice is the focus of the entire Bury Cross. The
traditional Majesty has been transformed into a second image
of the Crucifixion, in which the personification of Synagoga
is shown piercing the Lamb. The link back to front is fur-
ther reinforced by the fact that each Evangelist symbol is
placed in relation to the feast scene with which it is tradi-
tionally associated.[47]

The image of the Crucifixion on both sides of the
Bury Cross departs from the iconography traditional to the

[46]See Appendix II. [47]See Appendix II.

earlier processional crosses of the Easter rites, where the
two aspects of Christ's nature were separately represented--
through the Majesty of the Lamb on one side and the cruci-
fied Christ on the other--and alternately displayed. In the
eleventh century, the liturgical symbols of the Easter rites
began to overlap those of the Mass: the Gospel book, which
originally was the only object other than the sacraments
permitted on the altar at Communion came increasingly to be
included in the Easter procession; the cross and reliquaries
of these rites began to be set on the altar during Mass.
The High Mass culminating the Easter procession was the orig-
inal point of intersection between the two rituals.[48]

The Majesty side of the cross--symbolizing, as does
the Gospel book, the divine Christ--was probably the side
first displayed at the altar during the Mass. The image of
the crucified Christ of the Good Friday rites, so critical
to the rebirth in life and resurrection in death of the be-
liever, became the focus of the Mass sacrifice only as a re-
sult of the theological shift, which began to crystallize in

[48]J. Jungmann, The Mass of the Roman Rite: Its Ori-
gins and Development, I (New York, 1950), p. 312 and pp. 442-
47, for the Gospel book in the liturgy. See also Metz, The
Golden Gospels of Echternach, pp. 20-21. For the introduc-
tion of the cross into the eleventh-century Mass, see Braun,
Das christliche Altergerät, p. 467, n. 6, and p. 469, n. 24.
Jungmann, Mass, II, p. 292, n. 89, discusses the stipulation
in the Consuetudines of Farfa, of 1040, that during Mass,
before the Pater Noster, a crucifix, the Gospel book, and
relics be set out in front of the altar. See also ibid., II,
p. 445, n. 41. For the inclusion of the Gospel book in the
Essen Depositio, see Chapter III, p. 123.

twelfth century, concerning the meaning of the Host as Christ's human rather than his spiritual flesh.[49] The impetus for the shift occurred in the liturgies of the North, particularly in Germany and in England. It is in these artistically most progressive regions--where the image of the dead Christ was first accepted and where the extra-liturgical Easter dramas were most often opted for--that the initial stages of the gradual displacement of the Gospel book at the Mass through the transformation of the processional cross to a single-faced crucifix as a stationary fixture at the altar are most clearly reflected.[50]

The Bury Cross is particularly important because it shows its clear connection with the form and iconography of the older processional cross even as it transforms it into an altar cross. A late eleventh-century copper and gilded processional cross from the parish church of Sankt Maria Lyskirchen in Cologne represents an interesting step in the direction that the Bury Cross was to take (Fig. 131).[51] Apparently, the two sides of this cross are an amalgam. The

[49]See Chapter II, pp. 74-76, and notes 84-86.

[50]Braun, _Das christliche Altargerät_, p. 173. The final installation of the crucifix came with the reordering of the Missal by Pope Pius V in 1570. By the thirteenth century, although the crucifix on the altar was a common expression of the renewal of the sacrifice at the Mass, it could be substituted for as well by a retable or wall painting, cf. _ibid._, pp. 469-70.

[51]Cologne, Parish Church of Sankt Maria Lyskirchen; processional cross, Cologne, end eleventh and first quarter of the twelfth century, cf. _Rhein und Maas_, p. 268, H 7.

engraving on the back is one of the earliest known examples
of a typological representation of the Crucifixion and the
Sacrifice of the Mass on a cross. The middle medallion
shows the enthroned _Ecclesia_ holding a victory banner and
the chalice. The medallions to left and right depict Cain
and Abel with their offerings of the wheat and the lamb.
Similarly split are the ·sacrifices of Abraham and of Isaac
which fill the two medallions below the central one. On the
top of the shaft is a medallion containing Melchisidek offer-
ing up the chalice and the bread. The front shows the Hand
of God emerging from a cloud above, with the sun and moon in
quarter circles on the arms which are partially overlapped
by a superimposed crucifix of gilded silver in the shape of
a _tau_ cross, dating to the first quarter of the twelfth cen-
tury. The silver crucifix shows Christ in a collobium stand-
ing majestic and upright on the cross--the apocalyptic Christ
of the Last Judgment. Additional holes on the cross, how-
ever, confirm that this was not the original arrangement.
The installation of a second corpus here, like the possibil-
ity that the one on the Bury cross was added later or only
sometimes used, is an indication of the evolving state of
the liturgy and its visible symbols in this period.[52]

There are other signs of the transition from the pro-
cessional cross of the Easter rites to the altar cross of

[52]See Chapter II, pp. 95-96 and notes 119-21, and note 103
of this chapter.

the Mass. It is perhaps not accidental that the examples of cross feet expounding the theme of Adam redeemed are now separated from the cross they once held (Figs. 101 and 102).[53] Such an iconography, more particular to the Easter rites, tends to draw the focus away from the image of the crucified when the cross was used as a symbol of the Mass. Moreover, its theme, so closely tied to the more stable placement of the cross at the Altar of the Cross in front of the rood-screen, was less appropriate when the locale of the Mass was the High Altar or at any of the other altars throughout the church.[54]

Iconography of Reliquaries Associated with the Depositio

The Easter iconography developed in connection with the crosses remains more fully intact in twelfth-century reliquaries which have been preserved. They take a number of forms: the simplest is in the shape of a rectangular box decorated with vividly colored champlevé enamels and distinguished by a bold border of copper "hob nails," such as the one in the Metropolitan Museum (Fig. 132).[55] The sides

[53]See Chapter III, p. 135, and notes 77-78.

[54]See Braun, "Altarordnung," passim, for the placement of the altar in the early church and the proliferation of altars and their locations in the medieval period.

[55]New York, Metropolitan Museum; Enamel reliquary, Danish or North German, ca. 1100-50, cf. Metropolitan Museum of Art: The Middle Ages. Treasures from the Cloisters and the Metropolitan Museum of Art. Catalogue of exhibition at the Los Angeles County Museum of Art and the Art Institute of Chicago, 1968, which gives the full bibliography.

show a Crucifixion, sometimes together with a Nativity, and single figures of saints or apostles framed by columns or arches. The lid carries a representation of Christ--the Christus Judex or the Lamb of God--in every case surrounded by the four Evangelist symbols. The ten reliquaries of this group are dated 1100-50, and traditionally thought to be Danish, although the possibility of a North German provenance has also been suggested.[56] Due to later restorations these boxes have undergone, it is not clear if the bronze crucifix attached to the middle of the back of the lid of the one in Copenhagen was the usual arrangement: it shows a corpus on the front and the Majesty with Evangelist symbols on the back (Fig. 133).[57]

A Crucifixion frequently crowns other forms of the reliquary, for example the so-called "provisur-pyxis" in the Hildesheim Treasury (Fig. 120).[58] The base, resting on

[56]J. Braun, Meisterwerke der deutschen Goldschmeidekunst der vorgotischen Zeit (Munich, 1922), p. 8; William M. Milliken, "A Danish Champlevé Enamel," The Bulletin of the Cleveland Museum of Art, VI (June, 1949), 101ff.

[57]Copenhagen, National Museum; Enamel Reliquary, North German or Danish, ca. 1100-50, cf. Braun, Meisterwerke, notes on Fig. 31.

[58]Hildesheim, Treasury; Reliquary from Kloster Escherde, Lower Saxony (Hildesheim), twelfth century, cf. Victor H. Elbern and Hans Reuther, Der Hildesheimer Domschatz (Hildesheim, 1969), pp. 28ff. The suggestion that the object is a reliquary and not a pyx, first made by A. Bartram (Hildesheim Kunstbarste Kunstschätze--not available in N.Y.C.) in 1916, was taken up by Bloch, "Die Weimarer Kreuzfuss," p. 17. See also note 22, for the corpus' being on the back of the cross. Another example of a reliquary with a Crucifixion (now lost) is the reliquary coffret in the Xanten Cathedral

diagonally set lions' paws has the shape of a double-choired
Romanesque church with a nearly square central core. This
central area is hinged so that it can be opened, and is
topped by a pinnacle crowned with a crucifix; the head of
Tartarus is seen at its base. On the reverse of the cross
is a representation of the Lamb of God and Evangelist sym-
bols. While it may also have served as a pyx, the idea that
this object is primarily a reliquary gains credence when it
is seen in relation to other monuments of this type.

There are a number of reliquaries with a comparable
architectural base in which the Descent from the Cross rather
than the Crucifixion is represented. One from St. Servatius,
Maastrict, is particularly striking because the reliquary
base takes the recognizable form of an Easter Sepulchre
(Fig. 22).[59] The core of the sepulchre is a rectangular
box, its front side engraved with three sleeping soldiers.
On the lid sits a small rectangular building flanked by two
large angels. Through the triple-arched opening of the long

Treasury; it contained a piece of the True Cross, cf. Brus-
sels, Palais des Beaux-Arts: Trésors du Moyen Âge Allemand,
No. 59 (1949), pl. 37.

[59]Nuremberg, Germanisches Nationalmuseum; Reliquary
from St. Servatius, Maastrict, ca. 1100 (drawing), cf. Es-
senwein, "Ein Reliquiar," pp. 2ff.; Hermann Schnitzler, "Eine
Neuerwerbung des Schnütgen Museums," Der Cicerone: Anzeiger
für Sammlung und Kunst Freunde, II (1949), 50ff., discards
the early eleventh-century date proposed by Essenwein in
favor of one in the early twelfth century; A. Boeckler, Ars
Sacra: Kunst des früher Mittelalters, exhibition catalogue,
Bern and Munich, 1949-50, No. 203, returns it to the ele-
venth century.

sides of this building, one sees the top half of the figures
of Joseph and Nicodemus burying the body of Christ in a hol-
low space in the cover of the box below. Set on top of the
roof is a five-figured Descent from the Cross: the body of
Christ is being removed from the lignum vitae cross, from
whose base issue two volutes supporting Joseph of Arimathea
and the Virgin on the left, and Nicodemus--with his enormous
pliers--and John on the right. This unique monument in its
entirety thus depicts the two stages of the Depositio drama.
Its double-storied composition may be compared to such a
representation of the Deposition and Entombment as is found
in the Codex Egberti at Trier (Fig. 28). But the depiction
of the cross as the lignum vitae and the lions' paws on
which the sepulchre rests--an allusion to Mark's symbol of
the Resurrection--at the same time proclaim the assurance of
Redemption inherent in these sacred moments of the Good Fri-
day rites.

A further allusion to the Holy Sepulchre setting of
the Depositio drama recurs in a related reliquary also from
Lorraine, dated later in the twelfth century, in the Victoria
and Albert Museum in London (Fig. 5).[60] A rectangular cof-
fer, again resting on lions' paws, supports a double-choired

[60]London, Victoria and Albert Museum; Reliquary, Lor-
raine, ca. 1130, cf. Schnitzler, "Eine Neuerwerbung," p. 50.
Noteworthy is the unusual element of inhabited scrolls, cf.
Swarzenski, Monuments of Romanesque Art, Fig. 9 on p. 36,
which may be compared with those on the back of the cross of
Ferdinand and Sancha (Fig. 126).

structure with a central three-tiered tower flanked on either side by a dome and a turret. The building and its base are decorated with large round stones and bands of in-habited scrolls. The Deposition which again crowns the cen-tral tower appears to be very similar to the drawing of the Maastrict reliquary: the cross, still the lignum vitae, now has cabochon settings at the ends; the volutes issuing from its base are only more elaborate.

Another Deposition--this time in ivory--connected with a reliquary is preserved only as a fragment in the Schnütgen Museum and dated between 1070 and 1100 (Fig. 32).[61] All that remains is the central portion of the lignum vitae cross showing Joseph of Arimathea supporting the still up-right body of the dead Christ, crowned, as a small-sized Nico-demus kneels to remove the nail from the right foot with his pliers. What is left of the reverse shows that it was dec-orated with the now familiar Lamb of God and Evangelist sym-bols. Schnitzler has identified this piece as coming from Bamberg, and he suggests that it belonged on top of an ivory reliquary box decorated with plaques similar to, if not ac-tually, the set from St. Michael's cloister in Bamberg, now in Munich.[62]

[61] See Chapter I, note 28, and also Rhein und Maas, J 8.

[62] Schnitzler, "Eine Neuerwerbung," pp. 50-54, con-nects this Deposition with Goldschmidt, Die Elfenbeinskulp-turen, II, nos. 148-50, 152 and 153.

Monumental Representations of
the Descent from the Cross

But it was not only in the small-sized reliquaries of
the twelfth century, clearly derived from the Depositio ico-
nography, that the Descent from the Cross is prominent.
Monumental works on a large scale also mark this period.
One of the earliest, from the first quarter of the twelfth
century, is the large Deposition at the Externsteine, near
Horn, in Germany (Fig. 14).[63] The Externsteine is a huge
outdoor arena, thought originally to have been a pagan site
later taken over for Christian use, with underground chapels
housing an altar and a sarcophagus tomb. It would appear
from the layout of the arena as a whole and from the iconog-
raphy of the Descent, carved from a stone ledge, that an im-
pressive Easter pageant was performed here. The composition
includes many of the usual elements of a Descent from the
Cross: the dead Christ is removed from the cross by Joseph
of Arimathea and Nicodemus, with Mary and John to left and
right. Personifications of the sun and moon have been bor-
rowed from the Crucifixion composition, a feature, if not
standard, at least not unique to this example. The bent
tree on which Nicodemus stands is an interesting deviation
from the norm: it may, like the volutes stemming from the
reliquary tops, allude to the living wood of the cross fol-
lowing Christ's sacrifice.

[63]See Chapter I, note 28.

There are other elements of this composition, how-
ever, which tie it more closely to the Easter rites. The
damaged figures of Adam and Eve which appear below, while
not usually seen in a Descent from the Cross, we have come
to expect in the redemptive iconography of the cross and its
feet. Most puzzling to scholars has been the presence and
identity of the figure above. Schiller says it is God the
Father, his right hand blessing Christ who is represented in
the form of a small soul tucked under his arm, as he holds
the Resurrection banner in his left.[64] However, if one sees
this work in terms of the Easter dramas it was undoubtedly
designed to illuminate, I think it becomes clear that this
figure is instead the Resurrected Christ--a telling clue is
his crossed nimbus--and that he appears as the Judge who
blesses with his right hand and carries his own Resurrection
banner. If so, the little figure of the soul would belong
to Adam, a depiction of his resurrection from his grave at
Golgotha through the sacrifice of Christ, the New Adam.[65]

The most prominent examples of the monumental Descent
from the Cross in this period are the carved wood groups
(Figs. 15 and 16). Although there is no firm documentation
on this point, the likelihood is strong that they were origi-
nally designed for the Easter rites. Localized as they were

[64]Schiller, Ikonographie, I, p. 180, notes on Fig. 558.

[65]Schmitt, R.D.K., cols. 158-62, for the theme of the Old and New Adam.

in Spain and Italy, however, the question is open whether
they were associated with the Depositio drama as it was de-
veloped in the Benedictine orders or were part, instead of
the more popular Easter pageants, the sacra rappresentazione,
as they were called in Italy.[66] Even if true, however,
there are indications that the groups did not stray too far
from the church. Those preserved as a group were found set
above or behind the altar, thus also serving the more general
liturgical purpose of expounding the meaning of the Mass.
In some cases, the Deposition Christ was retained even after
the side figures had been discarded.[67] In Italy the strength
of this image of the dead Christ was especially strong. For,
separated from its original context, it turned into the power-
ful new Imago Pietatis, or Man of Sorrows, which emerged in
the early Trecento, an early example of which can be seen in
a fresco from Sta. Raparata in Florence.[68]

While the popularity of these groups is known only in
Spain and Italy, it is not certain that either country is

[66]"Sacra Rappresentazione," Enciclopedia Italiana,
XXX (Rome, 1936), p. 411.

[67]Francovich, "A Romanesque School of Wood Carvers,"
p. 6. Good documentation of this process accompanies the
Christ from Santa Maria di Roncione, near Deruta (Fig. 141).
The side figures belonging to this Christ were housed in wall
niches as late as the eighteenth century, ibid., p. 6.

[68]E. Panofsky, Early Netherlandish Painting, I (Cam-
bridge, 1953), pp. 273-74, gives an excellent summary of
this process. Francovich, "A Romanesque School of Wood Carv-
ers," p. 47, says the fresco in the crypt of the Duomo of
Florence, part of the earlier church of Santa Maria Raparata,
is by a follower of Giovanni Pisano.

their place of origin. The French Courajod Christ is the
earliest of all known examples of this type of corpus figure,
dating to the second quarter of the twelfth century (Fig.
17).[69] The provenance of this work has wavered from the
Auvergne--the home of the Madonna figures--to Burgundy on
the basis of its style. A close examination of the work,
however, would seem to place it more in the orbit of Tou-
louse. The elongation of the head, the shape of the mouth,
the curls of the beard and hair in neatly separated bunches,
the hair center-parted and combed flat down from the crown
are all features most closely comparable to the Christ on
the Moissac tympanum; the way the mustache joins the curls
of the beard is similar in a number of the seated elders
(Figs. 134-35).[70] Toulousan, too, is the device of the
circular drapery swirl at the knee. Not only the graceful
folds which uncover Christ's right knee but the gently loop-
ing double and triple folds down from the left leg, as well
as the costume complexity of the belt, and the way the sash
ends fall, appear more nearly related to the apostles from
St. Etienne--Thomas, for example--than any Burgundian fig-
ures.[71]

[69]Paris, Louvre; Courajod Christ, Toulouse?, second
quarter twelfth century, cf. Aubert, _Louvre: Sculptures du
Moyen Âge_, p. 18.

[70]Last Judgment, south portal tympanum, ca. 1115,
Church of St. Pierre, Moissac.

[71]St. Thomas, by Gilabertus, from St.-Etienne, Tou-
louse, ca. 1130, cf. Mesplé, _Musée des Augustins_, Fig. 5.

The stylistic identity links this especially fine work with the great French centers of the drama in the twelfth century, whose ties with Catalan Spain were long and strong. The similarity of this Christ to Spanish works is particularly marked in one from the Gardner Collection of the third quarter of the twelfth century, and one slightly later in Barcelona (Figs. 136-37).[72] In the finesse of its drapery and its delineation of the torso, the Christ from Barcelona has some echo of the genius of the Courajod Christ. The delicately rendered long thin nose and sensitive mouth of the Gardner Christ have been seen as so close to that of the Courajod that it is sometimes also thought to be French.[73] Neither of these corpora, however, fully approaches the masterful quality of its model in either realization of form-- in the tilt of the head, the pull of the ribs--or in psychological power. Moreover, their attribution to Spain is reinforced by their relation stylistically and by type to a Christ from the Diocese of Urgel (Fig. 138).[74] The Urgel

[72]Boston, Isabella Stewart Gardner Museum; wood corpus, Catalan-Pyrenean, third quarter twelfth century, cf. Gottfried Edelmann, "Notes on Wood Corpus for Crucifix, Catalan, XII c." Isabella Stewart Gardner Museum, October 28, 1958, unpublished, whose interpretation of the Spanish groups is followed here. Barcelona, Museo Mares, wood corpus, Catalan-Pyrenean, end twelfth century, cf. Palol, Medieval Art in Spain, notes on Fig. 164.

[73]Francovich, "A Romanesque School of Wood Carvers," p. 53.

[74]Barcelona, Museo de Arte de Cataluna; wood Corpus from Diocese of Urgel, Catalan-Pyrenean, 1147, cf. Palol, Early Medieval Art in Spain, notes on Fig. 161. Edelmann,

corpus contained a notice commemorating its consecration in 1147, making it the earliest preserved of the Spanish Christs. Given the difficulties of deciding what is archaic and what "modern" in the Spanish works, and therefore of setting a firm chronology for them, the evidence stylistic and historic--and simply the higher quality of the Courajod Christ-- would argue for its being the source of the Spanish inspiration.

In any case, it was clearly in Spain that the preference for this form took hold. Although only the Christ figure of the early Catalan-Pyrenean groups is preserved, a second group of five has emerged from Catalonia proper in the twelfth and thirteenth centuries, which include the two thieves as well as Joseph, Nicodemus, Mary and John; they are further distinguished by the fact that Joseph's left hand has been carved from the same block as the Christ. Of these Catalan groups--and perhaps the best known is the one from Eril-la-Vall (Fig. 16)--the latest is thought by Edelmann to be that from San Juan de las Abadesas, dated before 1251.[75] Their style is not without a rough charm, but at the same time it betrays the sense of a dwindling line.

The weak and derivative quality of these groups makes

unpublished "Notes," mentions the crucifix at S. M. de Salas de Bureba (Burgos) at San Salvador de Ona (Burgos) and one from the Cathedral of Roda de Isabena (Lerida).

[75]Following Edelmann, ibid., passim, they come from: San Juan de las Abadesas (Gerona), M.A.C., Barcelona; Church of Durro (Lerida), M.A.C.; Eril-la-Vall (Fig. 16) at M.A.C.

it doubtful that Spain is the source of the Italian groups;
conversely, their earlier chronology makes it equally hard
to argue an Italian source for the Spanish ones.[76] In fact,
in style and iconography they each take quite separate paths.
In none of the Italian examples are the thieves included.
Moreover, the Italian Christs consistently show both arms
detached from the cross and extended part-way down to the
side, while the Spanish groups always have the left arm
still nailed to the cross. Different, too, are the figures
of the angels, who often were part of the Italian groups
(Fig. 15). If an outside source is required, the derivation
of the Italian Madonna figures in wood from their slightly
smaller counterpart in the Auvergne would seem to add to the
possibility that the Depositions, too, are an adaptation of
an essentially French idea.[77]

and Vich; S. M. de Tahull, M.A.C., ex Plandiura Collection;
Mitg-Aran at Viella, Val d'Aran.

[76]The preference for Spain is assumed by A. K. Porter,
Spanish Romanesque Sculpture, II (New York, n.d.), pp. 8-19,
who knew only the Italian group from Volterra which is much
later than his early twelfth-century dating for most Spanish
examples, among which he would include the Lucca Volto Santo
and the Courajod Christ. Francovich, "A Romanesque School
of Wood Carvers," pp. 50-53, sees the Italian groups as the
source for the Spanish ones.

[77]Enzo Carli, La Scultura Lignea Italiana (Milan,
1960), pp. 10-14, on the other hand, cites the influence of
German metalwork on the earliest Italian wood crucifixes.
The theme of the Deposition was firmly rooted in Italian
sculpture of the twelfth century: along with Antelami's
Parma relief (Fig. 2), there is the architrave from Monopoli
(Porter, Pilgrimage Roads, III, Fig. 157) and the bronze
doors by Barisanus at Trani, ca. 1174, Ravello, 1179, and
Monreale, end twelfth century, cf. Boeckler, Die Bronzetüren,

Whatever their precise source, altogether about ten
wood Depositions have been discovered, or known by documents
to have existed, from the thirteenth century.[78] So far
these groups have stubbornly resisted efforts to sort them
out according to region and date because of their strict
conformity to a rather fixed composition through this hundred-
year period.[79] On the whole they remain consistently within
the Romanesque idiom, with the exception of the Tuscan ones
from Volterra and San Miniato al Tedesco (Figs. 139-40).[80]
The Volterra group, perhaps because it was the first to be
found, has been given more credit than it deserves in the

Figs. 131, 106, and 148. From the early thirteenth century,
when the wood groups began to be made; the portal at Monte
Sant-Angelo at Foggia (Porter, Pilgrimage Roads, III, Figs.
197-98) and the pulpit from the Church of San Pietro Scherag-
gio, now in San Leonardo in Arcetri, in Florence, cf. Crich-
ton, Romanesque Sculpture in Italy, Fig. 73b.

[78]The groups so far collected are: the Tivoli Depo-
sition (Fig. 15); the Virgin and John from the Cluny Museum
in Paris; the Christ in Perugia, from the Church of Santa
Maria di Roncione, near Deruta; Volterra; Church of San An-
tonio at Pesia; Vicopisano; Brimo de Laroussilhe Collection,
Paris; San Miniato al Tedesco; Bulzi (Sassani), Church of
San Pietro delle Imagine, Sardinia; Church at Roccatamburo
di Poggiodomo, now in curia of Bishop of Norcia. Professor
Florens Deuchler told me a new corpus has recently been
found in Lugano. See note 82, for a literary reference to
another group.

[79]The basic literature is found in Francovich, "A
Romanesque School of Wood Carvers," pp. 5-57; Carli, Scul-
tura Lignea Italiana, pp. 28-32; and Fernanda de' Maffei,
Mostra di sculture lignee medioevali, Museo Poldi Pezzoli,
Milan, 1957.

[80]Deposition from Volterra, Tuscan, 1260-80; Oratory
of the Arciconfraternita della Misericordia, San Miniato al
Tedesco, Florence, Deposition Christ with Virgin and John,
Tuscan, end thirteenth century.

evolution of these groups. The heightened explicitness in
the expression of Christ's suffering and in the more natural
poses of Joseph and Nicodemus are not so much a fresh inter-
pretation as a derivative of Nicola Pisano's tympanum at San
Martino, Lucca (Fig. 20), which itself is an outgrowth of
the more pictorial approach to the theme announced in the
Arcetri pulpit.[81] The relative stiffness of the Volterra
group--in terms of Gothic naturalism--when put next to Ni-
cola's tympanum betrays, as much as do the later groups from
Norcia and Pescia, the confining conventions of this form
that were to force its extinction by the end of the century.

The creative center which spawned this form of the
Deposition is Arezzo--the earliest of all the groups may
have been that, known only through Vasari's account, by Mar-
garitone d'Arezzo.[82] Of those preserved, the finest works--
the moving image of an Umbrian Christ in Perugia, from Santa
Maria di Roncione near Deruta, the group from the collection

[81]Francovich, "A Romanesque School of Wood Carvers," p.
17, saw the Volterra Deposition as the source of the tympanum
of Church of San Martino, Lucca, attributed to Nicola Pisano.
Crichton has argued for a date for the Lucca tympanum between
the Siena font and the Perugia fountain, 1260-77, rather than
at the beginning of Nicola's career, cf. Crichton, Nicola
Pisano, p. 112. For the Arcetri pulpit, see end note 77.

[82]Francovich, "A Romanesque School of Wood Carvers,"
p. 18, n. 21, quotes Vasari: "quattro figure de legno che
sono nella pieve in un Deposto di Cristo, ed alcune figure
poste nella capella di San Francesco sopra il battesimo,
elgi presse nondimeno miglior maniera poi che eboe in Firenze
veduto l'opere d'Arnolfo e degli altri allora piu famosi
scultori." Vasari attributes the group in the pieve to Mar-
garitone d'Arezzo.

of Brimo de Laroussilhe in Paris, and the one found locked
in the altar of the Cathedral of Tivoli outside Rome--all
fall stylistically within the Arezzo orbit (Figs. 141-42,
15).[83] The only one with any date at all is the Perugia
Christ; a later inscription saying it was made in 1236 is
considered fairly reliable.[84] The style is comparable to the
Tivoli Christ not only in the high refinement of the linear
delineation of the drapery and the subtle tension of the
modelling of the face and torso, but also in their mounting
on crosses on which a small cross has been similarly outlined
in faint relief. The Tivoli group is considered the earliest
of the known groups because of its similarity to two figures
of Mary and John in the Cluny Museum in Paris (Fig. 143).[85]
The Cluny figures draw the scattered Depositions back to
Arezzo because they are stylistically so close to the Madonna
and Child from Borgo San Sepolchro, signed by Presbyter

[83]Perugia, National Gallery; corpus from the Church
of Santa Maria di Roncione, near Deruta, an affiliate of the
Benedictine Abbey at Farfa, ca. 1236; Paris, Collection of
Brimo de Laroussilhe; Deposition group. It has been given a
later date, ca. 1260, due to the "more Gothic" bend of the
body of Christ, cf. ibid., p. 6, and Carli, Scultura Lignea,
p. 30, but this criterion is not valid; it is stylistically
related to the Perugia Christ and the Tivoli group. For the
Tivoli Deposition, see Chapter I, note 29.

[84]The Perugia Christ was repainted in 1492 by Niccolo
del Priore. An inscription from this time giving the date
as 1236 was found at the time of its restoration in 1784,
cf. Francovich, "A Romanesque School of Wood Carvers," p. 5.

[85]Paris, Cluny Museum; the Virgin and John, Arezzo,
ca. 1200, may belong to a Crucifixion, the original form of
the Italian wood groups, rather than a Deposition.

Martinus and dated 1199, that it is possible they are by the
same master (Fig. 144).[86] Francovich has compared the iden-
tical shape of the face and the features--the almond eyes,
the thin lips--and the hood-like arrangement over the head.
Similar, too, is the fall of the drapery in short ovals and
the gesture of the upturned hand and extended arm. The
Tivoli figures reflect these characteristics but in a manner
suggesting a date in the early thirteenth century, for they
show a style more fluid in pose at the same time that it is
tighter in drapery design.

The attribution of these works to Arezzo implies the
existence of an itinerant band of artists based there and
active throughout central Italy. Arezzo's location on the
main trade route north permitted the confluence of the native
tradition not only with the influence of Byzantine art, but
with that of Germany, whose importance for the evolution of
the wood crucifix was considerable.[87] To these older forces
must be added the fresh impact of the sculptor Antelami,
whose style was directly felt through his carvings of the
months on the Duomo facade. The Tivoli Joseph and Nicodemus
seem particularly close to such sturdy but energetic figures

[86]Berlin, Kaiser Friedrich Museum; Madonna and Child
by Presbyter Martinus, Arezzo, dated 1199. It has the fol-
lowing inscription: Factum est autem hoc opus mirabile
Domini petri abatis tempore Presbiteri Martini labore Devoto
ministrato amore, cf. Carli, Scultura Lignea, p. 22.

[87]Giannina Franciosi, Arezzo (Bergamo, 1909), passim.
See also note 77.

as the November (Fig. 145).[88] Antelami's, too, are the neatly falling parallel folds in the Tivoli drapery, something of the serenity of expression, and the same low-browed, smoothly modelled features. The head of Luna from the Parma Deposition is the favored comparison (Fig. 146).[89]

Antelami's Descent from the Cross at Parma

Francovich stops short of a firm attribution of the Tivoli group to Antelami, but his compelling comparison with the masterful style of the great marble relief from Parma permits us finally to arrive at this high point of Romanesque sculpture, a work whose iconography subtly recapitulates all the meanings implicit in the Deposition theme (Fig. 2). Such an assessment of Antelami's relief is by no means universal. Scholars have been hampered in their appraisal of it by unresolved questions as to its original location and the meaning of various elements within the composition which seem extraneous to a "normal" Descent from the Cross. Thus, Porter could brand it "crowded and confused," and Jullian misread the restraint of its emotional expression as evidence of psychological weakness.[90]

[88]Francovich, "A Romanesque School of Wood Carvers," p. 22. A comparison to November by Antelami on the facade of the Duomo, Arezzo, end twelfth century, is stronger than to his October.

[89]Ibid., p. 37.

[90]A. K. Porter, Lombard Architecture, III (New Haven, 1917), p. 161; René Jullian, "Les fragments de l'ambon de Benedetto Antelami à Parme," Mélanges d'archéologie et d'histoire: École française de Rome, XLVI (1929), 209-12.

Antelami's Deposition is now lodged in the wall of
the south transept of the cathedral church of Santa Maria
Assunta in Parma. In his monograph on this artist, Franco-
vich has forcefully argued for the idea, originally Venturi's,
that it belonged to a roodscreen or pontile which had spanned
the nave of the cathedral at the entrance to the choir.[91]
This view is now commonly preferred over earlier proposals
that it had been a pulpit decoration or an altar frontal.[92]
The thesis rests on evidence pieced together from documentary
sources which are fragmentary and mainly rather late. Out-
side of the knowledge that the cathedral was finished in
1046, restored following an earthquake in 1117, and that the
date of 1178 is inscribed on the Deposition relief, our in-
formation comes only from somewhat conflicting accounts from
the sixteenth century.

According to the chronicler Angelo Maria di Edoari Da
Erbe, there were three large reliefs of white Carrara marble
by Antelami which decorated a teatro resting on four columns:[93]

Benedetto degli Antelami . . . quale . . . di bassorilievi

[91]Francovich, Antelami, p. 118.

[92]Porter, Lombard Architecture, I, p. 295, says the
Deposition formed part of an altar to Nicodemus, whose rel-
ics belonged to the Parma Cathedral; Armando O. Quintavalle,
Antelami Sculptor (Milan, 1947), p. 31, n. 2, calls it a
pulpit or ambo outside the choir to the left of the princi-
pal nave. For the ambo idea, see also Jullian, "Les frag-
ments," passim.

[93]Francovich, Antelami, p. 114, cf. Parma, Palatina
MS 922, f. 231, a sixteenth-century copy of the original
manuscript, dated 1572.

a minutissimo taglio in tre tavole di marmo bianco di
Carrara, scolpì tutti li Misteri della Passione di Nos-
tro Signore, e l'eresse in forma di Teatro sopra quattro
colonne dove dal clero si leggono al popolo i giorni
festivi nella chiesa cattedrale gli evangeli.

Cristoforo dalla Torre, less specific about the decoration
of what he calls an evangelistario, does supply more details
as to its use which suggest the two men are both talking
about the same thing:[94]

Diaconi ac subdiaconi praebendarii Epistolam et Evangel-
ium solemniter decantant, Evangeliumque iis diebus, ad
Populi intelligentiam, extra Chorum in Evangelistario,
ad hunc finem ornatissime fabbricato, cui praesunt ad
hominis formam quatuor aenei Evangelistae excellenti
manu sculpti, per praebendarium Diaconum cantatur, nisi
forte missam cantaret Episcopus, quoniam tunc Evangelium
in Choro decantur.

A note in the margin reports that the evangelistario and its
stairs were destroyed in 1566, in order to open up the choir
area.[95] The four bronze Evangelist statues he mentions were
made for the structure by the Gonzate brothers in 1508.[96]
Other entries in church records report that these were in-
stalled on a top-piece or cornisonium resting on three marble
columns made at the same time.[97] The provision for such a
large superstructure as well as the ample space implied by
the performance of an Annunciation play documented in a

[94]Ibid., p. 114, cf. A Schiavi, La Diocesi di Parma,
II (Parma, 1940), pp. 115-16.

[95]Ibid., p. 114: "Anno 1566, quando Chorus apertus
fuit et scalae ad magnitudinem totius ecclesiae ampliatae
fuerunt, Evangelistae fuerunt amoti et Evangelistarium de-
structum fuit."

[96]Ibid., p. 116.

[97]Ibid., pp. 114-15, records the pertinent entries.

fifteenth-century text--hence the teatro label--lead Franco-
vich to conclude that the structure was more extensive than
a simple pulpit, or ambo, as it is called in another docu-
ment.[98] He sees it as having been a roodscreen with a
staircase at either end leading from the nave to the choir.

Even if one might question individual aspects of Fran-
covich's reconstruction, it seems clear that his thesis is
essentially sound.[99] In fact, an examination of the sculp-
tural fragments traditionally associated with this structure
can be seen to confirm his findings, which now rest largely
on technical evidence alone. Not only the size of the exist-
ing pieces would seem to permit them to belong to such a
structure; their subject also conforms to the iconography
appropriate to a roodscreen and further expounded on proces-
sional crosses and reliquaries associated with the Easter

[98]Ibid., p. 116, cf. L. Barbieri, Ordinarium Ecclesiae
Parmensis e Vetustioribus excerptum reformatum, a. MCCCCXVII
(Parma, 1866), pp. 121-22, and L. Testi, La Cattedrale di
Parma (Bergamo, 1934), pp. 70-72. See Young, Drama, II, pp.
479-80, for text. Francovich, Antelami, p. 114, n. 7, is
incorrect in his challenge of the view of both Barbieri and
Testi that "in quo fit reverenter et decenter rapraesentatio
Virginis Mariae" referred to a carved image. Many such
carved figures of the Virgin and Gabriel survive which were
used in these performances, cf. Carli, Scultura Lignea, pas-
sim.

[99]It is possible that the lateral staircases could
have led to the upper story of the structure and have been
destroyed when it was. A third staircase, which Francovich
thinks is a mistaken reference on the part of Dalla Torre,
may have gone from the choir to the crypt, along whose upper
western border the roodscreen rested, cf. Francovich, Ante-
lami, p. 118, who quotes Dalla Torre, cf. Schiavi, La Dio-
cesi di Parma, p. 104: "olim trium scalarum auxilio ascende-
batur, sed nunc in una redacta est."

rites.

There are, first of all, the four lions in the Parma Cathedral (Fig. 147).[100] Their size and strong profiling have argued for their having supported a structure larger than a pulpit; for this reason, they have been identified as the base supports for the columns mentioned by Da Erbe. This assumption is borne out iconographically: as Resurrection symbols, more often in the abbreviated form of the feet alone, lions have frequently been seen to form the base of a reliquary or cross foot. Also preserved in the Parma Museum are three of a presumed series of four capitals which may have topped these column bases (Figs. 148-59).[101] Two carry scenes from the story of Adam and Eve. The four sides òf the first capital show: God leading Adam and Eve to Eden, the Temptation of Eve, the Original Sin, and Adam and Eve in their shame (Figs. 148-51).[102] The second shows the Expulsion of Adam and Eve from Eden, Adam tilling as Eve spins,

[100]Parma, Cathedral; Lion column bases by Antelami, ca. 1178.

[101]The capitals, now in the Parma Museum, were found in the collection of Domenico Bosi in 1880, and a fourth, now lost, was exhibited in the same year, cf. ibid., pp. 151-52. Porter, Lombard Architecture, III, p. 163, thinks that the capitals belonged to this structure, which he called a pulpit; he discounts their belonging to the Deposition on the basis of the reddish color of the marble, even though it is possible that all of the sculpture was originally polychromed.

[102]Francovich, Antelami, p. 152, challenges Porter, Lombard Architecture, III, p. 163, for the interpretation of the first side of this capital showing God reproving Adam and Eve.

and the additional representations of the Sacrifices of Cain
and Abel, and the Murder of Abel, as prefigurations of the
Sacrifice of Christ and its nullification of Adam's sin (Figs.
152-55).[103] While the variety of scenes depicted on these
capitals goes beyond the single indication of the first
couple's redemption through Christ's sacrifice usually ap-
pearing on crosses and their feet, it remains consistent with
roodscreen symbolism which connects the site of the cross to
Adam and Golgotha and to the place of the Last Judgment.[104]

The confirmation that these capitals belonged to the
same program as the Deposition has been seen in the altar
frontal from the Church at Bardone (Fig. 160).[105] Although

[103]Francovich, Antelami, p. 152. For Abel's sacri-
fice of the lamb as a prefiguration of Christ's sacrifice,
ca. also Philip, The Ghent Altarpiece, p. 102. Cain's sac-
rifice, here, and perhaps, too, on the cross from Sankt
Maria Lyskirchen (see Fig. 131 and p. 165 of this chapter) is
more usually associated with the iconography of the Last
Judgment according to which it is countered by Abel's offer-
ing, cf. Deshman, "Anglo-Saxon Art after Alfred," p. 181.

[104]For the importance of the theme of Judgment to
roodscreen iconography, see Philip, The Ghent Altarpiece,
pp. 102-04. The comparison for the capitals within the
wider context of the other sculptures of the Parma rood-
screen that immediately comes to mind is the program of the
Hildesheim doors, where scenes from the story of Adam and
Eve are placed in conjunction with those from the life of
Christ. For the roodscreen's having absorbed the earlier
iconography of the west work, including the concept of a
threshold or portal to the Heavenly Jerusalem, see Chapter
III, pp. 135-36.

[105]Porter, Lombard Architecture, I, p. 295, and Fran-
covich, Antelami, p. 260, both cite the influence of Ante-
lami's Parma relief on the Deposition from the Church at
Bardone, early thirteenth century. However, they reach op-
posite conclusions: the former to disprove and the latter
to prove the connection of the capitals to the Parma Deposi-
tion.

the style is rather provincial, the program is a subtle dis-
tillation of its model; there can be no question that the
Parma Deposition is the prime source for the main figures of
the composition, nor that Adam and Eve pushed away by the
angel, who replace the entire group of figures on the right
at Parma, were drawn from the program of the capitals which
were to be seen in conjunction with Antelami's relief.

It is thought that the fourth capital, like the third,
held a number of Old Testament scenes which were also to be
read as prefigurations of Christ's sacrifice and final Judg-
ment. The subjects of the third capital are not altogether
clear. One unmistakably shows the Judgment of Solomon and a
second depicts David told of the death of Absalom (Figs. 156-
57).[106] The others with less assurance have been identified
by Francovich as Solomon and Sheba and Sheba and Absalom
(Figs. 158-59).[107] The appearance of Old Testament refer-
ences on the Gunhild and the Bury St. Edmunds crosses makes
their inclusion here by no means inconsistent with the pro-
grams of either the processional crosses or the roodscreen.[108]

[106]Ibid., p. 152. Unlike the lions, the capitals are
not generally thought to be by Antelami himself, cf. Jullian,
"Les Fragments," p. 192.

[107]Francovich, Antelami, p. 152. See Porter, Lombard
Architecture, III, pp. 163-64, for his interpretation of the
subjects. The Judgment of Solomon is the only one about
which they agree. Jullian, "Les Fragments," p. 192, identi-
fied the scene of David told of the death of Absalom and
called it an image of the rebellion of the soul against God
purified by the blood shed by Christ.

[108]Here the iconography carries a double reference:

A companion altar frontal from the same church at Bardone showing Christ in Majesty in a mandorla surrounded by angels and Evangelist symbols has been educed to confirm the legitimate association of a second relief with the Antelami Deposition (Figs. 162, 2).[109] The badly damaged condition of the second Parma relief precludes any assessment of its style; one can only see that it, too, shows Christ in Majesty in an eight-shaped mandorla in the center, with the four Evangelist symbols, two on either side, and the four doctors of the church below--Jerome and Gregory to the left, and Ambrose and Augustine (now missing) on the right--thus elevated to the status of the Evangelists. At the extreme ends, two huge archangels each fill the entire height of the panel surface. Like the Deposition relief, this one is replete with labels that identify the figures and carries a long, only partially legible inscription across the top.[110] It, too, has a border of niello scrollwork which further couples the two reliefs, even though it is slightly larger

to the Judgment theme of the Gunhild Cross and to the eucharistic symbolism of the Bury Cross.

[109]Bardone, Church; Christ in Majesty, altar frontal, ca. 1200, cf. ibid., II, pp. 92-94. Parma, Cathedral; Christ in Majesty with Evangelist symbols and four doctors of the church, ca. 1178, cf. Francovich, Antelami, pp. 148-50. The relief was used as a sepulchral stone for Giambattista Cicognara, a general from Parma, who lived in the eighteenth century.

[110]Ibid., p. 149. The inscription on the Majesty relief: Rebus in actoris hii quatuor unius horis et ex specie factis ut corpora mistica nacti et non sine re certe pennis oculis q/ referta et I. . . .

in width than its more famous counterpart.[111]

Da Erbe had said there were three marble reliefs, and Francovich suggests that the third, now lost, was a Last Supper.[112] True or not, it is interesting that the two selected by the Bardone artist are the ones whose iconography coincides with the two sides of a processional cross, thus summing up the specific message of the Easter rites.[113] While the two reliefs, and possibly a third, can be seen simply as devotional images to illuminate the meaning of the Mass as it was regularly performed at the Cross Altar before the roodscreen, there are indications that it was more specifically for the Easter rites that these works were designed. So far, the only confirmation of the actual performance of a Good Friday ritual at Parma is a Depositio Hostiae text from the fifteenth century.[114] In this text, the sepulchre is

[111]The width of the Majesty relief is 3 meters; the Deposition, 2.30 meters.

[112]Ibid., p. 151.

[113]Other aspects of these reliefs are similar to metalwork. The scroll motif and the detailed inscriptions are common to processional crosses. In addition, Francovich, ibid., p. 150, says the appearance of Ecclesia and Synagoga and the application of stars to the base of the mandorla are derived from the iconography of ivories. He cites Goldschmidt, Die Elfenbeinskulpturen, II, no. 50.

[114]Young, Drama, I, p. 125, cf. Barbieri, Ordinarium, dated 1417:

Finita dicta Missa, descendant Dominus Episcopus cum canonicis et toto clero ad cappellam Sanctae Agathae, et Corpus Christi quod est ibi reconditum cum ea processione modo et forma et solemnitate quibus portatum fuit, inde devote accipiatur, et reporetur, et in Paradiso post

located inside the roodscreen, here called the paradisus,
evidently a small, doored chamber directly behind the main
altar--the Altar of the Cross.[115] Another text of the same
period indicates this area also to be the setting of a Visi-
tatio Sepulchri performed on Easter.[116]

But even without any earlier texts, it is clear in
the Deposition relief that the depiction of Christ's passion
and Resurrection as it was set forth in the Easter liturgy
has been interwoven with its sacramental meaning. The focus
of the relief is, of course, the figure of the Dead Christ
supported by Joseph of Arimathea as he is unnailed by Nico-
demus--his pliers now missing--from the cross, as Mary and
John look on. To this central core of participants in a
traditional Descent from the Cross, a number of other figures

altare maius reverenter recondatur, ut in Sepulcro, ibi
dimisso lumine copioso per totam noctem duraturo, cleri-
cis cantantibus responsorium Sepulto Domino, et cetera.
Quo finito, dicuntur Vesperae ante ostium Paradisi a
Domino Episcopo et clericis suis genuflexis, submissis
vocibus; et ipsis finitis, denudatur altare.

[115]The term paradisus, earlier applied to the atrium
in front of the western church of St. Sauveur at Centula,
retains the same meaning at the roodscreen by a process out-
lined in the previous chapter, see Chapter III, p. 114 and pp.
135ff.; see also note 104 of this chapter. This text, not
adduced by Francovich, also supplies additional clues as to
the enclosed character of the lower columned section of the
roodscreen, against which the main altar was set.

[116]For the Visitatio Sepulchri text, see Young, Drama,
I, p. 300, cf. Barbieri, Ordinarium, pp. 147-49. Young,
Drama, I, p. 125, n. 2, incorrectly refers to it as an Ele-
vatio. Apparently the Host was treated like a cross or cor-
pus and wrapped in a sindon, if we assume, as Young and most
other scholars do, that the term corpore Christi refers here
and elsewhere specifically to the host.

have been drawn into the image from a Crucifixion representa-
tion. Sol and Luna, who give the scene a cosmic reference,
are familiar transpositions to a Deposition, as are the an-
gels floating above the cross. Not so expected, however, is
the inclusion of a second representation of the Virgin in the
form of Ecclesia, the personification of the Church, holding
up the chalice, and Longinus the Centurion. Their presence
serves to stress the sacramental character of Antelami's
image: the wound made by the spear of the Centurion is the
mysterious source of the wine of communion which flowed into
the chalice. The prime importance of the wound in this image
is most subtly revealed through the gesture of Joseph of
Arimathea's embrace of Christ. With unsurpassed tenderness
he places his lips directly on it as he receives Christ's
body from the cross.[117]

Although the timeless sacramental theme is important
to this work, its primary aspect is the immediacy of the his-
torical moment of the Descent from the Cross. The viewer's
sense of being present at this moment is mainly effected by
the three Maries and John to the left and the five figures
to the right of the central group. The reverence and com-
passion of the historical witnesses is modestly echoed by
the other five, only loosely to be identified as members of

[117]Sarel Eimerl, The World of Giotto c. 1267-1337
(New York: Time-Life Library of Art, 1967), p. 42, is the
first to call attention to the fact that Joseph is kissing
Christ's wound. See Chapter II, pp. 66-67, notes 72-73, for
Amalarius' interpretation of the Mass.

the Hebrew population.[118] Their humble anonymity permits
the viewer to venture to identify himself with them and thus
to be drawn into the emotional center of the image.[119] The
oft-noted character of a ceremonial which dominates this work
is due to its being a visual statement of the Depositio
drama reenacted at this very spot on Good Friday.

A most arresting--and puzzling--feature of this com-
position are the four figures to the right, who, seemingly
indifferent to the central action, are absorbed by the pros-
pect of dividing Christ's mantle. The appearance of soldiers
gambling for Christ's cloak is not an unknown element in
Crucifixion images; it occurs in Byzantine marginal psalters
and is also found in Ottonian art.[120] In these instances,
the scene refers to the fulfillment of the Old Testament
prophecy recalled in John concerning the casting of lots for
Christ's mantle, because it was seamless and therefore not
easily divided.[121] But the scene depicted here is something
other than the traditional one. The action portrayed is not
the gambling for the mantle, but its imminent division with

[118]Francovich, Antelami, p. 130.

[119]Crichton, Romanesque Sculpture, p. 86, notes that
the figures "stand out for the most part at an equal distance
from the background and at an equal distance from the ob-
server," a quality which also tends to pull the viewer into
the composition.

[120]Egbert Codex in the Trier State Library, cf.
Schnitzler, Rheinische Schatzkammer, p. VI; Codex Aureus of
Echternach, cf. ibid., Fig. 37; Otto Gospels, ibid., Fig. 106.

[121]See Chapter II, p. 78, and note 93.

the aid of a mean-looking knife. It would appear that the
clue to the correct interpretation here comes not from the
Gospels but from the liturgy, in this case that prescribed
for Good Friday. Since the ninth century, in the Roman <u>Ordo</u>
for that day, the service begins in a darkened church, the
altar stripped bare, with Bible readings ending with the
Passion according to John.[122] Then follows a rather curious
episode: two deacons were to remove from the altar "in a
furtive manner" the cloth (sindon) on which the Gospel book
had been placed. This action was interpreted by Amalarius
as a commemoration of the flight of the apostles.[123] Hardi-
son, in describing this procedure, gives a second contempo-
rary version of the ceremony which has a more direct bearing
on Antelami's image:[124]

> In this ceremony two additional deacons hold sindons be-
> fore the altar until the words <u>partiti sunt vestimenta</u>
> <u>mea</u> (John 19:24). They then divide them and carry them
> furtively away in a pantomime of the soldiers who cruci-
> fied Christ.

That this part of the ritual takes place before the <u>Adoratio</u>

[122]Hardison, <u>Christian Rite and Christian Drama</u>, p. 129.

[123]<u>Ibid.</u>, p. 123. According to Amalarius, <u>Liber Offi-
cialis</u>, cf. Migne, <u>P.L.</u>, CV, col. 1026^c: "When the Gospel
is removed, that which is under it is snatched away, because
when our Lord was given over into the hands of evil men, the
apostles fled and hid like thieves." The Gospel book in
this ninth-century period was the chief symbol of Christ,
other than the altar itself.

[124]Hardison, <u>Christian Rite and Christian Drama</u>, p. 130.
This version is found in the <u>De divinis officiis</u>, falsely at-
tributed to Alcuin, cf. Migne, <u>P.L.</u>, CI, col. 1208^{c-d}. Hardi-
son notes, <u>ibid.</u>, p. 130, n. 117, that "the two actions in-
volving the sindon appear conflated in the <u>Regularis Concor-
dia</u>."

Crucis--and the Depositio--may help to explain the psycho-
logical separation of Antelami's group from the main focus
of the relief.

Along with the liturgical prelude to the actual moment
of the Depositio, Antelami's relief is further enriched by
the promise of Christ's Resurrection as a consequence of his
sacrifice. This aspect of its meaning is conveyed primarily
through the depiction of the cross as the lignum vitae. It
is also expressed through the presence of the Three Maries.
Although one or all of these figures are common to a Cruci-
fixion representation, they are rare, even if perfectly
appropriate, in a Deposition. Their appearance here must
carry, as it does at Aquileia (Fig. 94),[125] the additional
connotation of their part in the Visitatio Sepulchri drama.
The two upturned hands seem to allude to the Maries' sur-
prise at their discovery of the empty tomb on Easter morning.

Evidence of the Resurrection leads to the final theme--
the assurance of redemption to the faithful in the Last Judg-
ment--which is the lasting message of the relief. The idea
of Judgment is conveyed first of all through the triumph of
the Church, spelled out in the inscription ecclesia exaltatur,
in contrast to Synagoga's defeat and the accompanying words
sinagoga deponitur. The harsh rejection Synagoga receives
at the hand of the angel Raphael, however, is at the same
time contrasted with the blessing gesture of Christ, whose

[125]See Chapter III, pp. 129ff.

hand, assisted by the angel Gabriel, gently rests on Mary's head. The sense that all the faithful witnesses share in this blessing is subtly suggested by their deliberate reiteration of Mary's pose and mood. It is the blessing, in fact, which is the essence of the captured moment that we see.

The idea that all believers--the catechumens awaiting their Baptism and the faithful communicants, along with the dead, behind whose altar the relief was set and where the triumphant Easter mass was celebrated--were redeemed by Christ's sacrifice is here further marked by Antelami in an intensely personal way. It has to do with the inscription running across the top of the relief, long the subject of considerable controversy as to its interpretation. To the left, in letters that tend to be crowded and abbreviated near the cross, the inscription says: Anno mileno centeno septuageno octavo sculptor patvit mense secundo. The word patvit or patuit--reveals himself--has more sensibly been read as a shortened form of patravit--to bring to an end-- so that this section is now generally agreed to read: "In the year one thousand one hundred seventh-eight the sculptor completed [the work] in the second month [February]."[126]

A proper reading of the continuation of the inscription to the right of the cross--Antelami dictus sculptor

[126]Lara Vinca Masini, L'Antelami a Parma: Forma e Colore, 43 (Milan, 1965), p. 2.

fuit hic benedictus--has proved more elusive. The favored
translations are: "This sculptor was Benedetto called Ante-
lami" or "This sculptor was called Benedetto of Antelamo."[127]
The alternative is based on the observation that Antelami is
the genitive case and refers to a Lombard valley mainly known
for its architects and builders.[128] The logic runs that
Antelami, basically a builder, sought to emphasize his spe-
cial skill as a sculptor by repeating the word which already
appears in the first part of the inscription. As Mâle had
said of Millet, the reasoning is "ingenious but complicated":
it was not uncommon for a medieval artist to have multiple
talents.[129] If one simply returns to the text with an eye
to the reading which is grammatically most correct--hic is
used as an adverb and does not modify sculptor--the follow-
ing possibility emerges: "Said sculptor of [from] Antelamo
was here blessed." Considering the implicit meaning of all

[127]Porter, Lombard Architecture, III, p. 161, and
Francovich, Antelami, p. 125.

[128]Ibid., pp. 129-30, and Porter, Lombard Architec-
ture, III, p. 161; Porter also suggests that Antelami is
derived from antelam', a local Latin word for builder, so
that a third possible translation would be: "In February,
1178, the builder revealed his art as a sculptor; this
sculptor was called Benedetto." The tradition that the
sculptor's first name was Benedetto is derived from this
inscription together with the repetition of Benedictus on
the Parma Baptistery of 1196: Bis Binis Demptis Annis de
Mille Ducentis. In(c)epit dictus opus hoc sculptor Benedic-
tus. Usual translation: "In 1196 a sculptor named Bene-
detto began this work," cf. ibid., p. 134.

[129]See Chapter II, p. 54.

inscriptions on devotional images[130] and the specific mean-

ing of this particular work, it becomes most likely that it

was the artist's intention that he, too, be joined with the

company of the blessed.

[130]See, for example, notes 12, 26, 32, 27, 86. Among
the most compelling demonstrations of the meaning to the art-
ist of his creation concerns the head of a wood Christ carved
by Lando Pieri da Siena, also a goldsmith and the architect
of the "new Cathedral" of Siena begun in 1339. A World War
II bomb split open the head and revealed the long private
prayer of the artist to the True Cross, the Virgin, various
saints, and finally to Christ, adding the final admonition:
lui dovemo adorare e non questo legno, cf. Carli, Scultura
Lignea, p. 49.

CHAPTER V

CONCLUSION

A fresh look at the theme of the Descent from the
Cross, focusing on works of the twelfth and thirteenth cen-
turies, has sought to establish the relationship to the
extra-liturgical Depositio Crucis performance through their
common source in the Mass liturgy. While this insight was
Emile Mâle's point of departure, he did not apply it to this
particular theme. Moreover, he tended to see the manifesta-
tion of the influence of the drama on art only in terms of
the coincidence of pose and gesture that the artist seemed
to have drawn from the drama's performance. For the theme
of the Descent from the Cross and the Depositio, however,
the connections are not a matter of the influence of the
elements of composition of one on the other but lie instead
on a more profound level of interlinking meaning.

The depth of these connections is due in part to the
fact that the Depositio drama stays within the confines of
the Good Friday liturgy, never achieving the status of an
independent dramatic form. More important, however, is the
fact that this particular theme, in art as in the drama, is
rooted in the liturgy of the Mass as an illumination of that
portion of the Consecration that symbolizes the moment of

the Descent from the Cross. This interpretation runs counter to the traditional assumption of the strictly narrative origin of this theme--an assumption which is already challenged by the non-narrative elements in the works themselves, our earliest known examples both East and West to be dated in the ninth century. The relative rarity of the subject before the fourteenth century tends to belie its importance. While not obligatory in either narrative or iconic cycles of the earlier period, the Descent from the Cross, when it does occur--alone or in a cycle--often serves as a substitute for the Crucifixion. The appearance of the scene closely depends on the image of the dead Christ and regionally follows the course of the theological evolution of the Mass which finally led to the acceptance in the twelfth century of this image as the chief eucharistic symbol.

A firm rooting in the Mass can be established for the Depositio drama as well. The tendency to conflate the Depositio Hostiae with the Depositio Crucis has led to a clouding of what each ceremony represents and of their separate origins. My main concern has been with the Depositio Crucis and not the Depositio Hostiae, which started as a provision for the Reservation of the Host to be used for the Mass of the Presanctified on Good Friday and was later absorbed into the Depositio Crucis performance. The Depositio Crucis was added--in the tenth century so far as we know--to the Good

Friday liturgy immediately following the venerable ceremony of the Adoratio Crucis, which had originated at the Holy Sepulchre in Jerusalem. The Depositio Crucis based its form largely on the reenactment in the western Mass of the Descent from the Cross and the Entombment, according to the ninth-century interpretation of Amalarius of Metz.

Much of the richness of meaning that accrues to the representations of the Descent from the Cross in art is derived from the place of the Depositio Crucis within the Easter liturgy as a whole. The Easter ceremonies were designed to dramatize for the neophyte the full meaning of his death and rebirth through the sacrament of Baptism he received on Easter Saturday Eve. They were geared as well to a renewal of faith for each of the communicants through their identification with Christ's Crucifixion and Resurrection in the course of these three days. These rites were also meant to assure the faithful of their ultimate redemption at the Last Judgment.

The further connotations of rebirth, Resurrection and Judgment that have been grafted onto the sacramental meaning of images of the Descent from the Cross can best be understood in their original context: in a manuscript, as an illumination, for example, of the Good Friday liturgy or of the Office of Baptism (Figs. 11 and 75); in sculpture, as part of a reliquary used in the Depositio (Figs. 5, 22, and 32), or as an altar fixture or tympanum (Figs. 2, 15, 139-42,

18, 20, 21, and 83); in fresco, as an apse, crypt or west
gallery decoration (Figs. 23, 94, and 97). When the work
belongs to a church, the meaning of the image is vastly en-
riched by an appreciation of the architectural symbolism
which evolved in medieval churches in the course of the
ninth to the twelfth century. As the setting for the Easter
liturgy, various parts of the church have a specific sym-
bolic value that enhanced the art placed there just as it
did the drama's performance. Of particular significance to
the Depositio are the interlinking meanings of the Earthly
and Heavenly Jerusalem at the Altar of the Cross and the
westwork where the sepulchre was most apt to be located.
The embodiment in the rite of the themes of Resurrection and
Judgment was further reenforced by processional stations at
the crypt and the cloister.

The symbolism of the Depositio is more explicitly re-
flected in the iconography of processional crosses and reli-
quaries associated with the Easter rites. The theme of per-
sonal redemption through Christ's sacrifice expressed on
these crosses is often the stated prayer of the donor or
artist of a particular one. The greater emphasis on a eu-
charistic iconography to be found in some twelfth-century
crosses reflects the reversal of the original dependence of
the Depositio on the Mass at this time, when the crucifix
was increasingly accepted as the central symbol of Christ in
the Mass. In this same period, the two-sided processional

cross--with the crucified Christ on the recto and the Majesty and Evangelist symbols on the verso--of the early *Depositio* performance begins to be replaced by actual Descents from the Cross.

Examples discussed in the course of this study tend to single out one or another of the themes implicit in the image of the Descent from the Cross. Antelami's marble relief of 1178 designed for the roodscreen at Parma represents a kind of *summa* of the sacramental meanings combined with those derived from the Easter liturgy in a form intensely personal to both the artist and the viewer. Antelami's work, which must be seen together with its accompanying capitals and the Majesty relief, simultaneously demands the fullest understanding of the symbolism of the Mass, of church architecture as translated in the roodscreen, and of the Good Friday *Depositio* drama.

This study is a preliminary one in many respects. A number of questions--among them the precise origins of the *Depositio Crucis*, the relation of *Depositio* texts to one another, to particular monuments and churches--need to be explored in greater detail. Further works not included in this discussion remain to be tested against this thesis to show the extent to which it applies and to point out exceptions where it does not. Subsequent findings may well modify some of the conclusions that have been offered here. Nonetheless, it is hoped that a fruitful approach has been

opened up which might even be extended to themes other than the Descent from the Cross.

APPENDIX I

THE DEPOSITIO TEXTS: A SUMMARY

Major Depositio Texts

Rather than a comprehensive textual study, I should simply like to point out those texts which in the course of my research on the Depositio drama I have found to be the most useful.

1. London, British Museum, Cotton Tiberius MS. A. III. Regularis Concordia saec. xi, f. 19v-20r, which dates back to the time of Aethelwold, 965-75, and is our earliest known text.[1]

2. Liber de Officiis Ecclesiasticus of Jean d'Avranches, Bishop of Rouen, eleventh century,[2] and a related thirteenth-century text from Rouen, Paris, Bibl. Nat., MS lat. 904, Grad. Rothomagense saec. xiii, f. 92v-93r,[3] are suggestive of the early use of a corpus detached from the cross.

3. Two twelfth-century texts from Rheinau and Salzburg supply clues to early South German usage.[4]

[1]Young, Drama, I, pp. 133 and 582-83.

[2]Ibid., p. 555, cf. Migne, P.L., cxlvii, col. 53.

[3]Young, Drama, I, p. 135.

[4]Tauberts, "Mittelalterliche Kruzifixe": Rheinau (1114-1123), pp. 94-95.

4. Essen, Münster archiv. MS <u>sine sig.</u>, <u>Ordin. Assi-</u>
<u>dense saec.</u> xiv.[5] One of the fullest in describing not only
what was used in the rite but where in the church it was
performed.

5. Oxford, University College, MS 169, <u>Ordin. Berkin-</u>
<u>gense saec.</u> xv, pp. 108-09, 119-21.[6] This text from Barking,
near London, signals the English predilection for the vivid
in the <u>Depositio</u> performance.

6. Munich, Staatsbibl. MS lat 12018 <u>Ordin. Pruvenin-</u>
<u>gense saec.</u> xv-xvi (1489), f. 64v, 66v-67v, 73v-74v,[7] de-
scribes the more elaborate German rites, as does a 1517 text
from Wittenberg,[8] which is particularly interesting for its
incorporation of contemporary funeral rites.

7. London, British Museum, MS Harley 5289, <u>Miss.</u>
<u>Dunelmense saec.</u> xiv, f. 177r-177v from Durham,[9] and a six-
teenth-century record, also from Durham,[10] give a much
fuller description of the later English rites. To this text
of 1593 should be added <u>The Popish Kingdom</u> by Barnaby Googe,
a translation made in 1570 of Thomas Kirchmayer's <u>Regnum</u>
<u>Papisticum</u> written in 1553, which ridicules the rite and

[5]Brooks, "Sepulchre of Christ," pp. 97-98, and Young,
<u>Drama</u>, I, p. 562.

[6]<u>Ibid.</u>, I, p. 164.

[7]<u>Ibid.</u>, I, pp. 157-58, and Tauberts, "Mittelalter-
liche Kruzifixe," pp. 92-94.

[8]<u>Ibid.</u>, pp. 98-101. [9]Young, <u>Drama</u>, I, p. 136.

[10]<u>Ibid.</u>, I, p. 137.

indicates a degree of the scorn that eventually led to its suppression.

Other Texts

Young supplies references to all the _Depositio_ texts known to him in the index at the end of Volume II of _The Drama of the Medieval Church_.[12] He includes texts printed in Volume I and references to further examples previously published in earlier works by him and by other scholars. As a group, they largely data from the fifteenth and sixteenth centuries.[13] Of the earlier texts, eight are from the four-teenth century,[14] ten from the thirteenth century,[15] two

[11]_Ibid._, I, pp. 139-40. [12]_Ibid._, II, p. 571.

[13]The following references are from _ibid._, I. Six-teenth Century: Aquileia (pp. 143-44); Bamberg (pp. 172-73, 175-76, 562); Augsburg (p. 172); Berlin (pp. 164-65); Castel-lani, _Liber Sacerdotalis_ (pp. 125-30, 557); Cheimsee (p. 558); Constance (p. 123); Durham (pp. 137-39); Eichstatt (pp. 155-56); Gran (pp. 123-24); Halle (p. 562); Hereford (p. 563); Kirchmayer's _Regnum Papisticum_ (pp. 139-40); Meissen (p. 562); Rome (p. 562); Salzburg (p. 553); York (p. 561). Fif-teenth Century: Andechs (p. 556); Barking (pp. 164-65); Diessen (p. 558); Fritzlar (p. 561); Havelberg (p. 562); Hungary (pp. 147-48); Indersdorf (p. 550); Magdeburg (pp. 152-53); Mainz (p. 162); Moosburg (pp. 140-42); Parma (p. 125); Passau (p. 559); Prufening (p. 157); Raitenbuch (p. 556); Regensburg (pp. 558, 562-64); Treves (pp. 142-43, 562).

[14]_Ibid._, I, Fourteenth Century: Clermont-Ferrand (p. 558); Dublin (p. 168); Durham (pp. 136-38); Essen (p. 562); Exeter (p. 561); Fecamp (p. 555); Klosterneuberg (p. 558); Prague (p. 556); Salisburg (pp. 145-46).

[15]_Ibid._, I, Thirteenth Century: Benedictine-German (p. 556); Caen (p. 561); Haarlem (p. 561); Monastic-English (p. 558); Münster (p. 562); Padua (p. 617); Poitiers (p. 558); Ranshofen (p. 558); Rouen (pp. 135-36, 555); Zurich (pp. 153-54).

from the twelfth century,[16] and three from the eleventh century.[17]

See also the article by the Tauberts already discussed, and Brusin's book on Aquileia for literature on early Aquileia texts.[18] The likelihood that there would be earlier texts at Aquileia than the sixteenth-century one cited by Young was already suggested by his having related the known text from Aquileia to a twelfth-century version from Remiremont (Paris, Bibl. Nat., MS lat. 9486, Rituale Romaricense saec. xii, f. 41r-42v).[19] This in turn he relates to an eleventh- or twelfth-century Elevatio text from Augsburg (Munich, Staatsbibl. MS lat. 226).[20]

Liturgical relations between monastic foundations need to be further explored with a view to seeking out artistic

[16]Ibid., I, Twelfth Century: Remiremont (p. 560); Sigibert (pp. 566-67).

[17]Ibid., I, Eleventh Century: Regularis Concordia (pp. 133, 582-83); St. Gall (p. 130); Rouen (p. 136).

[18]Tauberts, "Mittelalterliche Kruzifixe," cite texts of the fifteenth century from Florence (pp. 90ff.), Siena (p. 91), Prufening (pp. 92ff.), and Brixen (pp. 106ff.). They also publish the sixteenth-century text from Wittenberg (pp. 98ff.) and earlier texts from Barking (fourteenth century) (pp. 96ff.), Rheinau (twelfth century) (pp. 94ff.), and Salzburg (twelfth century) (pp. 104ff.). A number of others with references to the literature are also mentioned. Brusin, Aquileia, p. 51, cites: Giuseppe Vale, "Storia della Basilica dopo il sec. IX: La liturgia nella chiesa patriarchale Aquileia" (Bologna, 1933), pp. 47ff. and 367ff.; E. Dyggve, "Aquileia e la Pasqua," Studi Aquileiasi (Aquileia, 1953), pp. 385ff.; P. L. Zovatto, "Il Santo Sepolchro di Aquileia e il dramme liturgico medioevale," Atti del'Accademia di Unine, Series IX-XIII (1954-57).

[19]Young, Drama, I, p. 560. [20]Ibid.

connections between regions as well. Moreover, an extension
of this method of drawing together related texts to include
all the Easter rites may well provide additional evidence
concerning the Good Friday drama. Easter texts sometimes
refer to the object--cross or corpus--buried on Good Friday
which is raised up in the Elevatio or miraculously no longer
in the Sepulchre at the Visitatio Sepulchri.[21] This approach
would be especially valuable in places where a Depositio
text is no longer preserved. In Spain, for example, we have
early texts of the Visitatio Sepulchri but none of the Deposi-
tio.[22] Although the Visitatio Sepulchri, unlike the Elevatio,
does not require the Depositio, close scrutiny of these
texts may prove that some version of the Good Friday drama
was, in fact, performed.[23]

[21]See for example a twelfth-century text from the
monastery of St. Lambrecht (Graz, Universitätsbibl., MS II.
798, Brev. monasterii Sancti Lamberti saec. xii ex., fol.
52r-53r [A]), ibid., I, pp. 363-64.

[22]Donovan, The Liturgical Drama in Medieval Spain, p.
51. These texts come from the Benedictine monastery of
Silos, near Burgos (London, British Museum, Add. MS 30848,
f. 125 and Add. MS 30850, f. 105v).

[23]See the discussion of this possibility based on
the monuments in Chapter IV, p.162.

APPENDIX II

THE MISSING BASE PLAQUE OF THE

BURY ST. EDMUNDS CROSS

When the Bury St. Edmunds Cross was acquired in 1963
by the Metropolitan Museum of Art in New York for the Clois-
ters Collection, the base plaque showing Christ before Caia-
phas was not attached to it.[1] Purchased subsequently from a
private collector in Berlin, the plaque was added to the re-
constructed base terminal--where it remains today--because
physically, stylistically, and iconographically it seemed to
fit.[2] Nevertheless, the legitimacy of placing the Caiaphas
plaque on this cross has been questioned. In the catalogue

[1]This appendix is to be published in Gesta in August,
1975. Reference to this cross as it is labelled in the
Cloisters Collection of the Metropolitan Museum of Art, New
York, is retained despite the current scholarly opinions
which question its Bury St. Edmunds provenance: S. Longland,
"'The Bury St. Edmunds Cross': its exceptional place in
English twelfth-century art," The Connoisseur, November,
1969, pp. 163-73; The Year 1200: A Centennial Exhibition at the
Metropolitan Museum of Art, I, written and edited by Konrad
Hoffmann (New York, 1970), p. 56; Peter Lasko, Ars Sacra:
800-1200 (Baltimore, 1972) pp. 166ff.; John Beckwith, Ivory
Carvings in Early Medieval England (London, 1970), No. 104,
pp. 141-43. Beckwith, ibid., p. 107, suggests a Canterbury
source. See also our note 9.

[2]Kurt Weitzman's discovery of a photograph of the
Caiaphas plaque in the files of Adolph Goldschmidt led to
its purchase for this cross; see T. P. Hoving, "The Bury St.
Edmunds Cross," The Metropolitan Museum of Art Bulletin,
XXII (1964), 323, and Figs. 1, 7 and 8.

of "The Year 1200" exhibition doubt was expressed and a photograph included of the cross as it was when it was originally acquired.[3] It is the intention of this paper to demonstrate the inappropriateness of the Caiaphas plaque to the Bury St. Edmunds Cross, and to suggest an alternative subject more suitable to this remarkable example of twelfth-century English art.

The cross is exceedingly well preserved with the exception of the portion at the bottom.[4] There, a prophet with his inscribed scroll is missing from the lowest part of the shaft on the back side of the cross; on the front, a fragment at the end of the long inscription running down the shaft to the left of the "Tree of Life" is also lost, as is the inscription on the adjacent scroll, which Adam holds as he clings to the foot of the cross--only the letter A remains. The missing base terminal has been reconstructed as a piece of wood with square faces and a thickness approximately two-thirds the length of its sides; the Caiaphas plaque has been affixed on the front square. It is assumed that, on the back square face, there should be an equally thin plaque showing an angel as the symbol of Matthew, in order to conform with the Evangelist symbols on the other

[3]The Year 1200, p. 52. The plaque is accepted as belonging to the cross in all the other references cited in note 1.

[4]I am grateful to Charles Little of the Medieval Department of the Metropolitan Museum of Art for the privilege of examining the cross at close hand.

three terminals of this side of the cross. It is further thought that two narrow ivory pieces, which may have carried the name of the donor--and perhaps of the artist as well-- were applied to the vertical sides to complete the covering of the exposed faces of this terminal.[5]

In addition to the size of the Caiaphas plaque, which is identical with that of the other terminal faces, other technical evidence has argued for its association with the cross. There are two holes on its back showing traces of copper or bronze; these holes would have accommodated pegs for fastening the plaque to a metal terminal similar in size and shape to the one now reconstructed in wood.[6] According to this reasoning, the metal unit, which at the core of the terminal would have been covered over with thin ivory pieces, would also have needed a narrower extension above the terminal in order for it to fit into the shaft of the cross, where further metal traces have been identified, and a similarly narrow extension below which would have permitted the cross to be joined to its holder.[7]

[5]Hoving, "The Bury St. Edmunds Cross," p. 324.

[6]Ibid.

[7]Ibid. The usual triangular projection by which the cross could be fitted into its holder can still be seen on the cross (c. 1000) for the imperial crown in the Vienna Schatzkammer and the altar cross of Roger of Helmarshausen, c. 1100-1110, in Frankfurt, Museum für Kunsthandwerk, cf. Lasko, Ars Sacra, Figs. 81 and 164. Often this projection was actually removed in a later period or simply cropped from a photograph for aesthetic reasons. The prevalence of the arrangement, however, is further demonstrated in minia-

These proposals are not entirely convincing. There is no precedent, so far as I know, for the complexity of this arrangement. A far simpler solution--and more logical in terms of the construction of the rest of the cross in seven interlocking ivory segments--would be a terminal made of ivory. If so, both the front scene and the angel of Matthew--as well as the inscriptions if they existed--would have been carved out of a single ivory block, as is the case for the other terminals. A place for the metal piece that fitted into the holder and up into the shaft of the cross would simply have been hollowed out of the ivory block.

There are more serious problems concerning the Caiaphas plaque when it is compared to the original portions of the cross. It is clear, first of all, that the ivory of the plaque is of a different quality: it is much paler than the warmer, more yellowish hue of the other segments; it has a brittle character, whereas the rest of the cross is almost waxy in appearance.

Compositional features are also at variance with the rest of the carvings. Instead of the numerous inscriptions, so plentiful and complete throughout the cross, there is the single word p[ro]phetiza written on an abridged strip placed near the left-hand figure.[8] This strip has an ambiguous

tures where the cross frequently shows a pointed base. See, for example, Peter Metz, The Golden Gospels of Echternach (New York, 1957), p. 37, or H. Jantzen, Ottonische Kunst (Munich, 1947), Fig. 106.

[8]Hoving, "The Bury St. Edmunds Cross," pp. 323-24;

character, floating against the background, quite unlike the
scrolls of the other three terminals, where each scroll is
clearly delineated and is held in the hands of an identifi-
able figure, whose words the inscription records. A lack of
clarity similar to the treatment of the inscribed strip ap-
plies to the composition of the Caiaphas plaque as a whole,
which is based on a different logic from that governing the
other reliefs. In the other terminal scenes of the cross,
the figures tend to adhere to a common ground line, even in
those scenes--the Women at the Sepulchre/Resurrection and the
Deposition/Lamentation--where two subjects are combined.
The cohesive impression of a common ground line is maintained
because no element deliberately denies it and because the
setting is minimal. In the Caiaphas plaque, the figures ap-
pear to be adrift on different levels of the picture surface;
this impression is emphasized by the reduced scale of the
city wall.

Perhaps the most telling distinction, however, may be
seen in the rendering of each element within the plaque.
There is nothing comparable elsewhere on the cross to such
schematic depiction of scenic detail as is found in the per-
functory outlining of the blocks of the wall. The flaccid,
cursory treatment accorded to the figures is also of a dif-
ferent order from that of the other carvings, which combine

Hoving calls the plaque Christ before Pilate. For the iden-
tification of the enthroned figure as Caiaphas, see Longland,
"'The Bury St. Edmunds Cross,'" p. 166.

flowing naturalism with tense energy in a style most closely
analogous to the miniatures of the Bury Bible.[9] Not only
does the Caiaphas artist eschew the clinging "damp fold" drapery
of all the other figures on the cross, but he also avoids the
careful delineation of every detail--from the features of
each face to the toes of each foot--elsewhere so scrupulously
dwelt on. A close look at the visible arm and hand of the
figure to the left may suffice to demonstrate the crudity of
the style of this plaque in comparison with the sophistica-
tion and craft of the rest of the cross.

But above all, the subject of the plaque does not fit
the program of the cross. The central medallion on the front
shows Moses and the Brazen Serpent, a familiar Old Testament
antetype for the Crucifixion. Just below the top terminal,
Pilate and Caiaphas dispute the title of the cross, an unus-
ual scene which serves to emphasize the wording of the title;[10]

[9]Hoving, "The Bury St. Edmunds Cross," pp. 334-35,
makes the comparison to Cambridge, Corpus Christi College,
Ms 2, dated 1121-1148. Longland, "'The Bury St. Edmunds
Cross,'" pp. 170-71, bases her objection to the Bury St.
Edmunds provenance on the divergence of the inscriptions on
the cross, which she dates c. 1180, from those on Abbot Sam-
son's rood-screen of about the same year. The 1180 dating,
suggested by Hoving, "The Bury St. Edmunds Cross," and also
confirmed by Beckwith, Ivory Carvings, p. 107, is not uni-
versally accepted. Lasko, Ars Sacra, pp. 166ff., would
place it early in the twelfth century. Hoving's stylistic
comparison to Master Hugo's Bury Bible argues for a mid-
century date, in which case the Bury St. Edmunds provenance
is not necessarily denied. Tempting but inconclusive is the
evasive record of a cross with two side figures by the same
Master Hugo, cf. C. M. Kauffmann, "The Bury Bible," Journal
of the Warburg and Courtauld Institutes, XXIX (1966), 63.

[10]See Longland, "'The Bury St. Edmunds Cross,'" pp.

just above the bottom terminal, Adam and Eve, symbols of
sinful humanity who would be redeemed through the sacrifice
on the cross, cling to the base of the "Tree of Life." The
scenes on the front faces of the upper terminals are further
extensions of the meaning of the Crucifixion; in addition,
each represents a major church feast: the Deposition/Lamen-
tation to the right signifies the Passion; the Women at the
Sepulchre and the risen Christ to the left, the Resurrection;
and the Ascension above. Christ before Caiaphas, a rela-
tively minor event in the Passion story, does not fit this
program because it has neither a direct bearing on the Cruci-
fixion nor is it one of the major feast scenes.[11]

If not Christ before Caiaphas, what should this side
of the lower terminal show? One alternative subject sug-
gested, although not analyzed in detail, has been the Harrow-
ing of Hell, in which Adam and Eve are led out of Limbo by
the resurrected Christ.[12] The scene occurs, for example, at
the lower end of a cross, together with two further post-

166-68, and idem, "Pilate Answered: What I Have Written I
Have Written," The Metropolitan Museum of Art Bulletin, XXVI
(1968), 410-29, for a full discussion of the Caiaphas-Pilate
dispute.

[11]Christ before Caiaphas is not a common subject, but
it can be seen within rather full cycles, such as the Otto
Gospels in Aachen and the Golden Gospels of Echternach in
Nürnberg, cf. H. Schnitzler, Rheinische Schatzkammer, I (Dus-
seldorf, 1957), Figs. 105 and 37.

[12]W. Mersmann, "Das Elfenbeinkreuz der Sammlung Topic-
Mimara," Wallraf-Richartz Jahrbuch, XXV (1963), 50; also,
The Year 1200, p. 52.

Resurrection appearances of Christ, on the cover of an
eleventh-century Gospel book in Milan.[13] While the Harrow-
ing of Hell on the lowermost plaque would be more consistent
with the Passion theme of the rest of the cross, it presents
difficulties of its own. There would, first, be a visual re-
dundance in having Adam and Eve appear twice so close to-
gether. Second, there would be a redundance of theme. The
depiction of Adam with Christ's blood streaming over his
shoulder as he and Eve cling to the foot of the living cross,
the "Tree of Life," already expresses the redemptive idea of
the Harrowing of Hell. Adam at the foot of the cross, at
the very place in which he was said to have been buried, ad-
ditionally carries the specific connotation of Christ, the
New Adam, as the salvation of the Old, in keeping with the
repeated correspondences on this side of the cross between
the Old and New Testaments.[14]

But if not the Harrowing of Hell, what then? Mers-
mann tentatively suggested that this space may have shown

[13]Book cover of Archbishop Aribert, 1018-1045, Ca-
thedral Treasury, Milan, cf. Lasko, Ars Sacra, Fig. 176.

[14]The Old and New Testament correspondences are marked
especially on this side of the cross by the central medallion
with Moses and the Brazen Serpent, by the presence of Zacha-
riah and his prophecy in the Passion scene on the right-hand
terminal, and by the inscriptions running down the shaft of
the cross. See Hoving, "The Bury St. Edmunds Cross," pp.
317ff., for a discussion of these inscriptions; also, S.
Longland, "A Literary Aspect of the Bury St. Edmunds Cross,"
Metropolitan Museum Journal, II (1969), 45ff. For a discus-
sion of the Old and New Adam, see Otto Schmitt, Reallexikon
zur deutschen Kunstgeschichte (Stuttgart, 1937), cols. 158-
62, and cols. 162ff., for a discussion of the Harrowing of
Hell.

either an Adoration of the Magi or a Nativity.[15] It is this
latter idea that I should like to put forward here for more
serious consideration. To do so demands that one look at the
cross in its entirety, taking into account the program of
its reverse side as well, for both sides of the Bury St. Ed-
munds cross form an iconographic unit.

The program on the back of the cross is an adaptation
of a Majesty scheme--the Lamb of God surrounded by the four
Evangelists, or, as in this instance, by their symbols. This
iconography is traditional on processional crosses and in
manuscript illumination since the eighth century. On ele-
venth-century crosses, the image of the crucified Christ is
occasionally substituted for the Lamb in the Majesty setting.[16]
On the Bury Cross, the two versions are combined: the pres-
ence of Synagogue shown piercing the Lamb's breast is a po-
tent allusion to the Crucifixion. The theme of the Old Law
supplanted by the New, so pronounced on the front, is re-
peated on this side not only in the central medallion but
also in the series of prophets and their sayings that line

[15]Mersmann, "Das Elfenbeinkreuz der Sammlung Topic-
Mimara," p. 50.

[16]A processional cross in Essen has cloisonné plaques
of the Crucifixion and Evangelist symbols on the front, from
Cologne, c. 1000; the back, showing the Lamb of God and
Evangelists on a "Tree of Life" cross, is dated to the second
quarter of the twelfth century, cf. Schnitzler, Rheinische
Schatzkammer, Figs. 146 and 147. The Lamb and Evangelist
symbols may also be seen on the "older" Mathilda cross in
the Essen Munsterschatz, ibid., Fig. 142, and on the Reichs-
kreuz in the Vienna Schatzkammer, cf. Mersmann, "Das Elfen-
beinkreuz der Sammlung Topic-Mimara," Fig. 42.

this face of the cross.[17]

The tight thematic interlinking of the cross as a whole is further evidenced by the fact that the extant Evangelist symbols on the back are related in liturgical tradition to the depictions of the Christian mysteries on the front.[18] The relation of scene to symbol depends on the position of the viewer: John's eagle and Ascension are seen above; Mark's lion and the Resurrection appear to the left on each side and Luke's ox and the Passion are viewed to the right. According to this system of correspondences, formally established by St. Gregory, the event associated with the angel of Matthew, which would belong on the bottom terminal, is the Nativity.[19]

[17]See Hoving, "The Bury St. Edmunds Cross," pp. 317ff., for the prophets and their inscriptions.

[18]F. Van Der Meer, Majestas Domini: Theophanies de l'Apocalypse dans l'art chrétien (Rome/Paris, 1938), pp. 223-27, and G. Schiller, Ikonographie der christlicher Kunst (Gütersloh, 1968), p. 186. Irenaeus, in the second century, was the first to identify the symbols with the Evangelists, deriving the formulation from the vision of Ezekiel: Contra Haereses, III, 11, 8, cf. J. P. Migne, Patrologia Graeca (Paris, 1857-1866), p. 7, cols. 885-90; Jerome, in his second commentary on Matthew, enunciates the developing correlation of symbol to scene, with the Ascension for John the most explicit pairing, cf. J. P. Migne, Patrologia Latina (Paris, 1844-1864), p. 26, cols. 15-22. With Gregory, c. 540-604, Homily on Ezekiel, Lib. 1, Hom. 4, cf. ibid., p. 76, cols. 815-16, the system becomes fixed for linking the symbols to the attributes of Christ, "who for us became at the same time man in his birth, ox in his death, lion in his resurrection, and eagle in his ascension." I am grateful to Robert Nelson for pointing out these references.

[19]P. Verdier, "La Grande Croix de l'Abbé Suger à St. Denis," Cahiers de Civilisation Medievale: X-XIII Siècles, XXX (Université de Poitiers, 1970), p. 16, cites the eighth-

Byzantine art had a parallel system of feast picture correspondence, but based on a reference to the Evangelist himself rather than to his symbol.[20] Only in Matthew's association with the Nativity do the formulations, East and West, coincide. A New Testament fragment from the first half of the tenth century shows the Nativity facing the portrait of Matthew.[21] In two twelfth-century manuscripts, the Codex Ebnerianus and Venice Codex Z 540, Matthew's portrait and the Nativity are juxtaposed directly on the same page.

century poem of Alcuin, Alcuini Carmina, 117, 1, which reiterates Gregory's system, discussed in note 19, and specifies the Nativity as the scene related to Matthew.

[20]The Byzantine system was based on a series of set Gospel readings for particular feast days. Although there was some latitude for substitutions, the usual correspondences were: Matthew with the Nativity; Mark with the Baptism of Christ; Luke with the Annunciation to the Virgin or the Birth of John the Baptist; and John with the Anastasis, cf. Cecilia Meredith, "The Illustration of Codex Ebnerianus: A Study in Liturgical Illustration of the Comnenian Period," Journal of the Warburg and Courtauld Institutes, XXIX (1966), 419-24.

[21]Baltimore, Walters Art Gallery, cod. W 524, cf. Illuminated Greek Manuscripts from American Collections; An Exhibition in Honor of Kurt Weitzmann, edited by Gary Vikan, The Art Museum, Princeton University, Princeton, 1973, No. 5, p. 64. Again, I am grateful to Robert Nelson for pointing out this example, which, as the catalogue indicates, contradicts Meredith's contention that this association is an invention of the Comnenian period. See note 20.

[22]Codex Ebnerianus, Oxford Bodleian Library, MS. Auct. T. infra I. 10, f. 23v, cf. Meredith, "The Illustration of Codex Ebnerianus," pl. 69a. Venice, Marciana Codex Z 540, cf. Bloch, Die Ottonische Kölner Malerschule, Fig. 440. For the other portrait pages, see Fig. 408: Mark and the Baptism of Christ; Fig. 420: Luke and the Birth of John the Baptist; Fig. 435: John and the Anastasis.

When the western system of correspondences begins to
be expressed visually, Gregory's formulation is most dis-
tinctly reflected in connection with the symbols for Mark,
Luke and John. It first appears in Ottonian Gospel minia-
tures where portraits of these Evangelists include, along
with their symbols, an allusion to the scene with which they
are associated.[23] However, it is in two ivory book covers
which show all four narrative scenes together with the Evan-
gelist symbols surrounding an image of the crucified Christ
that one finds an arrangement that more nearly approximates
that of the Bury Cross: the Crucifixion plaque from Liège,
dated 1030-1050, now in Brussels, and its near copy from
Cologne, dated 1040-1050, in Essen.[24] Both covers show the
Nativity below and the Ascension above a full depiction of
the Passion scene, which includes the thieves as well as

[23]An early eleventh-century Gospel book from Bamberg,
Munich, Bayr. Staatsbibl. Clm. 4454, contains portrait pages
of the Evangelists with their symbols and a reference to
their narrative scene: Mark with his lion and an image of
the resurrected Christ; Luke with his ox and with the Lamb,
symbol of the Passion; John with his eagle and a scene of
the Ascension. Matthew simply shows Christ crowned as his
symbol, cf. ibid., p. 111. In the Gospel book No. 18 in the
Hildesheim Treasury, dated 1010-1020, Mark's lion appears
with two sepulchres, an allusion to the Resurrection; the
Crucifixion appears atop Luke's ox; and, again, the Ascension
accompanies the eagle of John, cf. Francis J. Tschan, St.
Bernward of Hildesheim, III (Notre Dame, Indiana, 1952), Figs.
66, 71, and 76. Although Matthew's portrait page shows only
the angel symbol, Gregory's formulation affects the choice
of the Nativity and the Three Magi as subjects illustrated
within his Gospel, ibid., Figs. 61 and 59.

[24]Rhein und Maas, F 12. The Essen ivory is thought
to have been the gift of Archbishop Herimann to his sister,
the Abbess Theophanu, cf. ibid., E 12 (D 3).

Stephaton and Longinus on either side of the central image of the crucified Christ. Allusion to the Resurrection is made by two figures emerging from tombs below and above the thieves. The writing Evangelists with their symbols appear in each corner; they are not related specifically to the scenes but are placed according to their traditional ordering in a Majesty miniature.

The iconography of the Liège and Cologne plaques recurs in a slightly different form on the golden cover of a Gospel book of about 1020 in Aachen.[25] Here, Christ is expressed through a crux gemmata, into which a tenth-century Byzantine ivory of the Madonna Hodegetria has been set. The cross and a rich border of jewels and metalwork divide the cover into distinct sections. Scenes of the Nativity, Crucifixion, Resurrection, and Ascension appear in each of the corners.[26] The Evangelist symbols, still in an order unre-

[25]The book cover in the Aachen Treasury was originally made for the Carolingian Gospels in the Vienna Schatzkammer, cf. Schnitzler, Rheinische Schatzkammer, p. 23, discussion of No. 33 (Fig. 97).

[26]There is a set of four ivory plaques from Cologne of the second quarter of the twelfth century which carry the same themes. Three--the Nativity, the Crucifixion, and the Three Maries--are in the Schnütgen Museum in Cologne; the Ascension is in the Victoria and Albert Museum in London. See idem, Rheinische Schatzkammer, II (Dusseldorf, 1959), Figs. 80 and 81, for the Nativity and the Three Maries; Adolph Goldschmidt, Die Elfenbeinskulpturen aus der romanischen Zeit, III (Berlin, 1923), Nos. 11 and 7, for the Crucifixion and the Ascension. Separated as they are from their original context, one can only surmise that they, too, once belonged to the cover of a Gospel book, cf. Schnitzler, Rheinische Schatzkammer, II (1959), 32.

lated to their scenes, are paired on either side of the ivory.

In the program suggested for the Bury Cross, the rela-
tion of each symbol to its proper scene is clarified through
an adaptation of a scheme in which a portion of the liturgy
is applied to the plan of the church. The relevant moment
of the mass occurred at the Fraction, the ceremony in which
pieces of the Host were arranged on the paten in the form of
a cross to commemorate the seven important moments in Christ's
life.[27] In the late eighth century, Bishop Angilbert had
drawn four principal scenes from this formulation and im-
posed them on particular sites along the cruciform ground
plan of St. Riquier-St. Sauveur at Centula.[28] There, four
sculptural reliefs were arranged in the form of a _tau_ cross:
the Nativity stood to the west above the main portal at St.
Sauveur; the Passion was placed eastward on the great arch
above the crossing of St. Riquier, the church to which St.
Sauveur was joined; the Resurrection and the Ascension ap-
peared on the arches north and south which separated the
aisles from the transepts at St. Riquier.[29] In later single

[27]G. Bandmann, "Früh und Hochmittelalterliche Altar-
ordnung als Darstellung," Das Erste Jahrtausend, I (Dussel-
dorf, 1962), p. 377, n. 35, cites the symbolism of the Frac-
tion as prescribed at the Council of Tours of 567. Carol
Heitz, Recherches sur les rapports entre Architecture et Li-
turgie à l'époque carolingienne (Paris, 1963), p. 124, speci-
fies the seven Host particles as follows: corporatio, mors,
nativitas, resurrectio, circumcisio, apparitio, and passio.

[28]Ibid., p. 110.

[29]Edgar Lehmann, "Die Anordnung der Altäre in der
karolingischen klosterkirche zu Centula," Karl der Grosse,
III, Karolingische Kunst (Dusseldorf, 1965), p. 375, Fig. 3.

churches, the horizontal ordering was turned into a vertical
one: the place of the Passion was directly connected with
the Altar of the Cross at the entrance to the choir; that of
the Ascension and Resurrection with the High Altar further
east in the chancel; and the Marian altar--commemorating the
Nativity--was set in the crypt below in relation to the main
altars above it.[30] This tradition accounts for the appear-
ance of the Nativity below the Passion scene on the Brussels
ivory with the Resurrection and Ascension above. The place-
ment of the Nativity on the lower terminal of the Bury St.
Edmunds cross finds the same explanation. The resolution of
the symbol-scene correspondence on this cross thus represents
a merging of the symbolic ordering of scenes within the
church with the traditional ordering of symbols on a proces-
sional cross.

The liturgical basis for the arrangement of the scene
points to the most important factor underlying the iconog-
raphy of the Bury Cross: the specific purpose for which
this cross was designed. The program of the Bury Cross re-
flects the resolution of the theological controversy initi-
ated in the ninth century as to whether the flesh of Christ
present in the Eucharist "was His human suffering body or His
spiritual flesh existing forever in Heaven."[31] The latter

[30]Bandmann, "Früh und Hochmittelalterliche Altarord-
nung als Darstellung," p. 398, no. 154, and p. 400.

[31]Adolf Katzenellenbogen, The Sculptural Program of
Chartres Cathedral (Baltimore, 1959), p. 13. Ibid., p. 13,

position held sway for the most part until the mid-twelfth

century, and the Gospel book, the eucharistic symbol of the

divine Christ, was the only object--other than the sacra-

ments--permitted on the altar during the mass.[32] Meanwhile,

the emphasis was shifting to the former theory that it was

the corpus verum, His real flesh, that was present in the

Eucharist. An ambivalence toward which meaning should apply

is evident in the course of the eleventh century, when a

cross or crucifix was occasionally permitted on the altar,[33]

and when the newer eucharistic idea finds expression on Gos-

pel book covers, such as those we have discussed, and on

those processional crosses where the crucified Christ is

placed in the Majesty setting. Drawing on these transitional

examples, the Bury Cross transformed the processional cross

into a powerful new liturgical symbol, just at the time when

n. 26, Paschasius Radbertus was the first proponent of the
idea of the Eucharist as meaning Christ's human body, cf.
Liber de corpore sanguine Domini, Migne, P.L., p. 120, cols.
1267ff., written in 831 for Charles the Blad. This view was
countered by Ratramnus of Corbie, De corpore et sanguine
Domini, ibid., p. 121, cols. 125ff.

[32]J. Jungmann, The Mass of the Roman Rite: Its Ori-
gins and Development, I (New York, 1950), p. 312. Along with
the Gospel book, the second symbol of Christ was the altar
itself. For a discussion of the Gospel book in the liturgy,
see ibid., pp. 442-47; also, Metz, The Golden Gospels of
Echternach, pp. 20-21.

[33]For the introduction of a cross or crucifix into
the eleventh-century mass, see Joseph Braun, Das christlicher
Altargerät (Munich, 1932), p. 467, n. 6, and p. 469, n. 34.
Jungmann, The Mass of the Roman Rite, p. 292, no. 89, dis-
cusses the stipulation in the Consuetudines of Farfa, of
1040, that during mass, before the Pater Noster, a crucifix,
the Gospel book, and relics be set out in front of the altar.

the cross first gained a fixed place on the altar during the
mass, and before it took the standard form of the simple
crucifix.[34]

The theological shift expressed by the use of the
cross or crucifix as the chief symbol of Christ in the mass
also permitted the representation of the Nativity, the prime
expression of the moment of Christ's human appearance, in
this context. The sacrament importance of the Nativity
scene had been explained by St. Gregory in his Homily for
the Office of Christmas:[35]

> He is also for good reasons born in Bethlehem, for Beth-
> lehem means House of Bread. He is namely the one who
> says: "I am the living bread which came down from
> Heaven." Therefore the place where the Lord is born has
> been called the House of Bread because it should indeed
> happen that He would appear in the flesh, who refreshes
> the minds of the elect with inner abundance. . . . The
> new born babe lies in the manger to refresh all the
> faithful, namely the holy animals, with the grain of His
> flesh.

The sacramental character of the Nativity image had
previously been expressed in Mosan art: note, for example,
the blessing gesture of the Child in the Nativity on the
Brussels ivory.[36] It also appears in English art of the

[34]Braun, Das christliche Altargerät, pp. 469-70. By
the thirteenth century, the crucifix on the altar was a com-
mon expression of the renewal of the sacrifice at the mass,
but a retable or wall painting could be used instead. The
final installation of the crucifix came with the reordering
of the Missal by Pope Pius V in 1560, cf. ibid., p. 473.

[35]Translation quoted by Katzenellenbogen, The Sculp-
tural Programs of Chartres, p. 12; see also his notes 21 and
22. For literary references to the parallel between altar
and manger, cf. ibid., p. 12, n. 23.

[36]The Nativity is paired with the Sacrifice of Cain

same eleventh-century period and even earlier, in such rep-
resentations of the Nativity as are found in the Aethelstan
Psalter, ca. 925-940, and in the Missal of Robert of Jumi-
èges, 1008-1025.[37] In the Jumièges Nativity the sacramental
nature of the scene is emphasized through the altar-like
form of the creche where the Child is lying with the "holy
animals," the ox and the ass, in attendance. The prominence
of Joseph, who points to his eyes, is an allusion to his
role as the guardian of the heavenly bread.[38] Thus, the
placement of the Nativity on the base terminal of the Bury
St. Edmunds Cross would conform not only with the program of
the cross itself, but with the traditions native to English
art and to its Ottonian roots, to which the cross is so di-
rectly related.

and Abel on the Hildesheim doors, cf. Tschan, St. Bernward
of Hildesheim, Fig. 115. From the Hildesheim Gospel book
No. 18, see the apocalyptic representation of the Lamb who
opens the seventh seal of the book above, and the Child in
the altar-like manger with Oceanus and Terra below, cf.
ibid., Fig. 73.

[37]H. A. Wilson, Missal of Robert of Jumièges (London,
1896), pl. 1. The Nativity from the Aethelstan Psalter is
in Oxford, Bodleian Library, MS Rawlinson B 484, f. 85, cf.
E. G. Millar, English Illuminated Manuscripts from the Xth
to the XIIIth Century (Paris, 1926), pl. 2d.

[38]Katzenellenbogen, The Sculptural Programs of
Chartres, p. 14, n. 35.

SELECTED BIBLIOGRAPHY

Appuhn, Horst. "Der Auferstandene und das Heilige Blut zu Weinhausen." Niederdeutsche Beiträge zur Kunstgeschichte. Vol. I. Cologne, 1961, pp. 73-138.

Aubert, Marcel. Encyclopédie Photographique de l'art: Le Musée de Louvre; Sculptures du Moyen Âge. Paris, 1948.

_____, et al. Le Vitrail Français. Paris, 1958.

Bandmann, Günter. "Früh- und Hochmittelalterliche Altarordnung als Darstellung." Das Erste Jahrtausend. Vol. II. Dusseldorf, 1962, pp. 371-411.

_____. Mittelalterliche Architektur als Bedeutungsträger. Berlin, 1951.

_____. "Zur Deutung des Mainzen Kopfes mit der Binde." Zeitschrift für Kunstwissenschaft, X (1956), 153-74.

Beckwith, John. "An Ivory Relief of the Deposition." Burlington Magazine, XCVIII (1956), 153-74.

_____. Ivory Carvings in Early Medieval England. London, 1972.

_____. Ivory Carvings in Early Medieval England, 700-1200. Catalogue of the exhibition at the Victoria and Albert Museum. London, 1974.

Berg, Knut. "Une iconographie peu connue du crucifiement." Cahiers Archéologiques, IX-X (1947-59), 319-328.

Bernard, Honoré. "Premières Fouilles à St. Riquier." Karl der Grosse. Vol. III: Karolingische Kunst. Dusseldorf, 1965, pp. 369-73.

Beutler, C. "Ein Ottonischer Kruzifixus aus Trier." Das Erste Jahrtausend. Vol. I. Dusseldorf, 1962, pp. 549-54.

Biehl, W. Toskanische Plastik des Frühen und Hohen Mittelalters. Leipzig, 1920.

Bier, Justus. "Riemenschneider's Tomb of Emperor Henry and

230

Empress Cunegund." The Art Bulletin, XXIX (1947),
95-117.

Bloch, Peter. "Der Weimarer Kreuzfuss mit dem Auferstehend
Adam." Anzeiger des Germanisches Nationalmuseums
Nürnberg, 1964, pp. 7-23.

_____, and Schnitzler, Hermann. Die Ottonische Kölner
Malerschule. Vol. II. Dusseldorf, 1970.

Bober, Harry. The St. Blasien Psalter. Rare Books Mono-
graph Series, Vol. III. New York: H. P. Kraus, 1963.

Bock, Fr. Geschichte des Liturgischen Gewänder des Mittel-
alters. Bonn, 1859-71 (reprinted Graz, 1970).

Boeckler, Albert. "Das Erhardbild im Uta Codex." Studies
in Art and Literature for Belle da Costa Greene.
Princeton, 1954.

_____. Die Bronzetür von San Zeno. Marburg, 1931.

_____. Die Bronzetüren des Bonannus von Pisa und des
Barisanus von Trani. Berlin, 1953.

Boeckler, W. Ars Sacra: Kunst des frühen Mittelalters.
Exhibition catalogue. Bern/Munich, 1949.

Bond, Francis. Screens and Galleries in English Churches.
London, 1908.

Bonnell, J. K. "The Easter Sepulchrum in Its Relation to
the Architecture of the High Altar." Publications
of the Modern Language Association of America, XXXI,
No. 24 (1916), 664-712.

Braun, Joseph. Der christliche Altar in seiner geschicht-
lichen Entwicklung. 2 vols. Munich, 1924.

_____. Das christliche Altargerät. Munich, 1932.

_____. Meisterwerke der deutschen Goldschmiedekunst der
vorgotischen Zeit. Munich, 1922.

_____. Die Reliquiare des christlichen Kultes und ihre
Entwicklung. Munich, 1924.

Brieger, Peter. "England's Contribution to the Origin and
Development of the Triumphal Cross." Medieval Studies,
IV (1942), 85-96.

Brooks, Neil C. "The Sepulchre of Christ in Art and Liturgy

with Special Reference to the Liturgical Drama."
University of Illinois Studies in Language and Literature, VII, No. 2 (1921).

Brusin, Dina dalla Barba, and Lorenzoni, Giovanni. L'Arte del Patriarcato di Aquileia dal Secolo IX al Secolo XIII. Padua, 1968.

Brussels. Palais des Beaux-Arts: Trésors du Moyen Âge Allemand. April-June, 1949.

Burdach, Konrad. Der Gral. Stuttgart, 1938.

Cabaniss, Alan. Amalarius of Metz. Amsterdam, 1954.

Cabrol, F., and LeClerq, H. Dictionnaire d'Archéologie Chrétienne et de Liturgie. Paris, 1907-53.

Carli, Enzo. La Scultura Lignea Italiana dal XII al XVI Secolo. Milan, 1960.

Chambers, E. K. The Medieval Stage. 2 vols. Oxford, 1903.

Clemen, Paul. Die romanische Monumentalmalerei in den Rheinland. Dusseldorf, 1916.

Cohen, Gustave. Histoire de la Mise-en-Scène dans le Théâtre religieux français du Moyen Âge. Paris, 1926.

_____. "The Influence of the Mysteries on Art in the Middle Ages." Gazette des Beaux-Arts, Series 6, XXIV, No. 922 (1943), 327-42.

Conant, Kenneth J. "The Original Buildings at the Holy Sepulchre in Jerusalem." Speculum, XXXI, No. 1 (1956), 1-48.

Cook, Walter W. S. "The Earliest Panel Paintings of Catalonia, V." The Art Bulletin, X, No. 2 (1927), 1-48.

Cottas, V. L'Influence du drame "Christos Paschon" sur l'art chrétien d'orient. Paris, 1931.

_____. Le Théâtre à Byzance. Paris, 1931.

Coussemaker, E. Drames Liturgiques du Moyen Âge. Rennes, 1860 (new edition: New York, 1964).

Cox, J. C., and Harvey, A. English Church Furniture. New York, 1907.

Craig, Hardin. English Religious Drama of the Middle Ages. Oxford, 1955.

Creutz, M. Die Anfänge des monumentalen Stiles in Nord-deutschland. Cologne, 1910.

Crichton, G. H. Romanesque Sculpture in Italy. London, 1954.

_____, and Crichton, E. R. Nicola Pisano and the Revival of Sculpture in Italy. Cambridge, 1938.

Dalman, D. G. Das Grab Christi in Deutschland. Studien über christliche Denkmaler. Vol. XIV. Leipzig, 1922.

Dalton, J. N. Collegiate Church of Ottery St. Mary. Cambridge, 1917.

Dalton, O. M. Catalogue of Ivory Carvings of the Christian Era. London: British Museum, 1909.

Danielou, Jean. The Bible and the Liturgy. Notre Dame, Indiana, 1956.

Demus, Otto. Byzantine Art and the West. New York, 1970.

_____. The Mosaics of Norman Sicily. London, 1949.

_____, and Hirmer, Max. Romanesque Mural Painting. New York, 1970.

Der Nersessian, Sirapie. "The Illustrations of the Homilies of Gregory of Nazianzus: Paris grec 510." Dumbarton Oak Papers, XVI (1962), 195-228.

Deschamps, Paul, and Thibout, Marc. La Peinture Murale en France. Paris, 1951.

_____. La Peinture Murale en France au début de l'époque gothique, 1180-1350. Paris, 1963.

Deshman, Robert. "Anglo-Saxon Art after Alfred." The Art Bulletin, LVI, No. 2 (1974), 176-200.

Doberer, Erika. "Lettner." Lexikon für Theologie und Kirche. 2d ed. Freiburg-im-Breisgau, 1961.

Donovan, Richard. The Liturgical Drama in Medieval Spain. Toronto, 1958.

Downey, Glanville. "Nikolaos Mesarities' Description of the Church of the Holy Apostles at Constantinople." Transactions of the American Philosophical Society, New Series, Vol. XLVII, Part 6 (1957).

Duchesne, Louis. Christian Worship: Its Origin and Evolution. Translated by M. L. McClure. London, 1927.

Edelman, Gottfried. "Notes on Wood Corpus for Crucifix, Catalan, XII c." Unpublished notes for Isabella Stewart Gardner Museum, October 28, 1958.

Effmann, Wilhelm. Centula Saint-Riquier: Eine Untersuchung zur Geschichte der kirchlichen Baukunst in der karolinger Zeit. Munster in Westphalie, 1912.

Eimerl, Sarel. The World of Giotto c. 1267-1337. New York: Time-Life Library of Art, 1967.

Elbern, Victor H. Das erste Jahrtausend: Kultur und Kunst im Werdenden Abendland an Rhein und Ruhr. Vol. III: Tafelband. Dusseldorf, 1962.

_____, and Reuther, Hans. Der Hildesheimer Domschatz. Hildesheim, 1969.

Enciclopedia Italiana. Rome, 1936.

Essenwein, A. "Ein Reliquar des 11 Jahrhunderts in der Sammlungen des Germanischen Museums." Anzeiger für Kunde der deutschen Vorzeit, N. F., LXX, No. 1 (1870), 2-5.

Evans, Joan. Cluniac Art in the Romanesque Period. Cambridge, 1950.

Forsyth, Ilene Haering. "Magi and Majesty: A Study of Romanesque Sculpture and Liturgical Drama." The Art Bulletin, L, No. 3 (1968), 215-22.

_____. The Throne of Wisdom. Princeton, 1972.

Forsyth, William H. The Entombment of Christ: French Sculptures of the Fifteenth and Sixteenth Centuries. Cambridge, 1970.

Franciosi, Giannina. Arezzo. Bergamo, 1909.

Francovich, Geza de. Benedetto Antelami: Architetto e scultore e l'arte del suo tempo. 2 vols. Milan/Florence, 1952.

_____. "L'origine du crucifix monumental sculpté et peint." La Revue de l'Art, LXVII, No. 362 (1935), 185-212.

_____. "A Romanesque School of Wood Carvers in Central Italy." The Art Bulletin, XIX (1937), 5-57.

Frank, Grace. The Medieval French Drama. Oxford, 1960.

Friedlander, Max J. Early Netherlandish Painting. Vol. II: Rogier van der Weyden and the Master of Flemalle. New York, 1967.

Futterer, I. Gotische Bildwerke der deutschen Schweiz, 1220 bis 1440. Augsburg, 1930.

Gauthier, M.-M. Émaux du moyen âge occidental. Fribourg, 1972.

Goldschmidt, Adolph. Die Bronzetüren von Nowgorod und Gnesen. Marburg, 1932.

_____. Die Elfenbeinskulpturen aus der Zeit der karolingischen und sächischen Kaiser. 4 vols. Berlin, 1914-26.

_____. Die Elfenbeinskulpturen aus der romanischen Zeit. Vol. III. Berlin, 1923.

_____. German Illumination. Vol. II: Ottonian Period. New York, n.d.

_____, and Weitzmann, Kurt. Die byzantinischen Elfenbeinskulpturen des X-XIII Jahrhunderts. Vol. II. Berlin, 1934.

Grabar, André. Christian Iconography: A Study of Its Origins. Tenth Mellon Lecture. Princeton, 1968.

_____. Art of the Byzantine Empire. New York, 1963.

Graeve, Mary Ann. "Caravaggio's Painting for the Chiesa Nuovo." The Art Bulletin, XL, No. 3 (1958), 223-38.

Hamann, R. Die Abteilkirche von St. Gilles und ihre künstlerische Nachfolge. Berlin, 1955.

Hardison, O. B., Jr. Christian Rite and Christian Drama in the Middle Ages. Baltimore, 1965.

Haussherr, Reiner. Der tote Christus am Kreuz; zur Ikonographie der Gerokreuzes. Bonn, 1963.

Heitz, Carol. "Architecture et Liturgie processionelle à l'époque préromane." La Revue de l'Art, XXIV (1974), 30-47.

_____. Recherches sur les rapports entre Architecture et Liturgie à l'époque carolingienne. Paris, 1963.

235

Hennecke, Edgar. New Testament Apocrypha. Edited by Wil-
 helm Schneemelcher. Vol. I. Philadelphia, 1963.

Henri, Françoise. Irish Art of the Early Christian Period
 (to 800 A.D.). London, 1965.

Hirn, Irjö. The Sacred Shrine. London, 1958.

Hope, Sir William St. John. "The Sarum Consuetudinary and
 Its Relation to the Cathedral Church of Old Sarum."
 Archeologia, LXVIII (1916-17), 111-26.

_____. "Quire Screens in English Churches, with special
 reference to a twelfth century quire screen formerly
 in the Cathedral Church at Ely." Archeologia, LXVIII
 (1916-17), 85-97.

Hoving, Thomas P. F. "The Bury St. Edmunds Cross." The
 Metropolitan Museum of Art Bulletin, XXII (1964),
 317-40.

Hubert, J.; Porcher, J.; and Volbach, W. F. The Carolingian
 Renaissance. New York, 1970.

James, M. R. The Apocryphal New Testament. Oxford, 1926.

Janson, H. W. The Sculpture of Donatello. Vol. II. Prince-
 ton, 1957.

Jenkins, R. A.; Manly, J. M.; Pope, M. K.; and Wright, J. G.,
 eds. La Seinte Resureccion from the Paris and Canter-
 bury Manuscripts. Vol. IV. Oxford: Anglo-Norman
 Text Society, 1943.

Jerphanion, Guillaume de. Les Églises Rupestres de Cappa-
 doce. 2 vols. Paris, 1925.

_____. "Épiphanie et Théophanie: La Baptème de Jésus
 dans la liturgie et dans l'art chrétien." La Voix
 des Monuments. Paris, 1930, pp. 165-88.

The Jerusalem Bible. New York, 1966.

Johnstone, Pauline. The Byzantine Tradition in Church Em-
 broidery. London, 1967.

Jullian, R. "Les fragments de l'ambon de Benedetto Ante-
 lami à Parme." Mélanges d'archéologie et d'histoire.
 École Française de Rome, XLVI (1929), 182-214.

Jungmann, Joseph A. The Mass of the Roman Rite: Its Origins
 and Development (Missarum Sollemnia). 2 vols. New
 York, 1950.

_____. The Mass of the Roman Rite: Its Origins and De-
velopment. Abridged edition. New York, 1959.

Kantorowicz, E. "Ivories and Litanies." Journal of the War-
burg and Courtauld Institutes, V (1942), 56-81.

_____. The King's Two Bodies; A Study in Medieval Politi-
cal Theology. Princeton, 1957.

Kästner, R. W. Das Münster in Essen. Essen, 1929.

Katzenellenbogen, Adolf. The Sculptural Programs of Chartres
Cathedral. Baltimore, 1959.

Kauffmann, C. M. "The Bury Bible." Journal of the Warburg
and Courtauld Institutes, XXIX (1966), 60-81.

Kirschbaum, Engelbert. Lexikon der christlichen Ikonographie.
Vol. I. Freiburg im Breisgau, 1968.

Koechlin, Raymond. Les Ivoires Gothiques Français. Vol. II.
Paris, 1924.

Krautheimer, Richard. "Introduction to an Iconography of
Medieval Architecture.'" Studies in Early Christian,
Medieval and Renaissance Art. New York, 1969, pp.
115-50.

LaPiana, G. "The Byzantine Theater." Speculum, XI, No. 2
(1936), 171-211.

Lasko, Peter. Ars Sacra: 800-1200. Baltimore, 1972.

Legrand, E. "Description des oeuvres d'art et de l'église
des Saints-Apôtres de Constantinople, poème en vers
iambiques par Constantin le Rhodien." Revue des
études grèques, IX (1896), 63ff.

Lehmann, Edgar. "Die Anordnung des Altäre in der karolin-
gischen klosterkirche zu Centula." Karl der Grosse.
Vol. III: Karolingische Kunst. Dusseldorf, 1965,
pp. 374-83.

Longland, Sabrina. "A Literary Aspect of the Bury St. Ed-
munds Cross." Metropolitan Museum Journal, II (1969),
45-74.

_____. "Pilate Answered: What I Have Written I Have
Written." The Metropolitan Museum of Art Bulletin,
XXVI (1968), 410-29.

_____. "'The Bury St. Edmunds Cross': its exceptional

place in English twelfth-century art." The Connois-
seur, November, 1969, pp. 163-73.

Maffei, Fernanda de'. Mostra di sculture lignee medioevali.
Museo Poldi Pezzoli. Milan, 1957.

Mâle, Émile. L'Art Religieux de la Fin du Moyen Âge en
France. Paris, 1925.

_____. L'Art Religieux du XII siècle en France. Paris,
1928.

Marle, Raymond van. "Die Ikonographie der Afneming van het
kruis tot het eind der 14de eeuw." Het Gildeboek.
1925.

Martin, John. "The Dead Christ on the Cross in Byzantine
Art." Late Classical and Medieval Studies in Honor
of Albert Mathias Friend, Jr. Princeton, 1955, pp.
189-96.

_____. The Illustration of the Heavenly Ladder of John
Climacus. Princeton, 1954.

Masini, Lara Vinca. L'Antelami a Parma: Forma e Colore,
43. Milan, 1965.

Mathews, Thomas F. "Early Chancel Arrangements in the
Churches of Rome." Master's thesis, Institute of
Fine Arts, July, 1962.

_____. The Early Churches of Constantinople: Architec-
ture and Liturgy. University Park, Pa.: Penn State
University, 1971.

Meehan, D., ed. Adamnan's "De Locis Sanctis." Dublin, 1958.

McClure, M. C. The Pilgrimage of Etheria. Translations of
Christian Literature. Series III: Liturgical Texts.
London/New York, n.d.

Meredith, Cecilia, "The Illustration of Codex Ebnerianus."
Journal of the Warburg and Courtauld Institutes, XXIX
(1966), 419-24.

Mersmann, W. "Das Elfenbeinkreuz der Sammlung Topic-Mimara."
Wallraf-Richartz Jahrbuch, XXV (1963), 7-108.

Mesplé, Paul. Toulouse, Musée des Augustins: Les Sculptures
Romanes. Paris, 1961.

Metropolitan Museum of Art: The Middle Ages, Treasures from

the Cloisters and the Metropolitan Museum of Art.
Catalogue of the exhibition at the Los Angeles County
Museum of Art and the Art Institute of Chicago. 1968.

Metropolitan Museum of Art. The Year 1200. Vol. I: The
Exhibition. New York, 1970.

Metz, Peter. The Golden Gospels of Echternach. New York,
1957.

Meyer, E. "Reliquie und Reliquiar im Mittelalter." Fest-
schrift für C. G. Heise. 1950, pp. 57ff.

Meyer, W. Fragmenta Burana, Nachrichten der Königlichen
Gesellschaft der Wissenschaften in Gottingen: Ab-
hendlungen der Philogischen Historischen Klasse.
Berlin, 1901.

Michailides, G. "Échelle mystique chrétienne dessinée sur
lin." Bulletin de la Société d'Archéologie Copte,
XI (1945), 87-94.

Migne, J. P. Patrologia Graeca. Paris, 1857-66.

_____. Patrologia Latina. Paris, 1844-64.

Milchsack, G. Die Oster- und Passionsspiele. I: Die la-
teinische Osterferein. Wolfenbuttel, 1880.

Miljkovic-Pepek, P. "Une icone bilaterale au monastère
Saint-Jean-Prodome, dans les environs de Serrès."
Cahiers Archéologiques, XVI (1966), 177-83.

Millar, E. G. English Illuminated Manuscripts from the Xth
to the XIIIth Century. Paris, 1926.

Milliken, M. "A Danish Champlevé Enamel." The Bulletin of
the Cleveland Museum of Art, VI (June, 1949), 101-03.

Millet, Gabriel. "L'Art des Balkans de l'Italie au XIIIe
Siècle." Atti del V Congresso Internazionale di
Studi Bizantini. Vol. II. Rome, 1940, pp. 247-81.

_____. Recherches sur l'iconographie de l'Évangile aux
XIV, XV et XVI Siècles. Paris, 1916.

Morgan Library. Medieval and Renaissance Manuscripts: Ma-
jor Acquisitions of the Pierpont Morgan Library, 1924-
1974. New York, 1974.

Oertel, Robert. Early Italian Painting to 1400. New York,
1968.

Omont, H. Évangiles avec peintures byzantines du XI siècle. Paris, 1916.

_____. Miniatures des plus anciens manuscrits grecs de la Bibliothèque Nationale. Paris, 1929.

The Oxford Dictionary of the Christian Church. New York, 1966.

Pächt, Otto. The Rise of Pictorial Narrative in Twelfth-Century England. Oxford, 1962.

_____; Dodwell, C. R.; and Wormald, Francis. The St. Albans Psalter. London, 1960.

Palol, P. de, and Hirmer, Max. Early Medieval Art in Spain. London, 1967.

Panofsky, Erwin. Early Netherlandish Painting, Its Origins and Character. 2 vols. Cambridge, 1953.

Park, Marlene. "The Crucifix of Ferdinand and Sancha and Its Relationship to North French Manuscripts." Journal of the Warburg and Courtauld Institutes, XXXV (1973), 77-91.

Petrides, S. "Traités Liturgiques de St. Maxime et de St. Germain traduits par Anastase le Bibliothécaire." Revue de l'Orient Chretien, X (1905), 289-359.

Philip, Lotte Brand. The Ghent Altarpiece and the Art of Jan van Eyck. Princeton, 1971.

Pickering, R. P. Literature and Art in the Middle Ages. Coral Gables, Fla.: University of Miami, 1970.

Planiscig, L. Donatello. Vienna, 1939.

Porter, Arthur Kingsley. Lombard Architecture. Vols. I and III. New Haven, 1917.

_____. Romanesque Sculpture of the Pilgrimage Roads. 10 vols. Boston, 1923.

_____. Spanish Romanesque Sculpture. 2 vols. New York, n.d.

Procacci, Ugo. "Ignoto sculture lignee nel Pisano." Miscellanea di Storia dell'Arte in onore di Igino Benvenuto Supino. Florence, 1933, pp. 233-45.

Quintavalle, Armando O. Antelami sculptor. Milan, 1947.

Quirk, R. N. "Winchester Cathedral in the Tenth Century." Archeological Journal, CXIV (1959), 38ff.

Ragusa, Isa, and Greene, Rosalie B. Meditations on the Life of Christ: An Illustrated Manuscript of the Fourteenth Century, Paris, Bibliothèque Nationale, MS. Ital. 115. Princeton, 1961.

Rampendahl, Erna. Die Ikonographie der Kreuzabnahme vom IX bis XVI Jahrhundert. Bremen, 1916.

Ratkowska, Paulina. "The Iconography of the Deposition without St. John." Journal of the Warburg and Courtauld Institutes, XXVII (1964), 312-17.

Réau, Louis. Iconographie de la Bible. Vol. II: Nouveau Testament. Paris, 1957.

Restle, M. Die Byzantinische Wandmalerei in Kleinasien. 3 vols. Recklinghausen, 1967.

Rhein und Maas, Kunst und Kultur: 800-1400. Cologne, 1972.

Rickert, Margaret. Painting in Britain in the Middle Ages. Baltimore, 1965.

Ringbom, Sixten. Icon to Narrative. Abo, 1965.

Rock, Daniel. The Church of Our Fathers. 4 vols. London, 1905.

Rohault de Fleury. La Messe. Paris, 1883-89.

Sauer, J. Symbolik des Kirchengebaudes. Freiburg, 1924.

Sauerlander, Willibald. "Die Marienkronungsportale von Senlis und Nantes." Wallraf-Richartz Jahrbuch, XX (1958), 115-62.

Schapiro, Meyer. "The Image of the Disappearing Christ in English Art around the Year 1000." Gazette des Beaux-Arts, Series 6, XXIII, No. 913 (1943), 135-52.

Schiel, Hubert, ed. Codex Egberti der Stadtbibliothek Trier. Basel, 1960.

Schiller, Gertrud. Ikonographie der christlicher Kunst. 3 vols. Gütersloh, 1968.

Schlegel, Ursula. "Observations on Masaccio's Trinity Fresco in Santa Maria Novella." The Art Bulletin, XLIV, No. 1 (1963), 19-34.

Schmidt, Otto. <u>Die Miniaturen des Gero Codex</u>. Leipzig, 1924.

_____, ed. <u>Reallexikon der deutschen Kunstgeschichte</u>. 6 vols. Stuttgart, 1937.

Schnitzler, Hermann. "Eine Neuerwerbung des Schnütgen Museums." <u>Der Cicerone: Anzeiger für Sammlung und Kunst Freunde</u>, Heft 2 (1949), 50-54.

_____. <u>Rheinische Schatzkammer</u>. Dusseldorf, 1957.

_____. <u>Rheinische Schatzkammer: Die Romanik</u>. Dusseldorf, 1959.

<u>Das Schnütgen Museum</u>, eine Auswahl. Cologne, 1968.

Schramm, Percy Ernst, and Mütherich, Florentine. <u>Denkmale der deutschen Könige und Kaiser</u>. Munich, 1962.

Schwarzweber, Anne-Marie. <u>Das Heilige Grab in der deutschen Bildnerei des Mittelalters</u>. Freiburg, Breisgau, 1940.

Servières, G. "Les Jubés." <u>Gazette des Beaux-Arts</u>, 1918, pp. 355-80.

Simson, Otto von. "<u>Compassio</u> and <u>Co-Redemptio</u> in Roger van der Weyden's <u>Descent from the Cross</u>." <u>The Art Bulletin</u>, XXV, No. 1 (1953), 10-16.

_____. <u>The Gothic Cathedral</u>. New York, 1956.

Suau, Jean-Pierre. "Les débuts de la sculpture gothique dans l'Eure." <u>Nouvelles de l'Eure</u>, No. 49 (1973), pp. 48-71.

Swarzenski, Georg. "Aus dem Kunstkreis Heinrichs des Löwen." <u>Städel Jahrbuch</u>, VII-VIII (1932), 241-397.

_____. <u>Die Regensburger Buchmalerei des X. und XI. Jahrhunderts</u>. 2d ed. Stuttgart, 1969.

Swarzenski, Hanns. <u>Monuments of Romanesque Art</u>. Chicago, 1967.

Swoboda, K. M. "Der romanische Epiphanie-Zyklus in Lambach und das lateinische Magierspiel." <u>Festschrift für J. Schlosser</u>. Zurich, 1927, pp. 82ff.

Symons, Dom Thomas. "Sources of the Concordia Regularis." <u>Downside Review</u>, New Series, XL (January, 1941), 14-36, 143-70, 264-89.

Taubert, Gesine and Johannes. "Mittelalterliche Kruzifixe mit schwenkbaren Armen; Ein Beitrag zur Verwendung von Bildwerken in der Liturgie." Zeitschrift des deutschen Vereins für Kunstwissenschaft, XXIII (Berlin, 1969), 79-121.

Tschan, Francis J. St. Bernward of Hildesheim. 3 vols. Notre Dame, Indiana, 1951.

Vallance, Aymer. Greater English Church Screens. London, 1947.

Vallery-Radot, J. "Note sur les chapelles hautes dédiées à St. Michel." Bulletin Monumental, 1969, pp. 453-78.

Vanuxem, J. "Les Portails détruits de la Cathédrale de Cambrai et de Saint-Nicolas d'Amiens." Bulletin Monumental, CIII (1945), 89-102.

_____. "La sculpture du XI siècle à Cambrai et à Arras." Bulletin Monumental, 1955, pp. 7-35.

Vavala, Evelyn (Sandberg). La Croce Dipinta Italiana e l'iconografia della passione. 2 vols. Verona, 1929.

Velmans, Tania. "Le Tetraévangile de la Laurentienne." Bibliothèque de Cahiers Archéologiques. Paris, 1971.

Verdier, Philippe. "La grande croix de l'Abbé Suger à Saint-Denis." Cahiers de Civilisation Medievale, X-XII Siècles, XIII (Université de Poitiers, 1970), 1-31.

Vezin, Gilbert. L'Adoration et le Cycle des Mages dans l'Art chrétien primitif. Paris, 1950.

Vikan, G., ed. Illuminated Greek Manuscripts from American Collections: An Exhibition in Honor of Kurt Weitzmann. The Art Museum, Princeton University, 1973.

Volbach, W. F. Early Christian Art. London, 1961.

Vöge, W. Eine deutsche malerschule um die Wende des ersten Jahrtausend; kritische Studien zur Geschichte der Malerei in Deutschland um 10. und 11. Jahrhundert. Lintz, 1891.

Walter, Christopher. Review of Demetrios Pallas, Die Passion und Bestattung Christi in Byzanz: der Ritus--das Bild, Munich, 1965. Revue des Études Byzantines, XXVII (1969), 340.

Watson, A. The Early Iconography of the Tree of Jesse. London, 1934.

Weitzmann, Kurt. "A Tenth Century Lectionary. A Lost Mas-
terpiece of Macedonian Renaissance." Revue des Études
Sud-Est Européennes, IX, No. 3 (Bucharest, 1971).

_____. "Byzantine Miniature and Icon Painting in the
Eleventh Century." Studies in Classical and Byzan-
tine Manuscript Illumination. Chicago, 1971, pp.
271-313.

_____. Catalogue of the Byzantine and Early Medieval
Antiquities in the Dumbarton Oaks Collection. Vol.
III: Ivories and Steatites. Washington, 1972.

_____. "Eine vorikonoclastische Ikone des Sinai mit der
Darstellung des Chairete." Festschrift Johannes Koll-
witz, TORTULAC, Studien zu altchristlichen und byzan-
tinischen Monumenten. Rome, Quartalschrift, 30, Sup-
plementheft, 1966.

_____. "The Narrative and Liturgical Gospel Illustrations."
Studies in Classical and Byzantine Manuscript Illumi-
nation. Chicago, 1971, pp. 247-70.

_____. "The Origin of the Threnos." De Artibus Opuscu-
lum. Vol. LX: Essays in Honor of Erwin Panofsky.
New York, 1961, pp. 476-90.

_____. "Sinai Peninsula: Icon Painting from the Sixth
to the Twelfth Century." Icons from Southeastern Eur-
ope and Sinai. London, 1968.

Wilson, H. A., ed. Missal of Robert of Jumièges. London,
1896.

Young, Karl. The Drama of the Medieval Church. 2 vols.
Oxford, 1967.

_____. "The Dramatic Associations of the Easter Sepul-
chre." University of Wisconsin Studies in Language
and Literature, X, Madison, 1920.

LIST OF ILLUSTRATIONS

13. Peter Paul Rubens, Descent from the Cross, 1611-14; Antwerp, Museum (ibid., Fig. 564).

14. Stone relief: Descent from the Cross, 1115-30; Germany, The Externsteine, near Horn (Creutz, Die Anfänge, pl. V).

15. Wood sculpture: Deposition group, first quarter thirteenth century; Tivoli, Cathedral (Francovich, "A Romanesque School," Fig. 2).

16. Wood sculpture: Deposition group, from Eril-la-Vall (Lerida), second half twelfth century; Vich (Barcelona), Museo Episcopal: Christ, Joseph of Arimathea, and Nicodemus; Barcelona, Museo de Arte de Cataluna: Virgin and John (Palol, Medieval Art in Spain, Fig. 162--two thieves missing).

17. Christ from Deposition Group, second quarter twelfth century; Paris, Louvre (Aubert, Sculptures du Moyen Age, Louvre, Fig. 19).

18. North lunette, west facade: Descent from the Cross, ca. 1140; Foussais, Church of St. Hillaire (Porter, Pilgrimage Roads, VII, Fig. 1061).

19. Corner cloister pillar: Descent from the Cross, 1085-1100; Silos, Monastery of Santo Domingo (Schiller, Ikonographie, II, Fig. 556).

20. Nicolo Pisano ?, Descent from the Cross, 1260-77; Lucca, Church of San Martino (Crichton, Nicola Pisano, Fig. 77).

21. Tympanum: Descent from the Cross, ca. 1150; Schloss Tirol, near Meran, Chapel (photo: postcard).

22. Drawing of Reliquary from St. Servatius, Maastricht, ca. 1100; Nuremberg, Germanische Nationalmuseum (Essenwein, "Ein Reliquiar," Fig. 1).

23. West tribune: perspective photo, late eleventh century; St.-Savin-sur-Gartempe (Deschamps, Peinture Murale, pl. xxix).

24. Tabernacle, French, Limoges, second half thirteenth century; New York, The Metropolitan Museum of Art (photo: Metropolitan Museum of Art).

25. The St. Albans Psalter: Descent from the Cross, pre-1123; Hildesheim, Library of St. Godehard, p. 47 (Pächt, St. Albans Psalter, pl. 29).

26. Cloister capital from Ste.-Marie-la-Daurade: Descent

45

s, ca. 1120; Toulouse, Musée des Augustins
_ulouse, pl. 134).

_s Gospels: Descent from the Cross and Entombment,
_rth French, mid-ninth century; Angers, Municipal Li-
brary, Cod. 24 (Schiller, Ikonographie, II, Fig. 545).

28. Codex Egberti: Descent from the Cross and Entombment,
 ca. 980; Trier, Stadtbibliothek, cod. 24, f. 84b (ibid.,
 Fig. 544).

29. Gospels of Otto III: Crucifixion with Deposition and
 Entombment, ca. 1000; Aachen, Treasury (Bloch-Schnitzler,
 Malerschule, p. 61).

30. Ivory Deposition: English or North French, first half
 twelfth century; Rouen, Musée de Seine Inferieur (Gold-
 schmidt, Elfenbeinskulpturen, pl. VI, No. 22.

31. Ivory Gospel Book cover: Deposition, English, first
 half twelfth century, from Church of St. Maurice in
 Munster; New York, Morgan Library (ibid., pl. VIII, No.
 30).

32. Ivory reliquary top: Deposition, Rhenish, probably from
 Bamberg, 1070-1100; Cologne, Schnütgen Museum (H. Fil-
 litz, Das Mittelalter, I, Berlin, 1969, Fig. 333).

33. Deposition group fragment: Christ and Joseph of Arima-
 thea, from Cambrai, ca. 1180; Lille, Palais des Beaux-
 Arts (The Year 1200, I, No. 1).

34. Ivory Deposition fragment: Christ and Joseph and Arima-
 thea, North French or English, 1200-05; Dublin, Hunt
 Collection (The Year 1200, No. 56).

35. Ivory Deposition: Christ, Joseph and the Virgin, French,
 third quarter thirteenth century; Paris, Louvre (Koech-
 lin, Ivoires, pl. VIII, No. 19).

36. Byzantine Gospel Book: Descent from the Cross, eleventh
 century; Paris, Bib. Nat. Cod. gr. 74, f. 59v (Weitzmann,
 "Threnos," Fig. 7).

37. Byzantine Gospel Book: Descent from the Cross, eleventh
 century; Florence, Laurentian Library, cod. Plut. V.I.
 23, f. 59v. (Velmans, Tetrevangile, Fig. 122).

38. Byzantine ivory plaque: Deposition and Threnos, eleventh
 century; London, Victoria and Albert Museum (Weitzmann,
 "Threnos," Fig. 15).

39. Byzantine ivory plaque: Crucifixion with Deposition and Entombment, eleventh century; Munich, Staatsbibliothek (ibid., Fig. 8).

40. Homilies of Gregory Nazianzenus: Crucifixion leaf (detail), 883-86; Paris, Bib. Nat. Ms Grec 510, f. 30v. (ibid., Fig. 4).

41. Syrian Icon: Crucifixion, mid-eighth century; Sinai, Monastery of St. Catherine (Weitzmann, Icons, Fig. 6).

42. Painted Cross, Pisa No. 20, detail: Descent from the Cross, late twelfth century; Pisa, Museo Nazionale (Vavala, La Croce Dipinta, II, Fig. 437).

43. Ivory Diptych, French, fourteenth century; Paris, Louvre (Koechlin, Ivoires, pl. LXII, No. 237).

44. Bas-relief in exterior of apse: Three Maries at the Tomb, twelfth century; Dax (Landes), Church of St. Paul (Mâle, XII Siècle, Fig. 108).

45. Crucifixion window, detail of lower register: Three Maries at the Tomb, ca. 1165; Poitiers, Cathedral (ibid., Fig. 109).

46. Chasse, French, Limoges, 1200-20; Nantouillet, Church (ibid., Fig. 110).

47. Cloister capital: Three Maries at the Tomb, first half twelfth century; Mozac, Puy-de-Dome (Evans, Cluniac Art, Fig. 162b).

48. Tympanum: Three Maries at the Tomb, twelfth century; Chalais, Charente (ibid., Fig. 160a).

49. Cloister capital from Ste.-Marie-la-Daurade: Three Maries at the Tomb, ca. 1120; Toulouse, Musée des Augustins (ibid., Fig. 164b).

50. Cloister capital: Three Maries at the Tomb, early twelfth century; Herault, St.-Pons-de-Thomieres (ibid., Fig. 160b).

51. South facade frieze: Maries buying Spices, twelfth century; Beaucaire, Notre-Dame-des-Pommiers (Mâle, XII Siècle, Fig. 114).

52. Lintel of south portal, west facade: Maries buying Spices, ca. 1160-70; St. Gilles (Gard) (ibid., Fig. 113).

53. North wing, cloister: Three Maries above, Spice merchants

below, ca. 1170-90; Arles, St. Trophîme (Hamann, S̲t̲.
G̲i̲l̲l̲e̲s̲, Fig. 225).

54. Relief: Spice Buying, from Modena Cathedral, third
quarter twelfth century; Modena, Cathedral Museum (Mâle,
X̲I̲I̲ ̲S̲i̲è̲c̲l̲e̲, Fig. 115).

55. Relief: Three Maries at the Tomb, third quarter twelfth
century; Modena, Cathedral Museum (i̲b̲i̲d̲., Fig. 116).

56. Cloister capital from Ste.-Marie-la-Daurade: Christ
emerging from the Tomb, ca. 1120; Toulouse, Musée des
Augustins (i̲b̲i̲d̲., Fig. 112).

57. Custos Bertholdt, Lectionary from Monastery of St. Peter,
Salzburg: Three Maries at the Tomb, second half eleventh
century; New York, Morgan Library, M. 780, f. 31 (Swar-
zenski, R̲e̲g̲e̲n̲s̲b̲u̲r̲g̲e̲r̲, Fig. 86).

58. Ivory plaque from book cover, Liuthard group, ca. 870;
Munich, Bayr. Staatsbibliothek, Clm 4452 (Heitz, A̲r̲c̲h̲i̲-
t̲e̲c̲t̲u̲r̲e̲ ̲e̲t̲ ̲L̲i̲t̲u̲r̲g̲i̲e̲, pl. XLII).

59. Gero Codex: Initial M, 969-76; Darmstadt, Landesbiblio-
thek, f. 86r. (Schmidt, G̲e̲r̲o̲ ̲C̲o̲d̲e̲x̲, pl. XXVI).

60. Ivory panel: Women at the Sepulchre and Ascension of
Christ, North Italian, ca. 400; Munich, Bavarian National
Museum (Heitz, A̲r̲c̲h̲i̲t̲e̲c̲t̲u̲r̲e̲ ̲e̲t̲ ̲L̲i̲t̲u̲r̲g̲i̲e̲, cover).

61. Ivory Bookcover, Ada group, ninth century; Florence,
Museo Nazionale (i̲b̲i̲d̲., pl. XLI).

62. Uta Codex: Mark portrait page, 1002-36; Munich, Staats-
bibliothek, Clm. 13601, Cim. 54, f. 41v. (Bloch-Schnitzler,
K̲ö̲l̲n̲e̲r̲ ̲M̲a̲l̲e̲r̲s̲c̲h̲u̲l̲e̲, Fig. 413).

63. Three Maries at the Tomb and Harrowing of Hell, eleventh
century; Paris, Bibliothèque de l'Arsenal, MS 1186
(Brooks, "Sepulchre of Christ," Fig. 12).

64. Bamberg Gospels: Portrait of Mark, early eleventh cen-
tury; Munich, Staatsbibliothek, Cod. lat. 4454, Cim. 59,
f. 86v. (Goldschmidt, G̲e̲r̲m̲a̲n̲ ̲I̲l̲l̲u̲m̲i̲n̲a̲t̲i̲o̲n̲, II, pl. 40).

65. Cloister capital: Angels holding veiled cross, from Ste.-
Marie-la-Daurade, ca. 1100; Toulouse, Musée des Augustins
(Evans, C̲l̲u̲n̲i̲a̲c̲ ̲A̲r̲t̲, Fig. 159a).

66. Cloister capital: Angels holding veiled cross, ca. 1100;
Moissac (i̲b̲i̲d̲., Fig. 159b).

67. Donatello, Crucifix, polychromed wood, ca. 1412; Florence, S. Croce (L. Planiscig, Donatello, Vienna, 1939, Fig. 30).

68. West wall, north transept: Last Supper, ca. 1230; Neuenbeken (Westphalia), Church of Sankt Marien (Demus, Romanesque Mural Painting, Fig. 269).

69. West wall, south transept: Deposition, ca. 1230; Neuenbeken (Westphalia), Church of Sankt Marien (ibid., Fig. 270).

70. Ivory Deposition plaque, English, School of Herefordshire, ca. 1150; London, Victoria and Albert Museum (Beckwith, Ivory Carvings, Exhibition catalogue, No. 49).

71. Psalter of Henry of Blois: Crucifixion and Deposition, English, Winchester, ca. 1150; London, British, Museum, Cotton MS Nero C. IV, f. 22 (photo: Taurgo).

72. Psalter: Crucifixion and Deposition, English, ca. 1200; London, British Museum Arundel MS 156, f. 10v (Longland, Connoisseur, Fig. 112).

73. Bury St. Edmunds Cross, English, c. 1150; New York, The Metropolitan Museum of Art, The Cloisters Collection. Front and Reverse (photos: The Metropolitan Museum of Art).

74. Bury St. Edmunds Cross: detail of head of corpus (corpus from Oslo, Kunstindustrimuseet), English, 1180-90 (Beckwith, Ivory Carvings, Fig. 62).

75. Missal of Robert of Jumièges: Descent from the Cross, 1008-25; Rouen, Bibliothèque Publique, Ms. Y.6, f. 72r. (Wilson, Missal of Robert of Jumièges, pl. VII).

76. Buildings at Holy Sepulchre in Jerusalem, as of 348, plan by Conant (Conant, "Holy Sepulchre," pl. V).

77. Apse mosaic of Sta. Pudenziana, Rome, drawing by Wilpert, ca. 391 (ibid., pl. XI).

78. Column of the Flagellation in Basilica of Mt. Sion, drawing by Arculf; Vienna, Cod. 458, f. 9v. (Meehan, De Locis Sanctis, p. 62).

79. Church of St. Riquier-St. Sauveur, Centula, drawing by Petau, 1612 (Heitz, Architecture et Liturgie, pl. I).

80. Plans of altars at Centula: by W. Effmann, above; E. Lehmann, below (Lehmann, "Centula," Figs. 2 and 3).

81. Reconstruction of Constantinian basilica of St. Peter,
 by Frazer (Krautheimer, Studies, Fig. 12).

82. Porch frescoes, late eleventh century; St.-Savin-sur-
 Gartempe (Deschamps, Peinture Murale, pl. XXVII).

83. Puerta del Perdon, early twelfth century: León, Collegi-
 ate Church of San Isidoro (Palol, Medieval Art in Spain,
 Fig. 86, below).

84. Collegiate Church at Essen, drawing of facade and atrium,
 before 1848, by F. von Quast (Heitz, Architecture et
 Liturgie, pl. XVII).

85. Collegiate Church at Essen: Interior looking toward
 west work (R. W. Kästner, Das Münster in Essen, Essen,
 1929, pl. IV).

86. Elevation of westwork at Essen, by H. Jantzen (Heitz,
 Architecture et Liturgie, Fig. 21).

87. Collegiate Church at Essen, plan of eleventh century
 church, by F. Arens (ibid., fig. 39).

88. Column of Bernward of Hildesheim, ca. 1020; pre-World
 War II, Hildesheim, Cathedral (Tschan, Bernward of Hild-
 esheim, Fig. 147).

89. Easter Sepulchre, English, fifteenth century: Cranley
 (Brooks, "Sepulchre of Christ," Fig. 22).

90. Easter Sepulchre, fifteenth century; Constance, Cathe-
 dral: Moritzkapelle (Young, Drama, I, pl. VIII).

91. Easter Sepulchre, eleventh century; Aquileia, Cathedral
 (Brusin, Aquileia, Fig. 115).

92. Easter Sepulchre, tomb inside, eleventh century; Aquileia,
 Cathedral (ibid., Fig. 116).

93. Crypt, view from southwest, end twelfth century; Aquileia,
 Cathedral (Demus, Romanesque Mural Painting, Fig. 9).

94. Crypt fresco: Descent from the Cross, end twelfth cen-
 tury; Aquileia, Cathedral (Brusin, Aquileia, Fig. 139).

95. Mosaic fragment from San Marco: Holy Women, early
 twelfth century; Venice, Museo Marciano (ibid., Fig. 153).

96. Ascension Master, Fortitudo and Temperantia, late twelfth
 century; Venice, San Marco (Demus, Byzantine Art and the
 West, Fig. 148).

97. Right apsidiole: Descent from the Cross, twelfth century; Udine, S. Maria di Castello (Brusin, <u>Aquileia</u>, Fig. 187).

98. Chapel of the Holy Sepulchre, east wall, above: Christ in Majesty; below: Deposition, ca. 1220-40, Winchester Cathedral (Demus, <u>Romanesque Mural Painting</u>, Fig. 238).

99. Chapel of the Holy Sepulchre, East Wall, lunette: Deposition and Entombment, late twelfth century; Winchester, Cathedral (<u>ibid.</u>, pl. on p. 123).

100. Anselmo da Campiono, Roodscreen, 1160-80; Modena, Cathedral (Francovich, <u>Antelami</u>, Fig. 74).

101. Cross foot from monastery of St. Michael, Lüneberg, from Braunschweig, ca. 1170; Hannover, Kestner Museum (Bloch, "Die Weimarer Kreuzfuss," Fig. 21).

102. Cross foot, from Cologne, ca. 1130; Nuremberg, Germanischen Nationalmuseum (<u>ibid.</u>, Fig. 1).

103. East <u>Lettner</u>, ca. 1230; Naumburg, Cathedral. (<u>Lexikon für Kirche und Theologie</u>, VI, p. 993, Fig. 2).

104. Roodscreen, 1329-37; Gloucester, Abbey Church (Vallance, <u>Screens</u>, Fig. 47).

105. Roodscreen, mid-thirteenth century; Gelnhausen, Marienkirche (<u>Lexikon</u>, VI, p. 993, Fig. 5).

106. Gero Cross, wood, Cologne, 970-76; 187 cm.; Cologne, Cathedral (Elbern, <u>Das erste Jahrtausend</u>, Fig. 365).

107. Wood Crucifix, Lower Saxony (Hildesheim), ca. 1000, 162 cm.; Ringelheim, Church (<u>ibid.</u>, Fig. 431).

108. Wood Crucifix, Westphalia, mid-eleventh century; Benninghausen (diocese of Cologne), Church (<u>ibid.</u>, Fig. 364).

109. Wood Crucifix, Cologne, mid-eleventh century, 210 cm.; Gerresheim, Church of Sta. Margarete (<u>ibid.</u>, Fig. 363).

110. Holy Grave, ca. 1440; Weinhausen, Church (Appuhn, "Weinhausen," Fig. 99.

111. Reichskreuz, West German (Fulda?), ca. 1030, 77 cm.; Vienna, Treasury (a. Front: Elbern, <u>Das erste Jahrtausend</u>, Fig. 302; b. Reverse: Schramm-Mutherich, <u>Denkmale</u>, Fig. 145).

112. True Cross Reliquary of Bernward of Hildesheim, 996; Hildesheim, Treasury (Elbern-Reuther, <u>Hildesheim</u>, Fig. 1).

113. Theophanu's Reliquary Cross, West German, mid-eleventh
century, 44.5 cm.; Essen, Münsterschatz (a. Front:
Elbern, Das erste Jahrtausend, Fig. 203; b. Reverse:
Schnitzler, Rheinische Schatzkammer, 1957, Fig. 154).

114. Cloisonné Enamel Cross, Rhenish, c. 1000, 46 cm.; Es-
sen, Münsterschatz (a. Front: Elbern, Das erste
Jahrtausend, Fig. 377; b. Reverse: Schnitzler,
Rheinische Schatzkammer, 1957, Fig. 146).

115. Cross of Lothair, Rhenish (Cologne), end tenth century,
50 cm.; Aachen, Treasury (a. Front: Elbern, Das
erste Jahrtausend, Fig. 303; b. Reverse: Schnitzler,
Rheinische Schatzkammer, 1957, Fig. 92).

116. Early Mathilda Cross, Rhenish (Cologne), 973-982, 44.5
cm.; Essen, Münsterschatz (a. Front: Elbern, Das
erste Jahrtausend, Fig. 376; b. Donor plaque:
Schnitzler, Rheinische Schatzkammer, 1957, Fig. 145;
c. Reverse: ibid., Fig. 142).

117. Later Mathilda Cross, Essen (?), early eleventh cen-
tury, 45 cm.; Essen, Münsterschatz (a. Front: El-
bern, Das erste Jahrtausend, Fig. 378; b. Reverse:
Schnitzler, Rheinische Schatzkammer, 1957, Fig. 150).

118. Bernward's Silver Cross, Hildesheim, 1007-08, 20.2 cm.;
Hildesheim, Treasury (a. Front: Elbern, Das erste
Jahrtausend, Fig. 423; b. Reverse: Elbern-Reuther,
Hildesheim, Fig. 4).

119. Processional cross, Mosan, second half twelfth century;
Cologne, Schnütgen Museum (Das Schnütgen Museum, 1964,
Fig. 23).

120. Reliquary from Kloster Escherde, Lower Saxony (Hildes-
heim), twelfth century; Hildesheim, Treasury of St.
Magdalen (Elbern-Reuther, Hildesheim, Fig. 13).

121. Gisela Cross, Regensburg, c. 1006; Munich, Schatzkammer
der Residenz (Schramm-Mütherich, Denkmale, Fig. 143).

122. Tirolus Iafarinus, Italian processional cross, from
Belluno, first half of twelfth century; Princeton
Art Gallery (C. O. von Kleinbusch, Jr., Memorial
Collection) (photos Front and Reverse: Princeton
Art Gallery).

123. Dedication of cross by King Cnut and Queen Aelfygu:
Liber Vitae of New Minster, c. 1020-30; London,
British Museum, Stowe MS 944, f. 6r. (photo: Taurgo).

124. Last Judgment: <u>Liber Vitae</u> of New Minster; London, British Museum, Stowe MS 944: a. f. 6v; b. f. 7r. (photos: Taurgo).

125. Gunhild's cross, walrus ivory, Anglo-Saxon (?), c. 1075; Copenhagen, National Museum (a. Front: Beckwith, <u>Ivory Carvings</u>, Fig. 82; b. Reverse: <u>ibid</u>., Fig. 83).

126. Ivory Crucifix of Ferdinand and Sancha, Spanish, 1054-56; Madrid, Museo Arqueologico (a. Front: Fillitz, <u>Das Mittelalter</u>, Fig.125b; b. Reverse: Park, "The Crucifix of Ferdinand and Sancha," pl. 7).

127. Last Judgment, ivory, Anglo-Saxon, late eighth or early ninth century, 13.2 cm.; London, Victoria and Albert Museum, Webb Collection (Beckwith, <u>Ivory Carvings</u>, Fig. 1).

128. Aethelstan Psalter: Christ with Choirs of Saints, second quarter tenth century; London, British Museum, MS Cotton Galba A. XVIII, f. 2v. (Deshman, "Anglo-Saxon Art after Alfred," Fig. 1).

129. Aethelstan Psalter: Christ with Choirs of Saints, second quarter tenth century; London, British Museum, MS Cotton Galba A. XVIII, f. 21 (<u>ibid</u>., Fig. 2).

130. Last Judgment, ivory, Anglo-Saxon, late tenth or early eleventh century; Cambridge, University Museum of Archaeology and Ethnology (<u>ibid</u>., Fig. 4).

131. Processional Cross, Cologne, end eleventh and first quarter twelfth century; Cologne, Parish Church of Sankt Maria Lyskirchen (<u>Rhein und Maas</u>, H 7).

132. Enamel Reliquary, Danish or North German, c. 1100-50; New York, The Metropolitan Museum of Art (photo: The Metropolitan Museum of Art).

133. The Frøsler Casket, Danish or North German, c. 1100; Copenhagen, National Museum (Braun, <u>Meisterwerke</u>, Fig. 31).

134. Courajod Christ: detail, wood, second quarter twelfth century; Paris, Louvre (Aubert, <u>Louvre: Sculptures du Moyen Âge</u>, Fig. 20).

135. Tympanum: Apocalyptic Christ, c. 1115; Moissac, Church of St. Pierre (Fillitz, <u>Das Mittelalter</u>, Fig. 278).

136. Corpus, wood, Catalan, third quarter twelfth century;

Boston, Isabella Stewart Gardner Museum (photo: Isabella Stewart Gardner Museum).

137. Corpus, wood, Catalan, end twelfth century; Barcelona, Museo Marés (Palol, Early Medieval Art in Spain, Fig. 164).

138. Head of Christ, wood, Diocese of Urgel, 1147; Barcelona, Museo de Arte de Cataluna (ibid., Fig. 160).

139. Deposition group, wood, third quarter thirteenth century; Volterra, Cathedral (Francovich, "Romanesque School of Wood Carvers," Fig. 31).

140. Deposition group, wood, third quarter thirteenth century; Florence, San Miniato al Tedesco, Arciconfraternita della Misericordia (Carli, Scultura Lignea Italiana, Fig. xxxviii).

141. Crucifix, wood, from Santa Maria di Roncione, near Deruta, 1236; Perugia, Pinacoteca (Francovich, "Romanesque School of Wood Carvers," Fig. 12).

142. Deposition group, wood, first quarter thirteenth century; Paris, Collection of Brimo de Laroussihle (ibid., Fig. 1).

143. The Virgin and John, wood, c. 1100; Paris, Cluny Museum (Carli, Scultura Lignea Italiana, Figs. xxx and xxxi).

144. Presbyter Martinus, Madonna and Child, wood, from Borgo San Sepolchro, 1199; Berlin, Staatliche Museum (ibid., Fig. xvii).

145. Antelami, reliefs of the months: November, end twelfth century; Arezzo, Duomo (Francovich, Antelami, Fig. 528).

146. Antelami, Deposition: detail of Luna, 1178; Parma, Cathedral (ibid., Fig. 195).

147. Lion column bases, c. 1178; Parma, Museum (a. and b.: ibid., Figs. 207 and 208).

148. Capital: God leads Adam and Eve to Eden, c. 1178; Parma, Museum (ibid., Fig. 209).

149. Capital: Temptation of Eve, c. 1178; Parma, Museum (ibid., Fig. 210).

150. Capital: The Original Sin, c. 1178; Parma, Museum (ibid., Fig. 211).

151. Capital: Adam and Eve in Their Shame, c. 1178; Parma, Museum (_ibid._, Fig. 212).

152. Capital: Expulsion of Adam and Eve from Eden, c. 1178; Parma, Museum (_ibid._, Fig. 213).

153. Capital: Adam Tilling as Eve Spins, c. 1178; Parma, Museum (_ibid._, Fig. 214).

154. Capital: Sacrifice of Cain and Abel, c. 1178; Parma, Museum (_ibid._, Fig. 215).

155. Capital: Cain's Murder of Abel, c. 1178; Parma, Museum (_ibid._, Fig. 216).

156. Capital: Judgment of Solomon, c. 1178; Parma, Museum (_ibid._, Fig. 217).

157. Capital: David Told of Death of Absalom, c. 1178; Parma, Museum (_ibid._, Fig. 218).

158. Capital: Sheba and Absalom, c. 1178; Parma, Museum (_ibid._, Fig. 219).

159. Capital: Solomon and Sheba, c. 1178; Parma, Museum (_ibid._, Fig. 220).

160. Altar Frontal: Deposition, early thirteenth century; Bardone, Church (_ibid._, Fig. 193).

161. Altar Frontal: Christ in Majesty, early thirteenth century; Bardone, Church (_ibid._, Fig. 192).

162. Christ in Majesty, marble relief, c. 1178; Parma, Cathedral (_ibid._, Fig. 205).

ILLUSTRATIONS

I

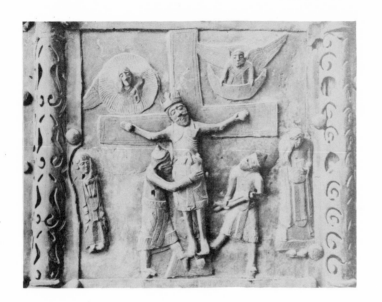

Fig. 1.

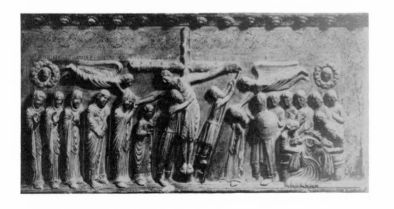

Fig. 2.

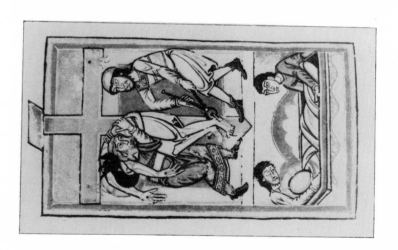

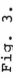

Fig. 4.

Fig. 3.

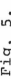

III

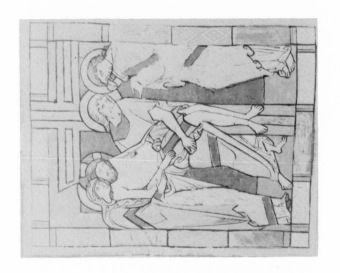

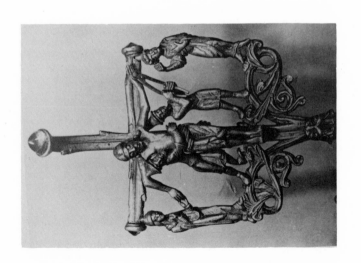

Fig. 6.

Fig. 5.

Fig. 7.

Fig. 8.

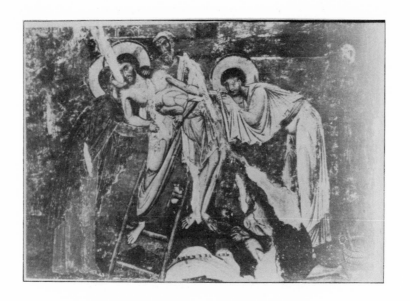

Fig. 9.

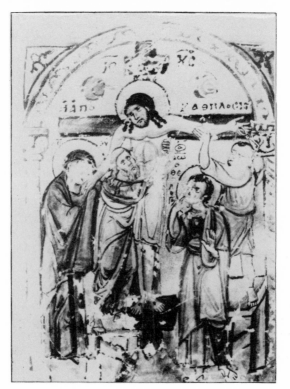

Fig. 10.

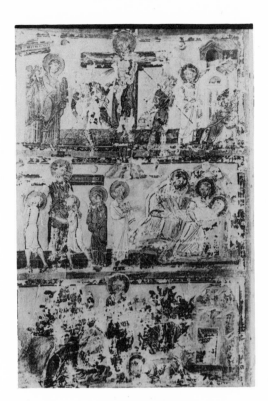

Fig. 11.

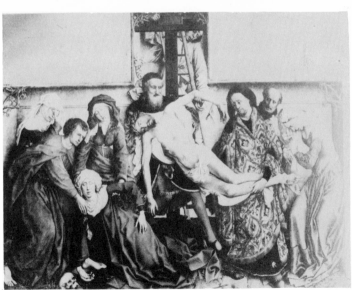

Fig. 12.

Fig. 14.

Fig. 13.

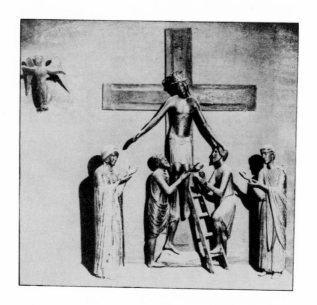

Fig. 15.

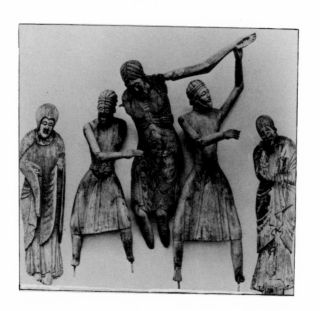

Fig. 16.

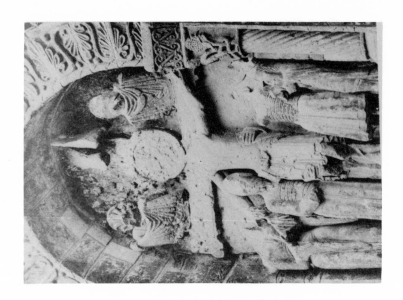

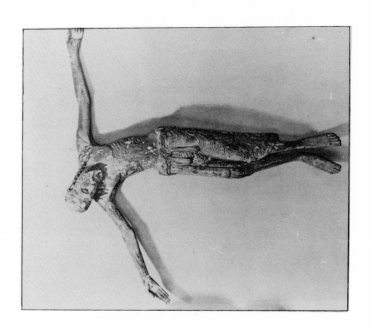

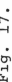

Fig. 18.

Fig. 17.

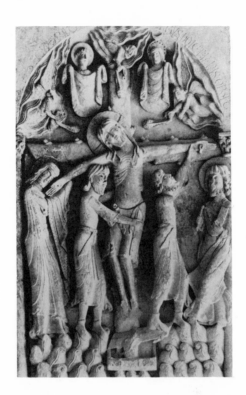

Fig. 19.

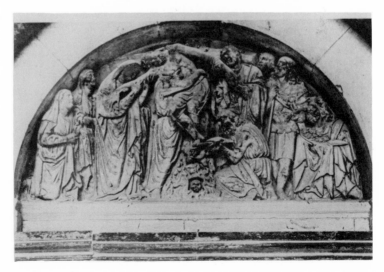

Fig. 20.

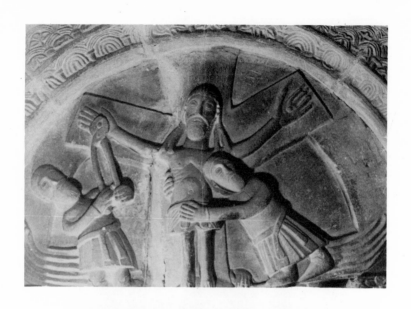

Fig. 21.

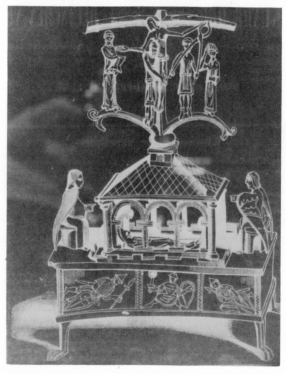

Fig. 22.

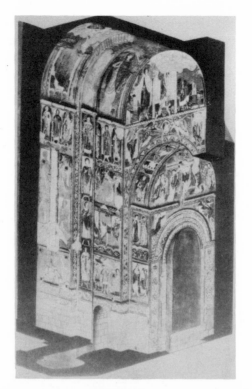

Fig. 23.

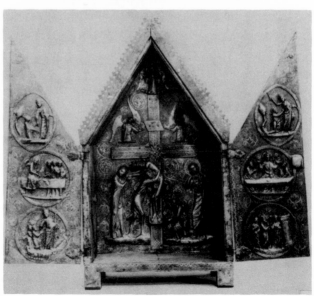

Fig. 24.

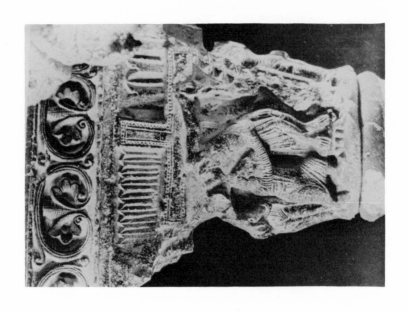

Fig. 26.

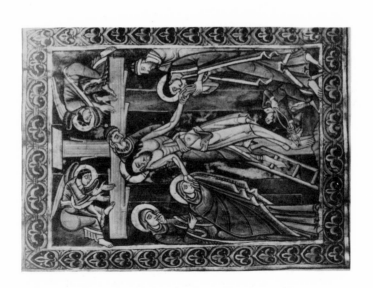

Fig. 25.

Fig. 28.

Fig. 27.

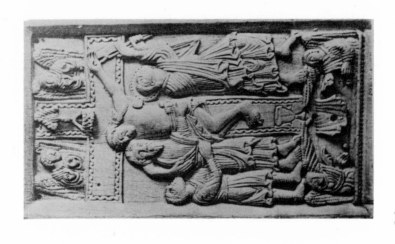

Fig. 30.

Fig. 29.

XVI

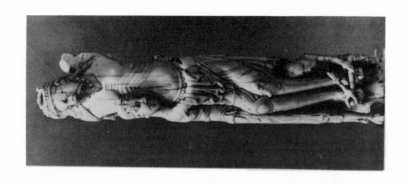

Fig. 32.

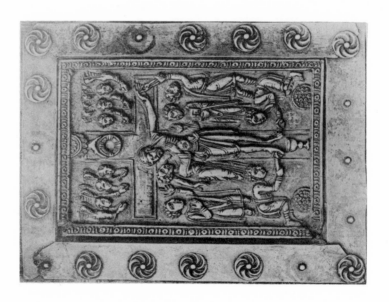

Fig. 31.

Fig. 33.

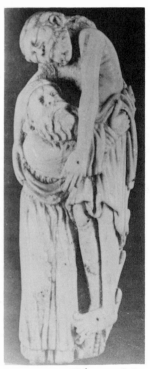

Fig. 34.

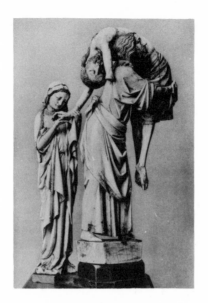

Fig. 35.

Fig. 36.

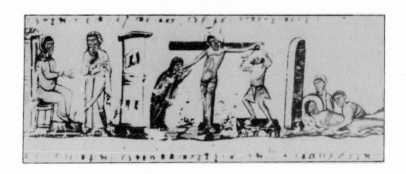

Fig. 37.

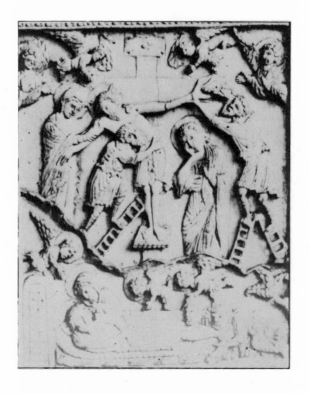

Fig. 38.

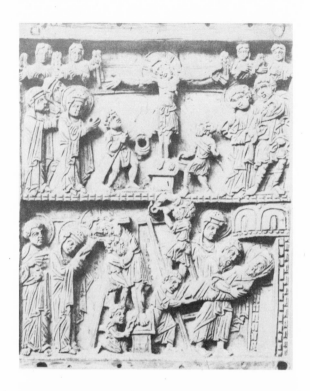

Fig. 39.

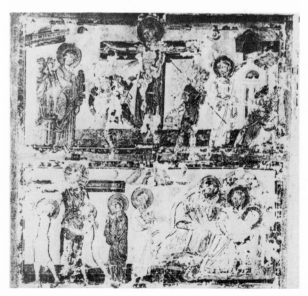

Fig. 40.

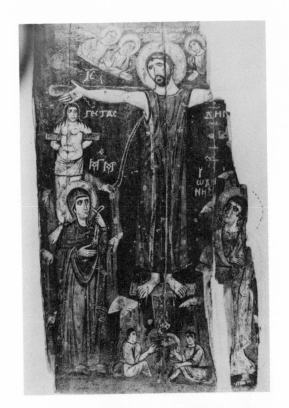

Fig. 41.

Fig. 42.

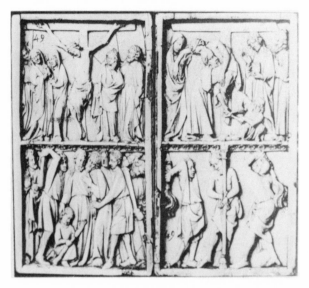

Fig. 43.

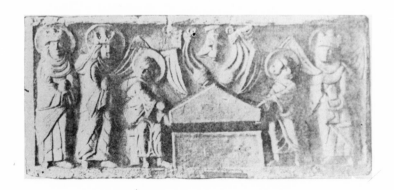

Fig. 44.

Fig. 45.

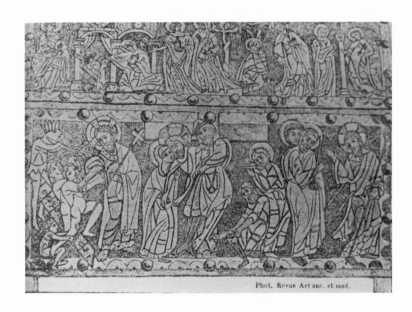

Phot. Revue Art anc. et mod.

Fig. 46.

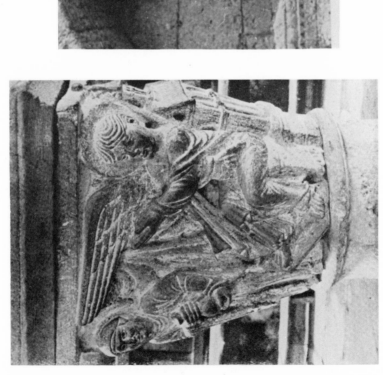

Fig. 48.

Fig. 47.

Fig. 49.

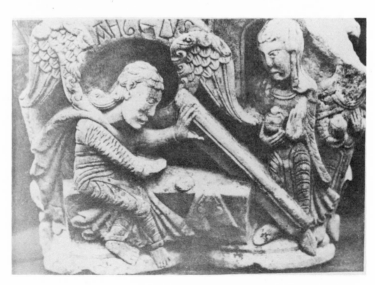

Fig. 50.

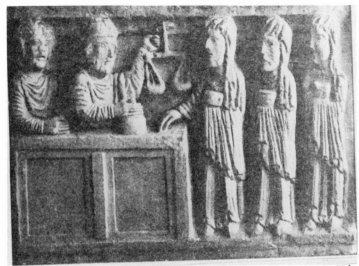

Fig. 51.

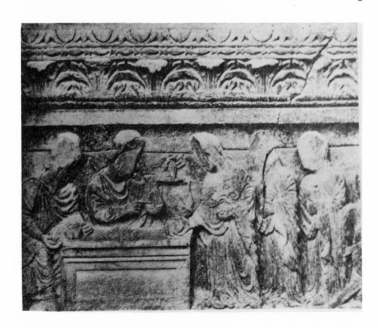

Fig. 52.

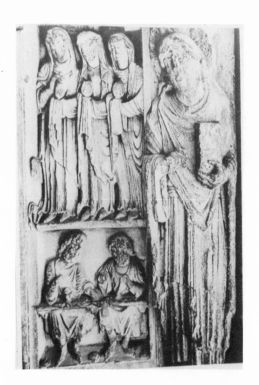

Fig. 53.

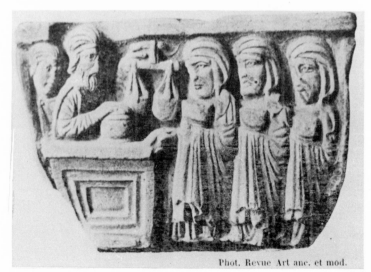

Phot. Revue Art anc. et mod.

Fig. 54.

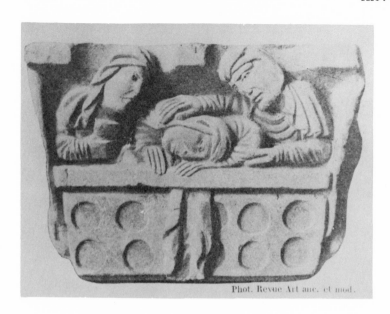

Phot. Revue Art anc. et mod.

Fig. 55.

Fig. 56.

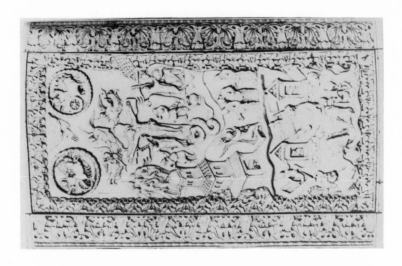

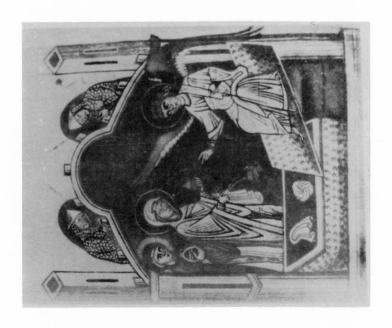

Fig. 58.

Fig. 57.

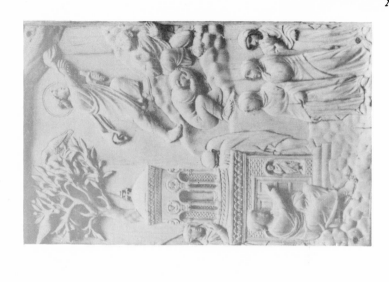

Fig. 60.

Fig. 59.

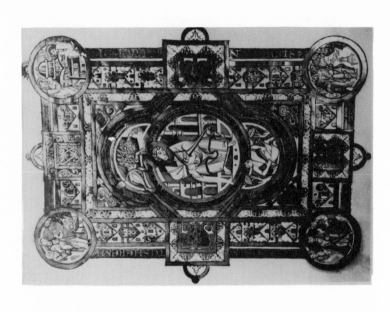

Fig. 62.

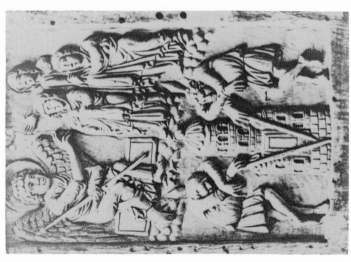

Fig. 61.

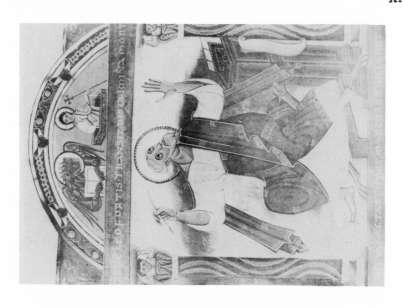

Fig. 64.

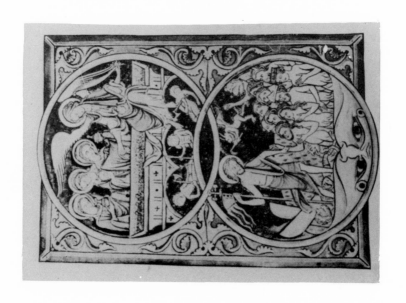

Fig. 63.

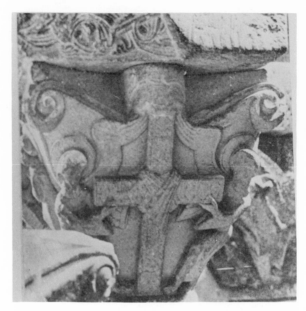

Fig. 65.

Fig. 66.

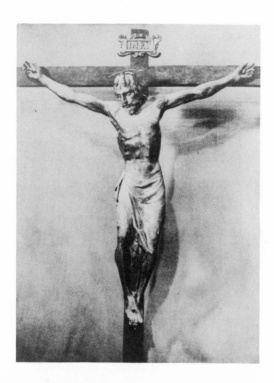

Fig. 67.

Fig. 68.

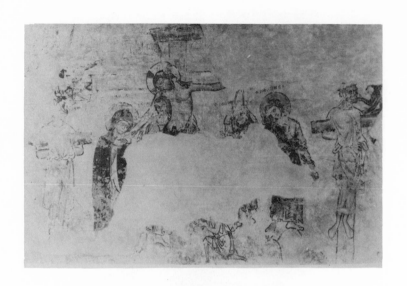

Fig. 69.

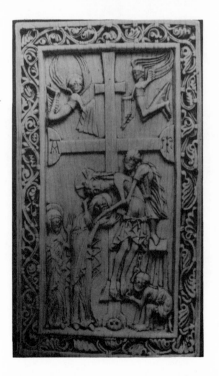

Fig. 70.

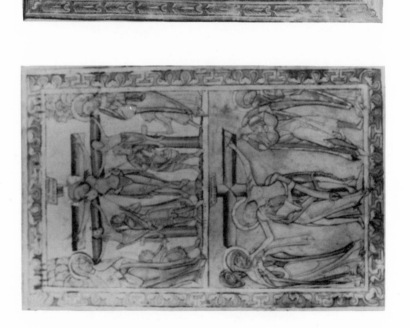

Fig. 72.

Fig. 71.

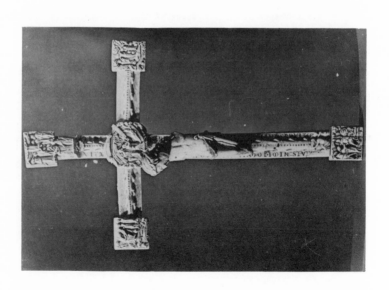

Fig. 73b.

Fig. 73a.

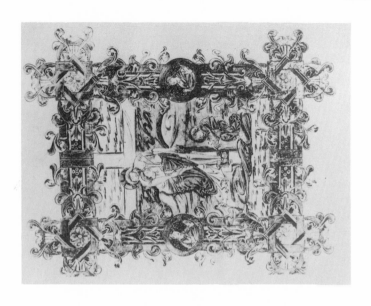

Fig. 75.

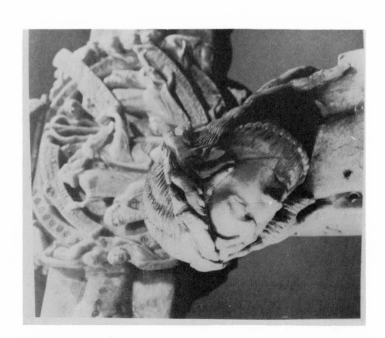

Fig. 74.

Fig. 76.

Fig. 77.

Fig. 79.

Fig. 78.

Fig. 2 Centula, Klosterkirche. Anordnung der Altäre nach Effmann

Fig. 3 Centula, Klosterkirche. Anordnung der Altäre, neuer Vorschlag

Fig. 80.

Fig. 81.

Fig. 82.

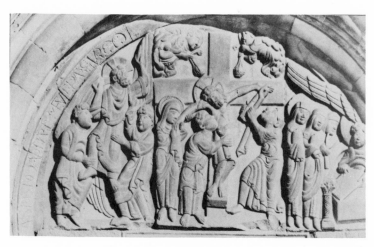

Fig. 83.

Fig. 85.

Fig. 84.

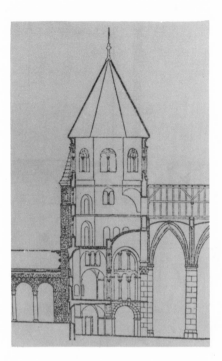

Fig. 86.

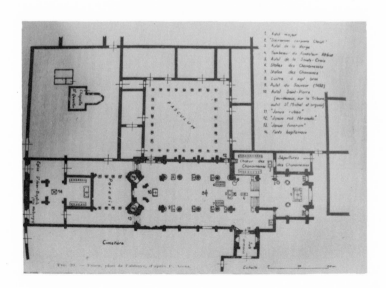

Fig. 87.

Fig. 89.

Fig. 88.

XLVI

Fig. 91.

Fig. 90.

Fig. 92.

Fig. 93.

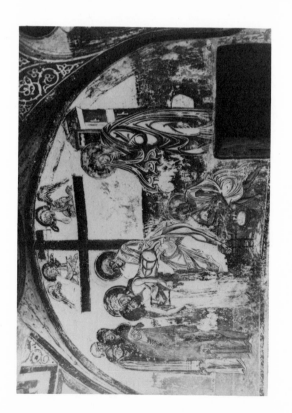

Fig. 95.

Fig. 94.

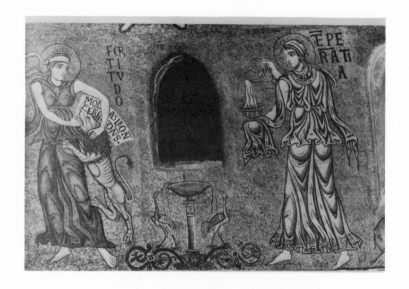

Fig. 96.

Fig. 97.

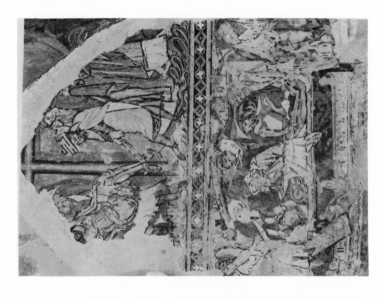

Fig. 99.

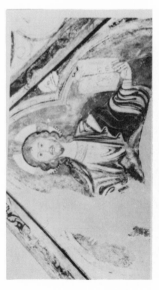

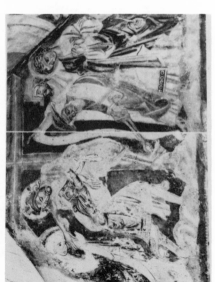

Fig. 98.

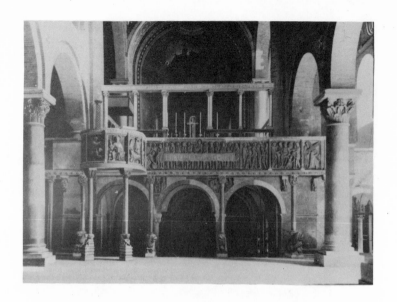

Fig. 100.

Fig. 101.

Fig. 103.

Fig. 102.

Fig. 104.

Fig. 105.

LIV

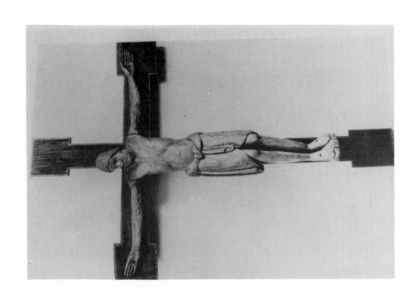

Fig. 107.

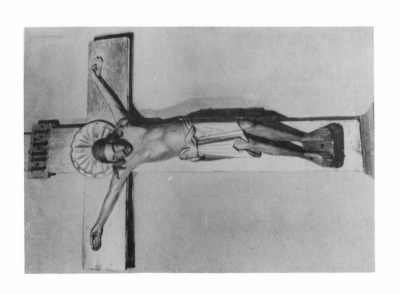

Fig. 106.

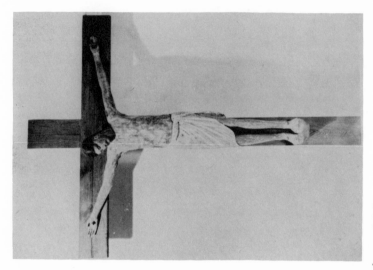

Fig. 109.

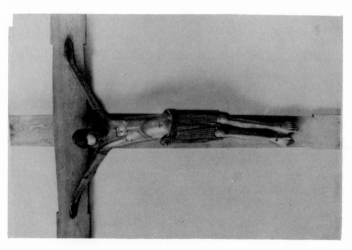

Fig. 108.

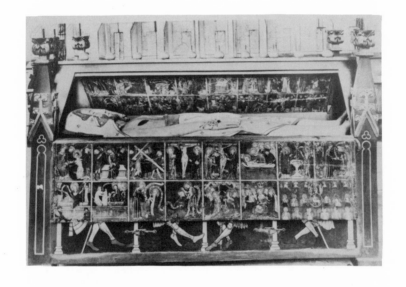

Fig. 110.

Fig. 111b.

Fig. 111a.

Fig. 112.

Fig. 113b.

Fig. 113a.

Fig. 114b.

Fig. 114a.

Fig. 115 b.

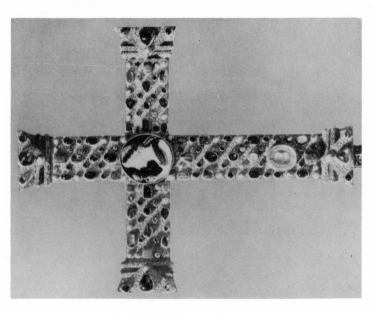

Fig. 115 a.

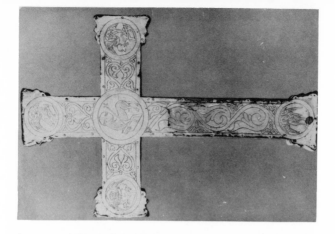

Fig. 116c.

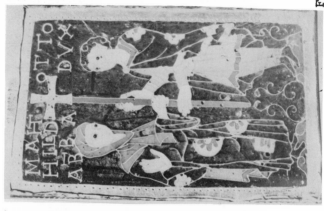

Fig. 116b.

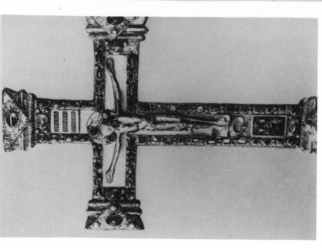

Fig. 116a.

Fig. 117 b.

Fig. 117 a.

LXIV

Fig. 118 b.

Fig. 118 a.

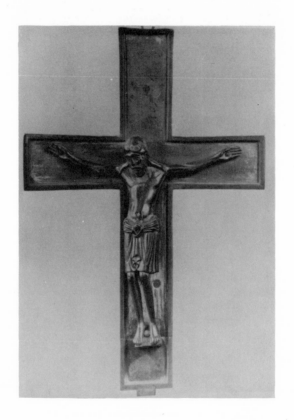

Fig. 119.

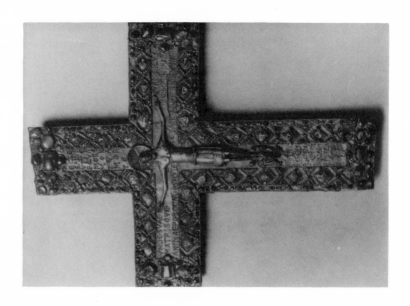

Fig. 121.

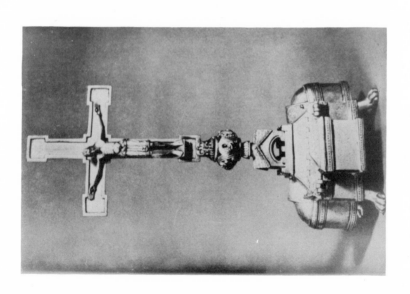

Fig. 120.

Fig. 122b.

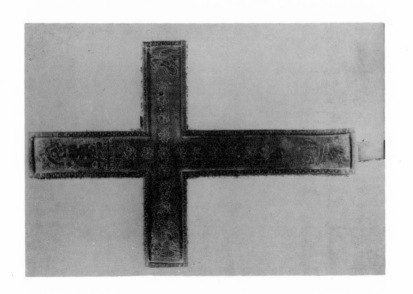

Fig. 122a.

LXVIII

Fig. 124b

Fig. 124a

Fig. 123.

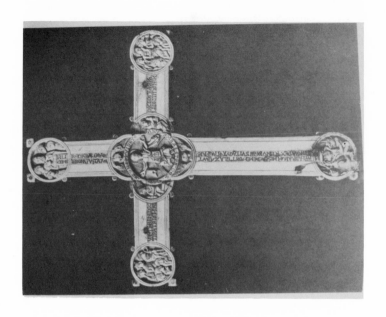

Fig. 125b.

Fig. 125a.

Fig. 126 b.

Fig. 126 a.

Fig. 128.

Fig. 127.

Fig. 130.

Fig. 129.

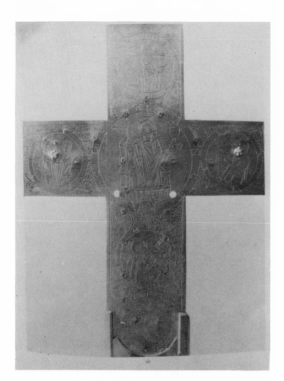

Fig. 131.

Fig. 132.

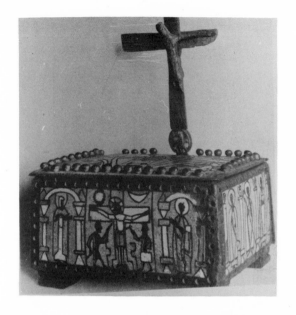

Fig. 133.

Fig. 134.

Fig. 135.

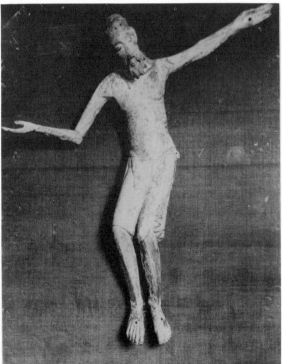

Fig. 136.

Fig. 138.

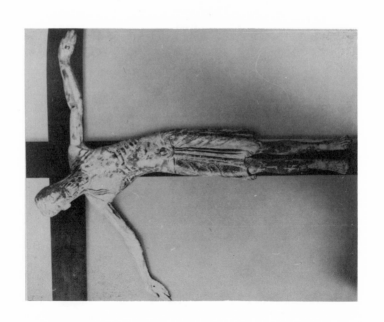

Fig. 137.

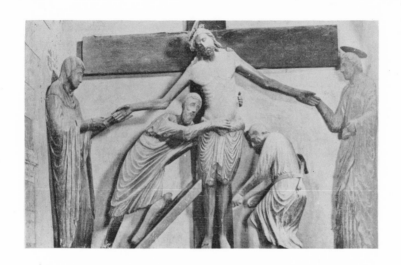

Fig. 139.

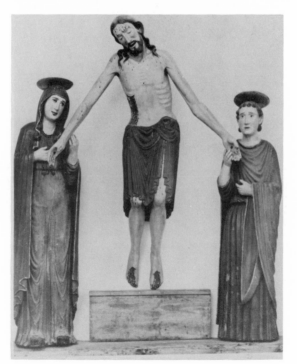

Fig. 140.

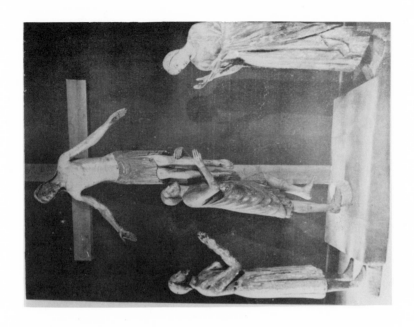

Fig. 142.

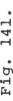

Fig. 141.

Fig. 144.

Fig. 143.

Fig. 145.

Fig. 146.

Fig. 147 a.

Fig. 147 b.

Fig. 149.

Fig. 148.

Fig. 151.

Fig. 150.

Fig. 153.

Fig. 152.

Fig. 155.

Fig. 154.

Fig. 157.

Fig. 156.

Fig. 159.

Fig. 158.

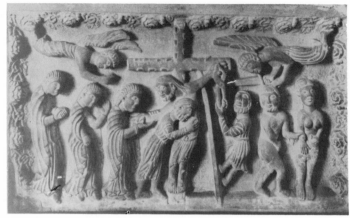

Fig. 160.

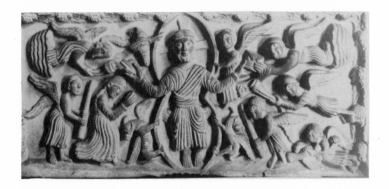

Fig. 161.

Fig. 162.